# Memory Passages

NATASHA GOLDMAN

# Memory Passages

*Holocaust Memorials in the United States and Germany*

TEMPLE UNIVERSITY PRESS
*Philadelphia • Rome • Tokyo*

TEMPLE UNIVERSITY PRESS
Philadelphia, Pennsylvania 19122
*tupress.temple.edu*

Paperback edition published 2022
Cloth edition published 2020

Library of Congress Cataloging-in-Publication Data

Names: Goldman, Natasha, 1970- author.
Title: Memory passages : Holocaust memorials in the United States and Germany
  / Natasha Goldman.
Description: Philadelphia : Temple University Press, 2020. | Includes
  bibliographical references and index. |
Identifiers: LCCN 2019010529 (print) | LCCN 2019011036 (ebook) | ISBN
  9781439914250 (E-book) | ISBN 9781439914236 (cloth : alk. paper)
Subjects: LCSH: Holocaust memorials—United States. | Holocaust
  memorials—Germany. | Memorialization—United States. |
  Memorialization—Germany. | Art and history—United States. | Art and
  history—Germany.
Classification: LCC D804.17 (ebook) | LCC D804.17 .G65 2020 (print) | DDC
  940.53/18640943—dc23
LC record available at https://lccn.loc.gov/2019010529

ISBN 9781439914243 (paperback : alk. paper)

♾ The paper used in this publication meets the requirements of the American National
Standard for Information Sciences—Permanence of Paper for Printed Library Materials,
ANSI Z39.48-1992

Printed in the United States of America

081222P

*Dedicated to* Joachim, Tobias, *and* Adam

# Contents

# Acknowledgments

THE FOLLOWING CHAPTERS are the result of the help, guidance, and encouragement I have received from countless individuals. In their earliest stages, parts of chapters are indebted to the gracious feedback I received from Thomas DiPiero, Michael Ann Holly, Catherine M. Soussloff, and Janet Wolff. I wish to thank Wolfgang Kemp, Charlotte Schoell-Glass, Martine Warnke, and Monika Wagner, of the Universität Hamburg. I thank the artists, Holocaust survivors and their families, archivists, librarians, and photographers who have generously contributed to my research; they include Constantin Beyer, Sebastian Fehrenbach, Debbie Feith Tye, Douglas Feith, Eddie Gastfriend, Samuel Gruber, Angela Lammert, Mark Lammert, Joel Shapiro, the late Abram Shnaper, Jochen Teufel, and the entire staff of the Ravensbrück archive. Many thanks to Jennifer Edwards, Ann Haas, and Martha Janeway, of the Department of Art at Bowdoin College, for their continuous support over the past nine years. Special thanks go to Sara Cohen, my editor, and to Jamie Armstrong, Michelle Beckett, Anne Clifford, and Cheryl Uppling, who copyedited my text. Thank you to my colleagues, students, and staff at Bowdoin College, Colgate University, Syracuse University, the University of Texas at El Paso, and, finally, the Fogg Art Museum at Harvard University, for bringing us back to Boston.

Three of my previously published essays form the basis for this book, and I thank the scholars with whom I worked, especially Paul Jaskot, Margaret Olin, and Helene Sinnreich. The published essays include the following: "From Ravensbrück to Berlin: Will Lammert's Monument to the Deported

Jews (1957/1985)," *Images: A Journal of Jewish Arts and Culture*; "'Never Bow Your Head, Be Helpful, and Fight for Justice and Righteousness': Nathan Rapoport and Philadelphia's Holocaust Memorial (1964)," *Journal of Jewish Identities*; and "Marking Absence: Remembrance and Hamburg's Holocaust Memorials," in *Beyond Berlin: Twelve German Cities Confront the Past*, ed. Gavriel D. Rosenfeld and Paul B. Jaskot (Ann Arbor: University of Michigan Press, 2008).

Financial support for this project was generously provided by the Fulbright-Hays Commission, DAAD (German American Exchange Program), Deutsche Forschungsgemeinschaft, the United States Holocaust Memorial Museum, and Bowdoin College.

Many friends and colleagues on both sides of the Atlantic contributed to this project in numerous ways. For enduring friendship and intellectual conversation, my thanks go to Daniel Bosch, Lisa Botshon, Karyn Butts, Hanneke Grootenboer, Nicole Kirby, Lisa Lee, Olaf Nommenson, Aurora Rodonò, and Jennifer Taback. For their thoughtful engagement with research about the Holocaust and for their feedback on my work I am gratefully appreciative of scholars Samantha Baskind and Steven Cerf. Five years of summer writing groups would not have been possible without the friendship and intellectual companionship of Connie Chiang and Vyjayanthi Selinger. Thank you, Russ Rhymer, for suggesting the title. I am indebted to my parents, Marilyn Bass Goldman and the late Marvin Goldman, for instilling in me a love of art and the interpretation of it. Thank you to my sister, Jessica Smith, and to my brother, Alexander H. Goldman, for always being there for me. Thank you also to the Homann family. I will always remember with great delight the neighborhood children running into my home and asking, "Did you finish your book??" And thank you most of all to my family, Joachim, Tobias, and Adam, who have witnessed my trials and errors, who are constant sources of joy, and to whom I dedicate this book.

# Memory Passages

# Introduction

## *Memory Passages*

OVER THE PAST EIGHT DECADES, Holocaust memorials have been commissioned by representatives of various publics, designed by artists and architects, and viewed by millions of passersby. The study of these sculptures is particularly enriching, as it intersects art history, history, memory theory (both individual and collective), politics, and cultural studies, among other fields. Tracing the development of such memorials from the postwar period to the early twenty-first century, this book analyzes case studies from the United States, the German Democratic Republic (GDR), the Federal Republic of Germany (FRG), and unified Germany. Memorials, a particular genre of public art, offer case studies in the humanities for how interpretations of the past have changed over time in different communities and nations, and whether or not visual forms embody those interpretations. The focus on the visual field makes this study different from those that precede it.

In this study, "visual field" refers to the art historical, social, political, historical, and philosophical contexts for the artistic conception of memorials, including aesthetic choices that do or do not respond to both commissions for those sculptures and public attitudes toward the Holocaust at the time of their commissions. This interest in the visuality of memorials adds a new dimension to the existing literature, which primarily focuses on politics, public dialogue, and collective memory. But the textual also plays an important role in this study, as the visual rhetoric of memorials does not always align with the documents associated with commissions, such as commemorative plaques, commission documents, meeting notes, and artists' statements. It is

therefore critical to interpret memorials as an expression of artistic, as well as societal, responses to the Holocaust, to consider visual and textual sources both together and separately—and to question whether they coincide or deviate from each other.

To gain a better understanding of the diversity of visual responses to the Holocaust, it was necessary to broaden the scope of this study beyond the canonical and much-discussed memorials in Washington, DC, and Berlin. Scholarly and public attention to memorials is subject to trends, tastes, and fashions in contemporary art—only those created by artists deemed important by the art world receive scholarly attention. This study, in addition to examining national memorials, also attends to overlooked memorials—which viewers and critics at the time deemed to be outside of contemporary art trends—to reveal what their function was at the time of their commissions and how they are still significant for us today. For both sets of memorials, when creative choices of artists and architects are considered, the memorials reveal attitudes toward the Holocaust that were prevalent at the time of their realization.

The memorials that have been overlooked in the literature, in travel guides, and in collective memory often are those that were designed at moments in time when commissioning bodies struggled to find the words with which to describe the Holocaust, and/or when the public was not necessarily ready for a work that clearly differentiated victims from perpetrators. Investigating the visual forms of those memorials reveals how artists and commissioners strove to find visual forms for a historical event that they had not fully processed. "Successful" memorials are not only the ones that receive acclaim from art and architecture critics, experience high volumes of visitors, and enter into the collective memory of the event to which the memorial is dedicated. Successful memorials, in this study, reach beyond our limits of imagining what is possible in the visual field of public space and include those that have been overlooked in the scholarship of Holocaust memorials.

When commissioned to design Holocaust memorials, artists most often use the visual vocabulary that they developed in previous works of art. What changes do artists make to their stylistic approaches when designing memorials, and why? Why have memorials changed from discrete sculptural objects in space to installation-based works that involve the viewer's bodily movement? How do visual motifs embrace or elide community needs in relation to Holocaust memory, and in what ways are visual forms in conversation with attitudes toward the Holocaust? Addressing these questions does not always result in steadfast explanations. But the work of investigating potential answers leads to a better understanding of the ways in which the needs, attitudes, and opinions of commissioning bodies, designers, and the public converge, or diverge, at particular moments in time.

Artists and their stylistic choices play fundamental roles in the creation of the collective memory of the Holocaust in any given community. My understanding of the phrase "collective memory" is formed by the work of several theorists. Following Pierre Nora, I understand collective memory to embody the myriad ways that communities remember their pasts, including, but not limited to, through literature, film, and political speeches that are available to large portions of populations and that help structure the memory of a historical event to which contemporary audiences may or may not have had direct access.[1] So, too, Maurice Halbwachs's famous conception of the term includes a definition that refers to "frameworks of memory." We only remember things because we belong to certain social groups that have already predetermined that those events are important to remember.[2] Halbwachs, writing in the 1940s, does not take into account traumatic memories—nor could he have, given that a full theorization of trauma and its relationship to memory and collective memory does not appear in medical literature until the 1960s. Traumatic memories are those that do not fit into predetermined categories, and victims of trauma are unable to fully process those experiences. As Dori Laub explains, psychological trauma is a condition that is akin to having "an empty void" in the psyche.[3] The emptiness in the psyche is the massive loss that trauma victims carry with them—loss endlessly repeated through nightmares and in daily life (therapy's goal is to address that repetition and guide a trauma victim toward functioning in daily life). A theorization of trauma appears in this study in discussions of works of art that introduce empty spaces and voids. Some works of art examined in this book, such as Peter Eisenman's Memorial to the Murdered Jews of Europe, incorporate empty spaces and voids that are, I explain, metaphors for what Laub refers to as "empty spaces in the psyche." When do memorials become part of the collective memory of a community, town, city, or nation—and why? Why have scholars overlooked some memorials in the literature on Holocaust memory? What aspects of Holocaust memory do those memorials reveal, and what aspects do they obscure? Do voids in sculptures help us sympathize with the trauma that victims and survivors endure(d)?

This book also addresses how inscriptions and commemorative plaques often tell us something by what they *do not* tell us. Commissioners of public art install plaques to provide basic information about the event or persons memorialized. Such plaques function not unlike wall labels in museum exhibitions— except that wall labels usually provide the artist's name, title of work of art, date of creation, and medium, along with other information that is appropriate to the work and relevant to the exhibition. Curiously, while informational plaques for memorials usually provide a title and date of installation, they do not always include the artist's name—and artists do not usually design the plaques. This

may be due to a desire on the part of commissioners to emphasize the event or person(s) being memorialized rather than the artist. Does the language on plaques, aimed to memorialize the Holocaust, embody the needs of communities? How does that language elide historical facts? What do these addenda reveal to us about attitudes toward the past?

The title of this book, *Memory Passages*, refers to those very aspects of the visual and the textual. The passages that have been written about memorials in commission meeting notes, in the media, and by artists and critics all help us interpret these works of art. And the sculptures themselves, to differing degrees, provide spaces of viewing—passages for walking around and through the works of art. To fully view a sculpture, one must walk around it. Perambulation is therefore an integral part of experiencing a sculpture. In recent years, artists and architects have expanded the field of that bodily engagement with sculpture. Not only do we walk around Holocaust memorials to see them; now we walk *through* them as well. Some designers of memorials create pathways by which we navigate between objects that make up the memorial, activating us to walk or meander. I argue that this walking, in turn, promotes new forms of memory, which is another subtheme of this book.

For decades, scholars and artists have struggled with the issue of how to represent the Holocaust in visual form. Theodor W. Adorno's dictum, "to write poetry after Auschwitz is barbaric," triggered debates concerning the limits of representation.[4] Saul Friedländer points out that often overlooked is another Adorno statement: "The abundance of real suffering . . . demands the continued existence of art [even as] it prohibits it. It is now virtually in art alone that suffering can still find its own voice, consolation, without immediately being betrayed by it. The most important artists of the age have realized this."[5] Henry Moore, selected to chair an international competition for the design of a Holocaust memorial at Auschwitz, conceded the difficulty of memory as it pertained to the plastic arts when he asked in 1958, "Is it in fact possible to create a work of art that can express the emotions engendered by Auschwitz?"[6] One of the strongest voices in this ongoing debate is that of Friedländer, who argues, "The extermination of the Jews of Europe is as accessible to both representation and interpretation as any other historical event. But we are dealing with an event which tests our traditional conceptual and representational categories, an 'event at the limits.'"[7] The case studies in this volume very much fall on the side of Friedländer—the very fact that artists were commissioned to create Holocaust memorials, and continue to do so, means that we are dealing with representation about the Holocaust. "The limits" to which Friedländer refers are the limits of understanding the horrors of the Holocaust. Adding to his famous statement, I demonstrate that contemporary attitudes toward the Holocaust add limits to the process of conceiving

of and designing very specific works of art—Holocaust memorials. In the two Germanys and in the United States, Jews remembered and talked about the Holocaust in the postwar years, but there were very real limits to those discussions in the wider, non-Jewish public. Those limits, in turn, affected how commissioners of Holocaust memorials worded their discussions, their calls for models, and their instructions to artists. Artists worked within those limits when designing works of art to fit those very commissions.

## Remarks on Vocabulary

A brief discussion of my choice of words, including *monument*, *memorial*, *antisemitism*, and *Holocaust*, is important to situate this study. *Monument* and *memorial* are closely related. Marita Sturken explains that *monument*, in English, refers to deceased individuals who engaged in acts of heroism, whereas *memorial* commemorates or honors innocent victims.[8] I temper Sturken's extremely helpful distinction by adding that it was only when victims of the Holocaust were seen as worthy of being depicted in public space that both countries started to use the word *memorial*.

In German, *Denkmal* (monument) has at its root two words. The verb *denken* (to think) implies that one will stop in front of a sculpture and think about its message. The word *Mal* (times) means the number of times something happens (as opposed to time in a general sense, or *Zeit*). If we parse the meaning of *Denkmal*, we see that the word asks us, when we are in front of a monument, to take this time to remember. This word is related to the phrase *Denk mal daran* (think about it). *Denkmal* refers to sculptures that memorialize individuals or groups who engaged in heroic activities, such as the myriad Bismarck monuments that can be found throughout Germany, dedicated to Otto von Bismarck (who unified Germany and was the first chancellor of the German Empire, 1871–90). *Mahnmal* (memorial), on the other hand, has its roots in the verb *mahnen* (to remind). Here, too, we are reminded to "take time to remind ourselves" of the sculpture's theme. *Denkmal*, rather than *Mahnmal*, is often used conventionally in German to refer to works in public space dedicated to the victims of the Holocaust. Peter Eisenman's 2005 Memorial to the Murdered Jews of Europe has the word *Denkmal* in the German title (*Denkmal der ermordeten Juden Europas*)—but in English, we refer to it as a "memorial" (*Mahnmal*).

The construction of public sculptures dedicated to the Holocaust internationally began in the immediate postwar period. They were often entitled with the word *monument*. A case in point is Nathan Rapoport's Monument to the Warsaw Ghetto Uprising (Warsaw, 1948), which is dedicated to the fighters and heroes of the uprising of the same name. So, too, in the 1960s,

the commission uses the word *monument* for his Monument to the Six Million Jewish Martyrs in Philadelphia. Likewise, in the FRG, the commission for Gerson Fehrenbach's 1964 sculpture dedicated to a destroyed synagogue referred to it as a *monument*. The use of *memorial* in the titles of sculptures in public space dedicated to the Holocaust in both Germany and the United States appears in the 1980s, when a greater consciousness toward victims and survivors developed in both countries. In the U.S. context, a case in point is the 1981 publication of Sybil Milton's *In Fitting Memory: The Art and Politics of Holocaust Memorials*.[9] In the FRG, Horst Hoheisel entitled his *Mahnmal Aschrottbrunnen* (Aschrott Fountain Memorial) in 1985. Throughout this study, I often refer to works as "monuments" when locating them in their historical contexts when either the word *monument* or *Denkmal* was used and as "memorials" when discussing those works as they have been received over time. In some cases, works that were originally entitled a "monument," say, in the 1960s, would now be referred to as a "memorial," because communities now tend to focus on remembering and mourning the dead rather than monumentalizing their heroic deeds.

In this study, and following the recommendation of the International Holocaust Remembrance Alliance's Committee on Antisemitism and Holocaust Denial, I use the term *antisemitism*, and not *anti-Semitism*.[10] As Doris Bergen explains, the term *antisemitism* is misleading, because "the adjective 'Semite' describes a group of related languages, among them Hebrew, Arabic, and Phoenician, and the people who speak them. . . . Use of the hyphen implies that there was such a thing as 'Semitism,' which antisemites opposed. In fact, no one who ever used the term . . . ever meant anything but hatred of Jews."[11] I therefore use the term *antisemitism*.

Finally, both *Holocaust* and *Shoah* refer to the anti-Jewish events of 1933–45. The former means a sacrifice burnt on the altar and came to be used in the 1950s. The latter is a biblical term and has been used since the Middle Ages; it means "destruction" in Hebrew. I use the word *Holocaust* in this study for purely practical reasons: works of art in public space dedicated to the murdered six million Jews of Europe have come to be known as "Holocaust memorials" rather than as "Shoah memorials."

## The United States and the Two Germanys

My study focuses on the United States, the GDR, the FRG, and post-1989 unified Germany, but I could have attended to memorials in many different countries. Israel, especially, has installed memorials on an almost yearly basis at Yad Vashem, its national site of Holocaust remembrance. Countries such as Denmark, France, and the Netherlands have followed suit. I focus

on memorials in the United States and Germany for several reasons. First, the United States played a decisive role in the rebuilding of the FRG in the postwar period. Its influence on West German politics and culture cannot be underestimated. Second, international contemporary art exhibitions such as documenta in Kassel (an international exhibition that takes place every five years) and Skulptur Projekte Münster (which focuses on international sculpture in public space and takes place every ten years) draw visitors from around the world. Meanwhile, the GDR had a close alliance with the Soviet Union, and the predominance of Russian socialist realism was the de facto state-sanctioned art style up until unification. The GDR's artistic community in the late 1950s, however, started to discuss how elements of the avant-garde could be expressed in public art, and those stylistic choices, in turn, were indebted to both prewar European and American influences.

Third, vital contemporary art centers in West Germany resulted in an exchange of artistic ideas between the two countries. By the late 1980s, FRG sculptors started to design Holocaust memorials that incorporated negative spaces—if not disappearing monuments.[12] Jochen Gerz and Esther Shalev-Gerz coined the innovative term *counter-monument* (*Gegen Denkmal*) for their 1986 Monument against Fascism, War, and Violence—and for Peace and Human Rights, in Hamburg. The work consists of a tall pillar that was lowered into the ground over time. As it was lowered, visitors were invited to inscribe messages on the column. Likewise, Horst Hoheisel's Aschrott Fountain Memorial (1985) takes the design of a former fountain—destroyed by Nazis in 1938—re-creates the fountain upside down and installs it underground. Such works are counter-monuments because they refuse verticality and heroism and utilize negative space as a metaphor for the absence of Jews and other victims of National Socialism. In his 1992 article, James E. Young first used in English the term *counter-monument* to describe works in public space that refuse to extol individuals and events and that question heroic monuments that feature figuration and verticality.[13] The counter-monument in Germany, and the theorization of it by Young, however, would not have been possible without the strides in contemporary memorial and art making in the United States.

As Young points out in his *The Stages of Memory: Reflections on Memorial Art, Loss, and the Spaces Between*, Maya Lin's Vietnam Veterans Memorial (1982), a watershed in memorial architecture, is a precursor to counter-monuments because it refuses the aesthetic features of the monuments that surround it. For instance, it features polished black granite, thereby contrasting with the white sandstone of Washington, DC. And it contrasts to the white verticality of the Washington Monument, the Lincoln Memorial, and the Jefferson Memorial by insisting on horizontality and employing the color black.[14] I would also add to

Young's compelling analysis that the Vietnam Veterans Memorial embraces a simplicity of form and utilizes words—influences of minimalism and conceptual art, respectively.

In the 1960s, artists such as Carl Andre and Donald Judd sought to remove all elements of narrative engagement, decoration, and composition from their works of art. Critics soon coined the term *minimalism* to refer to such works of art, and the terminology stuck. With its clear geometric structure of polished black granite angles, Lin's work borrows from the stripped-down forms of minimalism. But the memorial would never be called minimalist, for it contains words, which would have been anathema to the proponents of minimalism. The words are, in fact, the names of the soldiers who died or are missing in action. Lin's use of words stems (intentionally or unintentionally) from conceptual art practices, which date to the 1960s and are still in use today.

Lucy Lippard and David Chandler, in 1968, famously proclaimed that conceptual art heralded the "dematerialization" of the art object.[15] Works of art no longer had to be made of stone, clay, or paint. Instead, they could be made of words, or empty spaces, or sound—the materials of conceptual artists, who favored ideas over the "thingness" of sculpture. The Vietnam Veterans Memorial can therefore be said to employ modifications of minimalism and conceptual art, strategies that the sculptors of counter-monuments in Germany also adopted. The concepts of the disappearing monument, for the Gerz team, or the negative form, for Hoheisel, were possible because such ideas were already being explored in conceptual art circles—what could be more dematerialized than a disappearing monument? The exchange of ideas in the art world between the two countries is, therefore, imperative for understanding the development of memorials in both nations.

## An Interdisciplinary Field of Study

With the publication in 1993 of his book *The Texture of Memory: Holocaust Memorials and Meaning*, James E. Young instituted the topic of Holocaust memorials as an interdisciplinary field of study.[16] His book examines Holocaust memorials in Germany, Poland, Israel, and the United States from the point of view of collective memory, for the commissions and resulting works of art, he explains, are based on how communities remember the Holocaust. Since that watershed publication, Young has entered the international scene when it comes to commissioning works of public art dedicated to memorializing tragedy. Among others, he has consulted on the Berlin Memorial to the Murdered Jews of Europe, the National 9/11 Memorial and Museum in New York City, and the Memorial to Norway's Utøya Massacre.[17] His studies, including *The Art of Memory: Holocaust Memorials in History, At Memory's Edge:*

*After-Images of the Holocaust in Contemporary Art and Architecture*, and *The Stages of Memory*, offer excellent historical information and analyses about a plethora of sites and works of art.[18]

Young's studies have paved the way for more scholarly examinations of Holocaust memorials that investigate the complex relationships between commissions, politics, and history. Peter Carrier's innovative *Holocaust Monuments and National Memory Cultures in France and Germany Since 1989* (2005), for instance, analyzes the ways in which political strategists delegate to memorials the moral responsibility of remembrance, focusing on the negotiation of national historical identities.[19] For Carrier, public art becomes an instrument of political representation. Similarly, Caroline Wiedmer analyzes Germany and France in *The Claims of Memory: Representations of the Holocaust in Contemporary German and France* (1999).[20] While some of her analyses of objects overlap with mine, such as Gunter Demnig's *Stolpersteine* (*Stumbling Blocks*) project as well as the Berlin Memorial to the Murdered Jews of Europe, the visual forms of the sites are not her primary focus.[21] Trauma theory plays a key role for Wiedmer, but the visual ramifications of trauma—what I analyze as an attention to absence, walking, or solitary viewing—do not come into play. So, too, Jennifer A. Jordan's *Structures of Memory: Understanding Urban Change in Berlin and Beyond* (2006) is also an important sociological text with which my research is in dialogue.[22] She focuses on often-overlooked memorials in Berlin and pays particular attention to the social and political circumstances of their making, concentrating on the historical, economic, and legal contexts of memorials. Jennifer Hansen-Glucklich's *Holocaust Memory Reframed: Museums and the Challenges of Holocaust Representation* (2014) analyzes the museums including the United States Holocaust Memorial Museum (USHMM), Yad Vashem, and the Information Center beneath Eisenman's memorial in Berlin. She focuses primarily on the role of the museum as being framed with the country's "civil religion" and addresses architecture and its relation to the void.[23]

While traditional interpretations of high modernist works of art (minimalism, in particular) stress the materiality of the object, or its aggressive positioning in relation to the viewer, revisions to this thinking posit that modernism can seek to address memory and the Holocaust.[24] As Mark Godfrey explains, in the United States, some postwar modernist works of art, although alluding to the Holocaust via their titles, were rarely analyzed, at least in the early years, in terms of this seemingly blatant meaning.[25] Godfrey's *Abstraction and the Holocaust* (2007) is an innovative and pivotal point of departure for the topic of visual art and the Holocaust.[26] He examines how abstraction came to be a preferred style of Holocaust memorials and starts his analyses by asking to what extent abstraction fulfills the needs of memory. His open-ended discus-

sions bring commissions, rarely seen documents, and highly perceptive visual analyses to bear on his interpretations of painting, sculpture, and photography. Godfrey compellingly argues that abstraction is fully capable of providing a visual language for works of art dedicated to the Holocaust. Cases in point include Frank Stella's black stripe paintings such as *Arbeit Macht Frei* (1958) and Morris Louis's *Charred Journal: Firewritten* (1951). Comparably, Louis Kahn's proposed Holocaust memorial (1966–72) for Battery Park in New York City consisted of nine glass cubes that made an outright association between modernism and the Holocaust (the memorial was never built).

Other scholars focus their studies on works of art that respond to the Holocaust but are not necessarily memorials. Lisa Saltzman and Paul Jaskot, for instance, place national identity, postmodernism, and politics in the foreground of their research. While Saltzman locates Gerhard Richter's works in the social context of German religious cycles of commemoration, Jaskot resists the myth that there was "silence" in art criticism regarding the analysis of artwork and its relationship to the Holocaust in the postwar period in Germany.[27] Scholars such as Samantha Baskind, meanwhile, point out that the study of Holocaust memorials has been largely absent from art history, primarily because memorials are objects that do not easily fit into the canon of objects that the discipline deems worthy of analysis. Nonetheless, Baskind explains, these objects are worthy of analysis, for the simple reason that many artists created Holocaust memorials that incorporated "the artists' signature styles in some way."[28] In other words, memorials can be analyzed as objects that are part of an artist's oeuvre and therefore integrated into larger arguments about twentieth- and twenty-first-century art. Margaret Olin and Richard S. Nelson explain historical reasons for ways in which analysis of memorials and monuments has faltered within art history: "After the nineteenth century, most art historians thought monuments were no longer a proper object of study."[29] This belief, they explain, was widely held until Lin's Vietnam Veterans Memorial and, soon after, Young's work on Holocaust memorials. My study is informed by these scholars' works, and I add to them by focusing on the visual field. Historical sources, too, play a vital role in my analysis of memorials.

Scholarship about Holocaust memory in Germany and the United States is rich. In the context of the United States, Hasia Diner's *We Remember with Reverence and Love* (2009) is perhaps the most groundbreaking for its detailed analysis of the ways in which Jewish communities remembered the Holocaust in the postwar years.[30] Thomas Fallace's *The Emergence of Holocaust Education in American Schools* (2008) is unique for its analysis of the texts and materials teachers use to teach the Holocaust in the postwar period.[31] Integral to any study of East and West Germany is Jeffrey Herf's *Divided Memory: The Nazi Past in the Two Germanys* (1997), in which he explains ideological differences as well

as public commemorations in both countries.[32] Vital for a study of Holocaust memory in both the United States and Germany is Daniel Levy and Natan Sznaider's *The Holocaust and Memory in the Global Age* (2006). It compares the reception of events such as the Nuremberg trials (1945), the Eichmann trial (1961), the Holocaust television miniseries (1978), and the *Historikerstreit* (historians' debate) of the 1980s in Germany, among others events in the GDR, FRG, and the United States.[33] There are a great many sources about Germany in this regard, and I encourage my readers to peruse the selected bibliography for texts relevant to their concerns. For the intersection of the history of art and politics, I especially recommend Paul B. Jaskot's *The Nazi Perpetrator: Postwar German Art and the Politics of the Right*, which investigates how artists and architects in the postwar period "engaged with or reacted to the maneuvers of the right."[34]

My work builds on these innovative studies by looking, first and foremost, at the visual aspects of memorials. Exactly what do we see when we look at a Holocaust memorial? What forms present themselves, and what conclusions can we draw from them? Careful looking provokes questions: Why this style, that element, this motif, or that color? To answer these questions, I turn both to the commissions and to the previous works by artists. I also attempt to put the commission and the work of art in the context of larger attitudes toward the Holocaust in the countries in which these works reside.

For each work of art, I consult archival documents to determine the histories of the commissions and analyze memorials in terms of the artist's previous artistic production. Some chapters analyze memorials about which little to nothing has been written. These chapters, in particular, provide in-depth historical information about the commissioning process, including interviews with Holocaust survivors, artists, and family members of the artists, which contribute new information and points of view. When analyzing memorials about which much has been written (the contemporary works of art in the USHMM, the Berlin Memorial to the Murdered Jews of Europe, and Garden of Stones, in the Museum of Jewish Heritage [MJH], for instance), I present new interpretations based on earlier works by those artists and/or architects and introduce new theoretical approaches. Each artist and work of art is put into an art historical context that helps explain why the work of art looks the way it does, how it generates meaning in public space, and how its meaning shifts with changing attitudes toward the Holocaust in each country.

## Format and Content of the Book

The United States, the GDR, and the FRG all struggled in the postwar years to find visual forms for Holocaust remembrance. That struggle, in all three countries, continued in the post-1989 years, which I explore in the chapters.

For each country, I examine memorials that reveal local and national stories about how the Holocaust is represented, discussed, and situated in public memory of the Holocaust. My choice of objects is based on either the lack of scholarly literature about those sculptures and/or the significant stylistic contributions those sculptures make to the history of Holocaust memorials that have been heretofore overlooked. Every chapter examines a specific memorial or set of memorials, relying on archival research, interviews, and artists' biographies (when relevant to the interpretation of the work of art) to tell the story of the commission. Holocaust survivors and their families who wish to bring public attention to the memory of the six million victims often drive Holocaust memory in cities and towns outside of national capitals. The book contains chapters on the national sites of Holocaust memory that strive to define Holocaust memory for the United States and Germany as well as on memorials in larger and smaller cities that have been overlooked in the literature.

Chapter 1, "East and West Germany in the Postwar Years: Will Lammert and Gerson Fehrenbach," analyzes the ways in which postwar attitudes in both countries coalesced around specific memorials. Will Lammert's Burdened Woman (1959) demonstrates that while the GDR struggled to memorialize the Holocaust and relied on Christian themes disguised as socialist ideals in works of art, Lammert returned to expressionism to memorialize the dead. Interviews with the artist's family and archival documents reveal that elements of Lammert's biography (he was married to a Jew and fled to the Soviet Union during World War II) afforded him an unusual approach to Holocaust memory that changed the GDR's culture of memorialization.

In the West, meanwhile, the oft used motto "never again" not only referred to the Holocaust but also to the generic destruction of World War II, including the Allied bombing of Germany. The Münchener Straße Synagogue Monument (then West Berlin, 1963) was commissioned by the Schöneberg Borough Assembly. It is dedicated to the destruction of that synagogue on Kristallnacht (Night of Broken Glass; when thousands of synagogues and Jewish businesses were destroyed), but the language on the accompanying plaque is vague and speaks to the difficulty of addressing the destruction in an outright way. Minutes of Borough Assembly meetings reveal that while perpetrators of Kristallnacht and their victims were named in meetings, it was not acceptable for such information to be visualized—either in artistic form or in written text in public space—in the early 1960s.

Chapter 2, "A Forgotten Memorial and Philadelphia's Survivors: Nathan Rapoport's Monument to the Six Million Jewish Martyrs (1964)" addresses an early public monument to the Holocaust in North America; and it has been all but absent in the literature. A close examination of archives demonstrates the ways in which survivors bonded together in the postwar years to

ensure the lasting memory of the six million Jewish Holocaust victims. In 1961 the Philadelphia Holocaust Memorial Committee commissioned sculptor Nathan Rapoport, the sculptor of the Warsaw Ghetto Uprising Monument (1948) and Yad Vashem's Wall of Remembrance (1976), to create a sculpture dedicated to the victims of the Holocaust. The committee, consisting of Holocaust survivors and their children, placed the statue in the heart of the city, to which it was presented as a gift. At the time, the phrase "Holocaust survivor" was not yet widely used, and knowledge of the Holocaust was not widespread except within Jewish communities.

Chapter 3, "Monuments to Deported Jews in Hamburg (Hrdlicka, Rückriem, and Kahl) and East Berlin (Will Lammert)" examines memorials in the GDR and the FRG. In the GDR, Will Lammert originally designed the figures in what is now known as the Monument to the Deported Jews in Berlin (1985) as part of the Ravensbrück monument (see Chapter 1). The Ravensbrück commission, however, rejected these figures. Nonetheless, the Lammert family cast the sculptures in bronze and put them into storage. In 1985, the artist's grandson installed them in Mitte, Berlin, at a time when the GDR was rethinking this neighborhood as worthy of retaining its original architectural features—as well as its Jewish past. Known as the Memorial to Victims of Fascism in 1985, the sculptural group came to be known as Monument to the Deported Jews in the 1990s, after unification, when "victims of Fascism" no longer resonated in unified Germany.

Meanwhile, in the FRG, monuments in Hamburg Dammtor attempt to address the National Socialist past but stylistically fall short of their goals: one monument was never completed, another is easily overlooked, and the third often is overgrown with weeds. Nonetheless, grassroots organizing for the monuments demonstrates the commitment of the neighborhood to confront the past. Examples include Alfred Hrdlicka's unfinished Counter-Monument (1985–86), Ulrich Rückriem's minimalist Memorial to the Deported Jews (1983), and Margrit Kahl's Joseph-Carlebach-Platz Synagogue Monument (1988).

Chapter 4, "Memorial Functions: Shapiro, Kelly, LeWitt, and Serra at the United States Holocaust Memorial Museum (1993)" attends to works of art by Joel Shapiro, Ellsworth Kelly, Sol LeWitt, and Richard Serra. The commissions for works of art in the museum have been analyzed in depth by Mark Godfrey, and I add to his analysis in three ways: by explaining the historical context and the fact that, at the time of the commissions, a visual language with which to address the Holocaust had not yet been developed in the United States; analyzing previous works of art by the artists that address the Holocaust; and focusing on the works' interaction with the architecture of the building.

Chapter 5, "Walking through Stelae: Peter Eisenman's Memorial to the Murdered Jews of Europe (2005)" concentrates on Richard Serra's input (he

withdrew his participation in the project) into the first German national memorial to the Holocaust, which opened in 2005. The facilitators of the project, television journalist Lea Rosh and historian Eberhard Jäckel, had visited Yad Vashem in Jerusalem. "If they have a memorial, why don't we?" they wondered, creating the possibility of memory that crosses national borders, thereby influencing another country's collective memory as much as it does its own. The memorial became a watershed in Holocaust memorialization, especially for its vast field of stelae that provides spaces to walk, encouraging disorientation and individual memory work. I turn to Michel de Certeau and Henri Bergson to theorize memory and perambulation.

The Conclusion, "Andy Goldsworthy: Nature and Memory at the New York Museum of Jewish Heritage—A Living Memorial," investigates the role of natural materials in a memorial by an environmental artist. The MJH in New York City is dedicated to Jewish life before, during, and after the Holocaust and seeks to tell the history of American Jewry in the twentieth and twenty-first centuries through the eyes of those who lived it. Goldsworthy's Garden of Stones represents a departure in Holocaust memorial making by introducing natural materials that change over time. The project consists of eighteen boulders, each about 3–4 ft. in height and diameter and weighing 3–15 tons, each containing a dwarf chestnut oak tree, meant to symbolize the fragility and tenacity of life. I analyze the work as a "social sculpture" by interpreting it through the lens of Joseph Beuys and his 1982 project, *Aktion 7000 Eichen* (*Action 7,000 Oaks,* commonly referred to as *7,000 Oaks*), thereby highlighting the memorial's role in engaging the viewer and promoting healing for survivors.

Finally, a few words about how to use the images and how to understand the formats of titles of memorials in this book (which may be confounding for readers who are not art historians). There are fewer images for chapters in which I discuss memorials that are well known, as those images can be easily found online. I hope that my readers will look up the works of art that are not illustrated. More photographs are provided in chapters analyzing memorials that have been overlooked in the literature. In some cases, these images cannot be found online, so publication of them is vital for this study. Regarding the formatting of titles of works of art in this study (and following the conventions of the *Chicago Manual of Style*), the titles of works of art in public space that are memorials or monuments are *not* italicized. Works of art in public space that are sculptures but *not* memorials or monuments are italicized, as are sculptures that are exhibited in museums or galleries. These details are best explained at the outset to avoid any confusion for the reader. Even more important to this Introduction, however, are the reasons for this study.

By focusing on the visual and verbal fields of Holocaust memorials, we come to understand that sculptures in public space have the potential to

instill and provoke new ways to remember the past, memorialize events happening in our time, and warn the future. When artists, architects, and designers engage in new and unconventional approaches to sculpture dedicated to the Holocaust in public space, they create works of art that generate new forms of contemplation. Commissioners for works of public art, I hope, will learn important lessons about the ways that the wording of calls for entries affects the choices artists make for sculptures. Artists have the potential to learn how their predecessors worked through difficult histories and established new artistic vocabularies. Readers interested in the Holocaust or in cities such as Berlin, Philadelphia, Washington, DC, Hamburg, or New York City will uncover hidden histories about works of art and find new ways to engage with memorials that draw millions of people every year.

Written from an art historical perspective, *Memory Passages: Holocaust Memorials in the United States and Germany* traces the processes of commissioning, designing, jurying, and installing memorials by integrating heretofore unused archival sources and new interviews with commissioners, survivors, and artists. This study, therefore, weaves together art historical context, social history, and critical responses to memorials into my interpretations of Holocaust memorials. The Holocaust was not a genocide to end all genocides. There continues to be a need for commissioning, designing, and building memorials and public works of art dedicated to similar tragedies. Holocaust memorials in Germany and the United States represent some of the most innovative forms of sculpture in public space. Memorials to the Holocaust set the tone for memorials dedicated to other tragedies that followed, providing the public with a visual vocabulary with which to approach genocide and tragedies. Memorials will not stop genocide, but they are a constant reminder of human rights violations, ethnic cleansing, and genocides that continue around the world. Scholarship on both the more popular and the early, lesser-known memorials is essential to keep the debate about how we should remember atrocities of the past significant and alive.

# 1

# East and West Germany in the Postwar Years

## *Will Lammert and Gerson Fehrenbach*

MEMORIALS PRODUCED in the late 1950s in East Germany (GDR) and the early 1960s in West Germany (FRG) demonstrate the ways in which ideology, in the case of the GDR, and willful dismissal of historical events, in the case of the FRG, structured both the commissions and the final visual forms of works of art in public space dedicated to specific aspects of the Holocaust. While the GDR often blamed National Socialist atrocities on Western Fascism, the West took a position of willful repression toward the past until the mid-1980s. In addition, Berlin, the capital of the National Socialist regime, was itself split into East Berlin and West Berlin. Meanwhile, cities in both the GDR and the FRG had their own particular histories related to the Holocaust. In this chapter, I focus on case studies that are representative of attitudes at specific historical moments in both East Germany and West Germany until 1965. Specifically, I examine Will Lammert's Burdened Woman (Ravensbrück, 1957; Figure 1.1) in the GDR and an early Holocaust monument installed in the West: Gerson Fehrenbach's Münchener Straße Synagogue Monument (1963; Figure 1.2). Burdened Woman and the Münchener Straße Synagogue Monument have been mostly overlooked in the literature of postwar Holocaust memory.[1]

Will Lammert was trained in the avant-garde in the prewar years, lived in exile in the Union of Soviet Socialist Republics (USSR), and returned to East Berlin as a hero in 1951. This study demonstrates that an artist could create an expressionist memorial at a time when socialist realism was customary for public works of art, indicating a shift in attitudes toward both contempor-

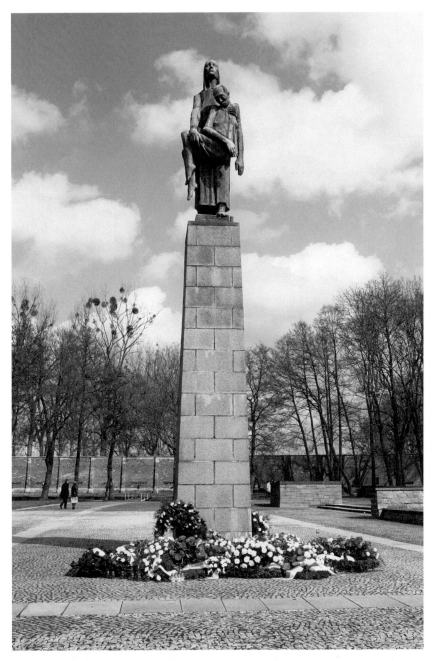

FIGURE 1.1 Will Lammert, *Der Tragende* (Burdened Woman or Bearing Woman), 1957. Installed 1959, Ravensbrück, Germany. Bronze. (Photo: Britta Pawelke, MGR/ SBG. © 2018 Artists Rights Society [ARS], New York / VG Bild-Kunst, Bonn)

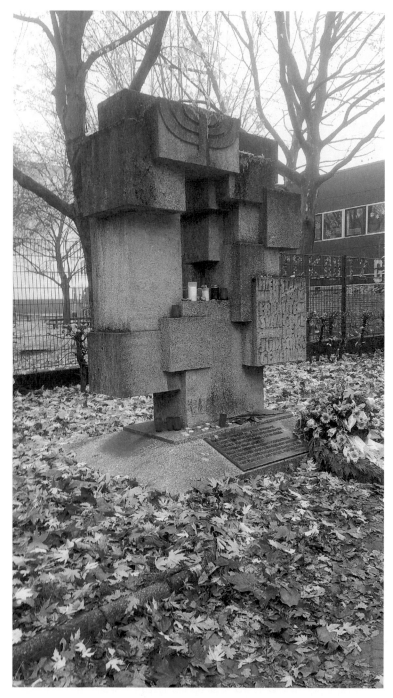

FIGURE 1.2 Gerson Fehrenbach, Münchener Straße Synagogue Monument. Installed November 25, 1963, Münchener Straße 34–38. Coquina. Height: 2.35 m. Plaque on base installed November 9, 1988. (Photo: Samuel D. Gruber. © 2018 Artists Rights Society [ARS], New York / VG Bild-Kunst, Bonn)

ary art and the Holocaust. In the case of Gerson Fehrenbach's Münchener Straße Synagogue Monument, in West Berlin, we encounter a commission that struggled to find appropriate language for a memorial. The result is a work of abstract sculpture that neither mentions the Holocaust nor the Jews of the neighborhood. It demonstrates how commemorative sculpture can end up being noncommemorative.

The main Jewish neighborhoods in 1933 Berlin were in Mitte and Charlottenburg, and the Jewish population of 160,000 prided itself on its assimilation and rich cultural life, a peaceful existence that Nazi power brutally interrupted. Many were able to flee, but about fifty thousand Berlin Jews were killed or died of starvation in ghettos, concentration camps, and death camps.[2] At the end of World War II, about eight thousand Jews remained in Berlin.[3] In the 1950s, both East and West continued to omit any significant acknowledgment of the murder of the Jews, Sinti and Roma, homosexuals, Jehovah's Witnesses, political dissenters, and other victims in public spaces. Neither East nor West marked the sites of deportations or destroyed synagogues to any significant extent; both commemorated individual Social Democratic or Communist resistance but rarely identified those remembered as Jewish.[4] This state of affairs would remain the norm until the late 1970s in the West and the mid-1980s in the GDR.[5]

## German Democratic Republic (GDR)

### The Ravensbrück Concentration Camp Memorial: Lammert's Burdened Woman

In the East, memorial exhibitions were installed in Buchenwald in 1958, in Ravensbrück in 1959, and in Sachsenhausen in 1961. To date, scholars have argued that these exhibitions served larger ideological purposes: to blame Nazi crimes on capitalists and Fascists and to celebrate Socialist martyrs instead of Jewish victims; the sculptures are socialist realism in style. Fritz Cremer's Buchenwald memorial is an example of a typical GDR memorial. In the sculpture at Buchenwald, the figures march as in a demonstration, carrying flags. They stride forward with energy; they embody the East German spirit of fighting. The surfaces of their bodies are smooth. Cremer sculpts in detail the figures' bodies, expressions, and clothing. The former director general of the state museums in East Berlin, Eberhard Bartke, wrote in 1960 that the artist had made visible the forces of the working class—the only forces superior to Fascism. The sculpture, in Bartke's words, "powerfully conveys the conviction that these forces are invincible, and that history, the powers of morality, humanism, mankind, indeed life itself are on their side; the future belongs to

them."[6] The sculpture, therefore, is devoted to the liberation of the camp, not to the suffering of the inmates.[7] An examination of Will Lammert's sculptures and maquettes for Ravensbrück shows that they serve as examples for the ways in which elements of expressionism were tolerated in postwar GDR.

In 1957, sculptor Lammert was commissioned to design the central monument at Ravensbrück, the women's concentration camp in the GDR. The approach he took was to a return to prewar expressionist styles, but the final product has little in common with his model. The artist designed a monument with two figures on a pylon and a group of figures at its base, but he died in 1957, before its completion. The existing monument is a tribute to his vision but radically differs from the one he planned. What makes this example so unusual is that Lammert did not design the figures in a socialist realist style; instead, he incorporated elements of expressionism. How he was commissioned, why he chose the style he did, and how the figures were received shed light on the changing attitudes toward World War II and its victims in the GDR.

Lammert had envisioned the monument at Ravensbrück in parts, consisting of the existing two figures on the pylon, which represent one woman carrying another, known as *Tragende* (translated as either Burdened Woman or Bearing Woman, but it appears in most English publications as the former, which is also used here) and a grouping of figures at its base (Figure 1.3). After the artist's death, his former student, Fritz Cremer, completed the design of the two figures—only the two figures on the pylon (Figure 1.4) were installed in 1959.[8] Lammert's family had the unfinished figures cast in bronze in 1959 and exhibited them in Berlin, Dresden, Paris, and other cities.[9] The grouping installed on Große Hamburger Straße in Mitte (a subject of Chapter 3) was created later, in 1985, by the artist's grandson, Mark Lammert, now a professor of painting at the Universität der Künste in Berlin.

This chapter analyzes the Ravensbrück monument in two ways. First, it turns to an interpretation of the literature on the Ravensbrück sculpture in order to better understand the role that the unfinished figures would have played had they been installed. I argue that Lammert intended them to depict *Strafestehen*—or torture by standing—at Ravensbrück. Second, it aims to explain why and how Lammert's seemingly expressionist memorial would have been acceptable to the GDR in 1959. While Western art historical attitudes toward the GDR up until the 1990s assumed that Soviet socialist realism was the de facto art style of the GDR, some elements of expressionism were being theorized in the late 1950s, at precisely the time when Lammert designed the Ravensbrück monument.[10] While the art historical context of the work reveals new ways to understand the sculpture, Lammert's unique story of exile also has bearing on the sculptural group.[11]

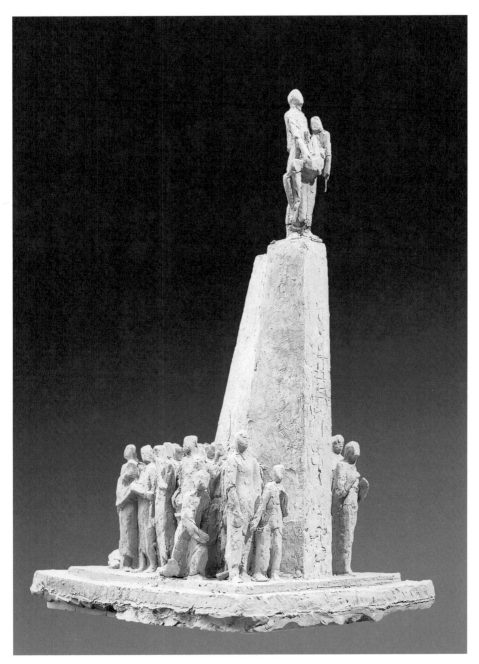

**Figure 1.3** Will Lammert, Clay maquette of Ravensbrück memorial, 1955–56. Ca. 57 × 29 × 42 cm. (Photo: Klaus Beyer. © 2018 Artists Rights Society [ARS], New York / VG Bild-Kunst, Bonn)

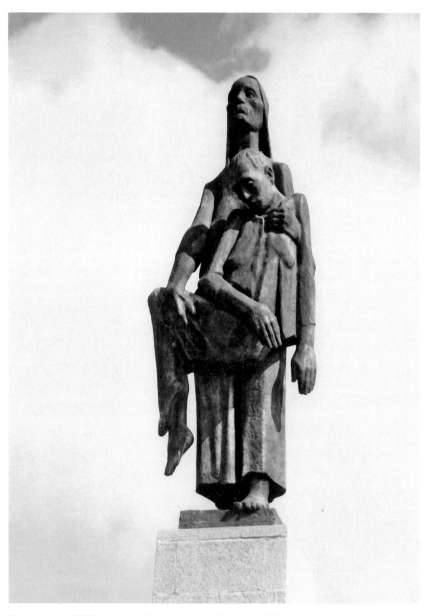

FIGURE 1.4 Will Lammert, Der Tragende (Burdened Woman or Bearing Woman), 1957. Installed 1959, Ravensbrück, Germany. Bronze. (Photo: Landesarchiv Thüringen—Hauptstaatsarchiv Weimar, Ernst Schäfer Kleinbildnegative, Streifen 47. © 2018 Artists Rights Society [ARS], New York / VG Bild-Kunst, Bonn)

Born in 1892 to a working class family in Hagen, Germany, Lammert exhibited great artistic talent at an early age. In 1910, he worked in the studio of Moissey Kogan. Karl Ernst Osthaus, a local philanthropist, art collector, and founder of the former Folkwang Museum in Hagen financially supported him and arranged a scholarship for Lammert to study at the Kunstgewerbe-schule (School of Arts and Crafts) in Hamburg. He studied there with Richard Luksch, who worked in a style representative of Jugendstil.[12] In 1912–13, he studied in Paris, entered the artistic circles of Moissey Kogan, Otto Freund-lich, and Alexander Archipenko, and mostly drew and sculpted nude female figures.[13] His works from this period are marked by experimentation with the female form and show influences of abstraction from both Kogan and Ar-chipenko. Both artists had a profound effect on his work until the 1930s. The most successful works of his student years were the *Golden Figures* (1914), nude female figures covered in a gold exterior, two of which were exhibited with great acclaim in the Werkbundaustellung (Werkbund Exhibition) in 1914. After he was wounded in World War I, Lammert turned to ceramic, fearing that his war injury would hinder his work in monumental sculpture in stone. Osthaus again came to his aid and provided a studio for the artist. Lammert focused on creating works depicting nudes, dancing figures, and portraits.[14] By 1920, Lammert was a central figure of the art scene in the Ruhrgebiet, Rheinland, and Westfalen and had founded an artist's colony and ceramic stu-dio in Margarethenhöhe, near Essen.[15] Later, Fritz Cremer, his former student, remembered the studio: "It was the meeting point of all artistic powers who dreamed of the freedom of the socialist morning."[16] In 1920, Lammert married Hedwig (Hette) Meyerbach, a physician and a Jew—a fact rarely mentioned in the pre-1989 literature.[17] After the philanthropist's death in 1921, the city of Essen outbid Hagen for the Folkwang Museum, and, in 1922, Lammert fol-lowed the collection to Essen. His major works of this period included public art in the Southwest Cemetery in Essen. *Mother Earth* (1925–27), a ceramic sculpture of about 5 m, was designed for the crematorium, while a 12 m high bas-relief Christ figure was commissioned for the exterior wall (1926–27).[18] *Mother Earth* recalled "Egyptian and Mexican sources . . . [it consisted of] ce-ramic blocks and was placed over the vertical entrance of the main façade . . . it represented an ancient Goddess of fertility on earth, carrying six bodies whose ashes will be borne into new life."[19] In 1931, he was awarded the Rome Prize and studied in the Villa Massimo. Lammert became a member of the KPD, the Communist Party of Germany, in 1932.

As a Communist, a practitioner of modern art, and a man married to a Jew, in 1933 he fled with his family, which now included two sons, to Paris (Jewish Aid organizations aided their exile).[20] There, Lammert exhibited drawings that were critical of National Socialism. The family lived in Jankel

Adler's studio, next to Bodo Uhse, the German writer and activist. Alberto Giacometti and Germaine Richier, whose works he admired, lived nearby. Meanwhile, back in his hometown of Essen, newspapers wrote about Lammert, the "Jewish-loving Bolshevist," who was known for his "degenerate art." (The Nazis, in 1938, destroyed almost all public works of art by Lammert, including the Christ figure and *Mother Earth* in Essen's Southwest Cemetery.) Because of poverty and his commitment to Communism, he moved to the Soviet Union in 1934, hoping to receive commissions as a sculptor. But as a non-Russian-speaking artist, he found it difficult to obtain work. He was also forced to rethink his artistic position in light of Soviet socialist realism.[21] He had success with his Thälmann bust (1939, plaster), the bust of Prof. I. A. Kablukow (1939, granite), and *The Soccer Player* (1939–40, plaster). In 1941, the family lived for a time in the Tatar Autonomous Socialist Soviet Republic. Lammert, his wife, and eldest son were enlisted in the Worker's Army in 1942 and worked in a munition's factory in Kasan. The family survived under harsh circumstances, and Lammert was plagued with depression and repeated bouts of pneumonia; Hette Lammert, as a physician, was transferred from the factory to work in a health clinic.[22] After the war, Lammert received a few commissions in Kasan in 1946–48 from both the Kasan City Museum and the Great Dramatic Theatre, but most often he was unemployed and tirelessly seeking permission to leave Kasan and return to Germany.[23]

The family was unable to leave USSR until 1951, when they finally returned to the then GDR. He chose to live in Berlin rather than in Essen (where he had spent the prewar years) as those who were responsible for destroying his work in Essen were still alive. The GDR offered Lammert funds so that he could begin his work anew. In 1952, he was accepted into the Berlin Academy of Arts, which provided him with a large studio on Pariser Platz the same year.[24] In 1953, he completed a bust of Karl Marx for the University of Berlin as well as a bust of Wilhelm Pieck and began work for the memorial at Ravensbrück.[25] In 1958, thinking back on Lammert's time in the Soviet Union, his friend Bodo Uhse wrote, "Lammert's immigration years were so horrible. His time in the Soviet Union gave him nothing artistically, instead, they destroyed him . . . he broke in two. And he needed years after his return to find, in the figures of the model for the Ravensbrück monument, his own artistic language once again."[26] Uhse described what he saw in Lammert's studio the day after the artist's death: "In the studio the photographer is there to take pictures. How much Lammert had worked since I had last visited. In half life-size the figures of the tortured women surround the high tower, and everywhere on the walls are the same figures." These figures, designed for the memorial's base, came to be known as the *Unfinished*. In 1959, Lammert was posthumously awarded the Service Medal of the German Democratic Republic, on the occa-

sion of the GDR's tenth anniversary,[27] and, in 1962, a Will Lammert Memorial Prize was founded and awarded yearly to sculptors until 1989.[28]

## Lammert's Sculptures for Ravensbrück

In Ravensbrück, about 139,000 women and children and 20,000 men from more than forty countries were imprisoned. Tens of thousands died there. It was inaugurated as one of the three major memorial sites of concentration camps in 1950: the others were Buchenwald, opened as a memorial site in 1958, and Sachsenhausen, opened in 1961.[29] These memorial sites were centrally planned by the GDR, which, according to Bill Niven, meant "uniformity, monopolization and politicization of memory."[30] The Association of the Persecuted by the Nazi Regime (Vereinigung der Verfolgten des Naziregimes) had been set up in March 1947 to represent the interests of victims of Nazism. But, by 1953, it was dissolved and the Committee of Antifascist Resistance Fighters was set up, reflecting the GDR's self-understanding as fighters against both fascism and capitalism. After that, workers' struggles were effectively favored over victims' interests. By 1961, a special statute on memorials in the GDR stated that the concentration camp sites were to demonstrate the following: the struggle of the German working class and of all democratic forces against the Fascist threat, the role of the KPD as a leading force against the Nazi regime, anti-Fascist resistance, SS-terror in the camps, international solidarity in the liberation of the camps, the resurrection of Fascism in FRG, and the historical role of the GDR.[31] According to Jeffrey Herf's analysis of photographs of the Ravensbrück opening ceremonies, the event was infused with "progressive faith in History and ultimate victory." It "fostered identification with History's winners, with the victors and heroes of antifascist resistance, not with lost causes such as the Jews."[32] According to Herf, East German anti-Fascist concentration camp memorials functioned as "churches of socialism." Heroism and resistance of the working class supplanted a Christian idea of death and salvation.

Burdened Woman (Figure 1.1) was installed for the opening of Ravensbrück on September 12, 1959.[33] An over-life-size standing woman carries a slumped-over woman. The two figures are situated on a 7 m high pylon, on a man-made peninsula that overlooks Lake Schwedt, into which the ashes of murdered women were thrown. In the distance is the city of Fürstenberg. The figure's foot seems to step forward, giving the impression that she is striding into the lake. It is the central memorial at the site, and visitors' experience at the camp ends at its base.

Because few publications regarding the commission exist, Susanne Lanwerd's 1999 account of the commission is most useful.[34] In 1948, the Zentrale Arbeitsgemeinschaft Ravensbrück (Central Working Group of Ravensbrück)

recommended an international competition for such a monument, but, upon Lammert's return in 1951 (and his subsequent successful commissions and exhibitions), the idea for an international search was abandoned in favor of granting the commission to Lammert.[35] In March 1955, Lammert recommended that figures representing the eighteen nations be placed behind the podium and that a monument of a woman who carries another woman be situated on the peninsula overlooking Lake Schwedt. A tentative contract between the Ministry of Culture and Lammert refers to this recommendation and awards the artist a sum of DM 200,000. The revised contract of March 1957 refers to the development of a figural group for the base of the monument and states that the sculptures should be made of ceramic (his aforementioned *Mother Earth*, in Essen, already had demonstrated that monumental public sculpture was possible in ceramic). The total award sum increased to DM 300,000. In April 1957, a letter from the Ministry of Culture documents the further development of the sculpture: now a high base with the carrying figure at the top and about twenty figures at its base. Burdened Woman was to be 3.2 m tall. Lammert died in October 1957 before the contract was finalized.[36]

A few days after Lammert's death, Lanwerd explains, a meeting took place between the Ministry for Culture, the artist Fritz Cremer (a former student of Lammert's in the Margaretenhöhe), and Hette Lammert, the artist's widow.[37] Here it was decided that the central figure (one woman carrying another woman) should be enlarged to a height of 4.6 m, with a total height (including the pylon) of 11 m. In addition, two figures, originally meant to stand around the base, *Woman with Scarf* and *Woman with Cut-off Hair*, would be enlarged and cast in bronze by sculptors Hans Kies and Gerhard Thieme, under the direction of Cremer.[38] The final decision at this meeting was to do away with the group of figures at the base. The two cast figures, meanwhile, *Woman with Scarf* and *Woman with Cut-off Hair*, were viewed by all three parties as fulfilling the purpose of Lammert's grouping at the base of Burdened Woman and were installed near the crematorium. Lanwerd explains that there is no further documentation to explain why the unfinished group at the base (the *Unfinished*) was decided against but believes the decision had to do with a changing attitude in the GDR toward official notions of "unity," specifically, that monumental works of art in public space should display unity in and of themselves as well as the unity between the artist and "the people."[39] The Buchenwald Collective and Fritz Cremer decided "the monumental effect of the *Tragende* [Burdened Woman] should not be splintered [i.e., the unity of the carrying figure should not be disturbed] by the isolated figures at the base."[40] However, Gerd Brüne argues that the *Unfinished* depicted the darker side of daily life in the concentration camp more so than Burdened Woman. The *Unfinished* embodied helplessness and exhaustion rather than the resist-

ance depicted by the two women on the pylon, and the decision not to include them was for this reason.[41] A representative of the Committee of Former Ravensbrück Prisoners, Emmy Handke, voiced concerns about leaving out the *Unfinished* figures—but she could not convince the others.[42]

Since the sculpture's inception, the interpretation of Burdened Woman has centered on the two women's embodiment of solidarity, struggle, and Christian redemption. These ideas are echoed in the Ravensbrück brochure, which was published in ten thousand copies and four languages shortly after the site was opened in 1959, and was presented to groups up until 1989. The first sentence of the brochure describes Ravensbrück as "Golgotha" or "Calvary." It continues: "It is a memorial to the women of strong will, to the women with knowledge, who stood firmly together and who supported and sustained their weaker comrades, the defenseless victims; it is a monument, built here to the everlasting glory of our heroines, who fought here to the very last breath."[43] Likewise, the first contemporary critics of the sculpture wrote about the women in terms of their powerful commitment to the collective and their impulse to start a resistance. But there was some disagreement about whether the sculptures embodied solidarity *and* struggle, or *just* solidarity.

Marga Jung, leader of the Committee of Former Ravensbrück Prisoners, for instance, criticized Burdened Woman on the grounds that "only the idea of solidarity was expressed, but *not* the struggle."[44] This echoed an official comment: "Everything bears heavy on the broad, naked feet, whose slight counter pivot stance expresses not striding but slow dragging along . . . the figure of a woman does accuse, but it does not manifest the struggle for the great social renewal."[45]

As a response to Lammert's sculpture, which did not completely fulfill East German needs for the messages of solidarity and resistance, Cremer was commissioned to install the sculpture, entitled *Group of Mothers* (1965), consisting of three female adult figures and two children, alongside the road leading to the entrance of the camp.[46] Three women together transport a stretcher. The woman at the front stands straight and tall and a child hides in her robes. The second woman has a cloth over her head and cradles a child in her arms. The third woman bends over a child on the stretcher.[47] Cremer employed socialist realism, in which the forms of the women would bring the past into the present and into the future. He described his figural group as "the perfect expression of that [socialist realist] idea."[48]

The unfinished group of female figures intended for the base of the monument, and first exhibited at a memorial exhibition for the artist in 1959, also prompted critics to write of their heroism. For instance, Peter H. Feist wrote in the 1959 catalog that accompanied the Will Lammert Memorial Exhibition: "Silent and determined the women stand there, but in their stand-

ing, they change themselves into a powerful force of striding forward. The emaciated crowd is weak and weaponless, but they are not passively patient. No one shows their pain; even the hesitant and the kneeling are held by the collective, in that they begin to raise their hands in angry protest. A mother throws herself over her dead child like a lion, who protects her young."[49] Feist interprets the figures via GDR ideology: the women raise their hands about to protest; and they hold together as a collective. The idea of solidarity among the women has been expressed in the literature from 1959 until recently, when Inse Eschenbach made a critical intervention by looking to survivor stories that contradict that image of harmony.

One survivor, she writes, stated that "one [woman] would look at another with envy and resentment. A dry piece of bread or a slightly larger bit of margarine or sausage was enough to provoke outbreaks of hatred and oaths of revenge"—the opposite of prisoners giving each other mutual support, according to Eschenbach, and of embodying the Communist struggle against Fascism.[50] At the same time, she argues, Christian redemption plays a role in the memorial site.

Eschenbach questions the interpretation of the Ravensbrück memorial site as being an "experience trail" that takes visitors through horror to Christian redemption.[51] The group of architects in charge of designing the memorial, the Buchenwald Collective, she explains, had opted for a concept that included the crematorium and the camp prison behind it in the first phase of the visitor's experience of the site. The tour of the camp finished at Lammert's statue, Burdened Woman (Figure 1.1). The statue thus points to new beginnings and the defeat of death. It embodies Christian ideas of salvation by representing a path from darkness to light.[52] Like other concentration memorial sites, rebirth and liberation is "the message the memorials convey, and the Ravensbrück memorial site is no exception in this respect, in that the causes of all the horror, dismay and grief commemorated at these sites are situated firmly in the past and that it is now time to turn to the present and the future."[53] Angela Lammert offers a different interpretation: since Burdened Woman faces toward the lake and away from the observer, it is not meant to be seen frontally, thereby denying the visitor access to a feeling of redemption.[54] Nevertheless, starting at the time of its installation in 1959, Burdened Woman was frequently referred to as the "Ravensbrück Pietà," reflecting the Christian narrative of redemption.[55]

I want to complicate the interpretations of struggle, mutual support, and Christian redemption by reinterpreting both the main figure and the incomplete grouping of women intended for its base. In the catalog to the 1959 Will Lammert Memorial Exhibition, Marlies Lammert, his granddaughter, explains that the sculptor interviewed many Ravensbrück survivors before designing the monument.[56] Among the stories he heard repeatedly were the

ones about *Strafestehen*, during which inmates had to stand for days on end against the walls of the cellblocks. Some women broke down and fell unconscious, but no one was allowed to pick them up. Once, the seemingly impossible occurred: a woman carried another woman, who had collapsed, into the cellblock.[57] Critics identify the woman who dared to do this as the Jewish Communist Olga Benário Prestes.[58] According to one survivor, Irma Jasper, Benário Prestes carried a woman of over sixty years, who fell unconscious after work, to the doctor's office. The doctor yelled, "What does this Jewish pig want?" Benário Prestes answered, "This is a sick woman who needs medical attention." According to Jasper, both were thrown out of the office and Benário Prestes was denied food for six days and punished with three weeks in solitude.[59] Further, Marlies Lammert writes, "it was no accident that he [Lammert] chose [to depict] a Jewess and a Communist, since he was married to a Jewess and a Communist"—his wife, Hette.[60] Lanwerd suggests that the group became known as "burdened woman"—and not "the Benário group"—as a result of the East German repression of Jewish prisoners in the early years of the postwar period (the history of the Jewish genocide was widely repressed in GDR and the concentration camp memorial sites were no exception).[61] Eschenbach makes a similar point: the genocide of the Jewish people, she writes, is not mentioned once in the Ravensbrück brochure. Jewish prisoners in general figure only marginally in this narrative, and if they do, they serve as a dark background against which the actions of the political prisoners appear all the more heroic. According to GDR ideology, an exemplary person (such as Olga Benário Prestes) should not stand in the foreground. A symbol of a female anti-Fascist fighter, not an individual, should take center stage.[62]

In light of this, I want to suggest that of the two English translations currently in use for the two figures on the pylon, Burdened Woman and Bearing Woman—both of which *are* adequate translations of *Tragende Frau*—the latter is in fact more appropriate. The standing figure is not just burdened by the weight of another woman; she is, in fact, carrying her burden to help the woman who had fallen—we might even call her "Carrying Woman." Furthermore, the women at the base—which were never installed in Ravensbrück—are most likely participating in the *Strafestehen* (torture by standing). Two figures cannot bear the endless torture and kneel to the ground. The others stand in mute silence. Lammert in fact has depicted not heroic fighting women but women who are enduring torture.

From the theme of the monument, I would like to now turn to a stylistic question, for the monument did not completely fit accepted East German conventions of the art of the period. GDR sculpture accepted in public space, as understood in the West up until the 1990s, was rejected as "pre- or

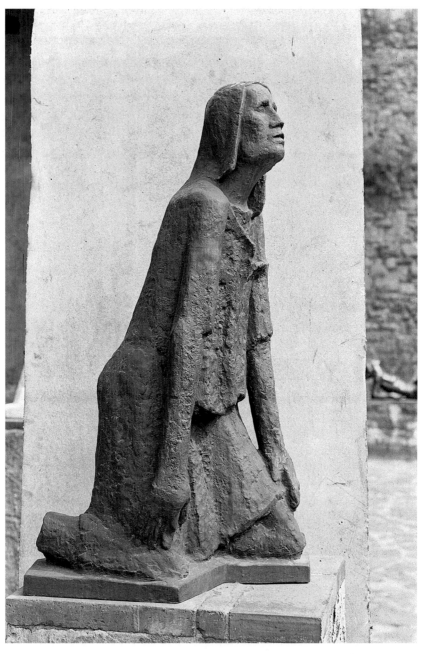

Figure 1.5 Will Lammert, *Kneeling Woman*, 1957. Part of the group of *The Unfinished*, exhibited at the Will Lammert Memorial Exhibition, 1959. Bronze. Height: 84 cm. (Photo: Klaus Beyer. © 2018 Artists Rights Society [ARS], New York / VG Bild-Kunst, Bonn)

antimodern, totalitarian state art," even though abstract art existed for the whole duration of the GDR.[63] Nevertheless, many monuments embracing the elements of Soviet socialist realism were constructed. This is no surprise, as, starting from 1949, artistic institutions were set up on the Soviet model and artists were taught the doctrines of socialist realism.[64]

Lammert's figures, on the other hand, show the markings in clay of the artist's hand (as can be seen in Figure 1.5). The figures appear elongated, their faces indistinct. Here, the emaciated figures are the exact opposite of East German heroines. The figures are not the smooth, abstract forms that Lammert was making in the 1920s and 1930s, but neither are they the socialist realist works that he made in the USSR. In returning to the GDR in 1951, Lammert seems to have reverted to an older, more expressionist approach. Marlies Lammert writes in 1986, "These figures . . . in comparison with the artistic praxis at that time, were perceived as unusual."[65] Likewise, critics at the time of the 1959 exhibition hinted at the unusual artistic style of the figures, without making negative remarks about them.

## The *Unfinished* Figures: 1959 Exhibition

When the *Unfinished* female figures (for instance, *Kneeling Woman*, in Figure 1.5) and a model of *Burdened Woman* were exhibited at the Berlin Academy of Arts in 1959, a few critics hinted at—but did not pursue outright—a critical stance toward the artist's chosen style. Elmar Jansen described the figures as being "finished although not finished."[66] Some critics excused the representations of weak women because they nonetheless embodied socialist ideals. For example, Lothar Lang wrote, "Lammert's figures are a socialist confession, even when they embody the tragic."[67] All of the critics noted the figures' immediate emotional intensity, but the surprising form of the figures went unremarked. Only once did one critic write of Lammert's "shock of simple forms," in the *Thuringer Tageblatt* in 1959.[68] One critic, Ingrid Beyer, writing in *Bildende Kunst*, was negative in an outright way, stating that *Burdened Woman* "stands at the end of the past, not at the beginning of the future" and that "this is what separates the work from socialist realism."[69] However, in 1962, critic Georg Piltz defended the sculptures' socialist message: "Resistance is condensed to action, and the objective of this action is the preservation of life for the sake of the future. *Burdened Woman* practices solidarity in the middle of Hell, the goal of which was to suffocate the human in people. They are invincible because they know to act as one with the actions of their class. They do not believe in the triumph of humanity . . . the Fascists could destroy these women, but they could not force them to submit."[70]

But most critics attribute the relative lack of negative criticism about his works to the artist's unusual story of exile and return. Lammert was a Communist who fled National Socialist Germany. The Nazis destroyed virtually all of his works. He was married to a Jew; he served in a labor camp in the Soviet Union and returned after eighteen years in exile to the GDR. He was, so to say, a special case—he was excused for moving outside of the normally expected iconography of East German art production because he experienced the war in ways that many others did not. He was considered a hero.

In addition, when the unfinished Ravensbrück grouping was exhibited in 1959, it was done so in the context of artistic exhibition that harkened back to the 1930s and Communist avant-garde art. John Heartfield, Lammert's friend, and himself a famous avant-garde artist from the 1930s, decided on the arrangement of the figures at the 1959 exhibition, putting them on a low podium, which was an unusual choice for an East German exhibition of that era. Heartfield was a Communist who actively created art against Hitler in the Nazi period. He fled Germany to England, where he permanently changed his name from Helmut Herzfeld to John Heartfield. In addition, Heartfield designed both the exhibition catalog and the exhibition poster. He designed the catalog so that in one particular two-page spread, the maquette of the Ravensbrück monument (which includes the *Unfinished* figures) occupies the right side, while a bright red page occupies the left.[71] Marlies Lammert attributes the critics' positive responses to the exhibition—and their avoidance of any critique of the works' abstract qualities—to Heartfield's engagement with the show.[72] Marlies Lammert implies that Lammert thereby was excused for creating works of art that harkened back to prewar abstract approaches more closely aligned to expressionism than to socialist realism because he was championed as a Communist war hero and was supported by Heartfield, who himself was championed as an anti-Fascist artist.

Furthermore, the narrative of GDR art history has changed dramatically since the 1990s—it is not just that Lammert's *Unfinished* sculptures did not fit into the prevailing notions of East German art but that East German critics were, in fact, radically revising Soviet socialist realism and were trying to find ways to prove that expressionism was not a "mystical, irrational cult of genius, to be outrightly rejected as an expression of subjective emotionality."[73] Instead, they argued that expressionism could very well be in the service of the workers. East German artists, Ulrike Goeschen argues, were trying to negotiate between the inheritance of socialist realism from the Soviet Union, the need to distance themselves from the realism of National Socialism, and their own artistic ideals. Already in 1957, the very year Lammert was working on these figures, Lothar Lang and Wolfgang Hütt, both highly influential

art critics, "defined expressiveness of line, optical conciseness, succinctness of composition and the emotional use of color as positive characteristics of expressionism," marking a permanent change in art circles about what was and was not allowed in East German art.[74] Lammert, therefore, came back to East Berlin at precisely the right time, at least in terms of the development of art criticism. The language of critics in 1959, who noticed the simplicity of the *Unfinished* forms and their radical reduction—Lothar Lang included—were participating in a discourse of East German art that was slowly welcoming back expressive forms. However, by the late 1950s in the GDR, artists, art critics, and historians were allowing some versions of expressionism to be voiced, as long as elements of solidarity and struggle were still present.

For instance, Peter H. Feist's 1959 analysis of the figures in the memorial exhibition catalog calls to attention an appreciation for the artist's style that emphasizes suffering, unity, and "the courage of the antifascists," who are at the same time "sketchily" modeled. As the essay was the first to address the *Unfinished*, it served as a model for all critics who came after and, therefore, deserves to be quoted at length:

> The women stand there in threatening silence. Wide naked feet are sucked to the ground. Lammert had once depicted a group of dancing and swaying women, full of euphoria and excited symbolism. Now he makes a group like a bundle (Pfahlbündel)—but this rhythm of apparent randomness is more exciting and thrilling than his earlier works, and these forms are true symbols: symbols of power and unity, of the courage of heroes of the antifascists. The women are not beautiful. Some of them would have been young, had they been free. Now they are the objects of horrible terror, haggard, shaved. But they are not depressed, because they will not let themselves be depressed. They stretch with the power of right; they carry their heads high. The faces blaze with excitement. If the bodies have become rotten, the breasts have fallen flabbily, the hands have become much too heavy for the thin arms—the necks reach free and energetically upward, the bodies slump under the robes with the real strength of plastic forms. Lammert reaped the fruits of his long efforts to express the female form. Even here he pays homage to the female form. No face, so sketchily or hollowed out they are, leaves us to doubt that they are women's faces. Hardly anyone . . . cannot see, that these cheeks, these necks, these mouths have longed for and long for loving caresses.[75]

Lothar Lang wrote sympathetically, in a review of the 1959 Will Lammert Memorial Exhibition, about the "deformed" bodies that signify the

horrors of the deportations while still invoking unity, "socialist confession," and "party affiliation":

> They [the women] are obviously rooted in compassion with the immeasurable suffering that fascism brought to our people, but also out of a sense of obligation on the part of the artist who wants to contribute with his works to preventing renewed suffering. Lammert's projects are more than an accusation. In his figures everything is deformed, if one understands under deformation the non-conformity with ideal body type. But Lammert's deforming has nothing to do with play . . . but rather makes palpable the misery, the hardship, the pain of these tormented women. To search for precursors to his expressive forms is as useless as situating Lammert mechanically in a specific stylistic development. Will Lammert was an innovator who did not copy anything, but instead critically processed traditional imagery on the basis of his world view and party affiliation. It appears to me that he found a sculptural language congenial to his concerns, which would be utterly inconceivable without this practice, since it permeates the content and form dialectically and transforms them to an unsolvable unity. Lammert's designs are a socialist confession, even when they embody the tragic.[76]

It is noteworthy that in Feist's 1963 introduction to the catalog of the Dresden Will Lammert exhibition, he removes all reference to "unity," "party affiliation," and "socialist confession."[77] Furthermore, in the last sentence of his essay, Feist includes the word *expressive* as one of the characteristics of Lammert's figures: "It has become even more clear, as he came ever closer to his class, that his art became richer and more full of life, in order to make more understandable to the people: without words, full of fantasy, *expressive* and truthful [emphasis added]."[78]

Expressionist figures, new to the culture of art making in East Berlin and most likely representations of women enduring torture by standing at Ravensbrück, took on a completely new connotation when they were installed as the Memorial to the Victims of Fascism (1985) in the former East Berlin, which is the subject of Chapter 3, "Monuments to Deported Jews in Hamburg (Hrdlicka, Rückriem, Kahl) and East Berlin (Will Lammert)." But first, let us turn to an abstract memorial installed in 1963 in West Berlin. While the final version of Lammert's Burdened Woman embodies GDR political ideals, the Münchener Straße Synagogue emerges as a commemorative sculpture that avoids the topic of its commemoration.

# Federal Republic of Germany (FRG)

## *Thirteen Cubes and a Menorah on Münchener Straße*

A sculpture, 2.35 m tall and consisting of thirteen blocklike forms, is situated in Berlin-Schöneberg, in the Bayerisches Viertel (Bavarian Quarter), along Münchener Straße, in front of a schoolyard (Figure 1.2). Thirteen coquina blocks (a material similar to limestone) of different sizes, some rectangular, some square, appear to be stacked in an asymmetrical fashion. Seen from the front (that is, from the sidewalk along Münchener Straße), the blocks are arranged around a central, asymmetrical void, through which one can see the neighboring elementary school in the background. The left uppermost block depicts a quasi-abstract seven-branched menorah. A sculpted inscription appears on a lower-right block. It reads: "Here stood the synagogue built by the Jewish community in 1909."[79] One block supports the sculpture, which in turn rests upon a large, thin, square granite base. A bronze plaque on the flat base reads: "Here stood a synagogue from 1909–1956. Due to its location next to a residential building, the synagogue was not destroyed on Nov. 9, 1938. After the expulsion and destruction of the Jewish citizens by the National Socialists, it lost its function and was fully taken down in 1956." A title is not provided.

The second plaque provides more information than does the inscription on the sculpture itself. Still, much is left unsaid. We learn that a synagogue once stood here but not who commissioned the sculpture. We discover that the synagogue was *not* destroyed on November 9, 1938. And *Kristallnacht* remains unnamed. We read that "it [the synagogue] lost its function" and that "it [the synagogue] was fully taken down"—but we are not told why it lost its function or who took it down. The plaque does not provide the artist's name and it does not mention the Holocaust or the murder of Berlin's Jews. One is left with a list of questions that neither the sculpture nor the inscription on the sculpture nor the bronze plaque answer: Who is the artist? Why a seven-branched menorah? Why a memorial consisting of blocks? Here I attempt to answer these questions by providing a brief history of the synagogue and the Schöneberg neighborhood, examining the artist's stylistic development, analyzing the commission, and interpreting the memorial in terms of its inscriptions and blocklike forms. Fehrenbach's memorial to the destroyed synagogue emerges as a work of art that is about what cannot be spoken, or depicted, in Berlin in the mid-1960s.

The Bezirksverordnetenversammlung von Schöneberg (Borough Assembly of Schöneberg; hereafter Borough Assembly) awarded German sculptor Gerson Fehrenbach the commission in 1963 and installed the sculpture the same

year. While the Borough Assembly representatives discussed the importance of the memorial for the community (as evidenced by meeting minutes), those conversations did not translate into the design of the memorial, perhaps because neither the representatives nor the artist had the conceptual tools with which to do so nor the historical distance with which to approach the topic. In 1960, when the process to commission this memorial began, public memorials in West Germany dedicated to the Holocaust did not exist (the more famous International Monument by Nandor Glid at the Dachau concentration camp was installed in 1968). In fact, West German communities avoided installing public monuments in general, as monumental objects in public space played a fundamental role in rallying the public to support National Socialist ideology.[80]

The memorial was installed at a moment in time when an artistic vocabulary for Holocaust memorials in the FRG had not yet been developed. Finding a visual language for a memorial dedicated to a destroyed synagogue, therefore, meant choosing an artist who used a modern vocabulary of abstraction, who was already known in German contemporary art circles, and who would create a work of art that was acceptable to both the artistic public and the general public—in sum, a choice that was safe. That is, the Borough Assembly did not want a public work of art that would clearly point to National Socialist guilt. It is, therefore, an ambivalent memorial, both in terms of its visual elements and in terms of the accompanying textual information. This ambivalence is echoed in the way in which the memorial is—or is not—entitled.

The title of the sculpture neither appears in the carved inscription nor on the bronze plaque. In the two German-language monographs on Fehrenbach, the model for the memorial is referred to as *Entwurf Gedenkstein für ehemalige Synagoge* (model for the memorial stone for the former synagogue). The title is ambivalent because in reality the synagogue is not "former"—it was destroyed. In a monograph of the artist, the memorial is entitled *Plastik IV/63 Gedenkstein für ehemalige Synagoge* (Sculpture IV/63 memorial stone for the former synagogue). The word *sculpture* serves to disengage the work from its purpose as a memorial (which is, however, noted in the subtitle) thereby emphasizing its role as a sculpture. In the face of this complicated system of entitling, for the purposes of this chapter, I refer to the final sculpture as the "Münchener Straße Synagogue Monument." The ensuing pages demonstrate that this little-known monument to a destroyed synagogue exemplifies local attitudes—in what was then West Berlin—toward the National Socialist past: a synagogue should be remembered in public space, but it was not necessary to convey either the details of the destruction or the ramifications of that destruction for its neighborhood.

## History of the Münchener Straße Synagogue

The Münchener Straße Synagogue was located on 37 Münchener Straße, in a neighborhood in the heart of the Schöneberg District in Berlin, commonly called the *Bayerisches Viertel* (Bavarian Quarter; because its streets were named after Bavarian towns), in which Jewish life flourished until 1941 (it was also known as Jewish Switzerland). Salomon and Georg Haberland built the neighborhood from 1900 to 1914. It features upper-class residential houses situated on quiet streets and in idyllic squares, and it was a central point for affluent Jewish intellectual life in pre–Nazi Berlin. The Bavarian Quarter was home to sixteen thousand Jews before the deportations to concentration camps began. Residents included Albert Einstein, Walter Benjamin, and Hannah Arendt.

The Synagogue Association commissioned architect Max Fraenkel to design the building in 1909 and it opened a year later.[81] The building consisted of two floors and was built of reinforced concrete. Of 836 seats, 388 were for women and 448 were for men. The synagogue was in the back of the building; in the front were the living and schoolrooms, the rabbi's room, and a prayer room for weekday services. In 1925, the Jewish community took responsibility for the complex.

On *Kristallnacht*, when synagogues across Germany were destroyed, the synagogue was not badly damaged because it was situated next to other (Aryan) buildings. This was the case throughout Germany: synagogues were spared if they were adjacent to Aryan buildings. The building was partially destroyed during the Allied bombings of World War II. By the 1950s, the building was in a state of disrepair and contained both antisemitic and philosemitic graffiti.[82] An image of Hitler was drawn on the bimah, accompanied by the words *Heil Hitler*. At the same time, the words *Bekennt zur Deutscher Geschichte 1933–45* (Own up to German history 1933–45) instruct the audience to accept their guilt. *Bekennen* as a verb is used if one confesses or admits to having made a mistake and the writing on the wall is therefore a call to raise consciousness.[83] The synagogue was completely demolished in 1956, with the permission of the Jewish community—a common state of affairs at the time, as Jewish communities throughout Germany often did not have the funds for reconstruction and local communities did not take the initiative to donate funds to do so.

## Gerson Fehrenbach: Nodules and Cubes

Gerson Fehrenbach was born in 1932 in Villingen, Germany. Although Fehrenbach was very prolific, won prizes, and participated in both museum ex-

hibitions and commissions for public art, he is seldom discussed in studies of contemporary sculpture.[84] His work can be characterized as employing either organic, bulbous forms, or cube-like shapes—or a combination of both.[85] The Münchener Straße Synagogue Monument falls into the body of work dedicated to cube-like forms and was based on a sculpture he had made in 1958, before the actual commission.

Fehrenbach did not have any association with Judaism; he was Catholic (an altar boy, according to his grandson) and was taught in the tradition of the classical modern.[86] As an artist, he was interested in figuration, abstraction, nature, and the human form. In 1946, he began his study of wood sculpture and took private lessons in drawing and painting. He visited exhibitions of Henry Moore's work in Munich (*King and Queen*, 1952), works of Gerhard Marcks in Freiburg, and Auguste Rodin exhibitions in London and Paris.[87] In 1954, the Freiburger Kunstverein awarded him a fellowship to Paris for his *Sitzender Jüngling* (*Seated Male Youth*, 1954). In Paris, Fehrenbach had the opportunity to visit the studios of modern masters, including Hans Arp, Constantin Brancusi, Antoine Pevsner, Nicolas Shöffer, Jean Tinguely, Georges Vantongerloo, and Ossip Zadkine, and he worked as a studio assistant for both Zadkine and Arp. Influenced by these artists, he made many nudes, portraits, and abstractions during his stay that are remarkable for their engagement with the European avant-garde. At the conclusion of his fellowship in 1955, he sought a place to study in the master class of sculptor Karl Hartung (not to be confused with the painter Hans Hartung, who is no relation and is famous for his *Informel* paintings), was accepted, and, after his Paris stay, moved to Berlin. It is worth briefly describing his teacher's works and outlook on contemporary art, particularly since Hartung was known for one of the first nonfigurative public monuments in the FRG, a project that coincided with Fehrenbach's study in his teacher's studio.[88]

Hartung was deeply influenced by the works of Rodin and Aristide Maillol, with whom he studied in Paris in 1929.[89] When Hartung returned to Hamburg in 1932, he realized that his working and living conditions as an abstract stonemason were becoming increasingly difficult because of the cultural policy under the Nazi regime. In 1936, he moved with his family to Berlin. In 1949, Hartung was appointed to the Hochschule der Bildenden Künste (College of Art) in Berlin, and, in 1955, he became the chairman of the Deutscher Künstlerbund (German Art Association). The same year, Hartung participated in the international contemporary art exhibitions documenta I (1955), documenta II (1959), and documenta III (1964) in Kassel. In 1956, Hartung's *Große Kugelform* (*Large Spherical Form*) was installed in Hannover and was his first work of abstract art in public space—and most likely the first work of abstract art in public space in Germany after World War II.[90]

*Large Spherical Form* is 1.9 m high and consists of a large circular form with an opening (or "break") at the top, which Heinz Ladendorf speculates can be interpreted as a metaphor for a divided Germany.[91] According to Godehard Janzing, as a result of this interpretation, the sculpture was installed in 1959 on its present site and was dedicated to the East German uprising of June 17, 1953. A plaque near the sculpture reads: *"Einigkeit und Recht und Freiheit"* (Unity and justice and freedom). Creating a public sculpture at a time when artists were wary to do so was, therefore, a key aspect of Hartung's work as an artist. Fehrenbach was his student during the mid-1950s, when Hartung was working on various phases of the reinterpretation of the 1948 sculpture.

Under Hartung's tutelage, Fehrenbach became interested in themes such as life after World War II, the atom bomb, Hiroshima and Nagasaki, and the Cold War. He was fascinated with the lowbrow material of cement.[92] He learned to interpret nature and started to concentrate on natural, abstract forms (there is some disagreement in the existing literature as to whether his work should be characterized as "Art Informel").[93] He studied nature, antique art, and the modern avant-garde in order to create his own sculptural language. Many of his works consist of organic forms, including nodules, which are based on his intensive study of nature; many others have strong vertical and horizontal axes and consist of cubic forms. His main materials were stone, bronze, and cement. He was inspired by motifs from mythology and religion. In such works as *Paar Relief* (*Relief Couple*, 1955), defined by quasi-abstract figures in heavy blocky forms, one can see how the artist was influenced by Henry Moore's emphasis on massive figures and organic, rounded forms. In the period between 1957 and 1959, Fehrenbach's work changed radically and started to invoke the block forms similar to those found in the 1964 synagogue monument. By 1957, Fehrenbach created a 24 cm standing bronze figure, entitled *Stehende (Athene)* (*Standing Figure [Athena]*; Figure 1.6), by employing about twenty-three cubes with slightly rounded edges that are stacked vertically on top of one another to imply a human form.

Fehrenbach's *catalogue raisonée* lists *Komposition* (*Composition*; Figure 1.7) from 1958 as the model for the synagogue monument; he chose this sculpture as one of the three models he presented to the Deputation des Bauwesens (Construction Committee; see the section "The Commission," below). The blocks are hard-edged and are sculpted to appear layered atop one another; one rectangular flat block functions as its base. The sculpture consists of thirteen cubes with a void in the center. The uppermost block, on which the menorah appears in the final version, is polished to a smooth surface. *Kubische Raumfiguration* (*Cubist Space Configuration*, 1959) demonstrates that in the late 1950s, the artist was preoccupied with creating figures out of abstract cubes. As opposed to *Komposition*, *Kubische Raumfiguration* consists

**Figure 1.6** Gerson Fehrenbach, *Stehende 57/II (Athene) (Standing Figure 57/11 [Athena]).* Concrete. 47 × 13 × 10 cm. (Photo: Klaus Beyer. © 2018 Artists Rights Society [ARS], New York / VG Bild-Kunst, Bonn)

**Figure 1.7** Gerson Fehrenbach, *Komposition*, 1958. Design for the Monument to the Former Synagogue. Coquina. 22 × 17.5 × 8.5 cm. (Photo: Klaus Beyer. © 2018 Artists Rights Society [ARS], New York / VG Bild-Kunst, Bonn)

of extremely rounded cubes in a more three-dimensional form, measuring 22 × 15 × 4 cm. Fehrenbach invoked stacked geometric forms such as rounded blocks, and later, hard-edged blocks, to depict human forms.

In the late 1950s and early 1960s, Fehrenbach was awarded several prizes and fellowships. In 1959, Fehrenbach was invited to the first Symposium of European Sculptors at the quarry in St. Margarethen, Austria, a symposium founded by sculptor Karl Prantl, which would become a center known for attracting contemporary sculptors.[94] The formative notion of the symposium was "to sculpt the images from stone that should bear witness to our times."[95] The fact that Fehrenbach was invited to the symposium speaks to his growing commitment to working on innovative sculptural forms that sought to define his generation of artists. He continued to work in cubistic forms, including his *Raumfiguration* (*Space Configuration*) and *Hantel*. In 1959, Fehrenbach was awarded the Prize of the Great Berlin Art Exhibition for his *Paar Relief* (1955) and *Engelspaar* (1956). A year later, he acquired his own studio and, in 1962, won a Villa Roma Prize to study in Florence. By the 1960s, his work turned to knobbier, more organic forms, such as *Liegende* (*Reclining Female Figure*, 1961) and *Wurzel III/61* (*Root*, 1961). The year 1963 marked a breakthrough for Fehrenbach. He participated in the 1963 Symposium of European Sculptors in Berlin with his *Grosse Knospe III/63* (*Large Nodule*, 1963), a large outdoor work that primarily consists of organic, amorphous forms, accompanied by a horizontal "cut" in the limestone on one side (this may or may not be a quotation of Hartung's "cut" in *Large Spherical Form*, discussed above). Fehrenbach's participation in the exhibition cemented his reputation as an international sculptor of modern art. The same year, he was awarded a teaching position at the Technische Universität Berlin as an assistant for Erich F. Reuter. Soon thereafter he received a commission for the Münchener Straße Synagogue Monument.

## The Commission

In March 1960, the Borough Assembly voted to expand the schoolyard of the Löcknitz Elementary School, which is situated on part of the former footprint of the synagogue. The occasion prompted a Christian Democratic Union (CDU) member of the Borough Assembly to recommend a memorial to the synagogue. As a result, the assembly voted to "make recognizable the former location of the Synagogue on Münchener Straße on which the events of the so-called 'Night of Broken Glass' will be pointed out."[96] The Construction Committee agreed with the recommendation of the Borough Assembly in their meeting of August 25, 1960, and decided to realize the honoring of the synagogue together with the design of the outdoor facilities of the Löcknitz school grounds.[97]

The Borough Assembly met again in September 1960 and voted to "dedicate to the synagogue a special section of the school courtyard's enclosure—across from the junction of Westarpstrasse and Münchener Straße."[98] The conversation, recorded in the meeting's minutes, reveals the way that committee members struggled to find the correct language for the memorial. The minutes are worth quoting in full:

BV. Treutler (CDU):

Ladies and gentlemen!
Many Schöneberg residents will remember, that until the year 1938 there was a relatively small synagogue in the Münchener Straße—the only one, as far as I know of—in Schöneberg. This synagogue was set on fire during the regrettable events of Kristallnacht on 11 Nov. 1938; later bombs fell on it, and the remaining ruins were cleaned up after the war. Now apartment buildings have been or are being built in that space. The CDU faction believes it is the right thing to do on this spot to make the existence of the synagogue visible in some appropriate form, especially now that a school is an immediate neighbor, and that it will be noted that that Jewish house of worship was destroyed on Kristallnacht. We are of the opinion that this would be a small contribution of the Schöneberg District for the Week of Brotherhood, and we are of the opinion that perhaps also it would be seen as a friendly gesture by the many former visitors of the synagogue who now live abroad. I take the liberty of suggesting in this context to give the stimulus to find out if a former rabbi who worked at the synagogue is still alive. Perhaps one could pass along this information to him. You are aware of the importance of such an attempt to try to restore our reputation in this regard.
Therefore, we ask for your consent to this proposal.

BV. Gebler (SPD)

In the name of the SPD Faction I'd like to add a small supplement and share that we agree. And I'd like to share that it was not only the synagogue that was destroyed—this is not only an opportunity to bring awareness about the destroyed synagogue, but also about the people who were rounded up and transported to the KZ-Lager after 1938/39. That, too, is one more reason, that it [the synagogue] must be recognized, and therefore we agree with this proposal.

CDU representative Treutler suggests that the public should remember the synagogue as a gesture of goodwill and his impetus to seek survivors (including

a rabbi) conveys a sign of openness. But the proposal is packaged as improving the district's reputation—and not on the necessity of remembrance. SPD (Sozialdemokratische Partei Deutschlands; Social Democratic Party) representative Gebler, however, makes clear that the act of remembrance should be not only about remembering the synagogue but also about remembering those who were deported and thereafter sent to concentration and death camps. For Gebler, the district's reputation was not as important as the remembrance of missing people. Neither refers to "Jews." The chairman of the meeting stated that the ultimate decision was with the Construction Committee.

Fehrenbach presented three models to the Construction Committee on December 12, 1962 (Figure 1.7; only one model survives). The committee unanimously agreed to the model of the freestanding sculpture, approximately 2.25 × 1.75 × 0.8 m. Fehrenbach's family recalls that the artist was approached by the commissioners and submitted an already-existing sculpture—*Komposition* of 1958, one of the cube sculptures with which he was already working—as a model that he then amended and revised in order to make it suitable for a public memorial.[99] The president of the Central Council of Jews in Germany, Heinz Galinski, as well as the Department of National Education, also accepted this design. The sculpture would be made of limestone. For purposes of "special identification," the Construction Committee decided that part of the design should include a "Jewish symbol" (but the Borough Assembly meeting minutes do not record a discussion about the nature of the Jewish symbol) and an inscription, reading *Hier stand von 1909 bis 1948 eine Synagoge der Jüdischen Gemeinde* (Here stood, from 1909 to 1948, a Synagogue of the Jewish community). In the meeting minutes, the sentence, "Here stood, from 1909 until 1948, a Synagogue of the Jewish Community," is crossed out by hand and replaced with, "Here stood the synagogue built by the Jewish community in 1909."[100] According to the minutes, the assembly accepted that change. The Borough Assembly stated the estimated cost to be DM 14,000.[101]

The minutes do not indicate the reason for the change in wording. The year "1948" was perhaps seen as confusing, as that date refers neither to the end of the war nor to the year in which the synagogue was fully razed (1956). By emphasizing the 1909 dedication of the synagogue, the committee effectively erases the events of *Kristallnacht*, Allied bombing, and the complete destruction of the building in 1956. The inscription only gives a partial story: a story of a synagogue's dedication—and, therefore, a story of life but not of destruction. It is also important to note that Gebler's opinion from the 1960 meeting, in which he stated that the remembrance of those deported and executed is most important, is effectively erased.

The memorial was installed on November 25, 1963. The event was covered in *Der Tagesspiegel*, the West Berlin daily newspaper.[102] Galinski, who in 1963

became chairman of the Jewish Community of Berlin, gave a dedication speech: "May the memorial become a place of contemplation. May the people who visit the memorial also remember that those synagogues twenty-five years ago were the places from which Jewish people were transported to extermination camps." His words emphasized not just the destruction of the building but also the deported Jews and echo those of Representative Gebler in the Borough Assembly. *Der Tagesspiegel* reported that the Evangelical Church called for a penitential liturgy and listed the locations where wreaths would be laid on the day of remembrance in Berlin. Two locations for wreath laying were at the sites of destroyed synagogues, including the memorial to the former Fasanenstrasse Synagogue (where the returning Jewish community built a community center in 1959), and at the memorial to the destroyed Levetzowstraße Synagogue— the latter noted in the article in *Der Tagesspiegel* as situated "at the corner of Levetzow Str. and Jagowstr.," thereby erasing any reference to the destroyed Levetzowstraße Synagogue altogether.

## Interpreting the Memorial

Armed with information on the history of the synagogue, the biography of the artist, and the details of the commission, let us turn once again to the memorial to reinterpret the roles and meanings of the inscriptions and the blocklike forms. In the case of the Münchener Straße Synagogue Monument, the inscription that appears on the sculpture elides the history of genocide altogether. Viewers are expected to be knowledgeable and thus able to fill in the gaps of missing information. In other words, viewers are expected to understand that the Jews were deported to concentration and death camps and to intuit why and how the synagogue was destroyed.

On January 20, 1988, to prepare for the fiftieth anniversary of *Kristallnacht*, the Borough Assembly voted unanimously to restore the memorial.[103] In June of that same year, the Borough Assembly voted unanimously to install a two-tiered base to avoid further damage to the sculpture and suggested the following text for a new bronze plaque: "Here stood a synagogue from 1909–1956. During the *Reichspogromnacht* on Nov. 9, 1938, the synagogue was not destroyed due to its location next to a residential building. After the expulsion and destruction of the Jewish citizens by the National Socialists, it lost its function and was fully taken down in 1956."[104] The text voted on by the Borough Assembly differs from the text on the bronze plaque that was ultimately installed, in one sense: while the words "during the *Reichspogromnacht*" (*Kristallnacht*) appear in the minutes, they do not appear on the plaque. The plaque reads: "Here stood a synagogue from 1909–1956. Due to its location next to a residential building, the synagogue was not destroyed

on Nov. 9, 1938. After the expulsion and destruction of the Jewish citizens by the National Socialists, it lost its function and was fully taken down in 1956." The Borough Assembly records do not explain why the phrase *Reichspogromnacht* was deleted from the final plaque.

As opposed to the 1963 inscription on the sculpture, the 1988 plaque indicates the full date range of the synagogue's existence. It states why the building was not fully destroyed on *Kristallnacht* and that Jewish citizens were both expelled and destroyed by the National Socialists. The Borough Assembly uses the passive voice for the last sentence—a grammatical device common in German but one that nonetheless greatly curtails the story of the ruins' removal in 1956.

The history of naming the events of November 9, 1938, is a curious one, and a discussion of it potentially reveals why the word *Reichspogromnacht* was omitted in the 1988 plaque. In the United States, especially in Jewish communities, *Kristallnacht* (Night of Broken Glass; the translation of *Kristallnacht* is simply Night of Crystal), commonly refers to the events of November 9–10, 1938, when Nazis rounded up thirty thousand Jewish men and deported them to concentration camps. Members of the Stutzstaffel (SS) and Sturmabteiling (SA), joined by German citizens and supported by bystanders, destroyed scores of synagogues, in addition to Jewish businesses and Jewish homes.[105] Historians understand *Kristallnacht* as the first step in what would become the Final Solution, which was formalized in 1941. But in Germany, the words and phrases used to delineate those events have a complicated history, as historians Harald Schmid and Alan Steinweis explain.[106]

To refer to what we now call *Kristallnacht*, the perpetrators and official Nazi departments used propaganda-tinged expressions such as "Jewish action," "November action," "retaliatory action," "special action," and "protest rallies." No one knows the origination of the term *Kristallnacht*, but it was widely believed in postwar Germany that Joseph Goebbels coined the phrase—and, therefore, Germans in the postwar period avoided using it. German reports of the exiled Social Democratic Party and the newspaper *The Red Flag* of the Communist Party of Germany referred to "Jewish pogroms," a much more to-the-point phrase, as *pogrom* was a Russian word known in Germany that referred to the plundering and destruction of Jewish property. Pogroms were widespread in Russia during the late nineteenth and early twentieth centuries and were carried out by local police—with the approval of the czar. The phrase "as the synagogues burned" was also used in the immediate postwar period, but the phrase leaves out violence against Jews, murder, and the perpetrators.

Many eyewitnesses to the persecution of the Jews also remembered other terms that circulated at that time, such as *Glasnacht* (Glass Night), *Gläserner Donnerstag* (Glass Thursday), *Nacht der langen Messer* (Night of the Long

Knives), and *10. November* (Tenth of November). Texts of the immediate postwar years include phrases such as *Reichsscherbenwoche* (Empire Week of Shards), *Kristallnacht* (Night of Crystal), *Judennacht* (Jews' Night), *Pogromnacht* (Pogrom Night), *November pogrom* (November massacre), *Synagogensturm* (synagogue storm), and *Synagogenfeuer* (synagogue fire), among others.[107] The fact that a nationwide event led to such an array of designations indicates that many people have perceived it as an extraordinary event that requires special naming. The use of *Reich* in such phrases reflects the expansion of terror on the entire national territory, but rarely was the homicidal violence against Jews directly mentioned. (Also, the dates of *Kristallnacht* are under debate by historians, who often limit the events to the one night, which reflects the state-sanctioned wave of persecution on November 9. But, in fact, the events of *Kristallnacht* had begun in some places already on November 7 and reached their peak on the morning of November 10.)

Since the anniversary to November 9–10 in the GDR in 1978, the term *Reichspogromnacht* was increasingly used, and, according to Harald Schmid, it was commonly used by 1988. That year, according to Schmid, marked the form of powerful, emotion-laden ceremonies that lacked historical context. Those ceremonies "fulfilled the ritualistic purpose of signaling recognition of the suffering inflicted on Germany's Jews during and after the pogrom, but they evoked the actual events of November 1938 in only the most general way," in which distinctions were commonly drawn between "the Nazis" and the German public, serving to exculpate ordinary German citizens from their active participation in the violence.[108]

In 1988, Philipp Jenninger, CDU member and president of the Bundestag, delivered what would become one of the most controversial speeches in twentieth-century Germany.[109] While he gave detailed accounts of the antisemitism of *Kristallnacht*, the German people, he said, had been by and large "passive" during the pogrom and that "only a few" had joined the organized violence of the SS and SA. His speech was delivered on November 9, 1988.[110] International outrage ensued, for by 1988 historians were questioning the myth of the so-called passive German bystanders. As the speech was given on November 9, it was the contemporary context in which the Borough Assembly made its decision to remove the word *Reichspogromnacht* from the plaque, which was installed on November 25. It may be the case that the Borough Assembly made the decision to avoid the word *Reichspogromnacht* in order to distance their memory work—the installation of the plaque with more information than the original inscription—from the Jenninger controversy.

The 1988 plaque is more explicit than the 1963 inscription and more in line with what was allowed to be spoken in the late 1980s—that is, a statement in which both victims and perpetrators are named. By the 1980s, for

instance, the FRG had entered a phase of making memorials dedicated to the Holocaust. Artists started to design "counter-memorials" in the 1980s, when German communities were ready to build memorials meant to question traditional sculptures, which, in turn, usually express both remorse and honor and take monumental—if not vertical—form. In contrast, counter-memorials were often underground, employed negative spaces, or were horizontal in orientation.[111] Such is the case for Jochen Gerz and Esther Shalev-Gerz's Monument against Fascism (Hamburg, 1986) and Horst Hoheisel's Negative Form Monument (Kassel, 1985). The 1988 plaque then reflects new ways to encounter the past in West Germany.

Fehrenbach was working with cube-like sculptures that depicted human forms in 1958, such as *Standing (Athena)* and *Cubic-Spatial Sarah*, when he designed *Komposition* (Figure 1.7), the model that would become the synagogue monument. We can, therefore, interpret the "blocks" of the memorial as an abstracted human form in the guise of a memorial to a building. According to Heinz Ohff, Fehrenbach "was influenced by Russian Constructivism of the 1920s: right angles and cubic forms grew from his figures, like dice. Together with [the American] sculptor Joseph Lonas, with whom he was friends, he tried to place each cube consistently, until it became a kind of scaffolding that reminds one of architectonic, but also tectonic, objects. But the figure stays hidden in the foundational substance of the sculpture. One of these works was the memorial for the destroyed Synagogue on Münchener Straße."[112]

In fact, the works from the late 1950s that consist of cubes all have titles that are reminiscent of figures: *Stehende 57/III* (*Standing Figure 57/III*, 1957); *Figuration (Mutter mit Kind)* (*Figuration [Mother with Child]*, 1957); and *Räumliche Figur* (*Spatial Figure*, 1958). All are abstracted figures, but none have voids or empty centers, as the memorial design does. Instead, they are "full," with cube-like shapes.

The Schöneberg Jews may not have been named in the original inscription—only becoming present in the bronze plaque installed in 1988—but human form was nonetheless in the background of Fehrenbach's artistic approach during the late 1950s, when he was worked on his cube-like constructions. When facing the memorial on the street, viewers might do well to remember SPD representative Gebler's words in 1960: the memorial should commemorate not only the building but also the deported Jews. From today's vantage point, one might be tempted to interpret the sculpture as an abstracted figure, in line with the artist's other works of the late 1950s, or to interpret the void in its center as a metaphor for the missing Jews. But I hesitate to make such a claim. Instead, the historical context of the memorial, the discussion of the minutes, the content of the inscription and plaque, and the visual elements of the sculpture indicate that the sculpture was and is more about leaving things out than making ideas clear:

visitors are left wondering why the synagogue was not destroyed on *Kristallnacht*, why it was razed in 1956, and how many Jews lived in the Bavarian Quarter. The memorial is more about what could and could not be said—and shown—in 1963 than about what the sculpture actually conveys through textual and visual means.

## Overlooking the Memorial

Why is there a dearth of literature about this memorial? Here are four potential explanations for why Fehrenbach's memorial has been overlooked. First, Fehrenbach, while known in Germany, never achieved international recognition as a sculptor; therefore, scholars of public art and memorials do not immediately recognize his name. This state of affairs, in fact, was common for German sculptors in the immediate postwar period. During the 1950s and 1960s, West German artists struggled to find an artistic vocabulary that both distanced them from National Socialism and resisted quoting the prewar avant-garde in a facile way. Abstract sculpture in the early 1950s, such as those works by Karl Hartung (Fehrenbach's teacher) and Hans Uhlmann played a marginal role.[113] On the international scene, artists such as David Smith, Henry Moore, Barbara Hepworth, and Alberto Giacometti took center stage.[114]

Second, the memorial contains one quasi-abstract element and one inscription—but, today, both are difficult to recognize (or read) as being related to the Holocaust. The seven-branched bas-relief menorah fills up the entire horizontal and vertical space of the block on which it is carved (the uppermost block of the entire sculpture), while the inscription is on the lowermost block to the right. When it was installed, as evidenced by a photograph in *Der Tagesspiegel* from 1963, the sculpture itself was much lighter in color and the menorah and inscription were much darker. The colors have, therefore, become darker and lighter, respectively, over time. One can argue that Fehrenbach's menorah is more of an abstract geometric design than it is a representational seven-branched menorah, a symbol of Judaism since ancient times (it is also the emblem on the coat of arms of the modern state of Israel).

One's eye might be drawn to the two negative spaces to the right and left of the menorah's base before one realizes that the object depicted is a candelabra. In Fehrenbach's sculpture, the candelabra's branches terminate at the very edge of the uppermost block. Menorahs are usually depicted in relief with negative space above the oil cups (or candle holders). Such is the case in Nathan Rapoport's depiction of the menorah in both the Warsaw Ghetto Uprising Monument (1948) and his redesign of it for the Wall of Remembrance (1976) in Yad Vashem, the national site of Holocaust memory in Jerusalem, which I describe in Chapter 2.

For Rapoport, the menorah is crucial to the messages of both monuments. In Warsaw, the monument is a double-sided relief. The seven-branched candelabra is associated with traditional Judaism and is depicted on the bas-relief side of the monument, known as "The Last March." German soldiers with bayonets march figures to their deaths. The scene is in stark contrast to the front side of the monument, "The Ghetto Uprising," which depicts Mordechai Anielewicz, leader of the Warsaw Ghetto Uprising, surrounded by ghetto fighters.

When he reconceived the sculpture for Yad Vashem, where the two reliefs are installed side by side, Rapoport changed the seven-branched menorah on the Warsaw relief to an eight-branched menorah. The martyrs carry the eight-branched menorah, symbolic of the resistance of the Maccabees, as told in the book of the Maccabees and celebrated during the annual winter holiday of Hanukkah. For Rapoport, it was important to readjust the symbolic weight of the menorah for Yad Vashem, where the monument changed from memorializing the Warsaw Ghetto Uprising to celebrating Israeli soldiers as heroes and fighters. The heroism of the Maccabees is equated with the heroism of Israeli soldiers. Fehrenbach's menorah, on the other hand, appears to function more as a geometric design than as a symbol.

So, too, the sculpted text is also in bas-relief and is difficult to read. Each line has large blocks of limestone without text, making the words appear to be "stacked" in a similar way to the blocks in the sculpture. The wide font consists exclusively of uppercase letters (with the exception of the year, "1909"). Slightly uneven in appearance, it does not correspond to any existing fonts. The space between words (kerning) is at times quite large and at other times very narrow. The space between letters (tracking) is almost nonexistent, contributing to the overall difficulty of reading. Like the menorah, the edges of the letters push up against the top and bottom edges of the block of limestone.[115] This is the only Fehrenbach sculpture with hand-carved letters. While a clear symbol of Judaism (the menorah) and a statement about the synagogue (the sculpted text) are *visible*, they are not very *legible*. One could walk by the work and not realize its function as a memorial dedicated to a destroyed synagogue.

Finally, the literature on Holocaust memorials (namely, the work of James E. Young) began to be published in the early 1990s, prompted by the installation of Holocaust memorials in the 1980s. Such memorials include Renata Stih and Frieder Schnock's *Places of Remembrance* (1992–93), located in the Bavarian Quarter, that consists of a series of pop art–inspired site-specific works that take the form of street signs and remind viewers of the Nuremburg Laws that stripped Jews of their rights. A brightly colored icon is related to each law. "Jews may not sit on park benches," for instance, appears alongside the date the law was enacted as well as a bright red icon of a park bench. Thoughtful, concep-

tual, and visually engaging, the work has captured the imagination of academics and tourists alike. A Google search of "memorial" and "Bavarian Quarter" leads to page after page of websites about Stih and Schnock's stunning work of public art but nothing about Fehrenbach's synagogue monument. Fehrenbach's memorial fades into the neighborhood, while Stih and Schnock's work announces its presence in colorful works that are meant to provoke thoughtful engagement with the past and present. But Fehrenbach's work is worthy of close analysis for precisely that reason. It was created at a different moment in time, which deserves attention, a time when what is left out of memorials and plaques tells us more about attitudes toward the past than what is included.

## After the Memorial

After the successful completion of the Münchener Straße Synagogue Monument, Fehrenbach participated in an exhibition at the Rodin Museum in Paris and documenta III in Kassel. For these exhibitions, his works continued to be either cubist or organic and were modeled after human figures (*Sitting Figure*, 1966–70; and *Karyatid*, 1964–66). In the 1960s, Fehrenbach created public works of art for IBM in Frankfurt, the Bundeswehr, and the Hahn-Meitner Institut in Berlin. From 1969 to 1980, Fehrenbach was the chair of sculpture at the Technische Universität Berlin. He continued to produce major works into the 1980s, including his 1985 *Steinzeichen* (*Stone Drawing*) for the Berlin Horticultural Show, his 1989 sculpture for the exterior facade of the theater in Pforzheim, and another sculpture for a theater in Brandenburg in 1994. Today, the Löcknitz Elementary School sits on part of the original synagogue's footprint; the outline of the synagogue is nonetheless visible through the design of the landscape and the memory of the Jewish community continues.[116] Since 1994, sixth graders in the school have participated in a project to remember the deported Jews of the neighborhood. Each sixth-grade student is assigned the name of a former Jewish resident and Holocaust victim who used to live in the area. Each child researches his or her assigned individual and writes an essay on that individual's life. Integral to this project is participation in an ongoing memorial project on the school's grounds: the sixth graders each place a commemorative stone, on which is inscribed the name of the Jewish individual they researched, on a memorial wall in their schoolyard. By the late 1990s, the debate about Peter Eisenman's Memorial to the Murdered Jews of Europe (see Chapter 5) had created a new interest in and sensitivity to the former Jewish life in the city's history, and we can see how blocks take on a completely different significance in Eisenman's memorial.

# Conclusion

In the case of Lammert, national ideas about heroism proved to censor the artist's wish to depict at the base of the statue women who were being tortured. The *Unfinished* figures of Lammert's memorial would finally find a home in East Berlin in 1985 (see Chapter 3). In the case of Fehrenbach, individuals' desires to memorialize the death of citizens found expression neither on the plaque nor on the sculpture itself. And the artist, without any association to Judaism or the Jewish community, relied on an abstract form that he had already developed for this sculptural practice and adopted for the purpose of a memorial. In the former case, censorship came from above. In the latter example, a decision to be unclear about the past came from the commissioning process itself, at a historical moment when West Germans were not prepared to visualize or verbalize victims and perpetrators in outright ways.

In contrast, an American example in Philadelphia, the subject of Chapter 2, demonstrates that a motivated group of local citizens fought for a memorial to the Jewish victims of the Holocaust. Unlike Fehrenbach, who simply used an earlier sculpture as the model for the memorial, Nathan Rapoport, the sculptor of the Philadelphia Monument to the Six Million Jewish Martyrs (1964), developed a completely new visual vocabulary. Whether it was successful is partly the subject of the next chapter.

# 2

## A Forgotten Memorial and
## Philadelphia's Survivors

### *Nathan Rapoport's Monument to*
### *the Six Million Jewish Martyrs (1964)*

ATHAN RAPOPORT'S MONUMENT to the Six Million Jewish Martyrs (Figure 2.1) is a bronze sculpture situated at one of the busiest intersections in Philadelphia.[1] The monument depicts two women, two children, hands (seemingly unattached to bodies) holding daggers, a rabbi, and a Torah, all surrounded by the flames of a menorah. The sculpture was installed in 1964 and is located on a triangular plaza at the corner of Sixteenth and Arch Streets, within view of city hall, at the entrance to the Benjamin Franklin Parkway, the boulevard where such cultural institutions as the Philadelphia Museum of Art, the Franklin Institute, the Rodin Museum, and the recently moved Barnes Collection are situated. Up until the plaza's renovation in 2018, the sculpture was rarely designated on maps and has gone practically unremarked in U.S. literature on Holocaust memory.[2] In fact, it was not until 1980 that Rapoport's sculpture was listed in a book on Philadelphia's public art.[3] Except for the service on Holocaust Remembrance Day (hereafter called the Yizkor Service)—which takes place annually in April, when thousands of Philadelphians gather to commemorate the six million Jews and the other victims of Nazism who were murdered in the Holocaust—the space receives little formal attention by non-Jews. This is not a surprise for the 1960s and 1970s, since during that time, while Jewish communities in the United States were interested in the subject of the Holocaust, as Hasia Diner so eloquently argues, non-Jewish Americans had little or no concern for the topic.[4] Philadelphia, however, was an exception. As one of the earliest monuments in public space in the United States, it reveals the tenor of its moment in history, which can be seen

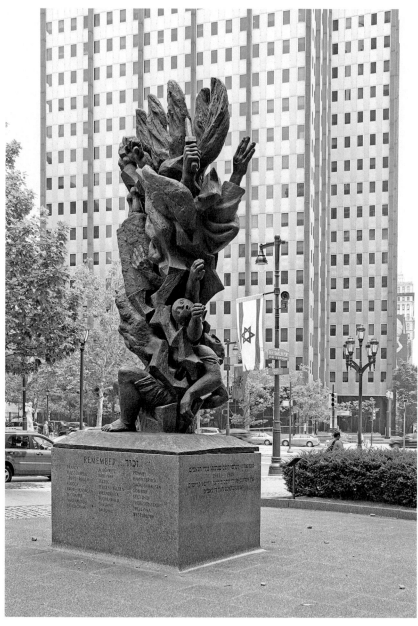

FIGURE 2.1 Nathan Rapoport, Monument to the Six Million Jewish Martyrs, Philadelphia, 1964. Benjamin Franklin Parkway and Sixteenth and Arch Streets. Bronze and granite. Height: 18 ft. (Photo: Ralph Lieberman. © Elencweig Family)

in the aesthetic and political debates and discussions around remembering the Holocaust in *visual form* in America during this era.

The monument was commissioned by a base of well-established German-Jewish immigrants as well as by "New Americans" (Holocaust survivors). The two groups did not overlap either socially or politically, and it took the efforts of one local survivor and philanthropist, Dalck Feith, to bring the groups together. In 1967, a few years after the monument was installed, the Memorial Committee organized itself under the auspices of the Jewish Community Relations Council (JCRC). The Memorial Committee was instrumental in creating one of the earliest Holocaust education programs in U.S. public schools, organized opposition to antisemitic activities, and brought together Philadelphia's Christian and Jewish communities.[5] While the general public may have paid little attention to the monument, the Memorial Committee played a highly public role in promoting Holocaust memory and Jewish life in Philadelphia. This chapter seeks to weave Rapoport's monument into the dialogue of Holocaust memory in the United States by explaining the artist's sculptural contributions to Holocaust memory, relating the commission of the monument, and revealing how the work of the Memorial Committee impacted both Jewish and non-Jewish communities in Philadelphia.

The *New York Times* did not mention the Monument to the Six Million Jewish Martyrs in its 1987 obituary of Rapoport, instead invoking his more famous Warsaw Ghetto Uprising Monument of 1948 and his Liberation monument, in New Jersey, of 1983.[6] Very few sources on Holocaust memory in the United States mention the monument. Sybil Milton, in her 1991 book on Holocaust memorials, briefly mentions Rapoport's Philadelphia monument and posits that it has been forgotten because of 1960s attitudes toward the Holocaust in the United States: "The downtown center-city site, visible daily to thousands of motorists and pedestrians, had little demonstrable resonance, in part a response to the florid and heavy-handed design and in part a reflection of its awkward location on an island on a heavily traveled urban street. It was perhaps still too early in the mid-1960s for the average American to perceive the Holocaust as more than an uncomfortable foreign experience."[7] If the "average American" refers to non-Jewish Americans, then I would agree with her statement, as Hasia Diner and Alan Mintz have debunked the myth of silence regarding the Holocaust in Jewish communities.[8]

For the general, non-Jewish public, books, films, and articles about the Holocaust did not focus on the harrowing details of the lives of victims and survivors in concentration camps, in death camps, or on death marches. *Anne Frank, the Diary of a Young Girl*, for instance, published in English in 1951, brought to an American audience the story of a young girl in hiding, not the story of life in a concentration camp or death camp.[9] When the book was

adapted for stage and screen in the early 1960s, "the more identifiably Jewish part of the *Diary*—Anne's nightmare, the Chanukah celebration, and the Gestapo hammering on the Franks' door—never appeared . . . because the producers, who were themselves Jewish, felt compelled by their own sense of what would sell to 'tone down' the play's Jewishness."[10] They believed that the story would be more successful if it had a universal appeal about the strength of the human spirit. In 1962, the Eichmann trial brought public attention to a war criminal's life and activities, but the focus was on Eichmann and his crimes not on the lives of victims and survivors.[11] Hannah Arendt published a series of articles about the trial in the *New Yorker*, reaching a large but limited public audience and focusing on the bureaucratic criminal mind, a phenomenon she called the "banality of evil."[12] In 1978, American public television aired *Holocaust*, but that miniseries, like the published diary of Anne Frank, tended to downplay the Jewish dimensions of the characters, prioritizing entertainment over education.[13] The Holocaust became a more integral part of America's story in 1979, when then president Jimmy Carter initiated its federal memorialization, which in 1993 took the form of the USHMM, firmly placing the Holocaust into the United States' understanding of itself as a nation (see Chapter 4).[14] In the same year the museum opened, *Schindler's List* became a Hollywood blockbuster and director Steven Spielberg sent free copies of the film to every high school in the United States, along with an educational supplement.[15] But in the 1960s, the general, non-Jewish public did not have access to direct descriptions of life in the camps or the plight of Holocaust survivors in the postwar years.

Rapoport's Philadelphia sculpture might have received more attention if Rapoport himself had become a more famous artist. But he appears in neither Oxford Art Online nor Grove Art Online, both of which are art and art history research databases. Nor did he achieve great fame in Israel, where a film produced in 2003 carried a telling title: *Nathan Rapoport: From the Holocaust of Man to the Holocaust of the Artist—The Artist That Israel Forgot.*[16] James E. Young writes, "A sculptor like Nathan Rapoport will never be regarded by art historians as highly as his contemporaries Jacques Lipchitz and Henry Moore. . . . Unabashedly figurative, heroic, and referential, his work seems doomed critically by precisely those qualities . . . that make it monumental . . . it may be just this public appeal . . . that leads such memorials to demand public and historical disclosure, even as they condemn themselves to critical obscurity."[17] Just as Young was one of the first scholars to bring the history of Rapoport's Warsaw Ghetto Uprising Monument out of obscurity,[18] so too do I attempt to elucidate the history behind another obscure work by the artist, his 1964 Philadelphia monument.

One way to reveal its history is to examine the inscriptions on the monument's base, which was not installed until 1966 (its construction was delayed

due to lack of finances). The three inscriptions in English, and one each in Yiddish and Hebrew, make clear its purpose as a memorial dedicated to Jewish Holocaust victims. The side of the base facing the triangular plaza lists, under the word *Remember* in English and Hebrew, the concentration camps, death camps, and sites of mass murder in which relatives of Philadelphia survivors died. The side facing Sixteenth Street reads:

THE HOLOCAUST
1933–1945
*Now and forever enshrined in memory are the six million*
*Jewish martyrs who perished in concentration camps*
*ghettos and gas chambers*
*in their deepest agony they clung to the image of humanity*
*and their acts of resistance in the forests and ghettos*
*redeemed the honor of man*
*the suffering and heroism are forever branded upon our conscience and*
 *shall be remembered*
*from generation to generation*

One side of the base is written in both Yiddish (the first line) and Hebrew (the last line) and faces Arch Street. It is the only inscription on the base that explicitly names "the Nazis":

*In memory of the six million Jewish Holy Souls, who persevered through*
 *the Nazis*
*1933–1945*
*Remember our brothers, the Holiness of HaShem, who were murdered*
 *at the hands of the Nazis.*[19]

Finally, the side of the base facing Benjamin Franklin Parkway reads:

*Presented to the City of Philadelphia*
*The Association of Jewish New Americans*
*In Cooperation with the Federation of Jewish Agencies of Greater*
 *Philadelphia*
*April 26, 1964*

This chapter takes this last inscription as a point of departure, as it clearly states that two groups dedicated the monument: the Association of Jewish New Americans (hereafter, AJNA) and the Federation of Jewish Agencies of Greater Philadelphia (hereafter, the Federation) which represent two very sep-

arate groups of Jews living in Philadelphia at the time. An examination of Rapoport's other works places the monument into a context of the artist's sculpture dedicated to the Holocaust.

## Nathan Rapoport: Sculptor of Holocaust Memorials

Rapoport created Holocaust monuments, or public sculptures that referred to the Holocaust, that were installed in Poland, Israel, and the United States. One of the challenges in analyzing his works is that there is a dearth of published material about him. Richard Yaffe's *Nathan Rapoport: Sculptures and Monuments* (1980) is the only publication that provides an overview of the artist's life and work.[20] While the narrative appears to be chronological, dates are rarely provided either for Rapoport's life or for specific works of art. James E. Young covers much of the same material regarding Rapoport's most famous work of art, his 1948 Warsaw Ghetto Uprising Monument, and bases his narrative on a 1986 interview with the artist as well as on Yaffe's book.[21] In discussing aspects of the artist's life that have particular bearing on the Philadelphia monument, I refer to these sources as well as to my interview with Edward Gastfriend, a Holocaust survivor involved with the Philadelphia monument's commission and with whom Rapoport stayed when he visited Philadelphia.[22]

Rapoport's Warsaw Ghetto Uprising Monument brought him international acclaim among Jewish communities, but Western art critics, especially, saw it as "Socialist Realist kitsch."[23] Given its historical importance, the work's style seems to have cemented this impression by critics, but not all of his works fall into this category. Many of his early works, as I demonstrate, were highly naturalistic, not socialist realist, while the Philadelphia monument incorporates elements of both abstraction and naturalism. Unfortunately, there are no extant documents that show why Rapoport moved from a completely naturalistic style to an expressionist semifigurative style. One can only guess that life circumstances, and exposure to different kinds of art, moved him to experiment with different styles. Rapoport was especially influenced by the work of Lipchitz, with whom he became lifelong friends—Rapoport's experimentation in abstraction might have been a result of this friendship.

Rapoport was born in 1911 to working-class Jewish parents in Warsaw. At age fourteen, he hoped to study painting at the Warsaw Municipal School of Art but chose to study sculpture after learning there were no available spots open for painting students. Rapoport gravitated toward the monumental aspect of sculpture, completed busts of local families to earn money, and soon thereafter entered the Warsaw Academy of Art. He was then a member of Hashomer Hatzair (Young Guard), a left-wing Zionist youth organization, but saw his art as neither particularly Jewish nor contemporary. In 1936, he

received a scholarship to study at the Fine Arts Academy in Paris and another to travel to Italy. That same year his sculpture *Tennis Player*, a highly naturalistic work, won a "sports in art"–themed competition at the Warsaw Academy of Art. Representatives of the Polish government informed him that they wanted to send *Tennis Player* to Berlin for an international exhibition that year. When the artist replied that he was uncomfortable sending the sculpture to Hitler's Germany, the committee told him to either send the sculpture to Berlin or return the prize money. He chose the latter.[24] Although he studied for some time in Paris among the avant-garde, Rapoport remained dedicated to the human form, according to Yaffe, partly as a result of his stay in Italy and his studies of Michelangelo. He managed to return to Paris in 1938 for an international competition, where he met Lipchitz; Rapoport, Lipchitz, and Le Corbusier won prizes at the competition.[25]

Rapoport returned to Warsaw in June 1939, just months before the Germans invaded Poland. Taking his portfolio with him, Rapoport and other artists fled to the USSR, settling in Białystok. Russian authorities soon called Rapoport to Minsk to work for its art commission, which appreciated his figurative sculpture.[26] Not long after, the Nazis overran Białystok and Rapoport never heard from his fellow Polish artists there again. In Minsk, a studio was provided to him, and he received the favorable attention of, and commissions from, Mikhail Vasil'evich Kulagin, the second secretary of the Communist Party of the Belarusian People's Republic. Rapoport continued to work in Minsk until the Germans arrived, at which time he fled with his family via train to Alma Ata (today, Almaty), Kazakhstan. There, he was drafted into a labor battalion and was sent to Novosibirsk. Coincidentally, Kulagin, since being promoted to first secretary, was there at the same time, heard of Rapoport's plight, removed the artist from the labor battalion, brought his family from Alma Ata to Novosibirsk, and provided Rapoport with an apartment and studio.

In 1943, news of the Warsaw Ghetto Uprising reached Rapoport via Jewish historian Berl Mark. In 1940, the Germans packed four hundred thousand Jews into the 1.3 square miles of the walled-off Warsaw Ghetto. By 1942, hundreds of thousands had been deported to their deaths or killed in the ghetto and the fifty-five thousand to sixty thousand Jews still living there were threatened with deportation. Groups of underground Jewish organizations, numbering about five hundred individuals and led by Mordechai Anielewicz, organized efforts to resist deportation beginning on April 19, 1943. Armed with pistols, grenades (many homemade), and a few automatic weapons, they resisted deportation until Anielewicz was captured on May 8. Jews continued to hide until May 16, when the Germans destroyed the entire ghetto. It was the longest and most coordinated Jewish resistance during the Holocaust.[27] As soon as Rapoport heard news of the uprising, he started work on the clay

model (maquette) of the monument and took it to the Moscow Art Commission. Members stated that the model was "too narrow—nationalistic in approach," an attitude that Young convincingly argues was code for "too Jewish."[28] After the war, Rapoport took the model to the Jewish Committee in Warsaw, which saw to it that the monument was built.

This work, the Warsaw Ghetto Uprising Monument (Figure 2.2), made Rapoport famous as a sculptor of Holocaust memorials and cemented his reputation as a socialist realist sculptor. While the details of its commission can be found elsewhere, important here is the fact that Rapoport employed the figurative style in which he was trained in Warsaw, and which he continued to develop in the Soviet Union.[29] Janet Ward describes the Warsaw monument as being designed in the "victorious anti-fascist style of Socialist Realism [that] cannot be repeated these days without trespassing into the territory of overbearing kitsch."[30] I would argue, however, that the styles of the two sides of the monument (the "fighters" and the "martyrs") differ greatly. While the "fighters" side is highly naturalistic (one can see details of clothing and veins on hands), the "martyrs" side is naturalistic but does not display the heroism of Soviet socialist realism. One could hardly call this side "Socialist Realist kitsch." Nonetheless, the ideological meaning of the monument is unambiguous: to situate Holocaust memory with an emphasis on resisters and heroes. Fifteen thousand people attended its unveiling, including guests from the United States and Israel.[31] Soon after, Rapoport moved to Paris, around 1948.[32] In the early 1950s, he took up residence in Ramat Gan, outside Tel Aviv, and also established an apartment and studio in New York City.

In the years between the completion of the Warsaw monument and the installation of the Philadelphia monument, Rapoport received various commissions, about which little has been written. Worth mentioning is Rapoport's highly naturalistic monument for Yad Mordechai, a kibbutz named in 1943 for Mordechai Anielewicz. The kibbutz was the scene of a battle with Egyptians in Israel's 1948 War of Independence. In commissioning Rapoport's monument, the kibbutz aimed to recognize the heroism of its fighters in 1948, the heroism of the Warsaw Ghetto fighters in 1943, and all the way back to the young David (later King David) in the biblical story of David and Goliath. Rapoport situated the sculpture in front of a water tower that was damaged in the 1948 fighting, thereby emphasizing the heroic nature of the figure. A monument for Kibbutz Negba was dedicated to the fighting of 1948, and for which Rapoport chose heroic, socialist realist figures including an Israeli soldier, a pioneer, and a nurse. The figures stand side by side, hands locked. These commissions cemented Rapoport's reputation as a sculptor of monuments dedicated to Jewish resistance. Each is naturalistic and emphasizes heroism, an important theme for the new State of Israel.[33]

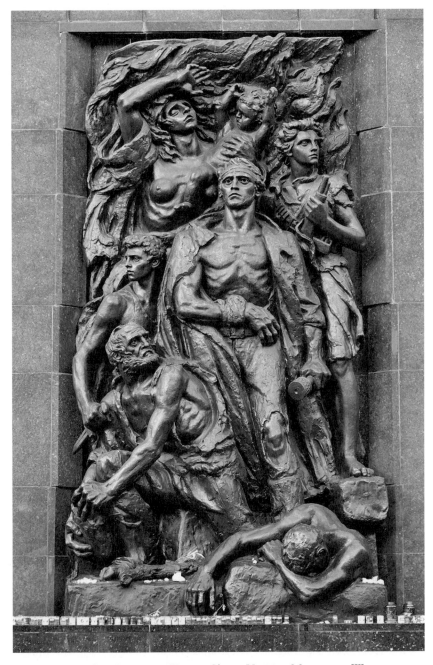

**Figure 2.2** Nathan Rapoport, Warsaw Ghetto Uprising Monument, Warsaw, Poland, 1948. Bronze. Detail: Fighter's Relief. (Photo: Adrian Grycuk. © Elencweig Family)

While the Yad Mordechai, Kibbutz Negba, and Warsaw monuments depicted victims who were heroes and resistance fighters in a socialist realist style, the Philadelphia monument focuses on figures who might be innocent victims, survivors, or children and are depicted in an expressionist, semifigurative style (Figure 2.1). The female figure at the base of the Philadelphia monument leans back and physically supports the entire sculpture. While markings on the original clay are visible, Rapoport does not provide many naturalistic details. The highly figurative man (often called the "rabbi" in newspaper articles) is one of the few overtly Jewish figures in the sculpture. The figure's arms are raised, and his fingers are parted in the recognizable ancient gesture of Jewish priestly benediction (Figure 2.3). On his forehead he wears the tefillin, or phylacteries, used daily in prayer by observant Jews. In certain light, however, when stark contrasts between protruding and receding elements are visually emphasized, this overtly Jewish element might go unnoticed. Abstract and roughly worked figures of a mother and child emerge from the abstract flames above the woman's legs, and a nearby child reaches for safety. One bronze hand, so figurative that protruding veins are visible, holds the Torah aloft (Figure 2.4). The Torah, however, is sculpted in such a way that the two scrolls might be mistaken for abstract forms. Two other highly figurative hands, unattached to bodies and their veins bulging, hold daggers: a tribute to Jewish resistance during the Holocaust (Figure 2.1). While the flames surrounding the figures take on sharp, abstract, geometric angles (Figure 2.1; this might be the reason some sources refer to "barbed wire"), the flames at the top of the sculpture are rounded, fanning out as a Hanukkah menorah does, thus metaphorically blending the "flames of destruction" (i.e., the Holocaust) with the "flames of resistance" (the flames of the candles of the *hanukkiah*, or Hanukkah menorah, traditionally associated with heroic Jewish resistance to tyranny related in the book of the Maccabees and celebrated during Hanukkah, the Jewish Festival of Lights).

The focus on "all victims," ordinary children, men, and women (including resistance fighters), was important for American Jewish organizations. Unlike Jews in Israel, Jews in the United States preferred not to represent themselves as fighters and resisters exclusively, although that was the default choice in the late 1940s and 1950s.[34] The United States came out of World War II as a world power, while Israel was a fledgling state under attack by its neighbors. Thus, Rapoport chooses a different style for commissions, adapting his central concerns to particular commissions. But in many ways, Rapoport was working in a vacuum when it came to creating a public sculpture dedicated to the Holocaust.

A distinct vocabulary for memorializing the Holocaust had not yet been developed in American artistic circles. Up until the mid-1960s, for instance, Yad Vashem (the Israeli site of Holocaust memory) discouraged American

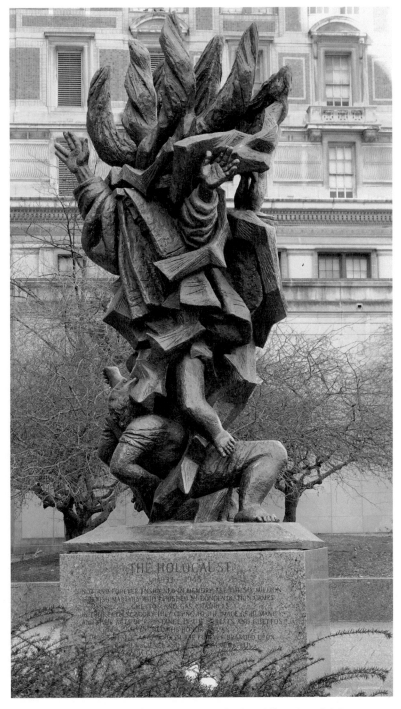

**Figure 2.3** Nathan Rapoport, Monument to the Six Million Jewish Martyrs, Philadelphia, 1964. Benjamin Franklin Parkway and Sixteenth and Arch Streets. Bronze and granite. Height: 20 ft. (Photo: Max Buten, Lower Merion Historical Society. © Elencweig Family)

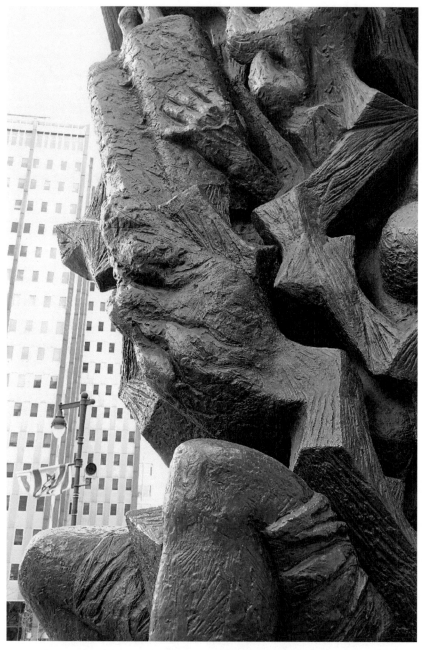

FIGURE 2.4 Nathan Rapoport, Monument to the Six Million Jewish Martyrs, Philadelphia, 1964. Benjamin Franklin Parkway and Sixteenth and Arch Streets. Bronze and granite. Height: 18 ft. Detail: Abstract woman and child. (Photo: Max Buten, Lower Merion Historical Society. © Elencweig Family)

Jewish institutions from creating Holocaust memorials. The administrators of Israel's national site of Holocaust memory saw itself as solely responsible for the task.[35] Yet, by the end of the decade, Yad Vashem revised its policy of nonsupport for Holocaust memorials in other countries. The debate over the never-constructed New York City Holocaust memorial shows how the Jewish community, and artists, struggled to find a visual form appropriate to the enormity of the Holocaust.

Rapoport submitted a maquette of Scroll of Fire to the New York commission. The scale model consisted of two larger-than-life-size "scrolls," on which were depicted figurative scenes of Jewish resistance from biblical times to the present, including scenes of the Warsaw Ghetto Uprising. According to Mark Godfrey, Eleanor Platt of the New York City Art Commission thought that the sculpture "would create a 'precedent,' encouraging other 'special groups' to approach the city in order to have their communities' histories represented" (a statement that might be read as belittling the Holocaust's importance to non-Jews and implying that memorializing the Holocaust is problematic only because Jews may further press their parochial interests as a "special group").[36] Platt's statement echoes that of the Moscow Art Commission, which deemed Rapoport's maquette for the Warsaw Ghetto Uprising Monument "too nationalistic." Platt's statement might (also) be read as "too Jewish" and was perhaps one reason the sculpture was not chosen. In 1971, however, it was installed in Martyrs' Forest in Israel's Jerusalem Hills.

In the 1960s and 1970s, sculpture was entering a phase of what Rosalind Krauss calls "the expanded field," and what Lucy Lippard refers to as "the dematerialization of the art object."[37] Sculpture was no longer a discrete object in space, made of wood, stone, bronze, or clay, meant to be viewed in a gallery— especially in New York City, arguably the center of the art world at the time. Sculpture was being completely redefined. It could be made of fiberglass, rubber, or felt; or it could be a performance. Rapoport's model, which depicted figurative scenes of Jewish history, might have looked out of date to the New York City Art Commission—even in a context where public art was not yet the norm.

Early public art programs favored works by icons of modernism. The first "Percent for Art" program in the United States was initiated in Philadelphia in 1959. The Percent for Art program was devoted to "aesthetic ornamentation of city structures" and ensured that approximately 1 percent of the construction cost of public buildings were set aside for "art allocation."[38] In her history of Philadelphia's program, Penny Balkin Bach writes, "It was thought that public art on a more human scale might be able to salvage an increasingly bleak urban environment."[39] (The commission of the Monument to the Six Million Jewish Martyrs, however, was not associated with the construction of a public building, and, therefore, public funds for it were not available.)

The national move toward public art began in the 1970s, when works by icons of modernism were most often chosen: Pablo Picasso, Alexander Calder, and Henry Moore, all artists who were not working in the "expanded field"[40] but were employing modernist abstraction. While the implicit meaning of Platt's comment may have been that the work was "too Jewish," she might have also implied that the sculpture did not fit the latest conceptions of sculpture. Louis Kahn was approached by the art commission to design a model for a New York memorial. Unlike Rapoport's model, Kahn's model employed a modern, stripped-down aesthetic. In fact, it was so devoid of symbols that Kahn was encouraged by the commission to include some elements symbolic of Judaism. He changed the model accordingly (but the memorial was never built, a history that has been detailed in other publications).[41]

Rapoport did not participate in a dialogue about the possibility of making art after the Holocaust. In the USSR, where Rapoport worked from 1941 to 1945, Jews did not have the opportunity to question whether representation of the Holocaust was possible. They were, instead, trying desperately to make public the basic facts of *Einsatzgruppen* activities in Ukraine under a government that did not, until the 1990s, allow those facts to be made public. At the same time that Rapoport was creating the model for his monument to the Warsaw Ghetto Uprising, for instance, Ilya Ehrenburg and Vasily Grossman tried to publish *The Complete Black Book of Russian Jewry*—which detailed the 1942 wartime massacres, including the largest, at Babi Yar, where thirty-five thousand Jews were killed in three days—to no avail.[42] Soviet authorities would not allow publication until 1944. In this context, Rapoport's use of socialist realism in the Warsaw Ghetto Uprising Monument can be seen as his attempt to tell a visual story with details that would be clear to the viewer. The historical context of Rapoport making a Warsaw monument while living in the USSR, however, was quite different than when he was working in Paris and Israel, making a monument dedicated to Holocaust survivors, which was, in turn, commissioned by survivors in Philadelphia.

## The Commission

Rapoport was commissioned to create the Philadelphia monument by the Committee for a Memorial for the Six Million Jewish Martyrs, established in 1962 (hereafter referred to as the Six Million Committee).[43] It was made up of individuals from two organizations: AJNA and the Federation. Dalck Feith was chair of the Six Million Committee and vice chair of the Federation; Edward Gastfriend was vice chair of the Six Million Committee and vice president of the AJNA; Harold Greenspan, meanwhile, was also vice chair of the Six Million Committee and treasurer of the AJNA; and Abram Shnaper

was founder and president of the AJNA. Each was fundamental in moving the project forward.[44] These two organizations demonstrate how a group of survivors of limited economic means (the AJNA) worked together—albeit not always easily—with an organization of primarily wealthy Jewish business-men of German descent (the Federation) to commission, raise funds for, and install the monument. Up until this time, the two Jewish groups moved in completely different spheres of Jewish life in the city.

The articles of incorporation detail the role of the Six Million Commit-tee. It makes clear that the goals of the committee were not only to build the monument but also to foster awareness and education about the Holocaust in Philadelphia:

> To foster understanding and appreciation for American principles and democratic institutions, to educate Americans about the dangers and evils of dictatorship, to memorialize the six million Jewish martyrs of Nazi persecution by the erection of a monument in their memory, to act otherwise solely for charitable and educational purposes, including contributions to Gratz College, Philadelphia for a course in contem-porary Jewish history, and contributions to [non-profit] organizations.[45]

As a teenager, Shnaper had known Rapoport in Poland, where they were both members of Hashomer Hatzair.[46] In 1953, Shnaper organized Holo-caust survivors into the AJNA in Philadelphia, which was one of about a dozen such organizations in the United States.[47] From 1953 on, the group of one hundred and fifty families "met in hired halls and held a service in Yiddish, giving speeches and writing poetry about the horrible days during World War II."[48] The AJNA provided emotional and social support for the survivors. At the time, the phrases "Jewish New Americans" or "greeners" also referred to Jews who had survived the Holocaust and come to the United States. (The term *Holocaust survivor* did not become commonplace until the 1970s. Following this trend, in 1982 the AJNA changed its name to the As-sociation of Holocaust Survivors.)[49] According to Shnaper, by 1961, following an incident of radical-right antisemitic activity in Philadelphia, the survivors were galvanized to start a fund-raising campaign for a Monument to the Six Million Jewish Martyrs.[50] In an AJNA quarterly bulletin, a column called "Our Youngsters Write" gathered reactions of young Jews to the lack of Ho-locaust education in the schools. One young writer stated that he supported the construction of a monument because of the lack of this topic in schools: "The neglect of our usually praised educators to mention the savagery and inhumanity which befell the Jews during their catastrophe is positively unfor-givable. If a free and unprejudiced society is to exist the public must be edu-

cated so that the masses will be aware of what could happen, when fanaticism and intolerance secure domination."[51] The members of the Federation, on the other hand, consisted of a strong network of Jews who were businessmen in Philadelphia. Among its administration were three men who became active in the commission of the memorial: President Sylvan Cohen, Vice President Dalck Feith (noted above), and Leonard Goldfine, a philanthropist. Feith, as a Holocaust survivor and successful businessman, proved to be the one person who could easily communicate with both the AJNA and the Federation. A brief synopsis of his personal history helps us understand why he was so invested in the monument.[52]

Originally from Niebylec, Galicia (present-day Poland), Feith had been a member of the Zionist group Betar, the youth movement of Vladimir Jabotinsky's Union of Zionist Revisionists.[53] Working in the 1930s as a merchant seaman on ships from many countries, Feith helped European Jews escape Nazi Europe by smuggling them aboard those ships. He had done preparatory work to immigrate to Palestine but did not receive a permit to do so from the Palestine administration, most likely, he told his family, because Zionist officials who were politically opposed to Jabotinsky and Betar dispensed such permits. At war's outbreak, he was working on a British merchant ship. Soon after, the British sent Feith to Glasgow to train as a marine engineer. In January 1942, he sailed on a British merchant ship to Nova Scotia, where he transferred to an Estonian merchant ship headed for Newport News, Virginia. There he entered the United States and decided to head for Philadelphia, a large, not-too-distant city with a Jewish population. Upon his arrival, he sought out federal authorities at the Customs House and volunteered for service. Impressed with his many languages, his skill with marine engines, and his knowledge of European ports, officials at the Customs House helped him get a job in the Philadelphia Navy Yard, where ships were being built for the war effort, and then arranged for him to join the U.S. Merchant Marine.[54] During the war, the Germans killed Feith's parents, four of his sisters, and his three brothers.

After the war, John Stern of the Hebrew Immigrant Aid Society (HIAS) helped Feith start Dalco Manufacturing Company, which made metal boxes for electronic components. (They were used, for example, for microwave equipment for a company that in the 1950s pioneered the development of America's cable television industry, in which Feith invested heavily.) By the 1960s, Feith had amassed substantial wealth and was a major donor to many Jewish and non-Jewish causes.[55] His closest friend was J. Sydney Hoffman, a judge, through whom Feith became acquainted with many prominent Philadelphians, such as politicians, judges, and city hall officials. As a survivor admired by many in the city for his wartime service to the United States, for his "American dream" business success, and for his philanthropic generosity, Feith developed

friendships with many influential people in Philadelphia business, political, and social circles. In the Jewish community, Feith was known and trusted by both the AJNA and the Federation. His sympathies were clearly with *all* Jews, whether long-standing citizens of Philadelphia or "Jewish New Americans."

Feith's daughter, Deborah Feith Tye, remembers that it was not until the 1980s that she realized that her father was a "Holocaust survivor." This reflects attitudes of the Jewish community toward the Holocaust in the 1960s and 1970s, for the phrase "Holocaust survivor" did not come into use until the late 1970s and early 1980s (thus the Association of Jewish *New Americans*). It was only in the 1980s that any Jew who survived Nazi Europe—even someone who escaped as a seaman, as Feith did—was considered a "Holocaust survivor."[56]

Feith's role was to secure one-half of the funds for the monument from the Federation. In an oral interview (in the early 1980s, the Federation conducted oral interviews with important individuals in the Jewish community to document that community's history), he detailed the difficulties in convincing the Federation that the project was a worthy one. He drew attention to long-standing divisions between the established Jewish community and new immigrants:

> My main problem was that the opposition came from the Federation. At that time, I was a little *macher* [go-getter]. People meant well but didn't have the understanding. Six million Jews deserve a monument. I was told at the Federation by the Executive Committee and by the Board; they told me they need hospitals and let's look forward. And I had to be very diplomatic. I hate to tell you what I wanted to say. But I wanted to win, and in order to win you have to keep your mouth closed. But I stood up to some people and apologized to some people, and finally I won it. I'm very proud of that money. The monument was the first one in the United States of that kind.[57]

Feith noted that the Federation "was once under the domination of the German Jews." The interviewer asks, "Were there still remnants of that kind of thing in the 1960s?" Feith answers, "You always had that kind of thing around."[58]

Feith not only arranged for a major gift from the Federation in support of the monument—he also donated funds himself. Rapoport recalled in 1984 that "one man saved the hour through his generosity and commitment to the project. Feith, a Jewish communal leader, contributed the remaining funds needed to complete the monument."[59] Feith's donation did not go unnoticed by Shnaper, who wrote in a letter to Feith:

> Our sages have written, "there are three crowns: the crown of learning; the crown of priesthood; and the crown of royalty." However,

the crown of good name excels them all because it alone is a tribute to the personality and character of the man. It was this "crown" that you lent us when you elected to work with our Association of Jewish New Americans in bringing our great dream to realization. . . . We know we must thank you from the very depths of our hearts, because together with our strenuous efforts and all the valuable time you so generously gave our project, it was the well-earned goodness of your name, truly a crown, which in the end brought our Monument to recognition of the entire community.[60]

While the exact amount of Feith's contribution is unclear, the AJNA was about 40 percent short of their contribution goal; it is reasonable to assume that Feith's donations made up for that shortfall.[61]

Once they convinced the Federation to support the monument, the committee then needed the mayor's approval. Feith, Gastfriend, and Shnaper approached Mayor James H. J. Tate and City Council Head Paul D'Ortona to secure approval of the monument as a gift to the city. The mayor accepted the gift. But his approval "didn't mean anything," Feith explained, without the assent of the art commission, which was "totally waspy."

Feith, Gastfriend, Goldie Hoffman (the politically active wife of Feith's friend J. Sydney Hoffman), and Rapoport made a presentation to the art commission. Rapoport brought with him an eighteen-inch bronze model of the monument.[62] Unlike the monument, the model is highly abstract. The figure of the rabbi with outstretched arms, for instance, can barely be made out on the model, but the hands parted in priestly benediction are visible. While the flames at the top of the bronze model are recognizable, the figure of the woman at its base is absent altogether. According to Gastfriend, Rapoport was keenly aware that the semifigurative female form might offend members of the Orthodox Jewish community. Nevertheless, the artist chose to depict a female figure in the final version, despite his own reservations.[63] Another extant version of the monument is a plaster cast that depicts the Torah, children, hands with daggers, and the female figure at the base. But the head of the female figure is missing—or is bent so far forward it cannot be seen. (The model was kept in a garage for some time, and some pieces fell off; it is, therefore, unclear whether the full female figure was ever part of the plaster model.)[64] There is no evidence, however, that Rapoport ever showed the plaster model to the art commission. Instead, he and the Six Million Committee presented the more abstract bronze model.

The bronze model presented to the art commission in January 1964 was, in fact, so abstract that Guiseppi Donato, the only sculptor on the art commission, questioned whether the symbolism of the sculpture was appropriate.

He said he preferred a monument that "represents the great sacrifice of the Jews"[65]—that is, with recognizable Jewish symbolism. According to Gastfriend, at this meeting Rapoport *did not* explain that there would be overt, semifigurative details of the Torah, the dying mother, or hands with daggers in the monument.[66] Since the monument was already at casting stage, art commission chairman Roy F. Larson said it was not the time to suggest changes but to determine if the gift was acceptable. The art commission accepted the gift on January 9 but had yet to determine where it would be installed.[67]

At the same time, however, there is some evidence that the Six Million Committee had its own hesitations about Rapoport's model. A letter dated January 10, 1964, from Jacques Lipchitz to Lucille Weinstock, treasurer of the Six Million Committee, indicates that he was responding to her request for an evaluation of Rapoport and the monument. Lipchitz writes, "To tell the truth I was very surprised that a great Jewish artist like Rapoport needs a recommendation from anybody. It does not really pay honor to the Philadelphia Jews to need such a thing. I have seen Rapoport working this summer in Italy. It is a superb work of art and does not need any recommendation."[68] As the art commission accepted the model on January 9, it appears the committee went ahead and supported the monument, even without yet receiving Lipchitz's letter.

Still, the bronze model was abstract, whereas the final sculpture combines abstraction and figuration, including overt symbols of Jewish resistance, religion, and martyrdom. Why? It is the case that some of Rapoport's models are more abstract than the final sculptures, as photographs in Yaffe's 1980 book make clear. Examples include the model for the *Brotherhood of Man* (sculpture in Toronto, Canada, 1986), and the model for *Gad Manela* (sculpture in Tel Itzhak, Israel, date unknown).[69] It is also possible that Rapoport described what would be changed in the actual monument in the meeting (minutes of the meeting do not exist). Feith's son remembers that, in the 1970s, he asked his father why Rapoport's bronze model (then in the Feith family home) was more abstract than the finished sculpture. Feith responded that he and Goldie Hoffman thought the "more abstract" model would be more acceptable to the art commission than a model with overt Jewish references; it is not clear whether Feith and Hoffman then knew that the finished sculpture would be more figurative.[70] While there is no written documentation to support the son's anecdote, it does demonstrate that Feith and Hoffman (and perhaps Gastfriend and Rapoport) were apprehensive about approaching the "blue-blood" art commission but that the art commission, in turn, wondered why there was not more Jewish symbolism in the model.

The extant documents relating to the monument's commission do not outline any criteria regarding content or style. Nonetheless, Shnaper and Gastfriend, in interviews given years later, recalled that they spoke at length

with Rapoport on these matters. Shnaper provided Rapoport with three criteria: to make visible the theme of "resistance during the Holocaust" (symbolized by the hands with daggers); the destruction of Judaism (symbolized by the flames and the woman at the base of the sculpture); and life after the Holocaust (symbolized by the Torah).[71] Gastfriend relates that Rapoport believed "Jewish symbolism had to be built into the Monument."[72] The latter part of the commission, "life after the Holocaust," was a new element for the artist to address, as Rapoport's previous works primarily depicted resisters and victims. Gastfriend, reflecting on the monument in 2013, stated, "There was a time when people felt that Jews were going like sheep to the slaughterhouse. Since I was part of it [the commission], I felt it was important that the monument show elements of resistance."[73] From Rapoport's point of view, the recent immigrants to the city "somehow felt that they would not be able to start a new life without paying tribute to the tragic past."[74]

Originally, the Federation hoped to install the monument at Gratz College, the oldest independent college of Jewish Studies in North America, located in Philadelphia at Tenth Avenue and Tabor Road, a rather remote side street north of Center City,[75] and a foundation stone was laid in 1962. But Shnaper, Feith, and Gastfriend insisted that the monument be placed in a prominent location in the city, fearing that its message would be lost at the marginal geographic location near Gratz College. Worried about a permanent home for the sculpture, Rapoport wrote from New York that a spot should be secured from the city.[76]

Rapoport detailed the progress on the sculpture, to be publicly unveiled in April 1964, in a series of letters to Shnaper. He chose to cast the monument in Pietrasanta, Italy, as it was less expensive than casting it in New York or Paris.[77] In a letter written from Pietrasanta, Rapoport states that he had invited Lipchitz to see the work and that the artist gave him "two, three good suggestions. He agreed that the statue is well designed."[78] Rapoport suggested text for the engraving of the base in a July 1963 letter to Shnaper, making clear that the monument should not be dedicated without a base: "I am not a writer, excuse me, and therefore don't take it to heart, but I would write: 'IN MEMORY OF THE GREATEST SORROW AND COURAGE' (in Yiddish, Hebrew, and English). On the third side: The monument was erected by the Association of Jewish New Americans—19th April, 1964."[79]

In April 1964, two weeks before the monument's unveiling, the artist described it to the media as "a majestic work, full of sentiment and sorrow, which wants to signify that even in times of peace humanity does not forget."[80]

Jewish public response in the Philadelphia press emphasized the monument's appeal not only to the Jewish community but to all Philadelphians. Rabbi Louis Parks, of the Young Men's and Young Women's Hebrew Association said that "this is a fitting statue for the City of Brotherly Love. I like to

think of it not only as a memorial to the Jewish martyrs of World War II, but of all martyrs—Jewish and Christian alike."[81] Feith echoed this sentiment, saying the monument "should prove to be an inspiration for all freedom loving people."[82] By that time, the art commission had approved a Center City location, but the exact site had not yet been agreed upon. By April 3, 1964, just twenty-one days before its dedication, the art commission announced that the memorial would eventually be placed in the proposed Freedom Square in the new West Plaza of city hall. At a meeting of the Fairmount Park Commission on March 9, 1964, Mr. Day of the commission advised that the City Planning Commission "has suggested the triangular piece of ground under the jurisdiction of the Fairmount Park Commission at the northwest corner of Sixteenth and Arch Streets, until such time as a permanent site is chosen."[83] As an alternative, Sister Gloria Coleman, of the Catholic diocese, arranged to have the empty lot at the Catholic high school, at the corner of Sixteenth and Arch Streets, available for the monument. Her offer was declined by the commission, as Rapoport preferred the triangular park across the street at Sixteenth and Arch Streets, as the sculpture would be seen from many sides (i.e., seen from Arch Street, Sixteenth Street, and Benjamin Franklin Parkway).[84] But her participation at this stage of the process was remarkable and demonstrates the willingness of the Catholic Church to work with the Jewish community in remembering the Holocaust. The Philadelphia Office of the Commissioners approved the location of Sixteenth and Arch Streets on April 13, 1964, and the Fairmount Park Association officially accepted the location at their April 16, 1964, meeting.[85] The monument remains to this day at this location. Committee meeting minutes from 1966 indicate that plans to move it to West Plaza of city hall were soon forgotten.[86] According to Gastfriend, the artist was overjoyed at this central location and took many photographs of the site in order to fully understand how the sunlight there would hit the monument.[87] The Federation accepted the change in location but not without debate.[88]

The sculpture was unveiled at a dedication service April 26, 1964, just before Yom HaShoah. The range of religious and civic representatives demonstrates the reach that the Six Million Committee had achieved in the city. Present were Judge Nochem S. Winnet, Leon Goldberg (of the Jewish War Veterans), Rabbi Theodore H. Gordon (Philadelphia Board of Rabbis), Roy F. Larson (City Art Commission), Right Reverend Monsignor John H. Donnelly (Cathedral of Saints Peter and Paul), Rev. Herbert G. Hearheart (Greater Philadelphia Council of Churches), Abram Shnaper (AJNA), Leonard Goldfine (Allied Jewish Appeal), Dalck Feith (chair, Monument Committee), Edward Gastfriend (cochair, Monument Committee), and Mayor James H. J. Tate.[89] At the unveiling, Mayor Tate tied the monument to the history of Philadelphia: "Two hundred years ago, George Washington announced in this very city that we will give no sanction to

bigotry. We echo those same words today."[90] Philadelphia's history of democracy is echoed in the dedication brochure: "Philadelphia was seen as the appropriate location for this monument because of its historic role as the birthplace of American liberty and because it is the site of so many shrines to the struggle for human freedom."[91] The theme of brotherhood in Philadelphia is stated a second time in the brochure: "Remember that the Monument to the Six Million Jewish Martyrs calls on the citizens of Philadelphia and of the world, of every race, creed and walk of life, to uphold the principle on which this city was founded, of the Brotherhood of Man under the Fatherhood of God!"[92]

At the dedication, a chorus sang "Zog nit keyn mol" (Never Say), the Yiddish song commonly known as "the partisan hymn," which members of the Jewish resistance sang before embarking on missions in Nazi Europe.[93] Gastfriend relates its importance in a 2013 interview: "One never knew if this was their last walk, and yet they had hope of coming back."[94] Since that day, it has become a tradition in Philadelphia that Yom Hashoah is celebrated annually on that spot, and Benjamin Franklin Parkway is briefly renamed "Yom Hashoah Avenue" in honor of the day of remembrance.[95] After the dedication, Shnaper did everything he could to gain international attention to the monument, even writing to the premier of Israel, Levi Eshkol, asking him to lay a wreath there.[96] Shnaper received a negative reply from the Israeli Embassy in Washington.[97] Nonetheless, it was with great pride that Shnaper showed me a newspaper clipping from the *Jewish Exponent*, June 5, 1964, which shows Eshkol visiting the monument and laying a wreath.[98]

The story of the monument's commission says much about the integration of Jews into city life. A movement of government reform in Philadelphia in the postwar period brought Jews from outside of political life into its center. The formation of the State of Israel gave a common cause to diverse Jewish groups in the city in 1948.[99] By the 1960s, in a study of the leadership of 199 Philadelphia organizations, Jews held 19.7 percent of the top positions, a thoroughly changed condition from decades before, when Jews were excluded from such positions altogether.[100] That is to say, by the time the monument was commissioned and realized, Philadelphia Jews played an influential role in city life.

But, by 1965, the state of the statue and surroundings were described as "disgraceful" by the *Philadelphia Inquirer*; the "plot is barren, there is no grass, scattered bushes, no protective hedging, a broken brick wall near the monument, debris, no marking or plaque describing what it represents or who dedicated it; discoloring of the statue."[101] The *Jewish Times* referred to the monument as a "neglected refugee" in disgraceful conditions.[102] In response to the crisis over the deteriorating space around the memorial, in 1966 the AJNA and the Federation joined forces to create a citywide Memorial Committee for the Six Million Martyrs (hereafter referred to as the Memorial Committee, not to be confused with the Six Million Committee responsible for commissioning the

monument), under the auspices of the JCRC. It was the first such committee to be founded outside the State of Israel.[103] It would not only organize the yearly Yizkor Service but also influence local public education on the Holocaust and foster understanding between Jewish and Christian organizations. The memorial's lasting impact is not just its physical presence but also its role in the formation of the Memorial Committee for the Six Million, which helped determine how the Holocaust would be remembered in Philadelphia's public sphere.

## The Memorial Committee for the Six Million and Holocaust Memory in Philadelphia, 1966–79

The Memorial Committee originally undertook to organize the Yizkor Service by bringing together disparate Jewish congregations and services into one main citywide service. But as the materials in its archive demonstrate, the Memorial Committee became actively involved in issues pertaining to Jewish life in Philadelphia and abroad. Whatever the limits of the sculpture's citywide resonance, the committee had a major effect. Its members included individuals from the AJNA, the Federation, and the Catholic diocese. Its mission is explicitly stated in the notes from the first meeting in 1966:

> Its purpose, in addition to the Annual Yizkor Service, is to conduct a year-round educational program to broaden the impact of remembrance of the Holocaust, to work toward the prevention of reoccurrence whether directed toward the Jewish people or any other group, and to strive to eliminate the evils of bigotry and racism and actively uphold the cause of religious freedom, racial equality and human dignity. The Committee has established a special Speakers' Bureau. Among the notable personages the committee has officially invited to the monument for special wreath-laying ceremony are Prime Minister Ben Gurion and Israeli Ambassador to the United States, Yitzhak Rabin.[104]

In the notes from its February 1967 meeting, the committee further refined a series of goals:

> The preparation and publication of a brochure summarizing the history of the monument and its significance, with the goal of having the widest distribution possible.
> The monument should be visited by schools, conventions, and tourists.
> The creation of a Speaker's Bureau to address Jewish and Christian civic organizations regarding the Holocaust.

Funds should be raised for a grant for a Master's thesis on the Ho-
locaust.

Libraries should be equipped with a corner of European Jewry and
the Holocaust.[105]

These projects were put in place in short order, for by 1972 the Memorial Com-
mittee listed as its ongoing projects not only the annual observance of Yom
Hashoah but also a survey of teaching in religious schools, a speakers' bureau, a
list of films and books about the Holocaust, a conference of Holocaust organi-
zations, the promotion of visits to the memorial, a permanent traveling exhibit
related to the Holocaust, and "library shelves" on the Holocaust (a program of
donating books on the Holocaust to public schools).[106]

The Memorial Committee reached out to other Jewish institutions to find
out how the Holocaust was being taught in schools in the United States. In
response, it received from the American Jewish Committee a brochure entitled
"Guidelines to Jewish History in Social Studies Instructional Material." Of
thirty-four pages, one paragraph is dedicated to the Holocaust.[107] Notes from
1971–72 indicate the Memorial Committee was worried that the Holocaust was
not being taught in Jewish institutions.[108] A 1972 letter to the Memorial Com-
mittee from the American Association of Jewish Education made clear that an
analysis of teaching the Holocaust versus *not* teaching the Holocaust in public
schools had not yet been conducted by their organization.[109] Evidence of the
Memorial Committee's activities can be found in letters, such as the one from
a librarian at the Abraham Lincoln High School in Philadelphia, who thanked
the committee for the set of books, which were cataloged, put into circulation,
and checked out by students learning about World War II.[110] In 1973, the Me-
morial Committee instituted the Mordechai Anielewicz Arts Competition and
Exhibition, held annually ever since.[111] Throughout the 1970s, demonstrations
were held at the monument site in support of Soviet Jews denied exit visas by
the USSR.[112] By the late 1970s, the committee moved beyond Holocaust educa-
tion and addressed bigotry and antisemitism on Philadelphia public television.

In the summer of 1977, WHYY Channel 12 in Philadelphia announced
plans to interview David Duke, then head of the Ku Klux Klan, and Frank
Collins, head of the American Nazi Party.[113] The committee, under the auspices
of the JCRC of Philadelphia, wrote to WHYY headquarters that "the Associ-
ation of Jewish New Americans sees the program as a threat to their survival."[114]
The committee asked for letters of support and received copies of letters sent to
WHYY from the American Jewish Committee, the Baptist Ministers Confer-
ence, and the Polish American Affairs Council, among others.[115] In a letter to
James Karayn, president of WHYY, James H. Jones, of the Negro Trade Union
Leadership Council, wrote, "I am not a Jew, but I am a concerned Black Amer-

ican who can never forget the inhuman atrocities that befell the Jewish people under Hitler's Nazi party. . . . This sort of program will only incite racial strife and disunity."[116] U.S. congressman Joshua Eilberg, from Northeast Philadelphia, urged the general manager of WHYY to cancel the program.[117] It aired, but the outcry by both Jewish and non-Jewish organizations demonstrated that the Memorial Committee was able to organize a substantial protest. That same year, prompted by the WHYY incident, the Memorial Committee instituted the Annual Youth Symposium on the Holocaust.[118] Organized in partnership with the archdiocese of Philadelphia, the symposium involved school children from "city and suburban, private and parochial" schools.[119] The archdiocese's role in Holocaust education should not be underestimated.

After Vatican II in 1965, when Nostra Aetate reversed the long-held Catholic belief that the Jews had killed Christ, John Cardinal Krol, in Philadelphia, immediately established the Cardinal's Commission on Human Rights, with the goal of addressing human relations in the city.[120] Sister Gloria Coleman initiated the Ecumenical and Interfaith Council as well as the Holocaust Committee (renamed soon after to "Interfaith Committee"), which organized events for adults and worked with the Memorial Committee to establish the Youth Symposium on the Holocaust.[121] According to Monsignor Michael Carroll, who directed the Interfaith and Ecumenical Affairs Office in the 1960s and 1970s, the archdiocese of Philadelphia and the Memorial Committee were pioneers in the United States in bringing Holocaust education to the schools of the city.[122] By September 1977, Philadelphia schools required a course on the Nazi Holocaust, which was developed by Franklin H. Littell, a Memorial Committee member and faculty member in the Department of Religion at Temple University.[123] The Philadelphia Board of Education wrote to the Memorial Committee that a "series of five development sessions dealing with the Holocaust have been developed. Thank you for your unswerving support of our programs. Because of your efforts, we have been successful in introducing Holocaust studies into the Social Studies Program of the Philadelphia School District."[124] In April 1979, the archdiocese wrote to the Memorial Committee that on Sunday, April 12, all Christian congregations were encouraged to observe a special day of Holocaust Remembrance.[125]

Nevertheless, in 1974, *Philadelphia Magazine* called Rapoport's monument the "worst sculpture" in the city and referred to the work's "twisted swords, hairless heads, hammertoes and hammerfingers [*sic*] projecting. . . . It looks like one of those clouds of dust cartoonists use to signify a fistfight—suspended on a pair of fat seated legs."[126] Still, the Memorial Committee's work became known not only within Philadelphia; by March 1979, the Council of Yad Vashem in Israel invited members of the Memorial Committee to join the work of its institution and to write "policy for Yad Vashem and to direct its activities."[127]

The Memorial Committee suggested that Littell sit on Yad Vashem's board and financially supported his visits to Israel.[128] Thus the Memorial Committee began raising awareness of the Rapoport monument in 1967, and, by the end of the 1970s, it had gained the attention of Yad Vashem.[129]

In the 1980s, the Memorial Committee continued to organize the Yizkor Service but ceased to administer public programs. During that decade, many other Jewish organizations became active in this field in Philadelphia, including the American Jewish Congress (no longer in existence) and the American Jewish Committee, both of which engaged in the kinds of public programming for which the Memorial Committee had been responsible.[130]

In 1989, Bryn Mawr College hosted a program that brought twenty-two American and German college students together to learn about the Holocaust and about German-Jewish relationships. Mayor Goode spoke to the students at the site of Rapoport's monument and visited with the students at the homes of local Holocaust survivors.[131] Still, for about fifteen years, the Memorial Committee was active in public life, bringing the history of the Holocaust to many Philadelphians, Jews and non-Jews alike.

## Later Work

After the Philadelphia monument, Rapoport would create a few more Holocaust-related works for public space in the United States. In 1978, he was commissioned to produce two reliefs for the school of the New York Park Avenue Synagogue (dedicated 1980).[132] One depicts Janusz Korczak, director of the Warsaw Ghetto orphanage, and two groups of orphans, in a stylized fashion. Korczak, a Jew, voluntarily stayed with his orphans when the Nazis transported them to their deaths in 1942 (he had been offered sanctuary by friends outside of the ghetto; some claim that the gestapo offered that he remain in the ghetto at the time of the children's deportation) and was never heard from again.[133] The inscription dedicates the relief to "the one million children who perished in the Holocaust." In 1983, the artist fulfilled the commission for the Liberation Monument in New Jersey, dedicated to the American soldiers who liberated the concentration camps. It is figurative without any abstract elements. Rapoport's earlier experiment in expressionist quasi figuration with the Philadelphia monument was abandoned in his later Holocaust-themed works.

Starting in 2003, the Memorial Committee added a new program to its roster of annual events: the Dorothy Freedman Conversation with a Survivor. The program is held annually on the morning of the Yizkor Service and brings Hebrew High School youth together with a survivor and a related speaker, such as a liberator or a rescuer.[134] In 2006, a new organization, the Philadelphia Holocaust Remembrance Foundation, leased the land around the monument

from the city, for eighty years—for $1—and planned to build a Holocaust Education Center at the site, without disturbing the monument.[135] The foundation, on whose board Shnaper sat until his death in 2014, commissioned Moshe Safdie, an Israeli-Canadian architect who has been fundamental in designing Holocaust memorials, most particularly at Yad Vashem.

In an interview, Marc Felgoise, former chairman of the board, stated that the educational center was not an archival or exhibition space but would instead bring the memory of the Holocaust into dialogue with other tragedies and genocides, for both Philadelphia residents and tourists.[136] But the committee was unable to raise the necessary funds and the plan was abandoned in 2014. In May 2016, the Philadelphia Holocaust Remembrance Foundation unveiled a new plan for the site, consisting of a memorial plaza behind the Rapoport monument on the corner of Sixteenth and Arch Streets. It opened in October 2018. Designed by the landscape architecture firm WRT, LLC, it consists of three sections of a train track from the Treblinka camp in Nazi-occupied Poland, which are 4–6 ft. long and have been embedded in the pavement. Users can download a free app to hear survivors' testimonies about deportation. There is a sapling from a silver maple tree that was planted and cared for by children in the Theresienstadt camp in the former Czechoslovakia.[137] In contrast to the 1980 brochure of public art in the city that failed to mention the sculpture, the memorial now appears on many Philadelphia tourist websites.[138] And both "Museum without Walls," a website of the Association for Public Art in Philadelphia, and the Association for Public Art website provide a visual description, photographs of the monument, and a map with its location.[139]

## Conclusion

The monument's history demonstrates that survivors and the established Jewish community worked together to honor the dead and preserve memories—and, even more important, to create the Memorial Committee that would promote Holocaust education in public and parochial schools in Philadelphia. In a letter to Shnaper written just after the dedication of the monument, Rapoport wrote, "The Uprising in the Ghetto had taught us: never bow your head, be helpful, and fight for justice and righteousness."[140] The general public largely forgot the monument, but the Memorial Committee fought for justice and righteousness, actively seeking to spread knowledge about the Holocaust in Philadelphia's public sphere.

The story of the commission, design, and installation of Rapoport's monument builds on the work of Hasia Diner and James E. Young, among others, by delving deeply into the history of one early Holocaust memorial in public space. Like the examples that Diner provides, Rapoport's monument proves

that the Jewish community was actively talking about the Holocaust and fighting for its memorialization in public space. The artist, in turn, had to grapple with a new visual vocabulary. While we will never know exactly why Rapoport chose a combination of abstract and figurative elements, it is safe to guess that he was trying to create a visual vocabulary for events that had not yet been visualized in public space. As we see in the next chapter, artists in both East and West Germany were confronted with finding visual forms to commemorate events that had not yet been fully articulated by the general public. East Germany slowly moved away from ideological monuments that extolled the workers' heroism, while West Germany continued to have difficulty finding a visual language in public space that adequately addressed the past. The challenges that the commissions faced, as well as the decisions made by the artists, are examined in the next chapter.

# 3

## Monuments to Deported Jews in Hamburg (Hrdlicka, Rückriem, Kahl) and East Berlin (Lammert)

I N BOTH EAST GERMANY (GDR) and West Germany (FRG), official rhetoric distanced itself from remembering the Jewish victims of the Holocaust, but for very different reasons. Throughout the mid-1960s and until the 1970s, the GDR ignored or suppressed the Holocaust and the murder of the six million Jews. The country focused on rebuilding the economy during the period known as the *Wirtschaftswunder* (economic miracle), and memorialization of victims in public space did not occur until the 1970s. In the FRG, official rhetoric sanctioned all victims—regardless of religion—and placed blame on capitalism and Fascism, an attitude that was in place for decades.

For the West German case study, this chapter takes a cluster of memorials dedicated to victims around the area of Hamburg Dammtor.[1] The sculptures include Alfred Hrdlicka's 1985–86 Counter-Monument (Figure 3.1), Richard Kuöhl's 1936 War Memorial, colloquially known as the "76er Memorial" or "*Kriegsklotz*" (the latter is a nickname loosely translated as "war monstrosity"; Figure 3.2), Ulrich Rückriem's 1983 minimalist Monument for the Deported Jews (Figure 3.3), and Margrit Kahl's 1988 Joseph-Carlebach-Platz Synagogue Monument (Figure 3.4).[2] For the case study in the GDR, we turn to what was then called the Memorial to the Victims of Fascism (1957/1985), designed by Will Lammert and belatedly dedicated in 1985.[3]

## Hamburg Dammtor Memorials

Starting in 1978, with the airing of the American television miniseries *The Holocaust*, the FRG witnessed an opening up toward the past. The so-called

**FIGURE 3.1** Alfred Hrdlicka, Counter-Monument, Hamburg, 1985–86, unfinished. Details: *left*, Feuersturm (Firestorm); *right*, Cap Arcona. (Photo: Gesche-M. Cordes. © Alfred Hrdlicka-Archive, Vienna)

**FIGURE 3.2** Richard Kuöhl, Monument to the 76th Infantry Regiment, Hamburg, 1936. (Photo: Gesche-M. Cordes. © Gesche-M. Cordes)

**Figure 3.3** Ulrich Rückriem, Memorial to the Deported Jews, Moorweidenstrasse, Hamburg, 1983. Granite. (Photo: Gesche-M. Cordes. © Gesche-M. Cordes. © Ulrich Rückriem)

**Figure 3.4** Margrit Kahl (artist) with Bernhard Hirche (architect), The Joseph-Carlebach-Platz Synagogue Monument, Hamburg, 1988. Granite and black polished marble. (Photo: Gesche-M. Cordes. © 2018 Artists Rights Society [ARS], New York / VG Bild-Kunst, Bonn)

Sonderweg debate took place in the 1980s and prompted a public rethinking of the past. In this context, public works of art started to address the newfound sympathy for Holocaust victims, both Jewish and non-Jewish. In the 1980s, Holocaust memorialization in the FRG embraced the visual trope of the counter-monument, a phrase coined by James E. Young to describe memorial spaces conceived to "challenge the conventional premises of the monument."[4] While traditional memorials rely on figural representations that aim to either console or redeem viewers, counter-monuments ask for the direct conceptual involvement of the viewer via visual strategies of voids, emptiness, and/or a minimalist rhetoric. The constellation of memorials and sites of memory at Hamburg Dammtor and the university area, a neighborhood once central to Jewish life in Hamburg, comment in some way on the notion of *counter-monument*—but none are explicitly dedicated to the murdered Jews or any other victims' group of Hamburg.

Alfred Hrdlicka's unfinished Counter-Monument (1985–86), for instance, stands on Dammtordamm directly across from, and in deliberate opposition to, Richard Kuöhl's 1936 War Memorial. Ulrich Rückriem's minimalist Memorial for the Deported Jews, erected in 1983, stands in a small triangular park near Universität Hamburg. And Margrit Kahl's Joseph-Carlebach-Platz Synagogue Monument, built in 1988, traces the outlines of a destroyed synagogue's vaulting in Grindel, a neighborhood of the city. Until 2005, there existed only one public monument dedicated to all Jewish citizens of Hamburg who were murdered during the Holocaust; it was installed by the Jewish community in 1951 in Ohlsdorf Cemetery, far from the monuments around the university or Dammtor. Reflecting the needs of the Jewish community in the seclusion of a Jewish cemetery, the monument does not attempt to address Holocaust memory for the city as a whole.[5]

While Hamburg is often seen as a city that turned a cold shoulder to Hitler and National Socialism, recent historical scholarship resists the myth of a liberal Hamburg and instead lays bare the Nazi activities of Hamburg citizens and officials. Memorialization to the Hamburg victims of Allied bombing (known as the *Hamburg Feuersturm* [Hamburg firestorm]) was common. Some individuals in Hamburg, however, have accepted the difficult challenge of remembering Nazi atrocities. Cultural Senator Wolfgang Tarnowski was especially active in realizing several memorials, sometimes under tight budgetary constraints. More recently, the Grindelhof Citizen's Initiative has been active in the upkeep of the Joseph-Carlebach-Platz Synagogue Monument, as introduced earlier.

The counter-monuments at Dammtor are either postmodern or minimal. Here I emphasize Hamburg's political association with its National Socialist past, and the role of the counter-monument. Further, I contribute a political

rethinking of postmodernism and memorials to this dialogue. The works, located in an area bordering on or in Grindel, can be better understood if the people, buildings, and empty spaces of that neighborhood are explained. A short summary of Jewish life in Hamburg can, therefore, help provide a conceptual framework for the analysis of memorials located in and around that neighborhood.

## A Brief History of Jews in Hamburg

Four hundred years ago, Sephardic Jews fleeing the Inquisition in Spain and Portugal sought out the Hanseatic city on the Elbe as a home.[6] At the time, Altona (now a neighborhood in Hamburg) was part of Denmark and was less dismissive of the Jews and other minorities than the city of Hamburg. Many Jews lived in Altona but had their businesses in Hamburg.

In 1671, individual Ashkenazic communities united to form the Altona-Wandsbek-Hamburg community, which existed up until Napoléon I's occupation of the city in 1812. At the time, the Jewish population numbered 6,429, or 4.87 percent of the total population.[7] Napoléon I, who was intolerant of a religious community that ignored French borders, demanded that the group disband. Still, under Napoléon I's rule the freedoms of Hamburg Jews greatly increased, and Jews subsequently lived in various parts of the city that had previously been closed to them. After Napoléon I's reign, newly won freedoms were lost, which prompted Jewish communities to work for emancipation. A Jewish Reform movement was active in this regard and gathered at the Israelite Freischule and the first "temple" on Alte Steinweg.

In the middle of the nineteenth century, many Jewish families improved their social standing and prosperity and could afford to move to Neustadt and the new suburb at Grindel and around Alster Lake. These new Jewish neighborhoods led to the construction of the Orthodox synagogue at Bornplatz and the Neue Dammtor Synagogue. However, the relationship between the Reform and the Orthodox communities was fraught with difficulty. At the turn of the century, when there were 17,949 Jews in Hamburg (2.34 percent of the population), a Conservative movement was founded that attempted to bring both traditions together at the Neue Dammtor Synagogue, which was completed in 1895, near what is now Allende Platz.[8] When the Bornplatz Synagogue was opened in 1906, with Joseph Carlebach as rabbi, the Neue Dammtor Synagogue lost many of its members. The Bornplatz Synagogue was home to twelve hundred members and located on a main street; it was a symbol of Jewish self-confidence in the neighborhood known as Grindel. Regardless of community affiliation, all Jews in Hamburg encouraged education and participation in social and economic spheres. A Jew-

ish life blossomed in Grindel; Jews were well integrated in Hamburg life and were accepted, for the most part, by Hamburg's citizens.

During the Weimar Republic, full and legal Jewish emancipation was available to all 19,904 Jews living in Hamburg but was coincident with a rise in antisemitism.[9] Hamburg became a new center for learning in Germany, with assimilated and emancipated Jews such as Ernst Cassirer, president of the university, and Aby Warburg, art historian and founder of the Cultural Studies Library on Heilwigstrasse. The National Socialists would thoroughly destroy this vision of emancipation and assimilation.

Shortly after January 30, 1933, the systematic persecution of Hamburg's Jews began.[10] At the start, there were 16,973 Jews living in Hamburg. In April 1945, there were 647.[11] The NSDAP Gauleiter (party leader of a regional branch of the Nazi Party), Karl Kaufmann, was responsible for ensuring that "Reichspolitik" in Hamburg was total. The details of Jewish persecution in Hamburg are most recently made clear in the 2005 anthology *Hamburg im 'Dritten Reich,'* a comprehensive investigation of Hamburg during National Socialism.[12]

Hamburg's status as a *Führerstadt* (Hitler City) also deserves mention. In 1937, Hitler planned to completely redesign Hamburg, Berlin, and three other cities as *Führerstädte*, in which the power of the Third Reich would be spectacularly displayed through architecture and urban planning. As a port city of 1.7 million people, Hamburg's architectural task was to represent itself as a gateway to the world of modernity, which would prove the productivity of the Third Reich. Not least, it was to trump the United States and its famed Golden Gate Bridge with a suspension bridge planned for the Elbe with towers 100 m high.[13] Further plans included a 250 m high tower for the NSDAP Gauleiter; a 2,000 m long boulevard on the Elbe; a newly situated Universität Hamburg in Flottbek; and a meeting center to seat 150,000 people. None of these was built.[14] In light of these facts, it is clear that Hamburg was hardly the moderate Hanseatic city that supposedly gave Hitler a cold shoulder.

The fact that today many people claim "it was not so bad" in Hamburg during National Socialism demonstrates repression in the postwar period.[15] As Werner Johe puts it, "in the postwar period, no one really wanted to remember the connection between the words 'Hamburg and Hitler.'"[16] Hamburg was considered to be a refuge for liberal traditions since the Middle Ages,[17] the "capital of Socialism,"[18] and a city of liberal merchants. In 1947, Rudolf Peterson, Hamburg's first postwar mayor, declared that the citizens of Hamburg had moderated the elements of the radical right as a result of their Hanseatic worldview of trade and openness. This opinion was quickly disseminated, making it easy to forget the actions of citizens and officials during the Third Reich. In this supposed guilt-free environment, Hitler evaded Hamburg because it was either too "red" or too "Hanseatic."

The Forschungsstelle für die Geschichte Hamburgs von 1933 bis 1945 (Research Center for Hamburg History from 1933 to 1945) opened in 1949; the center closed by 1956 due to the dearth of publications. The center re-opened in 1960 as Forschungsstelle für die Geschichte des Nationalsozialismus in Hamburg (Research Center for the History of National Socialism in Hamburg) and extended its historical reach from 1918 to 1948, thereby considering both the rise of National Socialism and its immediate aftermath. In the 1980s, this institute turned its attention to the Nazi persecution of Hamburg citizens, and, in 1985, Geoffrey Giles argued that students in Hamburg were just as active in the Nazification of their university as were students in any other German institution of higher education.[19] In 1997, the institute became a public foundation of the City of Hamburg and was renamed Forschungsstelle für Zeitgeschichte in Hamburg (Research Institute for Contemporary History). It officially became part of the Universität Hamburg in 2000.[20] Recent scholarship, much of it published by the Forschungsstelle für Zeitgeschichte, attempts to rectify the picture of a "moderate" Hamburg. Hitler visited the city thirty-three times from 1915 to 1929, more than any other city in Germany, with the exceptions of Berlin, Munich, and Nuremberg. In the September 1930 Reichstag election, 18.3 percent of the voters voted for Hitler. In Hamburg, 19.2 percent voted for him, above the national average. Hamburg was not a *Mustergau* (model region) but it was also not the moderate Hanseatic city that supposedly gave Hitler a cold shoulder.[21] As more details about Hamburg's activities during National Socialism come to light, it becomes increasingly clear that Hamburg has been rethinking its myth of "moderation."[22]

## The Dammtor Memorials

Richard Kuöhl's 1936 War Memorial on Dammtordam has been a troublesome presence in Hamburg's public space and has sparked much debate: Should a Fascist-era memorial be destroyed, or should it be recontextualized to address current attitudes? Neither Hrdlicka's Counter-Monument nor Kuöhl's memorial at the site address the Holocaust directly, but together they constitute a paradigm for the city's representation of its history in public space (Figures 3.1, 3.2). Counter-Monument does not pay tribute to its former Jewish citizens; instead, it attests to the victimization of Germans.

The monument on Dammtordam honors Infantry Regiment 76, which participated in the Franco-Prussian War in 1870–71 and subsequently was mobilized in World War I in 1914. It is a sculptural block with eighty-eight marching soldiers, arranged in groups of four and dressed in uniforms of the then contemporary Wehrmacht. The nationalist tone of the inscription is

impossible to ignore: "Germany must live, even if we must die" (*Deutschland muss leben, und wenn wir sterben müssen*).

Kuöhl's monument was first installed as a critical response to Klaus Hoffmann and Ernst Barlach's War Victims Memorial of 1931, located in front of city hall (*Rathausmarkt*). It is a tall stele by Ernst Barlach and consists of a relief depicting a pregnant mother and mourning child. On its verso, an inscription reads, "Forty thousand sons of the city lost their lives for you."[23] After World War I, a controversy began over remembrance of war victims. Soldiers on the political right supported a cemetery honoring the dead, while the political left lobbied for an antiwar memorial. The war victims' alliance, in the meantime, suggested using the funds for social housing for the war widows and orphans. As a result, the Senate initiated a competition for a modern, inner-city memorial, resulting in Hoffmann and Barlach's design.[24] The 76er Association, the representative group of Infantry Regiment 76, successfully lobbied against the Hoffmann/Barlach monument, and, in 1933, the Senate finally gave them a space on Stephansplatz for their own memorial.

The famous inscription on the memorial is selected from Heinrich Lersch's poem "Soldier's Goodbye": "Let me go Mother / let me go. / Your last greeting I want to kiss you: / Germany must live, even if we must die!"[25] Because the poem dates from before the Nazi period and because the memorial itself is for the dead soldiers of World War I, the memorial is not easily defined as National Socialist. It is, however, designed in a style commensurate with National Socialism. Visually, the memorial fits with the Nazi architecture of Albert Speer in its massive form; conceptually, its unquestionable patriotism would have been familiar to National Socialist rhetoric.

After World War II, Allied directives required the destruction of all Nazi memorials. To save the 76er Memorial, the Office for the Preservation of Historical Monuments (Denkmalschutzamt) used a rule of exception—memorials that served the dead, individuals, and regular military individuals should not be destroyed—a decision that was controversial.[26] A local citizen wrote in the *Hamburg Free Press* in 1946 that "the memorial should be removed . . . [since] the Germany that 'should live, even if we die,' is already dead."[27] In 1957, the city installed a plaque "for the fallen of the Second World War."[28] The memorial remains in place and continues to be a conceptual stumbling block to this day.[29]

In the 1970s, citizens demanded the inscription's removal, instigating the formation of a radical right group in defense of the monument, which had come to be called *Kriegsklotz* (war monstrosity). In 1979, Representative Hermann Ibs (Social Democratic Party) supported a public competition to convert the militarist memorial into a pacifist one.[30] A 1982 competition called for a counter-monument to disrupt the 76er Memorial's message of the glorification of war.[31] Alfred Hrdlicka, a jury member, submitted the win-

ning proposal. The four-part work was to be installed in proximity to Kuöhl's monument without obscuring or altering it.

Hrdlicka's monument was to depict a broken swastika. Only two of the planned four parts have been installed. The first two parts, with the titles Hamburg Feuersturm (Hamburg Firestorm, dedicated on May 8, 1985) and Verfolgung und Widerstand (Persecution and Resistance, dedicated on September 29, 1986), memorialize the victims of the July 1943 Allied bombing of Hamburg and the May 1945 Allied bombing of the ship Cap Arcona, which housed Neuengamme internees.[32] The focus on the Hamburg bombing is revealing. In the aftermath of World War II, Germans often accepted the destruction of their cities as a price for the hubris of the Third Reich, while in public—and in private—they defined themselves as victims of Allied bombing. Neither Hamburg nor Hrdlicka's memorial were exceptions.

Hrdlicka's Counter-Monument does not mention the missing Jews. Instead, the victimization of Germans takes center stage. The two missing pieces (not built due to lack of financial support from the city) of Hrdlicka's installation were not exceptions and were to have been entitled Soldier's Death and The Image of Women in Fascism. Neither the monument nor the plaque placed by the city in its vicinity mentions the word *Holocaust*.

Visually, Hrdlicka's memorial practically disappears against the background of trees on Stephansplatz. The melting bronze forms of Hamburg Feuersturm and Verfolgung und Widerstand look almost transparent next to the 76er Memorial. In the evening, while the 76er Memorial is lit up by spotlights, Hrdlicka's is left in darkness. Hrdlicka chose forms that have a one-to-one relationship between image and meaning: a broken swastika, melting bronze, flames of fire, and figures writhing. Such figural representations are often associated with conventional monuments, such as Nathan Rapoport's Warsaw Ghetto Monument (1948), which might have provided a figural precedent for Hrdlicka, were it not for the melting, writhing forms created by Hrdlicka, whose figures contrast with the voluminous, muscle-bound figures of Rapoport.[33] Hrdlicka's unfinished memorial speaks of the city's reticence to engage in an ongoing discussion of Holocaust memorialization.

While Hrdlicka's Counter-Monument seems to fade into the background of Dammtordam, Ulrich Rückriem's Memorial to the Deported Jews stands out as a minimalist work in a lonely triangular park near the university (Figure 3.3). Among the places of deportation in Hamburg were the Jewish school on Karolinenstrasse, the community center on Hartungstrasse, and the building of the Provinzialloge of Niedersachsen on Moorweidenstrasse. In front of the last, on a triangular plaza, Jews waited in lines for deportation. Cultural Senator Tarnowski supported a memorial on this site and commissioned Rückriem to create it. The memorial was dedicated on January 21, 1983. Standing alone

in the park, the memorial consists of a granite block cut into seven stones and then reassembled. The entire park was to be the memorial. According to the artist, the rear side, facing toward Edmund-Siemers-Allee, was meant to evoke the Western Wall in Jerusalem. The front side suggested a protective house from which the Hamburg Jews were forced to leave.[34]

This minimalist monument, however, did not fulfill the didactic goals of the city. In an effort to more clearly define this site of perpetration, two information plaques were installed. In a strange way, the two plaques reiterate one another. While one describes the thousands of lives lost and the necessity to beware in the present, the other provides a specific population of Jews in Hamburg and more vaguely states that thousands of those lives were destroyed in death camps. Rückriem's memorial did not "depict" the facts of deportation—such are the pitfalls, perhaps, of counter-monuments, which, in refusing figural representation, do so in favor of visual metaphors that demand emotional and conceptual work on the part of the viewer. But the plaques did nothing to provide specific details of the destruction of the Jewish population.

Rückriem is not the first artist to employ minimalism to create works about the Holocaust. In Frank Stella's *Black Paintings* series, with such individual titles as *"Arbeit Macht Frei,"* the artist claimed the works were about paint and nothing but paint.[35] More recently, ever since Maya Lin's Vietnam Veterans Memorial (1982), minimalism has become the visual vocabulary par excellence for Holocaust memorials. This is the case at the USHMM. Sol LeWitt's *Consequence* (1993), for instance, is meant for contemplation between floors of historical documentation, its title prompting the viewer to engage in his or her own role in historical events. So, too, at the same institution, Joel Shapiro's *Loss and Regeneration*, consisting of two outdoor sculptures that are meant to be minimalist and nonpolitical, should direct the viewer toward memory (see Chapter 4).[36] These works complement the historical exhibition; they are deemed "appropriate" because the historical exhibition takes precedence over the work of art.

Such aesthetic choices have different significance in postwar Hamburg. A counter-monument that refuses the monumental forms of traditional memorialization, Margrit Kahl's Synagogue Monument on Joseph-Carlebach-Platz in Grindelhof (Figure 3.4) is just a few steps away from Rückriem's memorial and has witnessed a similar history of bronze plaque additions. In 1906, the Bornplatz Synagogue was the first synagogue open to the street in Hamburg. With twelve hundred seats and a 40 m high cupola, it was a symbol of the self-confidence of Hamburg Jews. On *Kristallnacht*, November 9–10, 1938, the synagogue was damaged but was not burned to the ground—in fact, it could have been rebuilt with its original walls intact.[37] In 1939, the Jewish community was forced to sell the land to the city well under value and was responsible

for financing its final demolition, which took place in 1940. During the war, a bunker, which still exists today, was installed next to the plaza. After 1945, the Universität Hamburg used the plaza for extra parking and the bunker as office space. In 1957, a modest plaque was installed on the back of the bunker. In part, the plaque reads: "Here stood the main synagogue of the German-Israelite community of Hamburg at the time of National Socialist tyranny. It was destroyed by a despotic act on Nov. 9, 1938." While the plaque dates the destruction of the synagogue to *Kristallnacht*, it does not name that antisemitic event outright but rather refers to it as a "despotic act," thereby masking antisemitism completely.[38] Furthermore, the statement is a historical half-truth: the complete destruction of the synagogue did not take place on *Kristallnacht* but rather was enforced by the city of Hamburg and paid for by Jewish citizens. The institutionalized antisemitism of the era is not fully addressed.

The Office for the Preservation of Historic Monuments and the Office of Cultural Affairs (with Cultural Senator Tarnowski, once again, leading the movement to do something about this space) expressed the need to make visible the history of the site. It was suggested that the buried foundations of the synagogue could be laid bare. However, the Jewish community did not support the proposal and explicitly requested that the ruins remain buried. A committee formed by the city administration then suggested that the footprint of the synagogue should be "redrawn" on the ground. The District Office (Bezirksamt) and Planning Department and Building Control Office (Baubehörde) were not interested. The Office of Scholarly Affairs (Wissenschaftsbehörde), prioritizing the university's needs, lobbied for converting the area into a parking lot.[39] It was only in 1983, when the city's Arts Commission became active, that German sculptor Margrit Kahl was chosen to design a memorial on the plaza. The city assigned Bernhard Hirche, an architect, to help realize her design.

Kahl suggested a stone mosaic that would project the vanished synagogue's vaulting schema on the ground. In 1986, the forty-eighth anniversary of *Kristallnacht*, Cultural Senator Helga Schuchardt put forth a proposal to the City Senate for the memorial, and Kahl's Synagogue Monument was installed in 1988. The ground mosaic indicates the synagogue floor and the vaulting in its original scale. On November 11, 1988, the plaza was newly named "Joseph-Carlebach Place" (Joseph-Carlebach-Platz) for Dr. Joseph Carlebach, the last chief rabbi in Hamburg, who served in that capacity until his deportation to Theresienstadt in 1941.

Following the commission's concept, the artist expressed the footprint and vaulting of the synagogue in black and gray granite imported from Israel, converting the plaza into a kaleidoscopic design. The visitor must imagine the height and depth of the original building and is encouraged to walk over the space where it once stood, thereby conceptually participating in the memorial. In its

insistence on the two-dimensionality of a drawing in stone, the memorial makes visible the absence of the destroyed building.

The lack of a conventional memorial with a clear message, however, prompted the city to install informational plaques. Shortly after the memorial was installed in 1988, a plaque was placed on the back of the former bunker that reads: "The monument memorializes the form of the house of god, it should be a warning that the irrational destruction is a crime against humanity. May the future put the descendants out of harm's way."[40] If the viewer is looking for information, the full text of the plaque provides the year the synagogue was built, the number of seats, and the fact that it was severely damaged during *Kristallnacht* in 1938. The reasons the synagogue was destroyed are not mentioned. In addition, the last statement is mysterious in its lack of clarity: Are the "descendants" meant to mean all Hamburg citizens, or only the descendants of Jews? The lack of clarity about the future underscores an unwillingness to fully elucidate the ramifications of the synagogue's history, a state of affairs that is echoed in Gerson Fehrenbach's synagogue monument (Chapter 1).

After the memorial was built, the plaza was ignored for years. Neither the District Office nor the Office of Cultural Affairs saw themselves as responsible for its care. The plaza was strewn with litter and weeds grew over the stones, making the architectural lines illegible. The Grindelhof Citizen's Initiative, founded in 2001, responded to this state of affairs. According to member Christine Harff, the Grindelhof Citizen's Initiative was formed to protest a new traffic plan from the city, under governance of the CDU, the Free Democratic Party, and the "Schill Party" (*Partei Rechtsstaatlicher Offensive* or Party for a Rule of Law Offensive).[41] The citizen's initiative thereafter became active in other aspects of life in Grindel, including the memorial on Bornplatz. With the support of the City Garden Department and as suggested by the initiative, a movement was founded in April 2003, metaphorically entitled *Lasst kein gras drüberwachsen* (don't let grass grow over it). Starting with this effort, the cleaning of the plaza could begin. Since 2004, groups from different schools in Hamburg have been responsible for the care of the plaza via social internships.

Abandoned by the city but supported by the citizen's initiative, the memorial is telling for the understanding of the Holocaust in the present. The city's willingness to allow a memorial to reach a state of disrepair is a sad indicator of Holocaust memory in Hamburg. It also demonstrates, however, the ways in which individuals can impact memory. The Grindelhof Citizen's Initiative, for instance, proved important for the upkeep of the memorial: memory is kept alive on an individual and group level for the Grindel community.

In September 2004, a new double-sided placard, providing photographs of the original synagogue and information about its history, was installed and sponsored by the Hamburg affiliate of the advertising agency JCDecaux, in

**FIGURE 3.5** Gunter Demnig, Stolperstein, 2005. (Photo: Gesche-M. Cordes. © 2018 Artists Rights Society [ARS], New York / VG Bild-Kunst, Bonn)

conjunction with the Grindelhof Citizen's Initiative. Lit up from inside at night, shining with a light blue color, the placard is the first memorial in Hamburg that mentions the murdered Jews of the city.

> *In the Pogromnacht of November 9, 1938, the National Socialists*
> *made this plaza a showplace for Jewish persecution. They damaged*
> *the synagogue and forced its demolition. . . . In the memory of*
> *the persecuted and murdered Hamburg Jews fifty years after the*
> *Pogromnacht of 9. November 1938 this plaza was officially named*
> *Joseph Carlebach Platz.*

JCDecaux is responsible for the placard's upkeep. It may be necessary that every generation add its own plaque, board, or memorial. In a post-postmodern setting, it is perhaps not ideal—but not surprising—that a private corporation has sponsored a memorial. Nonetheless, each act of memory certainly demonstrates the active role that local citizens play in their neighborhoods.

Memorialization in Hamburg continues. In the summer of 2005, Gunter Demnig, the artist of the European-wide Stolpersteine project, visited Hamburg and installed his bronze "stumbling blocks" on Hamburg's streets (the literal translation is "stumbling stones"; however, the phrase is equivalent to the English phrase "stumbling blocks," or things that get in the way of our

ideas or actions). The Stolpersteine (Figure 3.5) are bronze plaques that are placed in the sidewalks in front of homes where victims of Nazi atrocities lived. "A person is only forgotten when his name is forgotten," says Demnig.[42] On each plaque is inscribed the name of the person, date of birth, date of deportation, date of murder, and location of death. For EUR 95 one can sponsor the creation and installation of a Stolperstein. Perhaps the artist realizes what it has taken so long for others to understand: individuals can be powerful recorders of public memory. And a simple minimalist work of art declares that these people were victims of Nazi atrocities.

## East Germany: Will Lammert's Memorial to the Victims of Fascism (1985)

Out of the more than 170,000 Jews living in Berlin in 1933, nearly half left Germany before the outbreak of the war. Around 50,000 were deported to ghettos in the east and later to concentration camps. Only 9,000 survived the war by hiding in the city.[43] In the GDR, traditional memorials that glorify individuals were often built at the sites of concentration camps, which, in turn, often downplayed the Jews as victims. According to East German ideology, Jews were one victim group among many, and all victims suffered from Fascism.

An exception to the heroic monument—and to the attitude that Jews were not a specific victim group that needed to be memorialized—was the installation of Will Lammert's Memorial to the Victims of Fascism (1985). While typical GDR monuments were socialist realist in style, Lammert's 1959 figures are quasi-expressionist, harkening back to prewar modernism. Installed on Große Hamburger Straße, in Mitte, East Berlin, a former Jewish neighborhood (as well as the center of the workers' movement), the 1985 installation of the figural group demonstrates a new opening up toward the neighborhood's unique history and, in however small a step, to the memory of Berlin's deported Jews.

The memorial was installed on the fortieth anniversary of East Germany's *Tag der Befreiung des deutschen Volkes vom Hitlerfaschismus* (day of liberation from Hitler's Fascism) in May 1985. It consists of thirteen figures in a quasi-expressionist style. Eleven figures stand and two kneel (Figure 3.6). The three-quarter life-size figures are situated on a low base. There was a small public inauguration attended by the Councilor for Culture Helga Rönsch and the artist's family. A photograph and short description of the memorial appeared in the *Berliner Zeitung*, calling attention to the fifty-six thousand Jews who were deported from this spot to concentration and death camps.[44] A plaque near the sculptural group was installed by the city, which reads as follows:

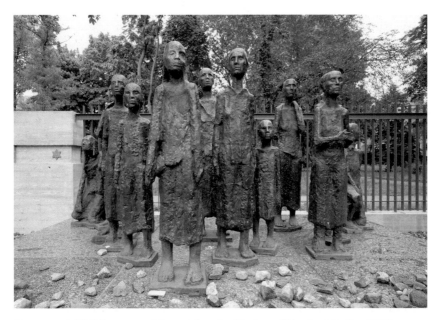

FIGURE 3.6 Will Lammert, Memorial to the Victims of Fascism, Berlin, 1985. Originally designed in 1957 for the Ravensbrück memorial (never installed; known as *The Unfinished*). Installed 1985, Große Hamburger Straße, by Mark Lammert. Also known as Monument to the Deported Jews. Bronze. (Photo: Jochen Teufel. © 2018 Artists Rights Society [ARS], New York / VG Bild-Kunst, Bonn)

> *On this site was the first old age home of the Jewish community of Berlin. In 1942 the Gestapo used it as a collection place for Jewish citizens. 55,000 Berlin Jews, from babies to the elderly, were dragged to the concentration camps Auschwitz and Theresienstadt, where they were bestially murdered.* NEVER FORGET/AVOID WAR/ PROTECT PEACE.[45]

By the early 1990s, the sculptural group was known as the first Holocaust memorial dedicated to the deported Jews of Berlin—East or West—and I therefore refer to it, in the historical context of the 1990s and after, as "Monument to the Deported Jews of Berlin."[46] In 2003, one scholar (Angela Lammert, the spouse of Mark Lammert, the artist's grandson) noted, "The disappearance of Lammert's work from the discussion of Holocaust memorials is remarkable."[47] This chapter takes a first step at redressing this lacuna in the literature.

The figures are unfinished—they are, in fact, referred to in the literature as *Die Unvollendete* or *the Unfinished Female Figures* (hereafter referred to as the *Unfinished*)—and were originally designed by Lammert for the base of

his memorial (see Figure 1.3) for Ravensbrück in 1957. The monument at Ravensbrück was meant to be a two-part memorial, consisting of the existing two figures on the pylon, which represent one woman carrying another, known as Tragende (Burdened Woman),[48] and a grouping of figures at its base. The artist died in 1957, however, before finalizing his design for the monument, and only the two figures on the pylon (Figure 1.1) were installed in 1959.[49] Lammert's family had the unfinished figures cast in bronze in 1959 and exhibited them in Berlin, Dresden, Paris, and other cities.[50] The grouping on Große Hamburger Straße in Mitte was created in 1985 (using the 1959 bronze casts) by Berlin-based painter Mark Lammert.

In Chapter 1, I argue that Lammert most likely designed the figures to depict Strafestehen—or torture by standing—in Ravensbrück. I also explained that while Western art historical attitudes toward the GDR up until the 1990s assumed that Soviet socialist realism was the de facto art style of the GDR, some elements of expressionism were being theorized in the late 1950s, at precisely the time when Lammert designed the Ravensbrück monument.[51] Here, I analyze the role that a monument for Ravensbrück plays in this particular neighborhood of Mitte, Berlin: standing silently, they are no longer legible only as women being tortured by standing. Instead, the sculptures signify, at the same time, the changing attitudes toward the history of the neighborhood in which the sculptural group is located: the deported Jews of Berlin, the harrowing aftermath of their deportations, and the metaphorical, improbable return of the deported Jews in sculptural form.

The Lammert family had the Unfinished first cast in plaster, in 1959, and then in bronze. The decision to do so (entirely at the family's expense) most likely saved the sculptures, for the clay maquettes were not made to be durable.[52] In 1968, the Berlin Nationalgalerie bought two of the bronze figures. Other Unfinished figures were acquired by the Nuremberg Museum soon after.

The sculptures did not find a permanent home until 1985, when Mark Lammert arranged them for what appears as a small park but is in fact a former Jewish cemetery, on Große Hamburger Straße. Mark Lammert chose the site not only for its small size, which he thought would be fitting for the three-quarter life-size figures, but also for its historical significance in terms of the history of the deportation and murder of Berlin's Jews, a history that writers and politicians were rediscovering in the early 1980s. As the figures are three-quarter life-size, they fit the old building style and neighborhood: the buildings in the neighborhood are no more than five stories high and the streets are narrow and curved. Additionally, the figures would be situated in a small plaza with natural elements—certainly not like the natural surroundings of the peninsula in Ravensbrück, but nevertheless a space seen by the Lammert family as not entirely foreign to Will Lammert's original concept.

The recommendation to install the sculptural group on Große Hamburger Straße was made by both the Lammert family and the Berlin Academy of Arts in 1983. The Lammert family approached Jürgen Schuchardt, city council magistrate of the Berlin capital of the GDR. The ministry approved, provided funds for, and installed the monument within two years—a relatively short amount of time. Mark Lammert relates that there are several reasons for the quick process of installation. By 1983, Will Lammert had become known in GDR as an important artist—a contemporary art prize at the Berlin Academy of Arts was named after him—and he had influenced a younger generation of artists who wanted to make both smaller works of public art and works of art that were modernist in style. Brian Ladd remarks that by the late 1980s the regime "lost control of its own iconography as the desires of competing constituencies and artists, the broader public and party leaders themselves—pulled in different directions."[53] So the time was right, in many senses, for the memorial to be installed. In addition, the memorial took so little time to install because of the changing attitudes toward the neighborhood.

## Rediscovering the Scheunenviertel

In East Germany, there was a renewed interest in this formerly Jewish neighborhood as well as a need to memorialize its former inhabitants.[54] The area is close to historical churches, such as the Pfarrkirche (1712) and the Sophien-kirche with its Baroque tower (1732–34), as well as to the most important gathering places for the workers' movement, including the *Handwerkerver-einshaus* (Artisans' Association Building) and the Sophienhöfe.[55] But more importantly, the site on which the sculptures stand has particular significance for the Jewish history of Berlin.

What is now an empty park behind the figures had been the oldest Jewish cemetery in Berlin, active from 1672 to 1827. Several prominent members of Berlin's Jewish community, including the philosopher Moses Mendelssohn, are buried there.[56] Berlin's first Jewish home for the aged was erected in a building just across the street from the cemetery, and the Jewish Boys' School was located on the adjacent property. The park is located in the Scheunenviertel in Mitte—literally meaning "barn quarter," a name derived from the fire code of 1672 that said flammable materials such as hay and wood should be stored there—and consists of the area of what is now between Rosenthaler Strasse and Karl-Liebknecht-Strasse.[57] It is adjacent to the Jewish bourgeois neighborhood of Spandauer Vorstadt, which was graced with its New Synagogue (1859–66).[58]

The Scheunenviertel, in turn, is commonly known as the "Jewish Quarter," a designation that goes back to the late nineteenth century, when it became a temporary home to Jewish refugees from pogroms in Russia (known

in Germany as "Ost-Juden") on their way to the Western German port cities of Bremen and Hamburg and from there on to the United States. By the 1910s and 1920s, the Scheunenviertel was also the residence of the impoverished, criminals, and prostitutes. For lack of money and papers, many Jews were forced to stay in Berlin for an extended period. After World War I, police roundups of foreigners, many of them Jews, often took place in the Scheunenviertel.[59] When the United States introduced the immigrant quota system in 1924, thereby reducing the number of Jews allowed to immigrate to the United States, the influx of Eastern European Jews into Berlin ceased as well. In early November 1923, an anti-Jewish pogrom occurred in the Scheunenviertel only days before the Itleer-Ludenforff coup in Munich.[60]

Following the March Reichstag elections after Hitler came to power, the Nazis organized a boycott of Jewish businesses and the vandalization of Jewish shops in Berlin and throughout Germany on April 1, 1933. On April 9, the Storm Troopers (*Sturmabteilungen* or SA) raided the Scheunenviertel and arrested many Jews. Eastern Jews were the first objects of German antisemitism and were the first to be sent to concentration camps.[61]

The gestapo confiscated both the Jewish Boys' School and the home for the elderly and converted them into internment centers that were used to hold Berlin Jews prior to their deportation. The assembly camp on Große Hamburger Straße became the central gathering place for Jewish deportations "to the east" from the fall of 1942 and until the spring of 1944.[62] The former home for the elderly on Große Hamburger Straße was transformed into a prison, complete with bars on its windows, a surrounding fence, nighttime illumination, and offices for the gestapo. The detained Jews were split up into three sections in the facility: the so-called Theresienstadt rooms (in Nazi propaganda, Theresienstadt was cynically referred to as a "spa town," where elderly German Jews could "retire" in safety; it was a strategy of deception, as the ghetto was a collection center for deportations to ghettos and killing centers in Nazi-occupied Eastern Europe), "East rooms" (reserved for those who would depart for Auschwitz), and, finally, "accommodation rooms" (for those persons whose destination and departure dates had yet to be determined).[63] Twenty-five to thirty armed policemen were posted there with instructions to shoot any prisoner who tried to escape.[64] In 1943, the Jewish cemetery was destroyed on orders of the gestapo. The Nazis desecrated the graves and turned the entire grounds into air raid shelters, the walls of which were reinforced with demolished Jewish gravestones. In April 1945, the authorities used the grounds as a mass grave for soldiers and civilians killed during Allied air raids. After 1945, the Scheunenviertel came under Soviet jurisdiction and later was made part of East Berlin. The Scheunenviertel was thus transformed by the urban changes of the 1920s, Hitler's destruction, and Allied bombings.[65]

The significance of the change in attitudes of the GDR toward the Scheunenviertel is explained in Florian Urban's *Neo-Historical East Berlin* (2009). Although Urban does not mention Lammert's sculpture, its history is directly related to the one he portrays, which is worth paraphrasing.[66] In the 1960s, all East Berlin master plans had scheduled the area for comprehensive demolition and rebuilding. The Communal Management for Living (or *Kommunale Wohnungsverwaltung*) was instructed by the GDR to spend money on basic maintenance of buildings, such as water pipes and coal ovens—but not on renovation. In 1963, reconstruction meant "complex modernization through demolition and renewal," to be completed by 1970. As Urban puts it, "The area was known for its crumbling façades, many empty storefronts with signs from the prewar period, bullet holes and empty lots."[67]

But by the 1980s that mentality had completely changed, and the GDR formulated a new interest in the neighborhood. Rather than demolition, the historical image of the neighborhood became popular, and the term *reconstruction* effectively changed its meaning. Instead of demolition, reconstruction meant that history was to be staged in period shops and restaurants.[68] Urban relates that plans to reconstruct the neighborhood were precisely formulated by the politburo, which, in 1976, passed a resolution entitled "Tasks for the Development of the Capital City of the GDR, Berlin." The resolution mandated that the area around Sophienstrasse and Große Hamburger Straße "be built as a section of Old Berlin respecting historic traditions."[69]

This interest in the Jewish neighborhood corresponded with other incidents of public interest in the history of Berlin's Jews. A citizens' initiative, for instance, actively tried to promote retaining, rather than destroying, local buildings.[70] Books by Heinz Knobloch were best sellers in the 1980s, especially his biography of Moses Mendelssohn, *Herr Moses in Berlin*, in which Knobloch wrote of Wilhelm Krützfeld, the courageous constable who protected the New Synagogue against attacks by Nazi groups.[71] A group of residents on Almstadtstrasse 16 cast a Star of David in cement in their backyard to commemorate former Jewish residents in the area.

This is not to say, however, that these events demonstrate a radical change in GDR attitudes toward the Holocaust and Jews as the primary victim group of the National Socialists. Urban rightly points out that the GDR still did not interpret the Holocaust as a crime of its own, and memory of the Holocaust always took a back seat in comparison to the killing of Communist activists. Jewish victims were counted as one group among many and were not explicitly commemorated as Jews—with the exception of Lammert's monument.[72] In addition, Jews, both the few survivors who remained in East Germany and the many who did not survive, were also implicitly associated with Israel and thus with a state with which the GDR did not have diplomatic relations—

and which it considered a subordinate of the capitalist arch enemy.[73] Urban explains:

> The way these memories were traced suggests that the investigations addressed only to a small extent the guilt of the grandfather's generation and the one-dimensional East German historiography with its many inaccuracies, and to a much greater degree the postwar generations' fascination with the exotic other that used to be a part of their familiar environment. At the same time, however, one can detect an attempt to approach the crimes of the Nazis on an individual level, which made them more accessible for the young and less associated with the socialist ideological ballast.[74]

Small indications of a renewed interest in the Jewish past, coupled with an officially sanctioned restoration of the neighborhood around Große Hamburger Straße, made for an ideal context for the Lammert family to propose the installation of the monument dedicated to the deported Jews.

The installation of the sculptural group was followed by other indications of an opening up to the Jewish past. Erich Honecker's formal reception of an Israeli delegation on November 9, 1988, was significant; on this date the East German head of state commemorated the fortieth anniversary of *Kristallnacht* and GDR leaders decided to rebuild the New Synagogue on Oranienburger Straße on the site of a building in which thousands of Berlin Jews were held captive before being deported to the concentration camps. One year later, the East Berlin government held an art competition for a "memorial for the activities of Jewish citizens in Berlin," which was to be installed on Koppenplatz, approximately 100 m north of the memorial on Große Hamburger Straße. Seventy-four artists submitted proposals. Karl Biedermann and architect Eva Butzmann's proposal for a memorial entitled Deserted Space won first prize. Biedermann's bronze sculpture, depicting a desk with an overturned chair, was a symbol for the hurry in which Jews left their homes and was accompanied by a poem by Nelly Sachs. But the sculpture was not installed until 1996.[75]

## Interpreting the Memorial

In Ravensbrück, the figures most likely were meant to represent women standing in the mode of *Strafestehen*; they were not accepted by the Ravensbrück administration because the figures did not depict heroic proletarian workers (see Chapter 1). If one does not know of the original commission at Ravensbrück, the all-female figures might go unnoticed when one walks by them on the Große Hamburger Straße. In the context of the Große Hamburger Straße,

that original meaning is lost but new meanings are gained: the sculptures signify the process of deportation that led to incarceration and murder, the improbable return of the deported Jews, and the changing attitudes toward the history of the neighborhood in which the sculptural group is located.

Let us once again turn to the accompanying bronze plaque, on which the memory of deportation and murder is clearly inscribed:

> *On this site was the first old age home of the Jewish community of Berlin.*
> *In 1942 the Gestapo used it as a collection place for Jewish citizens.*
> *55,000 Berlin Jews, from babies to the elderly, were dragged to the*
> *concentration camps Auschwitz and Theresienstadt, where they were*
> *bestially murdered. NEVER FORGET/AVOID WAR/PROTECT PEACE.*[76]

The idea that the figures could represent deported Jews, however, demands a certain suspension of disbelief on the part of the viewer. The figures cannot possibly *represent* the Jewish deportees, as those deportees would not have been emaciated in 1943. Why, then, might viewers accept that sculptures depicting deported Jews would look emaciated? The documentary photographs taken by newspaper photojournalists at the time of concentration camp liberations depict emaciated figures and were widely disseminated. The gaunt figures of the Lammert sculptural group, therefore, might trigger in the viewer's mind a connection to the emaciated figures of concentration camp photographs. The sculptural figures then encourage the viewer to make associations to deportation, incarceration, and subsequent murder in concentration camps—at the same time. Whereas the figures in Ravensbrück were meant to portray women who died in that camp, in Berlin they are meant to portray the Jewish population that is *about* to die (the deported) and that has died (those killed in concentration and death camps). And yet, the figures stand in front of a fence to a park that once was a graveyard. Today, a symbolic tombstone in honor of Moses Mendelssohn and a sarcophagus filled with destroyed gravestones are the only concrete reminders of the cemetery's history. The Lammert figures, in turn, comment on that history.

There is a sense that the standing figures represent the deported Berlin Jews coming back to confront the passersby, thereby enacting a sort of improbable return. They—women who have no graves of their own—show up in this former Jewish cemetery, transformed into a forsaken parklike open space.[77] The figures stand in front of the park, not *in* the park. In fact, they stand in front of a metal fence (installed by the neighboring Jewish school in 2008). And so, the viewer pauses: the sculptures are in front of a gate; they are smaller than life-size; they are near a park that once was a cemetery (Figure 3.6). They look out of place, and so they are. They attest not only to those who were

deported and those who died but also to a historical moment when administrators in the City of Berlin were rethinking this particular neighborhood.

In the 1980s, historians and scholars in East Germany became more interested in the history of the neighborhood as having been both a Jewish community and the center of the workers' movement. The neighborhood was suddenly seen in a new way by the city administration—the city refurbished store signs from the 1920s and 1930s, renovated buildings to their historical style (previously, the practice was to tear down and replace these structures with modern buildings), and put up plaques to mark the workers' movement. The Lammert family seized the opportunity to find a home for the sculptures and dedicated them to the deported Jews of the city.

Tourists and those who live in or visit the neighborhood walk by the sculptures every day. Perhaps the tourist takes a photograph (it is an outdoor sculpture and tourists tend to do that) or one who lives in the neighborhood passes by without really looking at the sculptural group. An investigation of the history and installation of the sculptural group reveals stories: the story of an artist returning from exile to rediscover his artistic roots in East Germany, the story of a neighborhood being refurbished, the story of an art milieu ready to revisit expressionism, and the story of sculptural figures originally intended for one site of atrocity but now marking a very different place that signifies a layered, difficult past.

In the context of Große Hamburger Straße, the female figures represent the deported Jews of Berlin, and stand in for all men, all women, and all children who were murdered. If one does *not* know their original commission at Ravensbrück, the all-female figures might go unnoticed. In fact, on the occasion of the fiftieth anniversary of the first train filled with deported Jews leaving Berlin, a newspaper article referred to the sculptural group as depicting "men, women, and children"—the link to Ravensbrück was effectively erased.[78] Where the figures were standing in torture at a concentration camp in the model for the Ravensbrück monument, they appear here to be waiting for deportation. At three-quarter life-size, they stand on a base at almost eye level to the passersby. One overlooks the emaciated figures—the Jewish deportees would not have been gaunt in 1943. But the idea of deportation encourages the viewer to take that next step, to imagine what soon happened to the Jews after deportation—their emaciation, their torture, their murder. Whereas the figures in Ravensbrück were meant to portray women who died in that camp, in Berlin they are meant to portray the Jewish population that is about to die. They ask for sympathy. They ask for thoughtfulness. They beseech one to pause and think a bit more about the neighborhood in which the passerby walks. In an urban setting, they take on an entirely new significance.

## Conclusion

A rethinking of history (Hamburg as a moderate city) is parallel to a reconsideration of traditional forms of remembrance in public space (the counter-monument). Hrdlicka's Counter-Monument questions the modernist monument but fails to address the murdered Jews of Hamburg; instead, it opts to emphasize the victimization of Hamburg's citizens. Rückriem's Memorial to the Deported Jews presents a worked-upon minimalist surface that was deemed "not enough" in light of the facts of history, and informational plaques had to be added to make sure those facts of the story were told. Margrit Kahl's Joseph-Carlebach-Platz Synagogue Monument refuses an object of remembrance and instead impresses the towering cupola of the former synagogue into the ground by delineating its architectural structure in two-dimensional granite and marble lines. Public art must be commissioned with an eye to future restoration, and, in this regard, Hamburg has failed in its duty to keep up the site. Instead, private funds from an advertising agency, a project initiated by private citizens, were used to clearly reference the murdered Jews of Hamburg on JCDecaux's placard. In the end, each memorial is not enough on its own. More can always be told. Individuals from each generation add their voices, in visual form, to a memorial landscape. Those additions should not necessarily be seen as addressing a supposed lack of a former monument but rather as evidence of changing attitudes toward the past. The historical view of the past will continue to revise itself in the hands of artists, historians, and citizens who refuse to see the past as static and unchanging. Just as memorial plaques have been added to monuments in Hamburg in order to better "see" the past, so too is this study an addendum to the histories to which it is indebted. If the examples in Hamburg indicate that West Germany had a difficult time choosing forms and words with which to remember the Holocaust, the example from East Germany demonstrates that some individuals were ready to make more outright statements about the past in public spaces and that changing political views allowed for the visualization of those changes in public space.

In contrast, by 1985, in East Germany, the politburo changed its attitude toward historical buildings in a former Jewish neighborhood. An opening up toward the past, concomitant with new attitudes in the art world that allowed for prewar avant-garde styles, contributed to a moment when the Lammert family could finally find a home for Will Lammert's thirteen figures, originally meant for Ravensbrück. Nevertheless, the specific history of the figures, as well as the subject they depict, remained unremarked for decades. At certain moments in time, only certain things can be said in text form, on commemorative plaques.

# 4

# Memorial Functions

*Shapiro, Kelly, LeWitt, and Serra at*
*the United States Holocaust Memorial Museum (1993)*

I N THE UNITED STATES, Holocaust memory culminated in the opening of the USHMM in 1993, thereby making Holocaust memory integral for the nation's definition of itself. Key to the opening was the commission of contemporary works of art that were meant to provide contemplative spaces of reflection in the museum. The idea was a radical one for the time, as public works of art dedicated to the Holocaust were few and far between—artists and architects had not yet developed a visual iconography for such works. The commissioning body, a subcommittee of the Art for Public Spaces Program (APSP), set out to find internationally recognized artists whose works would enhance the museum's historical and memorial functions, without directly engaging with historical material, as the subcommittee believed that viewers needed space to clear their minds and that works of art that were too literal in their association to the Holocaust would be overwhelming to viewers.

Of the many aspects of the museum, I focus on four works of art (all from 1993): Joel Shapiro's *Loss and Regeneration* (Figure 4.1), Ellsworth Kelly's two-part *Memorial* (Figures 4.2, 4.3), Sol LeWitt's *Consequence* (Figure 4.4), and Richard Serra's *Gravity* (Figure 4.5). Each was commissioned by the subcommittee, chaired by Nancy Rosen, which worked from 1990 to 1993 to choose works of art that would be appropriate complements to the main galleries: works that would allow for contemplation but not emotionally overwhelm the viewer or threaten the integrity of the history of the Holocaust (that is, open up the possibility of Holocaust denial).[1]

This chapter builds on Mark Godfrey's vital analyses of the same four objects in his *Abstraction and the Holocaust*.[2] Godfrey makes use of archival documents as he relates the commission of the works of art in the USHMM and analyzes the individual works in order to determine if abstraction is co-opted by virtue of the fact that the works are placed in the museum and if criticism of the program was fair. His answers are neither *yes* nor *no* but rather subtle investigations of the complex problems inherent in both questions. My goal is different than Godfrey's, as I analyze the works of art for the APSP in three ways.

First, the modernist and conceptual works by these artists create a productive tension in their struggle to negotiate the aims of modernism with the aims of memorialization at a historical moment when a public form for Holocaust memory had not yet been codified in the United States. I suggest that the commissions broke new ground in finding a visual form for Holocaust memory. Second, my analyses of the works of art engage with the artists' oeuvres: three out of the four artists (Shapiro, Serra, and LeWitt) had grappled with the Holocaust in previous works of art. Their proposals for the USHMM can, therefore, be interpreted as extensions of the artists' previous preoccupations with the Holocaust. Third, each work is powerfully in dialogue with the architecture of the exhibition spaces, thereby making connections to the overall themes of the museum, especially since the architecture is fundamentally a part of the museum's design and mission. A brief description of the museum helps ground the subsequent analyses.

## The Museum: An Overview

In 1979, the U.S. President's Commission for the Holocaust, established under former president Jimmy Carter, took on the task of creating an institutionalized collective Holocaust memory for the citizens of the United States. But what form that memory would take (a museum versus a park, for instance) had not yet been decided. Elie Wiesel was named chair of the commission. On the Day of Remembrance in 1979, Carter described the value of the museum to the American public, noting not only the role of the United States in liberation but also the guilt of the United States in having participated as bystanders: (1) American troops liberated some of the camps; (2) the United States provided a homeland for survivors; (3) the United States must take responsibility for not having acknowledged the Holocaust at the time; and (4) the world must learn the history so that it shall never happen again.[3]

In 1985, during the planning stage of the museum, former president Ronald Reagan visited Bitburg, the German national cemetery, where SS soldiers are buried alongside German soldiers. The incident set off an international debate

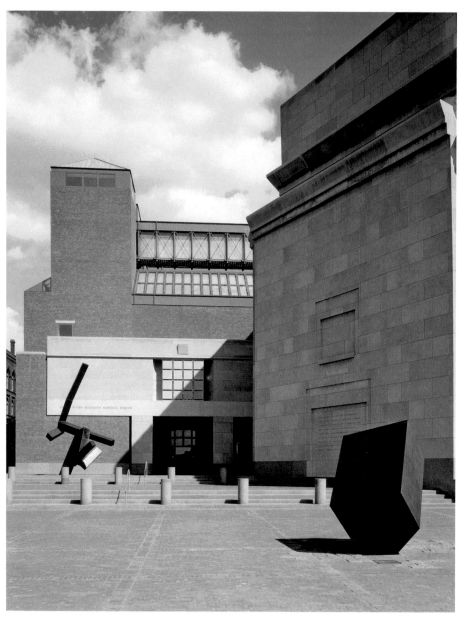

**Figure 4.1** Joel Shapiro, *Loss and Regeneration*, 1993. Bronze. *Tree*: 731.52 × 457.2 × 259.08 cm. *House*: 243.84 × 152.4 × 228.6 cm. (Photo: United States Holocaust Memorial Museum Collection. © 2018 Joel Shapiro / Artists Rights Society [ARS], New York)

**Figure 4.2** Ellsworth Kelly, *Memorial (Memorial I)*, 1993. Enamel on wood and composite. Curve: 289.6 × 838.2 × 5.1 cm. (Photo: Collection of United States Holocaust Memorial Museum, Washington, DC, artist commission and gift of Ruth and Albert Abramson and Family, 1993. © Ellsworth Kelly Foundation)

**Figure 4.3** Ellsworth Kelly, *Memorial (Memorial II)*, 1993. Enamel on wood and composite. Each panel: 274.3 × 162.6 × 5.1 cm. (Photo: Collection of United States Holocaust Memorial Museum, Washington, DC, artist commission and gift of Ruth and Albert Abramson and Family, 1993. © Ellsworth Kelly Foundation)

about the appropriateness of his and former Chancellor Helmut Kohl's actions. Jews and non-Jews around the world were horrified that a U.S. head of state would honor German SS members who were active during the Holocaust—and Chancellor Kohl, for his part, was shown to be naive about Holocaust memory in his own country in this international incident. As a result of Reagan's blunder, Elie Wiesel resigned as chair from the USHMM Commission in 1986.

The permanent exhibition of the USHMM tells the story of the attempted annihilation of the Jewish people by systematic state genocide and relates the stories of other victims of Nazism, including Roma and Sinti, Poles, homosexuals, the handicapped, Jehovah's Witnesses, political and religious dissidents, and Soviet prisoners of war. The three floors of the permanent exhibition, covering a total of 36,000 sq. ft., contain artifacts, oral accounts, documentaries, and photographs, which are used to tell the story of the Holocaust: from the seizure of power by the Nazis, with the first persecutions (fourth floor), to the creation of the ghettos and the Final Solution—mobile extermination units, concentration and death camps (third floor)—to resistance and aftermath (second floor). Architectural details, such as towers, reminiscent of concentration camp chimney stacks, punctuate the permanent exhibit. Also important for this analysis are the triangular-shaped exhibition areas between the floors of the permanent exhibit, which were designed to provide contemplative spaces. Both exhibition areas contain works of art: one by Kelly and one by LeWitt. The museum visit is completed at the Wexner Learning Center, an interactive computerized database that provides encyclopedic information about the Holocaust. The Hall of Remembrance, a synagogue-like space on the second level, at the exit of the exhibition, is a place set aside for contemplation and formal ceremonies. On the same floor, the Museum Research Institute functions as an international center of research into genocide and the Holocaust. Visitors exit the Hall of Remembrance and proceed back to the entrance, the Hall of Witness, where they encounter Richard Serra's sculpture *Gravity*. Since the museum predetermines the path of the visitor's viewing experience, I present the works in the order one would encounter them when visiting the museum.

FACING PAGE

**FIGURE 4.4** Sol LeWitt, *Consequence*, 1993. Wall drawing with plaster, paint, ink, and varnish. 339.725 × 1638.3 cm. (Photo: United States Holocaust Memorial Museum Collection. © 2018 Richard Serra / Artists Rights Society [ARS], New York)

**FIGURE 4.5** Richard Serra, *Gravity*, 1993. Weatherproof steel. 366 × 366 × 305 cm. (Photo: Collection of USHMM. © 2018 Richard Serra / Artists Rights Society [ARS], New York)

The facade of the USHMM on Fourteenth Street is a first indicator of a lapse between seeing, understanding, and meaning. The architect of the building, James Ingo Freed of Pei, Cobb, and Freed, metaphorically recalls concentration camp entrances and their lies; he states that the building puts visitors in a deceptive frame of mind, thereby separating them from the surrounding city of Washington.[4] The gate over the entrance at Auschwitz read *Arbeit Macht Frei* (Work Brings Freedom).[5] Just as the Auschwitz gate was a lie, also fake is the rotunda-like facade of the museum. Unlike a usual facade, which rests directly on the front of a building, the museum's facade opens to an empty plaza behind its walls and to the sky above. With deception already set in place, the visitors enter the Hall of Witness.

This entry hall, the Hall of Witness, is a three-story, sky-lit gathering place, made complex by stairways, doors, and steel girders. Visitors follow various paths, which move in different directions and contribute to an overall visual effect of disorientation. The building employs construction techniques of the industrial past: steel plates, bolted metal, rivets, and raw brick are all elements that hint toward past architecture and industrialism, of modernism that went awry.[6] The hall effectively greets the visitors by disorienting them. Upon paying the entrance fee, the visitor is given an "identity card"—a booklet with information about a specific Jewish victim of the Holocaust, which accompanies the visitor throughout the exhibition.

From there, the visitors go to the beginning of the exhibition by taking an elevator to the fourth floor. Groups of people enter the elevator simultaneously and watch a video in which President Dwight D. Eisenhower describes the camps as he saw them shortly after liberation. The visitors are immediately confronted with horrifying images. As in a railway car, the elevator exit door opens opposite the entrance. The first image one sees is a gigantic photographic enlargement of American soldiers liberating the camps—one that the media widely circulated in the United States, which thereby became a sign for Nazi horrors. "Given the limits of language that plagued even the most veteran print journalists who tried to report their impressions of the camps," writes Gavriel Rosenfeld, "words were soon surpassed by images as crucial aids to the act of bearing witness to Nazi crimes."[7] As Jeshajahu Weinberg notes, the museum is placed on the mall, and the voice of Eisenhower, the video, and the photograph serve to posit the United States as a starting point, as a key moment in the history of the Holocaust. The fourth-floor exhibition begins with "Nazi Assault," which chronicles the rise of National Socialism, 1933–39.

On the fourth floor, the visitor encounters one of the "tower" structures that houses Eliach's *Tower of Faces*, which has been lauded as the museum's heart since its opening. The structure of viewing this installation is significant, as one encounters it two times: once on the fourth floor, and again on the third floor.

In the fourth-floor iteration, photographs line the walls and continue up to a sky-light of the tower. By simply looking at the images, the viewer discerns the ways families and individuals grow up and enjoy or mourn the events of daily life: weddings, Bar Mitzvahs, and holidays.[8] Subjects are often in their finest clothes, ready to capture in photographs important life moments. The photographs stand in marked contrast to the photograph of Americans liberating a concentration camp, at the opening of the fourth-floor exhibition. There, the photograph is a sign of Nazi atrocity. Here, the photographs employ the visual codes of family photographs, where individuals or groups are photographed alone or in groups, in ways familiar to those who own family photo albums. In Marianne Hirsh's words, we have "stepped into a family photo album," where we immediately feel as though an individual portrayed could be one of our own family members.[9] We therefore identify and empathize with those who are portrayed.

The viewers who pass through on the fourth floor (and learn more context about the photographs on the third floor) imagine these individuals as members of their own family because the installation activates postmemory—no matter our religion, if any part of our family is of European descent, these photographs could have been our own relatives. The effect of such identification, especially in conjunction with the identity cards, is to make the visitor into a relative of a victim, thus reinforcing the message of victimhood in the museum. Jonathan Rosen worries that overidentification with objects in the museum leads to the conclusion that all visitors are in danger of leaving the museum "as Jews"—that is, as victims: "It may, to be sure, bring home the horror of the Holocaust but it may also foster a feeling of vicarious suffering not necessarily appropriate to his-torical awareness. The irony is that many Jews during the Holocaust scrambled to acquire false papers in order to survive the war—the papers of non-Jews. There is a reverse principle at work here, as if everyone were expected to enter the museum an American and leave, in some fashion, a Jew."[10] There is a danger in exhibiting objects that suggest identification with the victim, for bearing wit-ness suddenly turns into "becoming the victim." One of the museum's goals is to provide visitors with an opportunity to reflect on how the Holocaust is still relevant for contemporary life as well as on the many incidents of oppression and intolerance they may encounter. If the visitor "becomes the victim," he or she necessarily co-opts the possibility of reflecting on what it might mean to be in the position of the perpetrator or bystander. Unmediated access to the past, then, has larger ethical ramifications.

The experience of viewing the room is a melancholy one. When one looks up to the skylight above, the photographs function as surfaces on which light reflects eerily, creating black surfaces, as though the photographs have been emptied of their content. Close inspection of the photographs, however, shows that they are "filled" with associations. The viewer may note that a particular

figure in one image reappears in another. The room instills the memory of individuals through the repetition of faces in photographs, presenting images that provide a space for both wonder and pathos. The successes and happy moments in the photographs will soon disappear, but the installation does not "give" any more information; for this, one must wait for the third floor.

After viewing the space, the visitor continues on to the rest of the historical exhibition, which details events in Germany from Adolf Hitler's appointment as chancellor in 1933 to the slow dissolution of rights of Jews in Germany, culminating in *Kristallnacht* in 1938, and documenting the outbreak of World War II in September 1939. At the end of this floor, down a brief flight of stairs, is a lozenge-shaped room in which Ellsworth Kelly's two-part *Memorial* is installed.

## Placing the Works in the Context of U.S. Holocaust Memory

When the museum opened its doors, there were few previous examples of how the Holocaust should be remembered in public space (as Chapter 2 elucidates, one of the earliest Holocaust memorials in the United States, Nathan Rapoport's Monument to the Six Million Jewish Martyrs, was overlooked by the general public). The APSP had to determine the most appropriate forms for contemporary art in a museum dedicated to the Holocaust. To do so, the APSP members sought to understand memorials created in other countries. In 1990, in order to better understand what styles and forms had been used for Holocaust memory to date, the subcommittee circulated the then unpublished text from Sybil Milton's *In Fitting Memory: The Art and Politics of Holocaust Memorials* (published 1991) as well as Matthew Baigell's essay, "Jewish-American Artists and the Holocaust: The Responses of Two Generations" (published in book form in 1997).[11] Albert Abramson, a member of the subcommittee (who, together with his wife Ruth, funded Kelly's and Shapiro's works), also put together a report on all "existing public Holocaust sculptures/monuments."[12] That the subcommittee was reading texts that were yet unpublished—as well as creating a list of known Holocaust memorials—demonstrates the dearth of information available, at the time, on art about the Holocaust. James E. Young's groundbreaking *Texture of Memory* was published in 1993, the year that the museum opened. It contains an analysis of the historical exhibition and architecture and established the study of Holocaust memorials as a field of academic inquiry.[13]

An iconography of Holocaust memorials had been established by Nathan Rapoport in his Warsaw Ghetto Uprising Monument (1948), reconfigured as the Wall of Remembrance (1976) in Yad Vashem, Jerusalem, the national site of Holocaust memory. But by the early 1990s, the highly representational

**FIGURE 4.6** George Segal, The Holocaust, San Francisco, 1984. (Photo: San Francisco Arts Commission. © 2018 The George and Helen Segal Foundation/ Licensed by VAGA at Artists Rights Society [ARS], NY)

works had all the qualities the subcommittee wished to avoid: they tell an emotion-laden story of the uprising. In the mid-1980s, George Segal's The Holocaust (1984; Figure 4.6) was installed in San Francisco. Segal's outdoor sculpture employs the representational white cast figures (his process involves casting living bodies) for which the artist is known, in a built environment reminiscent of a concentration camp, including barbed wire, casts of bodies that lie on the ground, and one sculpture, of a man, who stands at the fence. Employing a more modernist vocabulary than Rapoport, Segal's installation nonetheless is laden with emotion, and, therefore, was not an appropriate model for the commissions at the USHMM. Kenneth Treister's The Sculpture of Love and Anguish (1985; Figure 4.7) in Miami is a 42 ft. high sculpture of an enormous bronze hand, including a number on the forearm that recalls the numbers tattooed on the forearms of Auschwitz inmates, as well as 130 human figures cast in bronze in various forms of writhing horror. It is naturalistic and metaphorical, both elements that the subcommittee wanted to avoid.

Of course, an example of a very different kind of memorial in Washington, DC, is right down the street: Maya Lin's Vietnam Veterans Memorial,

FIGURE 4.7 Kenneth Treister, The Sculpture of Love and Anguish, Miami, 1985. Bronze. (Photo: Kenneth Treister. © Kenneth Treister)

**FIGURE 4.8** Maya Lin, Vietnam Veterans Memorial, Washington, DC, 1981. Black granite. (Photo: Terry Adams, National Parks Service. © Maya Lin Studio, courtesy of Pace Gallery)

installed after a great deal of controversy in 1982 (Figure 4.8). Lin was an architectural student at the time her model was accepted. While she hardly had an established aesthetic, her model borrowed from forms of memorialization that were melded with an acute understanding of contemporary art forms, especially that of minimalism. Minimalism, an art form that was established in the 1960s by American artists such as Donald Judd, eschews the trappings of art objects (composition, narrative, decoration, etc.) and instead focuses on creating works of art that are "objects." The works have no decoration or words and often consist of repeating serial forms. (Tony Smith famously stated, during an interview, that he wanted to create neither a sculpture nor a memorial but an object.) One would never call Lin's memorial "minimalist": the fact that it contains over fifty thousand names of veterans, soldiers missing in action, and those who died would be anathema to the minimalism. But one cannot ignore the fact that it was a watershed memorial that introduced a highly stripped-down aesthetic. Curiously, a discussion of Lin's memorial does not appear in the meeting minutes of the APSP, but it was an integral part of memorial visual culture by the time the APSP began its deliberations

(the film *A Strong Clear Vision* made the history of the memorial clear to the public in 1995).

Other elements of visual culture in the United States are important to consider in terms of the commissions. In 1992, Art Spiegelman was awarded the Pulitzer Prize for his two-volume *Maus*, a graphic novel that traced the experiences of the author's father in Europe before and during the rise of National Socialism, in concentration camps, and during the aftermath of his rescue and subsequent relocation to the United States.[14] Most tellingly, *Maus* also explores Spiegelman's inheritance of his father's experiences and trauma and stands as one of America's first works of literature that blatantly addresses second-generational trauma.[15] Spiegelman renders himself at crucial moments, such as when young Art learns of his mother's postwar suicide, with the clothing of Holocaust survivors, looking out of a prison cell from behind bars. As a son of survivors, Spiegelman inherits the emotionally crippling behaviors that his father and mother developed as coping mechanisms, a psychological condition that was just beginning to be examined by psychologists at the time.[16] Spiegelman was, in fact, on the list of artists considered for the APSP.[17]

The following year, Stephen Spielberg's *Schindler's List* was viewed across the nation.[18] Over 120 million Americans viewed Spielberg's academy award–winning film, which related the story of the profiteer-turned-rescuer Oskar Schindler, who saved eleven hundred Jews.[19] The film included graphic images of concentration camps, gas chambers, Jewish transports, ghetto liquidation, and Nazi cruelty. Spielberg provided free screenings for almost two million high school students in almost forty states in the spring of 1994. The organization Facing History and Ourselves, dedicated to Holocaust education in public schools, created a study guide to accompany the film. After promoting the film, Spielberg founded the Survivors of the Shoah Foundation, which documented the testimonies of thousands of survivors. He requested Michael Berenbaum, deputy director of the U.S. President's Holocaust for the Commission, to head the foundation. While Spielberg's film was being screened across the country, Holocaust memory found a home on the Washington Mall in 1993. And the museum, with its attendant works of art, defined Holocaust memory for the nation.

## The Commission

The process of exploring the potential of site-specific art for the museum began in 1988, when the USHMM Museum Committee on Collections and Acquisitions recommended an APSP as well as a working subcommittee, the consultancy of an arts administrator, and an independent jury. Nancy Rosen, an independent arts consultant, was chosen as the administrator in

short order. The APSP mission is worth quoting in full: "The Art for Public Spaces Program . . . was established to commission works of excellence and extraordinary artistic merit which speak to the singularity of this institution, this site and this context—and which inspire and evoke important ideas and emotions about the Holocaust. The works are being commissioned to address specific architectural and programmatic locations throughout the Museum in ways that are distinct from the permanent or changing exhibitions."[20]

The APSP subcommittee organized a formal, invited competition to select artists for five different sites (this list would later be reduced to four): the Memorial Plaza at the Fifteenth Street/Raoul Wallenberg Place entrance (the "Mall" entrance to the museum); the black granite wall in the Hall of Witness; a stage/platform in the Hall of Witness; and two pie-shaped rooms at the end of both the fourth floor and the third floor.

In June 1990, the committee considered accepting works for the lounge spaces (referred to in the subcommittee's meetings notes as "Lounge A" and "Lounge B") commissioned by the British and Soviet governments (both liberators of the camps), but the committee decided against this idea due to the complications of accepting gifts of state.[21] A soon as that decision was made, the committee decided to commission works that would function as spaces of contemplation and quiet, which would function as counterpoints to the content of the historical exhibitions, and in which viewers could talk or sit quietly and contemplate what they had seen.

Soon after, the committee established a list of potential artists whose work included a wide range of styles. The subcommittee had a long discussion about whether to invite German artists.[22] Some members insisted that the goal of the subcommittee was to acquire the best work possible, regardless of the artists' nationalities. Others believed that German artists in the spaces would trigger negative feelings on the part of survivors and other visitors and, therefore, might interfere with the goal of contemplation that the committee was trying to achieve. No official decision was made at that meeting, but ultimately the committee invited a majority of American artists to attend.

Contenders for sculpture for the Memorial Plaza, for instance, included Magdalena Abakanowicz, Jonathan Borofsky, Jim Dine, Robert Morris, George Segal, and Joel Shapiro. The subcommittee determined that the commission for the plaza would contribute a major "symbol that would serve to identify the Museum and help to distinguish it from other official institutions."[23] Magdalena Abakanowicz, Christian Boltanski, Jim Dine, Leon Golub, Jannis Kounellis, among others, were short-listed to help James Ingo Freed design a crack in the black granite wall of the Hall of Witness, an idea the architect had voiced early on in the process (which would later be rejected). For the two lounge areas, Christian Boltanski, Audrey Flack, Leon Golub, Anselm Kiefer, R. B. Kitaj, Larry Rivers,

Art Spiegelman, and the Starn Twins were under consideration. Another exhibition space, referred to in the APSP files as "the stage/platform," on the concourse level, included contenders Magdalena Abakanowicz, Tobi Kahn, and Ann Sperry (this spot, too, was later rejected).[24]

The subcommittee named a jury of eight professionals in November 1990, including luminaries in the art world: Suzanne Delehanty, director, Contemporary Arts Museum, Houston; Howard Fox, curator of Contemporary Art, Los Angeles County Museum of Art; Gary Garrels, senior curator at the Walker Art Center, Minneapolis; Ziva Amishai-Maisels, chairperson, Institute of Languages, Literatures and the Arts, Hebrew University, Jerusalem; Raymond Nasher, founder, the Nasher Company, Dallas; Ned Rifkin, director, the High Museum of Art, Atlanta; Mark Rosenthal, adjunct curator, the Solomon R. Guggenheim Museum, New York; and Nan Rosenthal, consultant to the Metropolitan Museum of Art, New York.[25] The subcommittee and architect James Ingo Freed advised this committee.

By February 1991, the committee endeavored to finalize an artist collaborator for Freed's expressed wish to create a large "crack" in the granite wall of the Hall of Witness.[26] Such a crack would demonstrate the rupture in history. He narrowed his list of choices to Rebecca Horn, Robert Morris, and Richard Serra.[27] Freed selected Serra, but the crack in the wall was deemed too costly and too complicated (Serra also voiced his ambivalence about the project).[28] Instead of a crack in the wall, by May 1991, Serra proposed the fabrication and installation of a sculpture consisting of a powerful steel form, 12 ft. × 10 ft. × 10 in., which would be installed at the bottom of the stairs leading up from the base of the Hall of Witness and in front of the black granite wall. Both Serra and Freed agreed: "It would be much stronger, more original and more effective than the crack-line."[29]

The subcommittee shortened the lists of artists for the other three sites and decided on Joel Shapiro's proposal for the outdoor plaza site (Walter de Maria and Jonathan Borofsky had also submitted designs; de Maria declined to submit a proposal, citing scheduling problems).[30] Ellsworth Kelly was the first artist to visit Lounge A and was ultimately chosen. Some of the other artists expressed interest but were too busy with other projects and were not sure that they could accommodate the time schedule.[31] Kelly received instructions that his proposal should include a plan, a model, written description, and an optional summary statement. "It is the intention of the Council," writes Sara Bloomfield, executive director of the USHMM, "that Room A provide an opportunity for visitors to sit and reflect."[32] Serra had already been in conversation with Freed about his idea of a sculpture on the stairway leading from the Hall of Witness to the downstairs exhibition area, and his design was accepted. Sol LeWitt was chosen for the second lounge area. To substantiate the decision to choose LeWitt, Rosen wrote in a letter that the

Jewish Museum in Manhattan was exhibiting LeWitt's and Freed's designs for the USHMM in its upcoming *Sites of Memory* exhibition. By March 1993, the jury had finalized their decisions.

## Critics' Responses

Media coverage of the APSP commissions was either ambivalent or directly negative. For instance, among more ambivalent reactions is Michael Kimmelman's, from the *New York Times*:

> Not even these sculptures and paintings by four distinguished and gifted Americans—Richard Serra, Joel Shapiro, Sol LeWitt and Ellsworth Kelly—serve as more than footnotes in the context of this extraordinary new museum. Partly this is the case because of the brilliance and metaphorical richness of the building itself, designed by the architect James Ingo Freed of Pei Cobb Freed & Partners, which is a far more effective work of abstraction than any of these sculptures and paintings. Partly it is because of what else is inside the museum: the relentless and overpowering permanent exhibition of documents and artifacts installed on three levels of Mr. Freed's building.[33]

In the *Miami Herald*, Helen Kohen writes that the works "are mostly referential to their own work."[34] That is, the works are concerned with their own materiality (paint, Cor-Ten steel, bronze), follow a modernist sensibility, and do not have symbolic or referential meaning.

In contrast, Paul Richard's comments in the *Washington Post* were more blatantly critical than those outlined above: "It's not that it is bad art. Elsewhere it might triumph. Nor are these bad artists. In fact, Kelly and LeWitt, Serra and Shapiro, are among the best we have. But the Holocaust Museum's million-dollar Art for Public Spaces Program fails. It's unnecessary. No, it's worse than unnecessary. It distorts and misguides."[35] In "Art and Memory," Ken Johnson also took a critical approach, arguing that the abstract works do not convey any particular meaning and certainly do not fulfill the role of memorials: "To put a sharper critical point on it, we might ask whether works that are so reluctant to actively assert meaning or feeling—works that speak in the highly specialized language of modernist formalism—can compellingly engage the kind of popular audience that any memorial assumes."[36] Mark Godfrey, in his analysis on abstraction in the USHMM, asks, "Were art works used to create spaces for spiritual reflection; to nuance the moods of spectators as they passed through the exhibitions; to condense narratives into easily consumable symbolic forms; or even to uplift viewers by reminding them of the creativity of the human spirit?

If so, was abstraction asked to function in ways that these artists had never expected, and even in ways that they had previously resisted?"[37] The answers, Godfrey says, are complex: on the one hand, the artists "twisted their language in conformity with their expectations about the setting's requirements."[38] On the other hand, the commissions were unique opportunities "for these artists to put their language to work without compromise and in a completely new way so as to let abstract art confront Holocaust memory in extremely subtle and complex manners."[39] But I think that there is more to say here, especially since three of the four artists had addressed the Holocaust in public works of art created earlier than the USHMM commissions. While the Holocaust is not visualized in an outright way—indeed, the subcommittee expressly asked the artists to avoid narrative or outright references to the Holocaust—the subject nevertheless permeates the works because of their associations to the artists' previous commissions. I address the APSP works in the order in which one encounters them in the museum exhibition. If one enters from the Mall on Fifteenth Street, one immediately sees Freed's building and Joel Shapiro's *Loss and Regeneration*.

## Joel Shapiro, *Loss and Regeneration*

Of all the APSP works, Shapiro's two sculptures that make up *Loss and Regeneration* (Figure 4.1) most clearly refer to objects in the world. They are situated on the highest and lowest elevations of the museum's western plaza, respectively, are 100 ft. apart, and rest directly on the plaza—that is, without bases. *Regeneration* (originally entitled *Figure* by the artist) consists of nine rectangular shapes (the bronze was cast from the wooden sculpture, which was made of four-by-fours) attached to look as though the work might be in the process of either falling or ascending.[40] *Loss* (originally entitled *House* by the artist) is a form with which the artist had been working for years. In this case, the apex of its "roof" is wedged into the plaza—the house is upside down. The objects that Shapiro created for the USHMM are iconic of his works, for he had repeated such forms for decades, and they had always signified isolation, a head separated from its body, and/or falling bodies.

Shapiro entitled his original proposal "For the Dead and Surviving Children."[41] His description of the work is worth quoting: "The sculpture is made of two elements, a 'tree,' with figurative reference, and a 'house.' The house is dislocated, subverting a symbol of comfort, enclosure and continuity. The 'tree' embodies cycles of life, death, anguish, the overcoming of anguish—and possibilities of a future."[42] The "tree" would later be redefined as a "figure" by the USHMM, and the artist later reconciles the two interpretations in an interview.

About the works, Shapiro states that he sees "the tree as a body . . . a metaphor for life, for possibilities. But I also wanted the piece to be more

meditative, more about despair, more about destruction. The house that I've used in my work for years is a metaphor for thought, for the inability to sustain illusion."[43] He adds that he looked for "effects of perception. The house is more contained—the way a thought is contained. The tree is sprawling: dying aspiring to light."[44] On a bronze plaque near the sculptures is a quotation from a child's poem from the Terezín ghetto: "Until, after a long, long time / I'd be well again, / Then I'd like to live / And go back home again." When read in conjunction with the two sculptures, the "thought" that is the house is the thought of the child about his or her home.

Shapiro entered the New York avant-garde art scene in the late 1960s and 1970s, when it was dominated by the cool, formal abstraction of minimalism and when he began using the forms that he later quotes in the USHMM commission. In contrast to minimalist artists such as Donald Judd, Shapiro was drawn to simple imagery, such as tiny cast-iron sculptures—usually 7 in.—in the forms of a house, a chair, or a bridge, "suggesting or engaging human presence through memory, absence, or isolation."[45] Such tiny objects, installed in an empty gallery, might remind one of forgotten playthings—or of the playthings that one remembers from childhood. When these works were exhibited in the 1960s, Rosalind Krauss stated, "This strategy involved the idea of memory, for just as events become distant to us in memory, so the familiar figure of the house would be distanced by scale from the viewer."[46] I would go even further: the tiny objects were installed in gallery spaces where viewers experienced themselves as *overpowering* the small objects in space.

Minimalism was known to occupy gallery space in an almost aggressive way, demanding of the viewer that they negotiate around the negative spaces created by the art objects.[47] Carl Andre, for instance, said that he "wanted to seize and hold the place of that gallery—not simply fill it, but seize and hold that space."[48] In contrast, Shapiro's houses and chairs from the 1960s only take up small amounts of space. They invite close contemplation of objects that are directly related to human bodies: humans live in the safety of their homes (although not all homes or houses are safe for all people); humans rest on chairs. Dwarfed in gallery spaces, visitors loom over the objects. Whereas minimalism was about the power of the objects, Shapiro's houses and chairs seem to be about the power of the viewer. At the same time, however, Shapiro noted that even small objects could have an immense command of the space in which they are installed. That is, by drawing attention to their very smallness, they make the gallery space around them a huge void that is charged by all of the memories, emotions, and ideas that the viewer may have about the small houses. When the viewer occupies that void, he or she enters a charged space; in this way, the tiny house may "have an immense command" over the space. He even said that he understood his "house" sculptures (*Untitled*,

1980) as "human heads," and they were often positioned on their sides or even upside down.[49] And seeing the tiny houses as human heads creates a disturbing metaphor that suggests death and even murder.

The second sculpture on the plaza outside of the USHMM is *Regeneration*. It is based on the geometric figures and forms that Shapiro first began to conceive in 1976–80. First in wood and then cast in bronze, the once-small sculptures grew to be life-size objects. "At this point I had some real sense of elation, and I began to work larger. Smallness was no longer viable for me. . . . [I] worked with four-by-fours slapped together to make the figure. I wanted the pieces not to function as a sign anymore, but actually to function literally in space."[50] In the late 1970s, he started to create a sculpture that, in his words, "referred to a tree, but it also had an explicit reference to the human figure."[51] In particular, he created his first "tree/figure" sculpture in the period immediately following his sister's death. Working on that sculpture was a way to mourn her passing.

Themes such as isolation, a head separated from a body, and bodies that are either ascending or descending can be related to the Jewish experience in the United States—but Shapiro has never talked publicly about his Jewishness or the fact that his work commented on the alienation or isolation experienced by Jews (although he has commented on the fact that he grew up in a very left-leaning environment that was surrounded by an antisemitic archdiocese).[52] Shapiro had previously focused on Jewish themes. *For Jewish Museum 5748* (woodcut on paper, 1988) depicts rectangular and L-shaped parts that are connected to create an abstract figure. One rectangle, at the top of the figure, indicating a head, is separated from the rest of the composition. Shapiro made it to commemorate Rosh Hashanah (the Jewish New Year, literally translated as "Head of the Year") in the Jewish year 5748. If the top rectangle is a head, then the head "pops off" in celebration of the New Year. Like his abstract sculptural works from the 1970s, the print depicts connected rectangles that seem to form a figure. In this case, the figure signifies movement, as the rectangles are surrounded by bits of lines and triangles—all quite small in comparison to the larger rectangles—that serve to give the impression of a figure in action.[53]

The following year, in 1989, he submitted a model, consisting of a burned-out house, for the premises of the former police headquarters on Mühlenstraße in Düsseldorf, Germany. Unlike his earlier houses of the 1960s and early 1970s, this house is positioned "upright"—that is, with its roof pointed upward. In this case, however, the roof is depicted as burned out, creating a gaping hole with rough edges. The Düsseldorf commission rejected the proposal, but the work nonetheless demonstrates that Shapiro was actively involved in using his iconic house form in order to think about Holocaust memory. In light of these previous works, *Loss and Regeneration* takes on significance in the context of the USHMM. Themes that Shapiro had been working with for

years—such as figures that reference the dead, houses that are metaphors for heads severed from bodies—are objects that trigger memory.

## Ellsworth Kelly, Two-Part *Memorial*

Ellsworth Kelly's two-part *Memorial* (Figures 4.2, 4.3), located in Lounge A, concludes the fourth-floor exhibition, which, in terms of the viewer's experience, is the first part of the historical exhibition. According to the USHMM, Kelly's work consists of "four wall sculptures that span the walls of the room to create a distinct environment and to offer visitors a place to pause and to reflect as they circulate through the museum's permanent exhibition. The room is pie-shaped in plan, and includes a generous skylight at its northeast corner."[54] One part of the sculpture, which I refer to as *Memorial I*, is a *curve*, a term Kelly used to describe his works that take the form of an isosceles triangle—albeit with a curved base—with which Kelly had been working since at least 1955 (Figure 4.2). *Memorial I* spans 27 ft. and floats several inches from the wall. The other three elements, which I refer to as *Memorial II* (Figure 4.3), are rectangles that are each 9 ft. tall. They are mounted 4 ft. apart and float several inches from the wall. The sculptures produce shadows regardless of the time of day.

Godfrey argues that works such as Kelly's lose their radicality by being placed in a memorial museum for the Holocaust. While works that question the boundaries of painting and sculpture are successful and admirable in a gallery setting, the raison d'être of the work of art has, for some, no resonance in a museum for the Holocaust. The discourse of painting/sculpture, of questioning the medium and purpose of a work of art, puts the focus on modernism. But I want to claim that Kelly's works are radical because they refuse to define an appropriate artistic style for a work of art in a Holocaust museum—they refuse to be pinned down as "Holocaust works of art."

*Memorial I* calls attention to itself as occupying a space between painting and sculpture, as a modernist object that refuses traditional categories. Mounted objects that cast shadows have long been a preoccupation for Kelly, for whom the shadow becomes an element of the work of art. The fiberglass curve of *Memorial I*—mounted about 6 in. from the wall—casts a significant shadow on the white wall behind it, regardless of lighting. Kelly had for decades made works of art that called into question the relationships between painting and sculpture, composition and found objects, figure and ground. "I found the object," he said, about *Window, Museum of Modern Art, Paris* (1949), "and so I painted it." This breaking point for Kelly is often referred to in the literature on the artist. "From then on," Kelly has remarked, "painting as I had known it was finished for me. The new works were to be painting/objects, unsigned, anonymous. Everywhere I looked, everything I

saw became something to be made, and it had to be made exactly as it was, with nothing added. It was a new freedom: there was nothing to compose."[55] The inspired artist takes a composition that is already in place, paints it, and a new art object is born. In the case of *Memorial I*, Kelly looked to the architectural structures already in place in the room.

The vertex angle of *Memorial I* is in visual dialogue with the vertex angles of both the window and the triangular-shaped staircase. Ulrich Wilmes explains that Kelly's *White Curve* of 1974, a precursor to *Memorial I*, "underscores Kelly's dialectical handling of the color-form relationship as a figure that either affirmatively incorporates the architecture or interferes with it by way of contrast."[56] Moreover, the ways in which the triangular form of *Memorial I* is in dialogue with the window in the same room is not accidental—it represents an engagement with architecture long a part of the artist's practice. Previous arguments about Kelly's works in the USHMM overlook these associations.

The clean, stripped-down aesthetic for which Kelly is known is not minimalist—and the artist has long resisted categorizing his work. Still, works like *Memorial I* function with the same kind of "theatricality" with which Michael Fried famously defined minimalism (as "literalist") in his diatribe against that American movement.[57] For Fried, minimalist works are theatrical in that they call attention to themselves as works of art devoid of meaning. An actor, for instance, is "theatrical" when the audience is no longer able to suspend disbelief. In traditional theater of the kind that Samuel Taylor Coleridge describes, if an actor turns to the audience and says, "Please, turn on the light," we no longer see the actor as the character he is playing on stage but rather as a person who is acting. In the same way, a minimalist work calls attention to itself as a work of art that aims to be devoid of meaning, metaphor, and concept. In Fried's famous comparison between works by Donald Judd and works by Anthony Caro, Judd's consist of multiple, repeated shapes and a title that gives nothing away—*Untitled*. Caro, on the other hand, presents to us an abstract composition and an accompanying title that allows for metaphorical meaning, such as *Prairie*. According to Fried, in Judd's work, the box is a box and nothing more. And so, by choosing a stripped-down curve such as that in *Memorial I*, Kelly is calling on a tradition of art making that draws attention to itself as itself. The title, *Memorial I*, resonates with the Holocaust because it is explicitly named as a "memorial." It is important to note that the title was suggested by the APSP—it was not chosen by Kelly. The painting/sculpture, usually emptied of meaning in Kelly's oeuvre, suddenly becomes burdened with meaning, an addendum to the work that does not quite fit.[58]

The second part of *Memorial* (Figure 4.3) is installed in the same room, on the wall opposite *Memorial I*. It consists of a series of three rectangles, forms with which Kelly had experimented since the 1950s.[59] Like *Memorial*

*I*, it is clearly in dialogue with architectural aspects of the space, such as the rectangular windows above it and the rectangular open doorway to the right. Diane Waldman argues that the three rectangles form a triptych (the conventional form of a Christian altarpiece) and are, therefore, a fitting form for a memorial—a misplaced remark, given the Jewish victims.[60] Kelly himself likens the three rectilinear forms to "memorial tablets that in their anonymity, bear the names of all of the victims of the Holocaust."[61] According the USHMM, "The low-contrast, visually 'hushed' atmosphere of the room may be seen as a silent vigil for some pure, luminous experience amidst the darkest chapter of human history."[62] Kelly is making use of the architecture, windows, and doorways to speak to and be in conversation with the works of art, while at the same time finding connections to Holocaust memorialization.

These rectangles, like *Memorial I*, are mounted 6 in. from the wall and thus cast distinct shadows. Each white rectangle is like a blank screen onto which a viewer can project memories or thoughts about what he or she has just seen in the permanent exhibit.[63] In other sites, Kelly's white orthogonal works are not expected to be screens for projection. But here, Kelly's "minimal" work more or less coincidentally ends up being somewhat appropriate to the purposes of this very particular site.

Kelly's two-part *Memorial*, therefore, functions as a screen in the way that Marita Sturken claims that the black polished granite is a screen for visitors of the Vietnam Veterans Memorial, reflecting not only their faces and bodies but also their emotions.[64] But for Sturken, the Vietnam Veterans Memorial is not just a screen for physical and emotional reflections; it is also a screen for both hiding and revealing the complicated collective memory of the Vietnam War for the United States. Lin accomplished this multivalent "screen" by incorporating the chronological list of names of fallen soldiers, making clear the sheer numbers of dead in specific years. If visitors want to find a name, they must run their eyes and hands over thousands of names before reaching the particular name they seek. For Lin, the list of names makes the work specific to the Vietnam War. Kelly incorporates no such feature: we simply see the geometrically shaped planes with which Kelly has been working his whole career.

Dave Hickey writes, "Let me suggest that everything we say about Kelly's paintings is subsequent to their irrefutable eloquence. If they do what they set out to do, they do it every time, and we are never really done with them, because they are not ours and they are not us."[65] In the context of the USHMM, *Memorial* functions differently than his other work. One might say that "what they do" is "create artworks that are experienced for the impact of their form alone, as condensed fragments of vision."[66] Is form alone enough to memorialize the Holocaust? By interrogating the nature of Kelly's forms, we come closer to understanding its relevance in a museum dedicated to the Holocaust.

Mark Rosenthal provides a way to better understand the function of these particular forms in this space, for he suggests that the works are directed not toward absence but toward presence: "Kelly concerns himself with creating an abstract form that projects an intangible yet eloquent and undeniable presence. The object must have a bearing, a condition of being present and notable, concrete and magical all at once. But he never expresses a personal or human connotation."[67] If the works are not embodying the void or absence, then the portrayal of presence gives the visitor the "soothing, comforting element" that the USHMM hoped to achieve. Perhaps one of the reasons that critics had such a hard time with Kelly's works, calling them "cold," inappropriately "sublime," or indicators of American national identity, is because the artist makes visible a struggle to find an appropriate form for a work of art about the Holocaust—at a point in time when an appropriate visual form of a memorial in the United States had not yet been achieved. Rather than *Memorial* being either successful or not in achieving the status of a contemplative memorial, it demonstrates a struggle in the field of the visual at a historical moment.

## Sol LeWitt, *Consequence*

Sol LeWitt's wall mural occupies the second lounge area, which concludes the exhibition on the third floor. When LeWitt was first approached by the museum, he suggested a "wall-like sculpture with an irregular ('broken') top edge, made of black, concrete blocks to be stacked along the long diagonal wall of the room."[68] The suggestion was based on his Black Form—Dedicated to the Missing Jews (1987; Figure 4.9), for which the artist had taken up the challenge of creating a Holocaust memorial in Germany. Also worth mentioning is LeWitt's *Wall Drawing 396* of May 1983, which depicts a black five-pointed star, a yellow six-pointed star, a red seven-pointed star, and a blue eight-pointed star, drawn in color and India-ink washes. It is hard not to make a connection between the golden yellow six-pointed star and the yellow Star of David that Jews were forced to wear by the Nazis.

Black Form—Dedicated to the Missing Jews is a Holocaust memorial consisting of concrete blocks painted black for the first inaugural Skulptur Projekte Münster. (Founded in 1977, the exhibition takes place every ten years and features international artists working on art in public spaces.) LeWitt's sculpture in Münster expressed the artist's feelings upon visiting Germany in the 1980s: "Being Jewish, I noticed the absence of Jewish artists and curators, Jewish bakers and candlestick makers."[69] James E. Young recounted that when Black Form was installed in Münster, it offended many locals, who claimed that it interfered with parking and clashed visually with a pretty urban square. As a result, the sculpture was taken down in March 1988.[70]

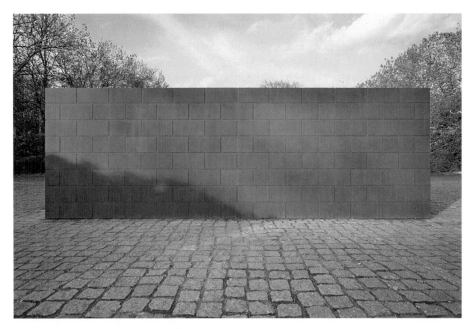

**FIGURE 4.9** Sol LeWitt, Black Form: Memorial to Missing Jews, 1987. Installed in Platz der Republick, Hamburg-Altona, Germany. Painted concrete block. (Photo: Bjoern Lafrenz. © 2018 The LeWitt Estate / Artists Rights Society [ARS], New York)

In 1989, Black Form was rebuilt and installed in front of the neoclassical town hall in Hamburg-Altona, a suburb of Hamburg, in slightly larger scale (2 × 2 × 5 m). For years, the city government in Altona had been considering a way to memorialize the destroyed Jewish community of the city. Black Form, in its 1989 iteration, looks from a distance to be two-dimensional: a black rectangle, or visual void, placed in front of city hall in Altona. It is only when the viewer gets closer to the sculpture that he or she will notice the cinder blocks that compose the sculpture and realize that it is indeed a three-dimensional form. LeWitt is famous for eschewing interviews and for his unwillingness to write artist statements about particular works, and he gives no written documentation as to his intentions for this sculpture (two billboards, to the right and left of the sculpture, relate the history of the Altona Jewish community).[71] But the black form seems to indicate a will to depict absence. About the work, the artist commented that it was "the most important work I have made to date."[72] When LeWitt suggested to the USHMM a project closely related to the Black Form, Nancy Rosen rejected it, stating that the jury and subcommittee "felt that the impact of a black block in Room 215 would be lost, that it was too dark and might be confused with other free-standing walls in the permanent exhibition."[73] As a result, Rosen asked LeWitt for a wall drawing

instead. The relevance of the Holocaust for LeWitt, therefore, came late in his career but was already in place when he created *Consequence*.

African American conceptual artist Glenn Ligon remarked that even though Black Form is a memorial to the Holocaust, it still remains a typical Sol LeWitt work of art. Ligon responded to Black Form in 1992 by creating his first wall drawing, *Untitled (James Baldwin)*, which pays homage at the same time to LeWitt and to Black Form. Ligon's wall drawing calls attention to the difficulty of creating art as a member of a minority group, a position he sees LeWitt also occupying in the context of Black Form. Ligon drew on the wall a powerful quotation from James Baldwin: "You see, whites want black artists to mostly deliver something as if it were an official version of the black experience. . . . And when you go along, you find yourself quickly painted into a corner."[74] Literally drawing himself into a corner, using LeWitt's wall drawing methods, Ligon called attention to the way in which LeWitt, as a Jew, created Black Form without "sculpting himself into a corner" as a Jewish artist. In Ligon's reading of Black Form, LeWitt did not want himself to be labeled as making "Jewish art" in the same way that Ligon clearly does not want to be labeled as a "black artist." In fact, LeWitt said in an interview that he did not feel that "'there is anything Jewish about my art (nor Chagall, Modigliani, Rothko, etc.).' He was, however, 'interested in subjects that involve Jewish history and the Holocaust particularly.'"[75]

I want to push Ligon's comment further here, for LeWitt was not only resisting a Jewish iconography that would identify his religious affiliation; he was also resisting the iconography of Holocaust memorials, as such iconography was being developed in the United States by artists such as Rapoport, Segal, and Treister. Like Kelly, LeWitt used his own artistic vocabulary and mapped that visual strategy onto a commission destined for the USHMM. If a cinder block sculpture could be both a LeWitt work of art and a Holocaust memorial, so too could a LeWitt wall drawing achieve the same goal.

In a lozenge-shaped lounge (referred to in subcommittee meetings as "Lounge B") almost identical to the area in which Kelly's *Memorial I* and *II* are exhibited, LeWitt's *Consequence*, a wall drawing, occupies one large wall (Figure 4.4). LeWitt's wall drawing is both similar to and different from Kelly's *Memorial*. Like Kelly's work, LeWitt's work has a title that was chosen by the museum, not the artist. But unlike Kelly, LeWitt made his work for the USHMM shortly after he created a Holocaust memorial in a public space. Therefore, we can consider his wall drawing as in dialogue with his previous engagement with the Holocaust.

*Consequence* is massive in size at 3.4 m high × 16.0 m long. It consists of five squares, arranged horizontally and separated by thick black lines. Each square has two common elements: a smaller central brown square surrounded by a

thin white line, which is surrounded in turn by a band of rust, black, ochre, blue, or orange. The central brown square causes one to perceive the surrounding colors differently—in relation to the central brown square, the dark blue functions differently than, say, the ochre color. The white lines, meanwhile, jump out at the viewer. LeWitt's original title for the work, "Progression of Colored Squares," points to his overarching concerns about geometry, conceptual art, and wall drawing. The museum, however, changed the title to *Consequence*,[76] believing that it would link the work more closely to the museum's historical exhibitions. The title of Kelly's *Memorial* signifies remembrance of those who were murdered by the Nazis. In contrast, the word *consequence* is an abstract idea, one conveying that something happened as a result of something else. Placed in the galleries directly following those that depict Nazi brutality and murder, it implies that there are consequences to genocide—or to ignoring genocide—but leaves those consequences unnamed. We are left to fill the blank spaces, should we wish to do so, with our imagined consequences.

LeWitt is famous for his conceptual wall drawings that are commissioned with instructions for completion.[77] When one purchases a wall drawing by LeWitt, one acquires only the instructions. The owner can choose to draw the work according to the artist's instructions or hire the artists' assistants to draw the work. Regardless of who completes the wall drawing, the result is a LeWitt work of art. By employing this unconventional method of artist creation, LeWitt questions the role of the artist's hand in creating a work authored by that artist and upholds the "idea" aspect of the art, to which he has been dedicated throughout his career.

Godfrey claims that the viewer—who will have just viewed the reign of Nazi terror and Yaffa Eliach's *Tower of Faces*—might very well see the LeWitt squares as photographic frames emptied of content.[78] Or, a visitor could envision the squares as being filled with the faces of Yaffa Eliach's installation.[79] There are many other readings that a viewer might entertain, but I would like to focus on the idea of photography, for LeWitt had, earlier in his career, worked with the repeated square formats of photographs. I turn to an earlier work by LeWitt, *Autobiography* (1980), a book consisting of one thousand black-and-white images that document the details of the artist's Hester Street studio in Manhattan, including pages with close-ups of his plants, closet, books, art, and so on.[80]

Almost all the photographs in *Autobiography* are arranged as a grid, six per page, with white borders between them. *Autobiography* is a rendering of LeWitt through the details of his apartment. Although LeWitt called it a "self-portrait," the artist appears only once in the one thousand photographs. What would it mean to read Eliach's *Tower of Faces* against *Consequence*, as Godfrey suggests (above), but through the lens of *Autobiography*? Eliach's work beckons us with a message: see and remember these people. LeWitt's

*Autobiography*, in contrast, wants to say something else: see this self-portrait and realize that I cannot show myself—I can only show the details of my daily existence, and they, too, will not tell you everything about me.

Perhaps the power of LeWitt's *Consequence* is this: *I cannot represent the biographies of the millions who died and so I provide you with empty frames*, or simply *I cannot represent*, which would thereby follow a long history of those who say that the Holocaust is unrepresentable.[81] Instead of completely aligning himself with that argument, however, LeWitt demonstrates that when representing the Holocaust, no singular approach will ever truly do justice to the crimes committed and to the memories of those victims. *Consequence* is like many of LeWitt's works: it asks the viewer to fill in the gaps. And the viewer can take on that challenge or simply move on.

Conceptual artist Mel Bochner said that the main thing he and Eva Hesse learned from Sol LeWitt was "a sense of ordered purposefulness. You did your work as clearly as you could; what you didn't know, you made apparent you didn't know. That's a lot more important than maybe it sounds."[82] *Consequence* implies what LeWitt does not know—the best way to create a work of art that would elicit contemplation in a museum dedicated to the Holocaust.

In 2005, about a decade after completing *Consequence*, LeWitt created two works of art (for two different synagogues, one actively used as a place of worship and the other as an exhibition space) that engaged references to Judaism and the Holocaust. LeWitt was an active member of Beth Shalom Rodfe Zedek Synagogue in Chester, Connecticut, and so the artist designed that congregation's new synagogue. He employed wooden roof beams that alluded to the ornate wooden synagogues that had dotted Poland before they were destroyed on *Kristallnacht* in 1938.[83] He also designed the doors of the ark (a structure that houses the Torah in the front of every synagogue sanctuary), in a brightly colored, geometrical pattern of the Star of David. He even designed a kippa to match! Two years before the end of his life, LeWitt embraced symbolic aspects of Judaism (the Star of David) and of the destroyed Jewish communities of Poland (the timber structure recalling the destroyed synagogues).

The same year, LeWitt was commissioned to create an ephemeral work of art for the synagogue in Stommeln, Germany (now part of the city of Pulheim), a former synagogue and exhibition space where ephemeral works related to the Holocaust have been commissioned by the city's Cultural Department since 1991.[84] LeWitt's 2005 installation, *Lost Voices*, was a site-specific sculpture consisting of a large brick wall in the synagogue that blocked access to about two-thirds of the main sanctuary, including the area where the ark would have stood. Accompanied by audio of the Rosh Hashanah and Yom Kippur liturgies (the holiest days of the Jewish calendar, marking the birth of the world and the Day of Atonement), the work is clearly dedicated to confronting and

working through the Holocaust. And for the first time, LeWitt chose to title the installation—"*Lost Voices*"—in a way that has clear resonance with the Holocaust and the lost citizens of Stommeln.[85]

According to his rabbi, LeWitt was an active member of the synagogue, attending its study sessions of the Torah. Direct signification of Judaism, which the artist had long eschewed in his conceptual works of art (and certainly avoided in *Consequence*) finally made its entrance in the context of his own synagogue and the exhibition space in the Stommeln synagogue. LeWitt set out to confront and examine the history of the destruction of the Jews in his works, both before and after creating *Consequence*.

## Richard Serra, *Gravity*

After paying tribute in the memorial space, the visitor descends the stairs back into the Hall of Witness, from where the journey through the museum began. Located near the black granite wall in the southwest corner of the Hall of Witness, Richard Serra's *Gravity* (Figure 4.5) is situated at the base of the stairs, on which viewers descend. It thereby demands interaction with the viewer.

Unlike Kelly and LeWitt, Serra had worked with the architect to determine the most appropriate size and place for the sculpture.[86] Godfrey explains that the work was plotted with the architecture in mind—namely, at the base of the stairway that leads back to the ground floor and the Hall of Witness. The sculpture cuts into the stairway at just the point where one would expect to walk freely, and so it provides, in Godfrey's words, "a kind of ballast . . . pitching into the floor."[87] Adding to his analysis, I will further point out that as one goes down the stairs, one reads the words "You Are My Witness," a quotation from the Bible, inscribed on the black granite wall. Dori Laub and Shoshana Felman argue that "bearing witness" involves tolerating the caesuras and interruptions of the narrative trauma; listening is work, and bearing witness means taking an empathetic stance in relation to the narrator. The viewer has just seen *Testimony*, a video of Holocaust survivors' testimonies, and has read the inscription on the wall; now the viewer encounters Serra's *Gravity*, and bearing witness takes both verbal and visual form. If listening forces viewers to accept interruptions and discordances in narratives told by survivors, then viewing *Gravity* demands that viewers accept an interruption of movement down the stairs and in the field of vision. Specifically, the sculpture interrupts the negative space of the stairway, slicing into the stairs where one usually expects to descend unencumbered. Serra's sculpture cuts into the space that people use on an everyday basis, invoking and provoking the viewer to negotiate and renegotiate his or her ambulation around works of art that may or may not be in the way—such was the controversy around *Tilted Arc*.[88]

Serra is infamous for *Tilted Arc* (1981), commissioned by the General Services Administration for Jacob K. Javits Plaza and the adjoining Federal Building, in Manhattan. *Tilted Arc* is 12 ft. high and 120 ft. long and is made of Cor-Ten steel. The sculpture was designed to bisect the plaza and be in visual conversation with the circular fountain already on site. For the workers who needed to access the Federal Building, however, the sculpture was in the way: It literally blocked access to the building. *Tilted Arc* was one of the most controversial works of public art in the second half of the twentieth century. Its critics deemed the work ugly, a place for potential terrorist attacks, and a wall against which people would urinate. As a result of the public debate and a series of public hearings dedicated to determining if the sculpture was appropriate in its current location, the work was removed in 1989. For Serra, removing the work from the site for which it was specifically designed was tantamount to destroying the work of art. The work's meaning derived from its position in a specific space, and the objective of the artwork was meant to be the bodily experience of walking around it, of feeling the inaccessibility of the other side of the sculpture, of being made aware of one's own body in space. Walking around the work does nothing but provide still more interpretations of its ever-changing form.

*Gravity* cannot defy gravity but submits to it. It is as if the artist asks us to suspend disbelief: one might imagine that the sculpture was on its way somewhere else and, in the midst of that transport, simply succumbed to gravity, fell, and remained where it landed. At the same time, the title provides a metaphoric association to seriousness: to the grave concerns of the Holocaust. Of course, Serra was never particularly known for giving titles that had metaphoric resonance: *Tilted Arc*, after all, was a physical descriptor more than anything else. But some of Serra's previous sculptures do take on metaphorical meanings. Take, for instance, *House of Cards* (1969), another title, like *Gravity*, that reflects on the medium and the effect that gravity has on objects: a house of cards can fall, but Serra's sculpture of four-ton Cor-Ten steel sheaths placed to mathematical precision to ensure stability will not. Serra's commissioned work, *The Drowned and the Saved* (1992; Figure 4.10) for the Stommeln Synagogue in Pulheim, Germany, is the only work of art the artist ever made that explicitly refers to the Holocaust. It was made one year before *Gravity*, so it is important to revisit the work, especially to better grasp the artist's understanding of the vital role of a sculpture's physical context.

In 1992, Serra was commissioned to install a memorial in the Stommeln Synagogue (in Pulheim), as part of its rotation of nine-month-long exhibitions (and for which LeWitt had exhibited *Lost Voices* in 2005, as discussed above). Entitled *The Drowned and the Saved*, after Primo Levi's famous account of the concentration camps, the sculpture consists of two L-shaped

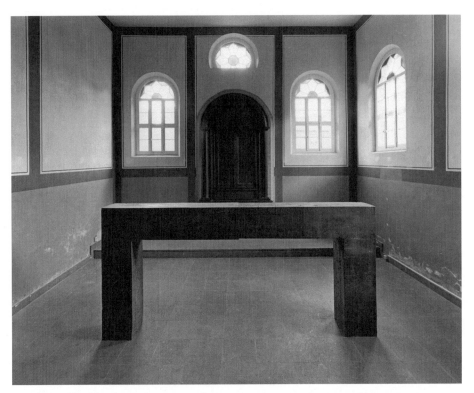

FIGURE 4.10 Richard Serra, *The Drowned and the Saved*, 1992. Installed in the Stommeln Synagogue, Germany. Forged weatherproof steel. (Photo: Werner Hannappel. © 2018 Richard Serra / Artists Rights Society [ARS], New York)

beams that are joined together to form a bench-like structure—or a bridge—which Serra once referred to as a "psychological icon."[89] The sculpture was installed in the central room of the synagogue. Just as important as the work itself is the exhibition catalog that accompanied it.

As readers, we often expect exhibition catalogs to illustrate a work of art (or works of art). Not so in Richard Serra's exhibition catalog that accompanied *The Drowned and the Saved*. The little book, about thirty pages long, has *only one* black-and-white photograph of the sculpture—and it appears on its back cover. Instead of providing photographs of the sculpture from various points of view, as many exhibition catalogs might do, Serra designed a catalog that de-emphasizes his work of art and instead focuses on the geographic region in which it resides. Specifically, the book illustrates, in alphabetical order, thirteen destroyed synagogues in the geographic area of Stommeln, known as Erftkreis, a district to the west of Cologne. The quotation on the first page, by Serra, explicitly refers to the importance of context, in this case

both geographic and sociological: "Art always manifests, either explicitly or implicitly, a judgement about the surrounding sociological context in which it participates."[90] The artist thus prepares the reader to encounter not the work itself but its context.

Every town mentioned in the catalog has a two-page spread dedicated to a synagogue in that town. On each of the thirteen two-page spreads, the left page is black, with the name of a town in white at the top of the page and a very short historical description of the fate of the synagogue of that town on the bottom half of the page. The right-facing page illustrates either historical photographs of the interior or exterior of those synagogues or the remnants of the buildings. The towns include small villages such as Bedburg, Elsdorf, Kerpen, and Sindorf. These are not large cities but rather small towns and villages, reminding the reader that Jews and their synagogues were everywhere in Germany. The effect of the brochure is to intimate that the experience of viewing *The Drowned and the Saved* is really all about the experience of understanding the context of destroyed synagogues in the area. Most were burned on *Kristallnacht* of 1938, some were bombed in 1945, and others were completely destroyed in the 1950s. Stommeln was only saved because the Jewish community sold it to a farmer in 1937, who thereafter used the building for storage and as a pigsty. The title, *The Drowned and the Saved*, not only refers to Primo Levi's book of the same name but also to the other synagogues in the geographic region of Erftkreis: those synagogues that were burned ("drowned"), and those that were sold ("saved"). Stommeln is the only village that restored its synagogue (in 1981–83) and opened it to the public for art exhibitions (it is also used by Cologne's Jewish community).

On the last page of the catalog, Serra provides one of the only biographical remarks of his career:

> It is difficult to defend yourself against retributions for an unknown. There is no preparation. To keep good faith with yourself, to understand yourself requires truthfulness, sincerity, a moral effort. Is that possible if part of your identity cannot be revealed?
>
> When I was five years old I would ask my mother: What are we, who are we, where are we from? One day she answered me: If I tell you, you must promise never to tell anyone, never.
>
> We are Jewish. Jewish people are being burnt alive for being Jewish.
>
> I was raised in fear, in deceit, in embarrassment, in denial. I was told not to admit who I was, not admit what I was.

The autobiographical remark is written not as a paragraph (note the breaks in the sentences) but also not as a prose poem. One might call it poetic

prose. The utterance does not necessarily call attention to its body—as does a poem—but rather to its referential meaning. It employs tropes such as repetition (anaphora, especially), but the text is far more notable for its referential elements, including the list of abstractions, the elliptical narrative, and its reference to world-historical events. It is a statement that is not quite a poem and not quite prose; just as the exhibition catalog is not quite a catalog of the exhibition and not quite a catalog of destroyed and still-standing synagogues.

The context of the sculpture becomes more than just the sociological context of the town in relation to other towns in Erftkreis. One also understands that the sculpture must be interpreted in the context of the artist and his experience of being a Jew in the United States, commissioned to create a work of art in Germany. One reads this statement of truth versus deceit, sincerity versus denial, before one even sees the sculpture itself on the back cover of the catalog. The photograph of the sculpture on the back cover, in turn, is not of the sculpture in situ but of the sculpture in the place it was made: in a foundry. This is not entirely unexpected, as exhibition catalogs often must be printed before the opening of an exhibition and, therefore, do not show the works of art in the exhibition space for which the catalog is made. The photograph appears on the back cover, almost as an afterthought, much like *Gravity* appears at the end of the visitor's experience of the USHMM.

If we interpret *Gravity* through *The Drowned and the Saved*, we understand that physical context is vitally important to the artist and that, when working with a topic such as the Holocaust, the artist's life and work is imbued throughout the work. To ignore the artist's previous works dedicated to the Holocaust is to understand *Gravity* out of context. Today, the official staff photographers of the USHMM often use *Gravity* as a background for photographs of Holocaust survivors. Perhaps the reason is because of the patina of the Cor-Ten steel: it is neither a smooth flat black background nor a colorful one. Photographers often choose backgrounds that resonate with the subjects of their portraits so that the personality of the sitter is infused throughout the photograph. The rusted black of *Gravity* gives an impression of an industrial setting, and the even lighting provides a perfect setting for a portrait. By becoming the backdrop for such photographs, the sculpture takes on yet another meaning: it becomes part of the identity of the survivors themselves.

## Conclusion

The works of art in the APSP at the USHMM were commissioned at a time when there was a dearth of information about Holocaust memorials as well as art about the Holocaust. Nonetheless, of the artists that were chosen by the commission, three out of four were Jewish and had compellingly grappled

with the theme of the Holocaust in their earlier works of art, in either overt or subtle ways. Accommodating that history gives us a deeper understanding of the works of art with memorial functions that fulfill the commission's goal to avoid overt representational aspects of the Holocaust while still providing spaces of contemplation. Although critics made negative comments at the time the museum opened, a closer look at the visual and textual fields surrounding the works of art reveals that, in three out of four cases, the artists had previously created works that addressed the Holocaust—without employing an all-too-easy iconography established in the United States by Rapoport, Treister, and Segal. The process of designing the USHMM lasted from 1979 to 1993, which overlaps with the hotly debated national Memorial to the Murdered Jews in Berlin. Planning for the latter began in 1988, and the monument and museum opened in 2005. Like the works of art in the USHMM, the national memorial in Germany is designed in a stripped-down, minimalist style. But Peter Eisenman's memorial became a watershed in memorial architecture for its groundbreaking method of introducing perambulation in a memorial structure—at a time when Germany was ready to allow individuals to wander, to think, and to remember in its national space of Holocaust remembrance; this is the subject of the next chapter.

# 5

## Walking through Stelae

### *Peter Eisenman's Memorial to the Murdered Jews of Europe (2005)*

THE BERLIN MEMORIAL to the Murdered Jews of Europe (hereafter the Berlin Holocaust Memorial), designed by architect Peter Eisenman, was a watershed in memorial architecture (Figure 5.1). It consists of undulating stelae, or concrete pillars (I use both designations), ranging from 0 to 4 m in height, and occupies a space of 19,000 m² in one of the most public spaces in Berlin. It is located just south of the Reichstag and the Brandenburg Gate and sits opposite the east side of the Tiergarten, the city park, and northeast of the rebuilt Potsdamer Platz. When the memorial was originally commissioned, the plot and the area surrounding it were completely empty. Now, the American Embassy flanks its northern side, apartment buildings are located on its east side, and the buildings of the state governments are located on its south side. The plot is an empty space in one of the busiest parts of Berlin; in this high-profile location, the debate surrounding the commission of the memorial was a source of grave contention and a very public reckoning of Germany's past.

The memorial was completed in 2005, and, so far, the critical discussion about the memorial has focused on an analysis of the debate surrounding the memorial or Eisenman's theory of architecture.[1] The initial model of the memorial, however, was submitted in 1997 by the joint team of Richard Serra and Peter Eisenman (Figure 5.2), a renowned sculptor and architect, respectively. Although Serra withdrew from the commission after he refused to incorporate former chancellor Helmut Kohl's requested changes, the artist's impact remains visible, but heretofore unremarked. Specifically, Serra's earlier works, such as *Shift* (1970–72), *Snake Eyes and Boxcars* (1993; Figure 5.3), *Gravity* (1993; Figure 4.5), and *The*

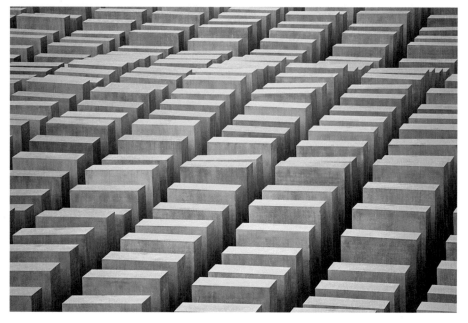

**FIGURE 5.1** Peter Eisenman, Memorial to the Murdered Jews of Europe, Berlin, 2005. Two thousand high-performance concrete stelae. 0–7.5 × 0.92 × 2.3 m. (Photo: Marco Priske. © Stiftung Denkmal für die ermordeten Juden Europas)

*Drowned and the Saved* (1992; Figure 4.10) are here analyzed as precursors to the Berlin Holocaust Memorial in that they incorporate ambulation, undulation of the ground, and the activation of memory—all elements that are intrinsic to the Berlin Holocaust Memorial. Walking in and around the sculpture becomes a part of the work itself, which in turn, I explain, is a catalyst for memory.

The 1997–98 Eisenman/Serra model was never built as originally designed. We can imagine, however, what its effect might have been, had it been built; we can experience the memorial in its current manifestation, especially when walking amid the rows of stelae. It is possible that as one enters the centermost part of the memorial, one gets closest to the original effect intended by the Eisenman/Serra team, for one does not encounter the natural elements (such as trees) that Eisenman later incorporated. One reaches the center by walking, and walking takes time. Just as the surface of the stelae of the Berlin Holocaust Memorial appear to undulate when viewed from the street, so too does the ground on which they stand ascend and descend. A single visitor can walk freely through the aisles between them—the spaces between the aisles are shoulder width. One cannot visit the memorial en masse, for it provides an individual experience: when one is lost, one is lost by oneself. The experience can be at times claustrophobic, anxiety producing,

FIGURE 5.2 Peter Eisenman and Richard Serra, winning submission for 1997–98 call for entries for the Berlin Memorial to the Murdered Jews of Europe. Four thousand concrete pillars, each 0–7.5 × 0.92 × 2.3 m. (Photo: Dirk Frank Studio. © Stiftung Denkmal für die ermorderten Juden Europas)

FIGURE 5.3 Richard Serra, *Snake Eyes and Boxcars*, Alexander Valley, California, 1993. Forged weatherproof steel, twelve blocks, six: 7 ft. × 41 in. × 41 in.; six: 48 × 41 × 41 in. (Photo: Dirk Reinartz. © 2018 Richard Serra / Artists Rights Society [ARS], New York)

or playful—in fact, children play games of hide-and-seek among the stelae. If the viewer is cognizant that the memorial is dedicated to the Holocaust, the black forms might seem oppressive and emotions might fluctuate. One might feel lost. If voices are audible, they are often calling out to their companions, "Where are you?" and the response, "Here," does not tell the visitor much at all. Feeling lost, looking for others, thinking, and imagining occur when a visitor walks or moves through the space. When walking, our minds are activated to wander or imagine—and such an activation of thought, imagination, and memory are fundamental to the experience of walking through the stelae of the Berlin Holocaust Memorial. Memory is activated as the visitor moves through space, experiencing the ground, the sides of stelae, negative space between concrete pillars, and other visitors. An analysis of Serra's earlier works—those that also invoke the body as integral to the experience of sculpture—in conjunction with the Berlin Holocaust Memorial, prompts a new evaluation of Serra's understanding of space, stelae, and memory and their implications for the final version of the Berlin Holocaust Memorial.

Invoking bodily movement among the stelae, in turn, triggers the possibility of memory. I analyze the ways in which theorists of memory invoke bodily perambulation in order to better understand the function of the visitor among Eisenman's stelae. Henri Bergson's invocation of *durée* (which I investigate in this chapter), emerges as that which embraces past, present, and future, a vital concept in understanding the philosophical underpinnings of the Eisenman/Serra model. Paired with the walking city dweller of de Certeau, *durée* becomes manifest in the space of a sculpture.

This text joins an ongoing debate about the role of abstraction in art after the Holocaust. Mark Godfrey posits that abstraction introduces a certain level of ambiguity in meaning that can both generate memory and tolerate the difficulties of traumatic memories.[2] Building on these arguments, I show that walking—and even stumbling—on, over, and through memorials generates a flow of memory that encounters past, present, and future. First, however, let us turn to the political and social dimensions of Holocaust memory in Germany during the time of the memorial's conception in 1988 until its opening in 2005, for the challenges that the commissioners and the public faced were ones that engendered a decade-long public conversation about the nature of Holocaust memory and the most appropriate visual form for it.

## The Berlin Holocaust Memorial: A Brief History

The Commission for a Berlin Holocaust Memorial began in 1988, when television journalist Lea Rosh teamed up with historian Ernst Jäckel and visited Yad Vashem. Their reaction was quite simple: "If Israel has a memorial, why don't

we?" It was Lea Rosh's initiative that got the project off the ground. With the first call for submissions, artists submitted 1,000 queries and 538 entries. The history of the Berlin Holocaust Memorial is one of thinking, choosing, vetoing, and rethinking. It is also a history of writing and more writing in the form of letters and articles published in newspapers. These texts include opinions and disagreements about themes, such as the definition of the Holocaust and the lessons to be learned from it; the victim groups to be or not to be acknowledged by the memorial; whether the "actual spaces" of Nazi destruction (the death and concentration camps) are more meaningful than memorials placed in public spaces not related to those sites of destruction; and the role of collective memory in contemporary German culture. Books about the memorial debate, in turn, consist of anthologies of selected articles and interpretive essays.

A synopsis of the debate's narrative, including the various competitions and submissions, provides a context for my analysis of the Eisenman/Serra model and the production of memory that viewers experience as they navigate through it. Rather than providing a detailed account, I point out the main themes of the debate, and do so with the knowledge that my own choice of events worthy of recording is predetermined and a reflection of my own research needs and values. Specifically, I pay close attention to the different models that were submitted and the reactions of jurors and the public to those models. I refer frequently to Ute Heimrod, Günter Schlusche, and Horst Seferens's *Der Denkmalstreit—das Denkmal?* a hefty tome that conveniently splits up the first ten years of the controversy according to decisions that were made and the controversies that they engendered and provides copious reprints of newspaper articles.[3] So too, James Young's (2000) account of his participation in the second round of entries also plays a vital role in this story.[4]

The idea for a national German Holocaust memorial began in the 1970s, when the spaces of Nazi terror were unearthed in the center of Berlin. In West Berlin, citizens' initiatives and the younger generation of Germans began a process of exploring and elucidating the repressed history of National Socialism. When the Martin Gropius Building (widely considered a beautiful historic building for exhibitions) reopened in 1981, for instance, attention was turned to its neighboring property: the so-called Prinz-Albert Plot. This space had been the center of the most important terror offices of the Third Reich: The Central Office of the Gestapo, the SS Leadership, and the Head Security Office of the Third Reich (Reichsicherheitsamt). The discussion of what to do with this plot of land culminated in 1983 with an international contest for rebuilding the site.[5]

In 1987, the 750th anniversary of Berlin, the Senatsverwaltung für Bau- und Wohnungswesen und Bauausstellung Berlin GmbH (Senate Department for Construction and Housing and Building Exhibition) organized a documentary exhibition called *The Topography of Terror* that was housed in a set

of provisional buildings. The surprising success of this decision prompted the Senate to think about a permanent exhibition for this site. In August 1988, a public discussion was scheduled in which Rosh suggested that a memorial to the murdered Jews of Europe should be built on this plot of land (the public already knew Rosh's name, for she had produced a television miniseries about the deportation and murder of the Jews in the National Socialist–occupied countries of Europe; still, the suggestion for such a memorial was not entirely positively received). Among other issues, some members of the public saw the fact that she limited the victim group to only Jews as problematic (and the topic would remain a point of contention throughout the debate). In addition, some argued that the history of the perpetrators—and not the victims—must be the central theme on the site. The "Initiative of the Gestapo Area," with Prof. Dr. Reinhard Rürup as speaker, suggested that the space be used as a learning center. Slowly, step-by-step, these suggestions coalesced into the foundation known as "The Topography of Terror," which was voted into existence by the Berlin Senate in 1992. The foundation planned to create a documentation and visitor center, to be opened in 1997, with the architectural plans from Swiss architect Peter Zumthor (that project was finally opened in 2010 after having experienced setbacks due to financial strains in the Berlin city government).[6]

Nonetheless, the historical exhibition would not function as a national memorial to the Holocaust, which was Rosh's goal. When Rosh and Jäckel founded Citizen's Initiative Perspective Berlin in 1988 with the recommendation of an "immense memorial in memory of the victims," their suggestion was met with little public interest. The group, therefore, decided that it needed the support of famous personalities to capture the public's attention. Meanwhile, Rosh led discussions on an artistic form for a national memorial. In 1989, artists Rugh Gindhart, Paul Pfarr, Horst Hoheisel, and Georg Seibert created the first submission for an "integrated remembrance site." It was at this point that the controversy over the conception of the national memorial began.[7]

The placement of the memorial was one of the first issues that Rosh and her supporters had to address. When the Berlin Wall fell in 1989, the reunification of Germany created a completely new urban topography and, with it, a new set of problems. Starting in 1990, Rosh's initiative took new form with the title Association for the Installation of a Memorial for the Murdered Jews of Europe (hereafter, the Association). It recommended that the memorial be built on the area of the former minister garden, north of Hitler's former Reich chancellery, which had been, until 1989, known as the "death strip" of the Berlin Wall—the place where East Berliners were shot as they tried to flee to the West.[8]

In 1992, the Association sought the support of the federal government and Berlin Senate. With the support of Minister of the Interior Rudolf Seiters and Berlin Cultural Senator Ulrich Roloff-Momin, the participating parties found

a solution. The dedication of a Berlin Holocaust Memorial would remain, for which the federal government made available the northern part of the former minister's garden. A memorial was also planned for the murdered Sinti and Roma. Parallel to the Association's efforts, the federal government decided to renovate the Neue Wache (The New Guardhouse) on Unter den Linden in Berlin, rededicating it to the central remembrance site for the "victims of war and violent dictatorship."[9]

Renowned German architect Friedrich Schinkel originally built the Neue Wache in 1818 as housing for the king's guards. During the Weimar period, the guardhouse became a memorial for the dead of World War I. In 1960, the building was rededicated by the GDR as the Memorial to the Victims of Fascism and Militarism. A guard of honor was posted outside. In 1969, the building was redesigned, with the addition of an eternal flame, stones for graves of the Unknown Soldier and Unknown Resistance Fighters, and urns containing earth from the concentration camps and World War II battlefields set in the floor. In 1990, the memorial was closed, and the East German army disbanded. In 1993, Chancellor Kohl rededicated it as the Central Memorial to the Victims of War and Tyranny. The rededication created controversy among art circles and historians, for the memorial was to be dedicated to "all victims," thereby making no differentiation between German victims of war and the victims of the Nazis.

Furthermore, Chancellor Kohl decided that Käthe Kollwitz's sculpture *Pietà* should be copied, enlarged, and placed in the center of the interior space. Kohl and his supporters believed that the form of a Christian pietà has universal connotations of mourning—a controversial idea, given the Jewish victims of the Holocaust. Against this background, Kohl met with Ignatz Bubis—who was at that time president of the Central Advisory Board of Jews in Germany—to come to a consensus about what to do with the messages promulgated by the Neue Wache versus the central Berlin Holocaust Memorial. Bubis suggested that the Neue Wache should remain and should be opened on November 14, 1993. In turn, Kohl supported the Berlin Holocaust Memorial. A trade-off was made, which meant that a memorial for *all* victim groups of the Nazis would not be created. The Kohl-Bubis understanding ignored potential input from the Central Advisory Board of the Sinti and Roma in Germany and its chairman, Romani Rose, as well as many other dissenting voices. Preparations began in 1993 for a public contest, with the goal of finding a form for the memorial.[10]

The various parties interested in the memorial found it difficult to write a competition call for entries, and it took them one year to do so. At the same time that the Association struggled to come up with a process for the central memorial, its members undertook a plan to realize an over- and underground remembrance site, designed by Harald Szeemann, on the site meant for the memorial.

The members of the Association were critical of the federal competition because it incorporated so few internationally known artists. In response, the federal competition announced that it would invite twelve such individuals. The competition call for entries, however, was not clear in its mission, for it neglected to provide a precise task for the artists. At the same time, the conflict-riddled process continued in which a fifteen-person jury had to be chosen. They, in turn, would choose five winners.[11]

In April 1994, the call for entries, entitled the "Artistic Competition for the Memorial for the Murdered Jews of Europe" was published in all regional newspapers. The 1994 call for entries begins by stating the inexpressibility of the horror of the Holocaust, calling it "Germany's heaviest crime, even today, half a century later." The text describes the memorial's physical placement in the city, emphasizing its relationship to Hitler's bunker and the later use of the area as the death strip between East and West Berlin. As for the artistic form that the memorial should take, the text reads: "Today's artistic energy shall connect symbiotically the compassion in mourning, emotional disruption (*Erschütterung*) and respect with the contemplation of shame and guilt. Insight should be allowed to grow, also for a future life of freedom, peace, equality and tolerance."[12] Twenty-six hundred parties (including individuals and people working in teams) answered the advertisement and requested competition materials. Out of these, 528 submissions were made in time for the October 28, 1994, deadline.[13]

The prize jury was made up of historians, artists, architects, and members of the parties who began the process. It met in January 1995, with the former Berlin-Brandenburg President of the Academy of Arts, Wolfgang Jens, as its chairman. Since the group could not decide on a winner in the space of the predetermined three days, they agreed to meet in the middle of March for another two days.

Among the 528 submissions were several notable designs that the public and jury deemed completely inappropriate—or downright outlandish—including those from Horst Hoheisel and the artist team Renata Stih and Frieder Schnock. Horst Hoheisel's design called for blowing up the Brandenburg Gate as a monument to the murdered Jews. For those familiar with Hoheisel's work about the Holocaust, his radical approach did not come as a surprise. Hoheisel, for instance, had created an upside down, underground water fountain in Kassel in 1985, which was to remember a fountain funded by a Jewish philanthropist that subsequently was destroyed by Nazis. His work prompted Young's coinage of the term *counter-monument*, referring to those works of art, especially Holocaust memorials, that resist monumentality and verticality. For those who were aware of Hoheisel's work, it was no surprise that the artist would design a counter-monument for the national competition.

Likewise, Renata Stih and Frieder Schnock's conceptual model, entitled "Bus Stop: Schedule," questioned traditional roles of memorials. The space re-

served for the memorial would become a kind of bus stop: Berlin City buses would stop at the sight and take visitors to sites of genocide, including destinations such as Sachsenhausen and Sobibor, as well as sites that would be less familiar to visitors who were not scholars of the Holocaust, such as Bremervörde and Hadamar.[14] The buses would load passengers at the memorial and bring them to the actual sites of persecution and death, thereby creating a "non-monument" (in the artists' words), which was meant to question the commission's goals of creating a traditional monument where political visitors could lay a wreath. Physically, the memorial plot was to be split by one street for bus traffic. Ticket windows, waiting rooms, information, documentation, and service were designed in buildings on the site. Stih and Schnock proposed an active, moving monument that defied traditional expectations of memorials.

Christine Jakob-Marks's submission consists of a 100 m square block of stone that covers the entire memorial area. As the block is 11 m high on one end, 7 m on another, and 1 m on another, it sits on the ground at a massive slant. Stones from Masada are placed upon it and the names of four million murdered Jews would be engraved on the slab. Space is left for visitors to walk without treading on the names, and empty space is left on the slab for the approximately 1.5 million unnamed victims.[15]

Members of the jury wrote that the Jakob-Marks model had an especially strong connection to the theme at hand: the victims are brought out of their anonymity (because all victims would be named), thereby doing away with the potential problem of "choosing" victims. Some members of the jury found the choice of stones from Masada sensible, since they signify strength and a will to fight.[16] The slanting of the slab was seen partly as unfounded, partly as indispensable. Still others found the empty space under the slab to be problematic; the height of the slant was also troubling. Some suggested that the large slab created a forceful and theatrical impression (seen negatively). Others thought the slab evoked many emotions (seen positively), for it generates trepidation and would be the correct form for this theme.[17]

Simon Ungers's submission consisted of a square steel sculpture of 85 m², which rests on four concrete blocks placed at each of the four corners. The four steel arms of the sculpture would be perforated with the names of the death camps and embrace an inner quadrant that is reached by stairs located directly under the arms. As there is no official entrance to the memorial, the visitor can choose which way he or she enters: one can move to the inside or remain on the outside, but it is only from the inside that the visitor can successfully read the names of the concentration camps. In order to reach the inner quadrant, one must walk under the weight of 6 m high steel walls. Sunlight throws the names of the concentration camps on the steps. In its physical openness, wrote the jury, the memorial offers a place for official events as well as for individual encoun-

ters. But it would not provide explanations, tours, or interpretations.[18] Some jury members criticized the model because of the limited number of concentration camps that are named on the steel arms.[19] The jury decided that Ungers's model was not an appropriate answer to the formulation of the problem, for "here no space of ritualized memory would be created." A space of ritualized memory, however, was not what the artist had in mind. "Whoever wants to mourn for the victims," the artist wrote, "must go to the spaces of destruction . . . our kind of memory is based more on the interests of the persecutors, and less on the victims."[20]

After a long and controversial discussion, the jury gave two first prizes: One first prize went to Jakob-Marks's group (including Hella Rolfes, Hans Scheib, and Reinhard Stangl), and the other prize went to Simon Ungers. Altogether, the jury recommended second prizes for seventeen works, with eight winners and eight works to be bought. In March 1995, these decisions were made public. Having chosen two first prizes, the jury handed over the final decision to the original commissioners. At the same time, the Association initiated a foundation called Stiftung Denkmal für die ermordeten Juden Europas (Foundation for the Memorial to the Murdered Jews of Europe), which would operate under the responsibility of President Roman Herzog to create donations for the memorial. In 1995, many of the submissions were exhibited in the House of Parliament.[21] In June 1995, the Senate for Building and Living announced that the Christine Jakob-Marks group submission would be realized (as discussed above, a gigantic slab on which the names of the murdered Jews are engraved). Immediately after the announcement, controversy broke out.

The debate over the Jakob-Marks submission centered on its perceived monumentality, the engraving of names, and the use of stones from Masada. It was thought that a gigantic memorial did not necessarily function as a metaphor for the crimes it seeks to memorialize. In addition, monumentality was connected to the gigantic dimensions of the architectural projects of Nazi architect Albert Speer, and, therefore, it was not appropriate for a memorial to Jewish victims. It was suggested that each individually engraved name of a Holocaust victim should receive an individual sponsor. This idea, in turn, was considered fundamentally crude—and, at the same time, it was feared that no one would make donations, resulting in national embarrassment.[22] The boulders from Masada connect the memorial to the historical event where the Jews of Masada, under siege from the Romans, committed collective suicide rather than be caught by their Roman enemies. But was mass suicide really an appropriate link to the Holocaust? Some saw the boulders in a positive light: the eighteen boulders from Masada conveyed the symbolic Hebrew number meaning "life" (the number "eighteen"), and they could also be understood as alluding to the Jewish tradition of leaving stones

at grave sites. The question about the appropriate form for such a memorial was above all the hardest in this public debate. Some only trusted modern art—with its abstract and hermetic forms—to bring the singularity and civilization-shattering murder of the Nazis to visual form. Others questioned whether art was *at all* able to answer the required questions of the call for entries.[23] Chancellor Kohl gave his veto two days after the official announcement that Jakob-Marks was the winner. He announced that the land was no longer available for the memorial. The debate became a fully public one.[24]

About a year after Chancellor Kohl's veto, in April 1996, the commissioners came together once more. The colloquium, with the help of representatives from various disciplines, addressed aspects of the memorial including history, aesthetics, and city space. Its members decided to have another three sittings between January and April 1997 to discuss the concept, iconography, and placement of the memorial. Of special concern was the memorial in relation to other remembrance sites in Berlin, Brandenburg, and elsewhere in the country. In addition, the question of whether the names of other victim groups should be included in the memorial remained an issue.[25]

The German Bundestag, meanwhile, joined the discussion over the memorial at a very late date (its members realized, as soon as Chancellor Kohl had announced his veto in the summer of 1995, that their participation was vital to the discussion). On May 9, 1996, the fifty-first anniversary of the defeat of the Nazi regime, the Bundestag met to discuss the memorial, mostly with the initiative of SPD representative Peter Conradi. He was supportive of building the memorial, especially in conjunction with the capital's move to Berlin. The majority of representatives supported the memorial but expressed disappointment with the submissions from the 1994–95 winners.[26]

Between January and April 1997, a three-day colloquium for the memorial was held. Each of the three sittings was organized around themes and the commentary of ninety participants—invited scholars from different disciplines as well as representatives from public life.[27] These sittings were meant to facilitate negotiation between the commissioners and scholarly discourse and were to have been moderated by a public personality. In the end, however, only those who were trustworthy to the government, the Senate, and the Association were invited, and the group ended up being fairly identical to the commissioners. Critics of the process were not invited. It became clear that there was a consensus that a memorial should be built but that the issues of placement and aesthetics were deeply divided. Berlin Senator Peter Radunski, in the name of the commissioners, suggested that a new commission be established that would call on new artists to make new entries.[28]

The placement of the memorial, its relationship to sites in the city, and its size all were factors in the controversy. After the area was chosen, new alterna-

tives were made, each of which required a research report about its historical background. One strong opinion against the placement was that it had no relationship to the sites of perpetration (i.e., the concentration camps and death camps) where the murder of the European Jews had taken place. Others suggested that there was no clear explanation of the connection between this area and the governmental center of Berlin. It seemed to some, such as Salomon Korn and Bruno Flierl, that the relationship between this area and the Topography of Terror (where a temporary exhibition had already been installed) was not made clear enough. The size of the minister garden was also criticized: Its monumentality was seen as an insufficient parallel to the greatness of the crimes committed by the perpetrators.

Finally, the area is in the middle of a heavily trafficked street network that could hardly evoke a space of quiet honor and remembrance. It is bordered on the west by Ebertstrasse, on which the Berlin Wall had stood from 1961 to 1989, on the north by Behrenstrasse, and on the south by the extended Französische Strasse, for which a traffic concept had, at that time, not yet been developed. This network of traffic was seen as "meaningless" or "isolated." The production of meaning, others disputed, would occur not on the space alone, but it would be generated through the connections and relationships between Brandenburg Gate and the Reichstag, Pariser Platz (the area on the eastern side of the Brandenburg Gate), the Tiergarten, and Potsdamer Platz, which would develop after the memorial was installed. At the end of the colloquium, the three commissioners of the memorial, the German government, the Association, and the Berlin Senatsverwaltung for Scholarship, Research, and Culture voted to keep the original memorial concept, but they voted to not realize any of the first submissions.[29]

A Findings Commission was established that consisted of Prof. Dr. Werner Hofmann (former director of the Hamburger Kunsthalle), Prof. Josef Paul Kleihues (Berlin architect), Prof. Dr. Dieter Ronte (director of the Bonn Kunstmuseum), Prof. Dr. Christoph Stoelzl (general director of the German History Museum in Berlin), and Prof. Dr. James E. Young (Amherst, MA).[30] This group was responsible for inviting artists and architects, consisting of groups and individuals from the first group of winners, other participants who had submitted proposals for the first commission, and new artists. About a dozen internationally recognized artists and architects were invited, including Peter Eisenman, Jochen Gerz, Rebecca Horn, Dani Karavan, Daniel Libeskind, James Turrell, and Rachel Whiteread.[31] The public viewed the shrinking of the group to renowned participants positively and with high expectations.

The second call for entries is markedly different from the first. The concerns and arguments that took place in the preceding years clearly influenced the writing of the second call for entries. James E. Young's impact on the new committee was vital, for the call for entries emphasizes that "memorials

of each country embody the experiences of these nations, self-idealization, political necessities and artistic traditions"—one of the central themes in his scholarly work on Holocaust memorials. Markedly different in the second call for entries is the description of the missing Jews:

> Each interpretation of this crime (the Holocaust), which alone reduces it to the horror of destruction, misses the enormous loss and emptiness, which it left behind. The tragedy of the mass murder of the Jews is not only that the people died in such a terrible way (many millions of other people were killed in similarly horrible ways), but also that so many are gone irretrievably. An appropriate memorial concept would take into account the empty space, which stayed behind and will not limit itself to the memory of terror and destruction. What was lost must be remembered, just as much as how it was lost.
>
> With the memorial to the victims, the Germany of today remembers the deeds and the enormous, irretrievable loss, the remaining empty space, which it left on the continent.[32]

The new call for entries recognizes not only the deeds of the Germans but also the missing people.

Regarding the physical placement of the memorial, the second text emphasizes the memorial's position as a "central square," easily accessible to visitors, and providing new entrances to, for instance, the Tiergarten (city park):

> With its function as a new and central but publicly accessible and unbuilt entry square between the inner city and Tiergarten, the memorial's placement will stimulate its contact with everyone who uses this passage. The pedestrian traffic should be pulled into the area around the memorial, rather than be strongly pushed away to the surrounding streets. The area is large enough to produce a space of quiet with its fitting protection, as well as to announce, through its open structure, a necessary "invitation."[33]

Physical context in the present takes precedence over physical space in the past: unlike the first call for entries, in the second, there is no mention of Hitler's bunker.

Nineteen submissions were made and four were named finalists in November 1997. The Findings Commission chose works from Gesine Weinmiller, Richard Serra/Peter Eisenman, Daniel Libeskind, and Jochen Gerz. These four submissions, together with the works from the previous competition, were exhibited publicly and were accompanied by presentations by the artists

and architects.[34] Jochen Gerz's proposed model, entitled "Why?" consisted of posts throughout the entire memorial grounds, the word *why* appearing as neon script in all of the languages of the murdered Jews of Europe. An adjacent learning center, "The Ear," would house a room containing video testimonials from the Shoah Foundation, as well as a room staffed by Israeli exchange students, who would be willing to help answer the question *Why?*

Daniel Libeskind's entry, "Stone Breath," consisted of walls with perforations. When the wind blew through the perforations, viewers were meant to hear the wind, which, according to the architect, encouraged viewers to consider the breath of victims.[35] Gesine Weinmiller's "Broken Star," meanwhile, was an abstract field of rectangular forms that, when viewed from a platform, anamorphically formed a Star of David. Among some of the more radical submissions was Reinhard Matz and Rudolf Herz's conceptual memorial, which required that a one-half mile stretch of the autobahn would enforce a speed reduction to 60 mph—a shock to most German drivers.

Weinmiller and Eisenman/Serra were chosen as the two winners. Young describes Weinmiller's model as one that embodies "quietude, understatement, and magical allusiveness." Young described Eisenman and Serra's model as "audacious, surprising, and dangerously imagined." Meanwhile, consensus gathered around the Eisenman/Serra model.

Discussions about the presentations were organized with the Bundestag president, representatives of the Senate parties, and well-known art critics. In January 1998, Chancellor Kohl made it public that he favored the work by Eisenman and Serra, who were, however, asked to revise their work. As a result of this request for changes, Richard Serra pulled out of the competition, publicly stating that he left for "personal and professional reasons."[36]

Among Chancellor Kohl's requests, the number of stelae would have to be reduced from four thousand to two thousand, and trees as well as an exhibition center would have to be integrated. Kohl wanted a space into which viewers would be invited and felt that the enormous number of stelae would serve to keep visitors away rather than invite them inside. Whereas Eisenman and Serra's model started at the sidewalk, Chancellor Kohl wanted to soften the perimeter of the sculpture. Trees, for instance, would create a more inviting periphery, making the site more like a traditional graveyard than a giant minimalist sculpture.

Such an approach to the design, with changes and revisions demanded by a commissioning body, was not acceptable to Serra, for whom the viewer's comfort level with a work of art had never been a priority. In fact, Serra's works rethink public space as one of confrontation between viewer and work of art. Viewers can approach and walk around his sculptures in public space but in their very accessibility they confront and confound the viewer: Serra was pre-

cisely interested in the ways in which sculptures block bodily movement from one point to another—whether in a gallery setting or in public spaces. He is infamous for his 1981 *Tilted Arc*, commissioned by the General Services Administration for Jacob K. Javits Plaza and the adjoining Federal Building, in Manhattan (discussed in Chapter 4), for which walking and physical context were vital to the work of art. For Serra, making the changes that Chancellor Kohl had requested was tantamount to destroying the work of art. Eisenman, on the other hand, as an architect used to working for patrons who frequently request changes in his designs, was willing to meet Chancellor Kohl's demands.

Just after the final revisions were accepted, it was discovered that the company responsible for the protective coating of the stelae, Degussa, was a child company of the one that was responsible for making Zyklon B gas, which was used in the gas chambers. The memorial itself became a site where the inheritance of the Nazi era is not only an inheritance of attitudes but also of money. Corporations in the postwar period were built on corporations of the Nazi period. To the Association's credit, the plan went forward. At every turn, decisions regarding the memorial encountered the Nazi past. It was time to make the past public—and part of the memorial.

The decision process hit another wall, however, when Berlin Mayor Eberhard Diepgen made it known that he was against the submission, the placement, and such a memorial altogether.[37] The fight became a national voting issue, until the secretary of culture of the SPD, Michael Naumann, suggested that a final decision should be made after the vote. The entire problem was shifted to the new Congress (Bundestag) to decide at the end of August 1998 or the beginning of September 1998. The memorial debate continued after the newly elected Bundestag in September 1998 began its sessions, when a need for the Congress to make a decision regarding the memorial became more pressing. In 1998, Gerhard Schröder was elected chancellor. In January 1999, Michael Naumann, the SPD secretary of culture, suggested the form of a combination of a "house of memory" with a memorial, with Peter Eisenman's submission in mind. Eisenman then designed an exhibition and library building. But how would the "house of memory" be filled? How should the documentation center differentiate itself from the other documentation centers already in Berlin? The newly formed Committee for Culture and Media (with Elke Leonhard as chairperson) prepared the ground for a decision for exhibitions and recommendations. The first meeting on March 3, 1999, consisted of members of the commissioners from 1997–98 as well as various experts and scholars. The second meeting, on April 20, 1999, in the days before the newly opened Berlin Reichstag, was dedicated to the connection between the memorial and the structure of the other memorial sites in

the city. The "combination" model was accepted. It was decided that by June 25, 1999, a final decision had to be made between either a memorial in the original conception or a combination of a memorial with a house of memory (favored by Secretary of Culture Michael Naumann).[38]

In January 1999, the Association decided on a memorial that would include a vast field of stone pillars, a 65 ft. high wall of books, and a research center for scholars. Chancellor Schröder approved of the decision and waited for parliamentary review. The government was ready to move to Berlin later that year, and the indecision of how to fill that space had become an embarrassment. Michael Blumenthal, a former U.S. Treasury secretary and head of the new Jewish Museum in Berlin, negotiated between Eisenman and Michael Naumann. The number of pillars was to be reduced from twenty-eight hundred to around two thousand, and a building called "the House of Remembrance"—consisting of an atrium and three sandstone blocks—was to be added. The building—an archive, information center, and exhibition space—was to be flanked by a thick, 100 m long wall to house one million books. The Wall of Books would contain works for scholarly use and was intended to symbolize the Schröder government's concern that the memorial be educational and useful rather than backward-looking and symbolic.[39] On January 26, 1999, the Parliament voted 314 to 209 (with 12 abstentions) to approve Eisenman's project. Mayor Diepgen denounced the project for its "monumentality" and said it would have no resonance for future generations. The Senate also approved, with a 325 to 218 vote, that the building should be only dedicated to Jewish victims. In response, Salomon Korn, a German-Jewish leader, expressed regret, saying that the decision created a hierarchy among the victims.[40] The former East German theologian Richard Schröder and SPD politician suggested that there also be a monument with the words, "do not kill" included at the site, written in all languages spoken by the Jewish victims. Throughout 1999, former Berlin mayor Diepgen continued to oppose the memorial and the debate continued in Parliament.

In July 1999, there were public worries over whether the twenty-seven hundred stelae would be vandalized, and if it would need police protection. The cost of the memorial soon became an issue, for the "House of Memory" would be more expensive than the planned DM 20 million. The costs increased to DM 50 million. In the meantime, the chairman of the German Sinti and Roma, Romani Rose, announced his support of a government-sponsored memorial to the five hundred thousand Sinti and Roma victims of the Nazis. By January 2000, there was no estimated time for completion of the memorial and part of the land's ownership was being disputed. Diepgen refused to attend the symbolic ground-stone laying ceremony on January 27, 2000, which sent the public into an uproar.[41] Chancellor Schröder, Parliament President Johannes

Rau, and Elie Wiesel, however, were in attendance. Chancellor Schröder called the symbolic event "a clear sign for not forgetting and an opportunity for a more intense discussion with the German past."[42] It was indeed a symbolic event, for it was a ground-stone laying ceremony where not a stone was seen. Soon after, an information board at the site was installed. It stated the following: "Beginning of construction 2001."

The last plan, decided on in July 2000, included an underground "House of Information,"[43] with projected costs of DM 50 million. "The Place of Information" cost DM 20 million, while the field of stelae cost DM 15 million.[44] There, an 800 m² exhibition space was planned, called "den Opfern Gesicht, der Erinnerung historische Bestimmtheit" (the Face for the Victim's Precise Memory). In December 2000, Michael Naumann resigned from his post as secretary of culture.[45] Julian Nida-Rümelin took his place.[46] A curatorial team was founded as part of the Foundation for the Memorial to the Murdered Jews of Europe, with Wolfgang Thierse, Bundespräsident, as chairman. The curatorial board of the memorial decided on an underground exhibition space, designed by German exhibition designer Dagmar von Wilcken.

The Berlin Holocaust Memorial was opened in 2005 with an accompanying "Site of Information." A total of 2,711 stelae undulate throughout the site. When one first encounters this massive memorial—the size of two football fields—one might immediately think of a cemetery. Cemeteries in Berlin, however, are frequently dotted with trees and shrubs and architectural details that range from small garden pavilions to statues—as well as to gravestones. In the underground exhibition space, four 150 m² rooms are named the Room of Silence, Room of Fate, Room of Names, and Room of Places. In the Room of Fate, one can trace the fates of single families. The stelae from above grow like gigantic stalactites from the ceiling, entering the underground space. Unlike those above, these upside-down stelae are lit from within. In the Room of Silence, squares of glass on the floor, in the pattern of the stele field above, are lit from below and inscribed upon from above.[47]

As noted above, Richard Serra withdrew from the competition, but his influence as a sculptor on the initial design for the memorial and the elements that Eisenman retained have been overlooked. By examining Serra's earlier works that either refer to the Holocaust or that utilize stelae-like forms, we can gain a more in-depth understanding of how Serra's understanding of the body, memory, and walking help generate meaning in the final version of Berlin Holocaust Memorial—even though it does not bear his name. By revisiting Serra's earlier works, in other words, our understanding of the Berlin Holocaust Memorial becomes more nuanced and more focused regarding the relationship between memory and walking.

## Serra: Kyoto Zen Gardens and Walking

In 1968, Serra made a six-month visit to the Myoshin-ji gardens in Kyoto, Japan, a visit that radically impacted his approach to sculpture and the body's role in relation to it.[48] Kyoto's Zen gardens impressed the artist for their rejection of Western spatial systems, including the Renaissance "window on the world," which encourages a single perspective, with orthogonals that lead the eye to the background of a work of art. Instead, for Serra, the gardens encourage peripatetic engagement, with multiple views at one time. As one walks along the ambulatory pathways of the Zen garden, the visual field that the viewer encounters is not framed in the traditional Western system of perspective: neither the viewer nor the work of art is situated in a fixed position.

The gardens, Serra explains, are rigorously concerned with the placement of objects, such as rocks, sand, and plants, along circular ambulatory paths. While one walks through the garden, the whole of the space "emerges only by constant looking." Serra writes, "Six weeks in the temple and gardens opened the issues of how one perceives and experiences space, place, time and movement. The gardens demanded clarity of attention. One had to analyze the abstract place-ment of the stones as well as grasp the syncretistic complexity of the whole."[49]

The viewer's focus in the garden is directed toward both individual elements and the overall design. "Constant looking" implies that as soon as the gaze alights on the rock formations, it is encouraged to continue looking for other rocks as well as for the negative spaces between them. In a conversation with curator Lynne Cooke about his visit to Japan, Serra describes his experience of the Zen gardens as "embodied vision": "The act of seeing and the concentration of seeing take an effort. The gardens impose that effort on you if you want to see them. It's another way of ordering your vision, and it slows down your vision."[50] Slow walking, slow looking, and the slow experiencing of space were all a part of Serra's understanding of the gardens. Vision itself slows down, which, in turn, forces the body to slow down. Serra translated his new experience of peripatetic viewing into visual form in his outdoor sculpture *Shift* (1970–72).

*Shift* consists of six sections of concrete triangular forms that seem to slice into the landscape, providing openings for movement depending on the side from which one approaches the sculpture. The wedges in the land clarify and define the hilly terrain, calling attention to dips and rises in the ground. Art historian Yve-Alain Bois notes, "as early as *Shift*, Serra has insisted that the spectator discover, while walking within the sculpture, the formless nature of the terrain: the sculptures point to the indeterminacy of the landscape. The sculptural elements act as barometers for reading the landscape."[51] Walking itself takes time because the viewer, ideally, should perceive the sculptural parts as individual objects, and, at the same time, understand the sculpture as a

whole. Serra remarks, "*Shift* takes at least an hour to see, just to walk and view it. The work was an extension of stepped elevations. . . . The land defined the work, the elements pointing to the landscape as it undulates in various directions. The dialectic of walking and looking into the landscape establishes the sculptural experience."[52] I want to point out the role of undulation in the above excerpt, as this very experience of a wavelike perception of the land reappears in the Berlin Holocaust Memorial. One walks through an undulating landscape, experiencing the negative space around each object, and finally understanding both positive and negative spaces—as well as the act of walking—as the work of art itself. Such a description, including the undulating landscape, seeing the work in time, walking, and looking, illuminates Serra's contribution to the design for the Berlin Holocaust Memorial.

Thus, for Serra, walking is related to memory: the act of walking around "includes and is dependent upon memory and recollection."[53] The discovery of walking and memory in Zen gardens was a breakthrough for Serra, which informed all his subsequent works. In 1993, *Snake Eyes and Boxcars* (Figure 5.3) was installed on private property in California. It consists of six pairs of stelae of forged weatherproof steel, installed on a slope. Each cube-like stela is black in appearance against the natural landscape and invites the viewer to wander between them. As a work in the land that includes undulating stelae, it foreshadows and functions as a precedent for the Berlin Holocaust Memorial. The hill is grassy and surrounded by trees. Depending on where one stands, hills or the dense growth of trees may appear in the background. Cooke writes that in physically interacting with *Snake Eyes and Boxcars*, we encounter a generally viewed space that we must experience bodily by navigating through it, which, in turn, provokes contemplation and memory, a strategy the artist had discovered in the aforementioned *Shift*.

In preparing *Snake Eyes and Boxcars*, Serra explored the grounds on which he would install the work, both on-site and off: he both walked the site's undulating ground and traced his fingers over a topographical map of the area: the shape of the land mattered. He placed the first of six pairs of stelae at the brink of a slope and the other pairs further down the hill. Each pairing was of two different heights, thereby exaggerating the undulation of the ground. One experiences form, landscape, and memory—but Serra means to leave the exact kind of memory unspecified. Is the viewer's memory of the shape of one form layered on to the next form, as the visitor ascends or descends the hill? Or is the viewer prompted to remember other sorts of things altogether? Serra leaves his articulation of memory vague, thereby allowing for the multiple aspects of memory to exist together.

As discussed in Chapter 4, in 1992, shortly before he began working on the USHMM commission, Serra accepted an invitation to create an ephem-

eral memorial in the Stommeln Synagogue in the Rhineland—a space in the city of Pulheim marked for Holocaust memory nine-month rotations of works of art. This project was much smaller than the Berlin Holocaust Memorial— and it was temporary. By invoking his understanding of the physical context of his works of art, memory, and his personal relationship to Judaism, Serra found a space to articulate his relationship to the past. While one could have navigated around the sculpture in the synagogue—as one would when viewing any sculpture, if given the space—*The Drowned and the Saved* does not necessarily encourage walking. Indeed, it functions more similarly to Serra's well-known self-contained indoor works.

In 1995, Serra was commissioned by the USHMM to create a work of art for the Art for Public Spaces Program, which was dedicated to commission artists to create works of art appropriate to the museum (see Chapter 4). Entitled *Gravity* (1993–95), it is displayed in the Hall of Witness, at the bottom of a staircase, "appearing as if it has fallen into the stairs, slicing into them from above."[54] As Mark Godfrey explains, Serra avoids allusions to the Holocaust in interviews about the work and states that the viewer should "discern the space physically rather than optically"—that is, the viewer should move around the object to be able to perceive it in its entirety.[55] As it is located at the base of a stairway, visitors can either navigate around the sculpture or walk by it (the sculpture is positioned in such a way that the viewer has a choice) in order to continue on their way. Put in the path of foot traffic, the sculpture assumes walking to be a part of viewing—a theme Serra had started thinking about in 1968 in Kyoto and that he continued to employ in all works, including *Gravity*.

For some viewers, walking around *Gravity* and experiencing the sculpture as a generator of negative space through which the viewer navigates is not enough: viewers want to find more explicit connections to the Holocaust. As in all of Serra's works, a factory-printed number marks the sculpture as having *not* been made by the artist's hand. On *Gravity*—and in the context of the USHMM—viewers might want to associate that number with the Holocaust and the tattooed numbers on victims' and survivors' arms from Auschwitz, an association Serra would never have encouraged. The function of so much contemporary art is to resist clear meaning and to instead allow viewers to generate a free flow of interpretations. In the case of the USHMM, however, creating a plethora of meanings could undermine the explicit mission of the museum: to make clear the murderous program of the Nazis so that the Holocaust may never happen again. Thus, works of contemporary art in the museum are in the tenuous position of being works of contemporary art—that is, of being works whose meanings are often left up to the viewer to discern—but also of being supportive of an exhibition program that needs to fix a definite meaning to the artifacts and objects in its exhibition spaces.

Important for the analysis here, too, is the potential for minimal works of art to function in a way that promotes imagination. In fact, Jeshajahu Weinberg, the director of the USHMM, stated that the Art in Public Places Program should be a counterpoint to the historical museum exhibitions and that they should promote contemplation and imagination.[56] These two memorials, *The Drowned and the Saved* in the Pulheim Synagogue, and *Gravity* in the USHMM—in conjunction with the earlier works in the landscape, such as *Shift* and *Snake Eyes and Boxcars*—provide a context of artistic production for how Serra approached his design for the Berlin Holocaust Memorial. Ballast, weight, undulation, and stelae come together in this gargantuan memorial model, created with Peter Eisenman. In fact, Serra is a part of a long Western tradition of linking walking with memory, which, in turn, can help us better understand how memory is activated in the Berlin Holocaust Memorial.

## Theorizing Walking and Memory

I now turn to accounts of memory that invoke perambulation, to equip us with new theoretical tools with which to better understand the Berlin Holocaust Memorial. Here, we begin far back in history: namely, with Rome. Roman rhetorician Quintilian recounts the myth of the origin of memory in his *De Oratore*.[57] In his telling, the nobleman Scopas of Thessaly held a banquet and hired the poet Simonides of Ceos to write a lyric poem in honor of his host. Simonides did so, but he changed the poem to include a passage in praise of the twin gods Castor and Pollux. Partly in anger and partly in jest, Scopas told the poet that he would only pay him half of the sum agreed upon for the song and that Simonides must obtain the balance from Castor and Pollux, to whom he had devoted half the poem. Shortly thereafter, a message was brought to Simonides that two young men were waiting outside who wished to see him. He went to meet them but could find no one. The mysterious visitors—presumably the twin gods—had in fact saved Simonides's life, for during his absence the roof of the banquet hall collapsed, crushing Scopas and all the guests beneath the ruins. The corpses were so mangled that the relatives who came to take them away for burial were unable to identify the bodies. Simonides, however, remembered the seating arrangement and therefore was able to identify the bodies. He is recognized as having invented a theory of memory based on space and order, but he is only recognized as such because the relatives of the deceased believed what he claimed, accepting that he was a good witness. As Amos Funkenstein asks, "Did the Greeks take into account the possibility that an eye-witness might be lying?"[58] Because no one was there to disprove him, Simonides's account was accepted and the origin of the art of memory is based on the supposition

that Simonides did not lie. If Simonides was considered to be a good witness, he was also a survivor, and so the tale embodies the double meaning of the word *witness*, both as "one who sees" and "survivor."[59] Group death, a supposed witness, the ability to order and store information, and the ability to walk away and remember are, therefore, integral parts of the theory of the mythical origin of memory. A kind of visual imprinting, dependent on the body's movement away from the scene, took place. The origin of memory is then based on a firsthand witness and privileges what one sees firsthand. To know what one knows, one must walk away from the scene.

There are other examples among the Romans of how motion, memory, and architecture were also connected. Frances A. Yates demonstrates how the ancients used the repository metaphor to create an "Art of Memory" to be used by orators. According to Cicero's formulation of this art, she relates, one must first associate an idea with an image. The memory worker then chooses an empty building (*locus*) filled with ledges, rooms, and balconies. By placing the images (*imagentes*) on the various architectural spaces of the imaginary room, the rememberer need only revisit his house and remove the objects in the correct order. The technique was used primarily by rhetoricians to remember entire speeches. By changing their rhetorical key points into images, orators could retrieve those points in the correct order. The orators had to follow certain rules so as to avoid hesitation during the process of recall. They had to choose, for instance, routes or buildings that were easy to remember, without allowing great distances between objects that might prove detrimental to easy retrieval.[60] Walking through a building is necessary in order to retrieve the memories that will help the orator remember his speech. The two modes of memory from antiquity are (1) based on firsthand experience, and (2) based on argumentation of a point. In both examples, the body is activated to move—to walk.

Walking has been associated with religious rites involving memory, especially in the Middle Ages. Maurice Halbwachs describes how pilgrims walked along the Via Dolorosa, thereby participating in collective memory—pilgrims walk the same route Jesus walked to his crucifixion; through retracing his footsteps, the memory of the Passion becomes inscribed in their minds.[61] Even when unable to visit Jerusalem, pilgrims enacted the scenes of the Passion in their own villages. For Halbwachs, these walks were fundamental for inscribing collective memory for a group. Mary Carruthers further explores this theme in her research on pilgrimages in Jerusalem. She states that "pilgrimage routes became a path in physical actuality for 'making one's way through'" biblical readings.[62] Here, walking was viewed as enacting a set of stories in order to remember those stories.[63] Walking, Carruthers argues, is not simply a matter of memorization. An object can prompt memory. Just as, for instance, the fictional creation of a building can aid an orator to remember his ideas in sequence, so,

too, can a more contemporary example, such as a memorial, provide a location that activates memory. Carruthers, in the midst of her discussion of medieval memory, turns to the Vietnam Veterans Memorial as an example of *memoria rerum*—remembering things. The memorial does not tell a story, she writes, but rather "invites—even requires—story-telling from those who see it."[64] What Carruthers does not mention is that in order to experience the Vietnam Veterans Memorial fully, one must actually walk along its two "arms" of 120 ft. each. Either remembering stories or telling stories to oneself as one walks and visits the memorial is intrinsically involved while experiencing the site. One remembers stories as one traverses the empty, negative space in front of the memorial—the negative space of the memorial—and it is to the idea of walking and remembering in negative sculptural space that I now would like to turn.

When one studies the visual arts, a basic understanding of positive and negative space is vital. In the case of sculpture, negative space is that which is not a part of the material sculpture itself but rather consists of the empty space around a work of art. Understanding negative space is integral to the training of artists. Students of art may be asked, for instance, to draw a nude figure by drawing the negative spaces around the figure. When one draws a bent arm, for instance, one starts by drawing the negative, empty space between, say, the bottom edge of the arm and the edge of the torso. Negative space in sculpture is just as important, as it changes shape as one navigates around a three-dimensional work of art. Both negative and positive inform one another and are integral to works of art.

In Edmund Husserl's account, as one moves from point A to point B, one recognizes one's own body as being the center of movement. It is in recognizing other kinds of objects—whether stones or other people—that one understands one's own kinesthetic possibilities, and those of others. It is here that empathy between people can occur. If Husserl is right, then walking among the stelae in the Berlin Holocaust Memorial generates a similar form of empathy; one's body is seen in relation to the stelae and only later in relation to others. The self, as a living body, only matters in conjunction with other living bodies. And it is life, ultimately, that is valued and explored while walking through the memorial. Or, one might encounter the empty spaces between the stelae as necessarily disturbing and disruptive; one might encounter what Eisenman and Serra called "the voids" of the memorial.

Referring to empty space around public art—negative space, that is—Russian conceptual artist Ilya Kabakov argues that it is precisely in emptiness that we can find meaning in public space, for as viewers of public space, we traverse the empty spaces between things.[65] It is in our traversing of space that meaning is generated. For Kabakov, it is not dialogue but the space between things that allows the viewer a space of thought. Kabakov suggests that there

are typically three different kinds of viewers of works of art in public space. First, we have the "master of the place." He or she is an inhabitant of the city, the streets, and the country where the artist has been invited to build his work. That person knows the streets and the shops and the monuments. He or she can either accept or reject a work of art placed in his environment. If that person accepts it, they may stop and look at the object. If they reject it, they will continue to walk and to ignore that object.

The second kind of viewer for Kabakov is the tourist—one who runs around the globe looking for the unique object that will reflect some trait about the place. That object will be worthy of a photograph to take home and signifies the uniqueness of the trip, as well as the ability of the tourist to recognize the object's unique qualities. The tourist considers him- or herself an outsider and someone who is able to see the most compelling elements of a landscape that perhaps even those who live there cannot or do not want to see.

Finally, Kabakov describes the flaneur (nodding to Walter Benjamin, and Baudelaire before him), the solitary passerby, who contemplates various distracting subjects, problems in life, culture, or his or her own memories. "In this case," writes Kabakov, "the public project [i.e., the work of public art] must fulfill the needs of the viewer who is escaping and is submerging into some kind of imagined space, such as the past, for example, which invokes certain associations and memories."[66] The work of art, in this example, provokes the flaneur to imagine different places and times.

There are limits to Kabakov's three viewers, however. When he writes that the master accepts or rejects works of public art in his or her everyday life, Kabakov assumes that walking takes place *outside* of the monument. In Eisenman's model, however, the master walks *within* the work of art. That is, he or she walks in the empty spaces between the stelae. Once inside the work of art, the master can still accept or reject it but can no longer reject it and continue on his or her own way. The master can reject the stelae of the Berlin Holocaust Memorial, but, in order to leave the memorial, one must still walk through the undulating paths created by the stelae, thereby giving him or her time to reconsider their original judgment. When Kabakov writes of the flaneur as one who immerses oneself in the present in order to contemplate various distracting subjects, problems in life, culture, and his or her own memories, Kabakov does *not* seem to imply that one of those distracting subjects could be genocide. Still, at its basis, Kabakov's theory of viewing public art hinges on the viewer navigating the spaces between things.

Similarly, for French philosopher Michel de Certeau, the act of walking in an urban setting is akin to a speech act. "Turns of phrase" in language are analogous to "composing a path" in the city.[67] Language and walking are intertwined. Helpful in understanding the act of walking and memory is de

Certeau's contrast between the role of synecdoche and the role of asyndeton. For de Certeau, when walking is akin to the linguistic asyndeton, "it selects and fragments the space traversed; it skips over links and whole parts that it omits."[68] Walking in city space is like forming parts of speech.

Kabakov, however, does not only address those who walk through cities and activate their memories; he also addresses those who walk but choose a moment of stillness in order to contemplate and view a work of art. In his public work *Looking Up: Reading the Words . . .* (Münster, 1997), Kabakov via a work of art investigates the actions of a person who takes a moment to rest in a city park and to contemplate the sky. Until one gets close up, the sculpture looks like an oversized-antenna situated in a public park. When one lies down underneath the antenna-cum-sculpture, however, the viewer notices that words occupy the space between the lines of the antenna. The words are created out of thick, metal wire that, depending on light, can be difficult to read. Once read, however, the words encourage free-flowing, associative thinking that is not restricted by place, politics, or history: "My dear! You lie in the grass, looking up / Not a soul around / All you hear is the wind / You look up into the open sky, up into the blue above, where the clouds roll by / It is perhaps the most beautiful thing that you have ever done or seen in your life" (my translation). For Kabakov, freedom itself is the pleasure in being able to think whatever one will in a moment of rest, beneath a work of public art. Those words are captured in the form of a sculptural radio antenna, implying that we are all senders and receivers of information, of thoughts running through the minds of other people as they, too, lose themselves in the empty sky. When we are walking, and we choose to stop and contemplate, we are at the nexus of many other ideas and thoughts that are being generated by other people—all the time.

Psychoanalyst Dori Laub, meanwhile, analyzes the void as a metaphor for psychological trauma. Voids are effective in commemorating the Holocaust, for they allude to psychological trauma, a condition that Laub refers to as "an empty void" in the psyche.[69] The emptiness in the psyche is the massive loss that trauma victims carry with them—loss endlessly repeated through nightmares and in daily life (therapy's goal is to address that repetition and to guide a trauma victim toward functioning in daily life). Let us now take this theoretical paradigm of walking and remembering in the void to a more nuanced analysis of the Berlin Holocaust Memorial.

## Analyzing the Memorial through the Lens of the Theory of Walking and Memory

After Richard Serra dropped out of the competition, the model necessarily was attributed to Peter Eisenman. The more than twenty-seven hundred stelae undu-

late over a then rebuilt environment in the center of Berlin. No longer a wasteland between East and West (as it was in 1988, when Rosh and Jäckel first conceived of the idea for a memorial), the space, located between Potsdamer Platz, the city park, and the Brandenburg Gate, was by 2005 a fully fledged tourist destination. Edged with some trees, as Chancellor Kohl had recommended, the site welcomes visitors to explore—and visitors have a distinct set of reactions.

The viewer walks through the memorial of 2,711 stelae, constantly looking at the geometric forms, the ground below, and the sky above, taking the time that Serra discovered was needed in his visits to the Kyoto Zen gardens. One remembers the stelae just seen as one rounds a corner and sees another block that is similar, but different from the one just seen. As we walk through the memorial, we might "pick up" memories of the Holocaust that we have gleaned from family stories, historical accounts, film, or literature. These memories will not necessarily have an order, as Yates's theory of memory prescribes. Rather, as in Carruthers's discussion of pilgrimages, objects can prompt memory, inviting the kind of storytelling about the past she described when referring to the Vietnam Veterans Memorial.

At the Berlin Holocaust Memorial, we walk as a Kabakov-like "master," "flaneur," and "tourist"—all at the same time. The master is the inhabitant of Berlin who either accepts or rejects the memorial's presence. The tourist is the person who visits the site as one of many sites in Berlin, sometimes related to "Holocaust tourism," and sometimes related to general tours of the city itself. The flaneur most likely does not pass by with "an immense joy to set up house in the heart of the multitude," as in Baudelaire's sense, but rather remembers, allowing associations and memories to infiltrate the ambulatory experience of the memorial.[70] The act of walking in the memorial is not circumscribed to a particular path that one can repeat. We gather memories, judge the space, and, ultimately, we leave it—we walk away.

Similar to Kabakov's viewer of the work of public art in the form of a radio antenna, the visitor to the memorial can let free thoughts that he or she might experience in the negative spaces of the memorial. The memorial itself can be seen as enacting Kabakov's antenna in that it brings together many people who will be thinking about or pondering the Holocaust. When one walks in the memorial, one is not invited to lie down, as one is invited by Kabakov's antenna (one most likely would be trampled on by the next visitor turning the corner of another stelae, for instance). Still, even if one cannot lie down, one does see the sky. In fact, in myriad photographs of the memorial, the sky plays a crucial role, for the undulating outline of the stelae can best be seen against the blue or gray sky. We are free to look at the memorial and the sky at the same time.

A viewer who does *not* suffer from psychological trauma might stumble into the physical negative space of a memorial—a void—thereby enacting a

metaphorical encounter with trauma.[71] An ability to allow that void to be visualized in public space, however, is very much a historical and art historical dilemma, and one that Eisenman and Serra addressed in the artist statement that accompanied the original submission.

## The Artists' Statement: Reading, Walking, Remembering, and the Void in the Text

The artists' statement, which accompanied the original submission, explicitly refers to the voids and spaces that are necessary for remembrance, allowing the past to interweave with the present and the future. Eisenman and Serra write of the significance of both the ground and the tops of the stelae in creating spaces of instability, which, in turn, is metaphorical for two different types of time, narrative time and duration:

> Remaining intact . . . is the idea that the pillars extend between two undulating grids, forming the top plane at eye level. The way these two systems interact describes a zone of instability between them. These instabilities, or irregularities, are superimposed on both the topography of the site and on the top plane of the field of concrete pillars. A perceptual and conceptual divergence between the topography of the ground and the top plane of the stelae is thus created. This divergence denotes a difference in time, between what the philosopher Henri Bergson called chronological, narrative time and time as duration. The monument's registration of this difference makes for a place of loss and contemplation, elements of memory.[72]

When Eisenman refers to "chronological, narrative time" and "duration," he is loosely paraphrasing Bergson's notions of "time" versus "duration," or "homogeneous time" versus "heterogeneous time," respectively.[73] Homogeneous time can be broken up into bits that can be manipulated into thought and language—that is, intellectualized. Duration is heterogeneous time, where past, present, and future coexist.[74] In order to think about homogeneous time, which consists of an infinite set of moments laid out together, we have to "freeze" time. Duration, in contrast, cannot be measured.[75] Things in the world have a real duration, argues Bergson, "but the source of difficulty is in *the homogeneous space and time which we stretch out beneath them*" [my emphasis].[76]

If we see the concrete pillars as a visual mapping of Bergson's theories, heterogeneous duration occupies the undulating surface of the stelae, while "homogeneous time" occupies the ground. It is "stretched out beneath" duration. For Eisenman, embracing past, present, and future together with chronological

time was of primary importance. Eisenman concretizes Bergson's notions of time and creates spaces where the body navigates on homogeneous time (the ground), via perambulation, while being aware of heterogeneous time (the tops of the pillars).

The space is indeed a field of undulation, uncertainty, surprise, and exploration. Time and contemplation are invoked in the statement—as are disorientation and devotion. These themes are echoed in one of Eisenman's essays on architecture, entitled "Written into the Void," which focuses on the legacy of the written versus spoken word in architecture.[77] Eisenman proposes that architecture is a kind of language, and, further, that writing itself is a kind of architecture. The "void" is the abyss between spoken and written words.

The bodily experience of the visitor was most important to Serra, as he described in a joint interview with Peter Eisenman in 1998: "The theme here is the visitor's time and his or her individual movement."[78] Later, after Serra left the competition, Eisenman repeated this theme in an interview: "This monument tries to distance itself from traditional memorials and to make a more experiential space for the visitor. It becomes an experience of one's own body."[79] The experience of the body, in turn, can be understood as engaging in the act of walking so as to generate stories, in the way that Carruthers describes for pilgrims enacting the Passion. Those stories, in turn, might be about the past, present, and the future, or the space of what Bergson calls *durée*. We are walking through voids that, for Laub, enact a metaphorical encounter with trauma. The memory work continues after we leave, just as Simonides explains: we experience, we walk away, and then we remember. Memory is activated as the body moves through space, experiencing the ground, the sides of stelae, the negative space between concrete pillars, and other visitors.[80]

## Conclusion

A German citizen or an international tourist walks among the stelae, is confronted with strangers, and feels lost and alone. Every corner of every stelae, every open path, represents another point of view, another concrete memory of stories spoken, or silences noted. Robert Musil once noted that the danger in public monuments is that one can walk by them without taking any note of their significance.[81] It is hard to walk by the Berlin Holocaust Memorial without noticing it, for it is monumental in the space that it takes up. One would have to walk an entire city block, with the head turned toward the Tiergarten, to not see the memorial. It is easy to walk into it. The stelae around the outer perimeter of the monument are only a few centimeters above the ground, with shoulder-width walkways between the rows. One can easily stop, but when one stops, one cannot possibly see the memorial in its entirety nor experience the

negative spaces that it creates. In a sense, the stelae invite passersby to venture in. Once among the stelae, it will be hard to block out the thought processes—and bodily engagement with the objects—that most undoubtedly will occur.

The very public discussion about the memorial was a watershed moment in German history for its open dialogue about the past and the degree to which the public engaged in conversations about suitable visual approaches to the past. At the time of the debate, the discussion about the memorial practically became a memorial in and of itself, as Young has argued. From today's vantage point, however, Eisenman's memorial has generated publications, films, theater productions, and school curricula that demonstrate that the lessons of the Holocaust are still very much on the minds of Germans today. One might say that while the debate was a German memorial for the turn of the century, the actual memorial is a work of art for the twenty-first century.

# Conclusion

*Andy Goldsworthy: Nature and Memory at the New York Museum of Jewish Heritage—A Living Memorial*

OBERT MUSIL WROTE THE OFT QUOTED PHRASE, "There is nothing more invisible than a monument."[1] He claimed that people walk by monuments in their daily lives, but that those individuals rarely stop to think about the themes to which those monuments are dedicated. Less often quoted, however, are Musil's remarks on how a monument might avoid the pitfall of invisibility: "In short, monuments also ought to try a little harder, as we must all do nowadays! It is easy for them to stand around quietly, accepting occasional glances; we have a right to ask more of our monuments today. . . . Why doesn't our bronze-cast hero at least resort to the gimmick, long since outdated elsewhere, of tapping with his finger on a pane of glass? Why don't the figures in the marble group turn, like those better made figures in shop windows do, or at least blink their eyes open and shut?"[2] In short, Musil asks memorials to do more to catch our attention, to provoke us, and to encourage us to think. This study has attended both to memorials that are often overlooked in the literature (and on the street) and to those that introduce new forms of visual engagement, thereby attracting the attention of passersby. By looking at the overlooked, and analyzing their histories and reception, we learn a tremendous amount about how the Holocaust was understood at various moments in time and in different geographic locations. Those overlooked monuments are often invisible because the process of commissioning, designing, and subsequent reception of the works were hampered by attitudes that aimed to keep certain kinds of information—such as naming victims and perpetrators—silent. By attending to those that provoke—that

"tap on the glass" of our expectations, so to say—we learn that experimentation in visual form is most often acceptable when the commissioners, the publics, and the artists are ready to address the more difficult facets of the past.

A municipal group commissions a Holocaust memorial, either in an open call for submissions or by choosing an artist or architect. In an ideal scenario, commissioners outline the themes of the memorial and artists and architects try to fulfill those guidelines. But the process of commissioning a Holocaust memorial is never that simple. Sometimes commissioning bodies are unable to articulate fully what they would like to memorialize—or why. Artists, for their part, often rely on the visual strategies and styles they employed in previous works of art. Both groups' ideas are circumscribed by history. In the case of the commissioners, the degree to which their communities have come to terms with the past greatly impacts the language they employ in the commission—and in the bronze plaques that accompany memorials. Artists employ visual vocabulary with which they have previously worked, which, in turn, is often dictated by larger artistic movements and styles. Commissions, as James E. Young explains, are impacted by public attitudes toward the Holocaust—the collective memory of the Holocaust that is embodied in books, films, and political speeches. Further, consider this: when artists are commissioned in more than one country, their artistic choices migrate from one place to another. An overlapping of styles, artistic choices, collective memory, and personal memory ensues. In this book, I have attempted to investigate memorials in Germany and the United States by analyzing the commissions, artists' decisions, conclusions of juries, and the works of art themselves by foregrounding the language of commissions and the visual field. By "visual field," I mean the details of the final memorial, the works of art previously made by the artists (and that impact their approach to a commission), and the artistic dialogue prevalent at the time.

Language is a theme woven throughout this book. The language employed in commemorative plaques that accompany memorials often elides historical facts that, had they been mentioned, would have named perpetrators and victims. This was especially the case for early memorials, when, in Germany, the process of *Vergangenheitsbewältigung* (coming to terms with the past) had not yet been established. Examples include Gerson Fehrenbach's Münchener Straße Synagogue Monument (1964), the cluster of memorials at Hamburg Dammtor, and Will Lammert's Monument to the Deported Jews (1985). In contrast, the Jewish community in the United States was quite outspoken about the need for Holocaust memory, and the plaque accompanying Nathan Rapoport's Monument to the Six Million Jewish Martyrs in Philadelphia (1964) is an example of such explicit language.

Artists retained, adapted, or radically changed their visual vocabulary when fulfilling commissions. In West Berlin, Fehrenbach returned to an

already-designed sculpture and adapted it for the commission to memorialize the destroyed Münchener Straße Synagogue in 1963. The commission and the final work of art are ambivalent about Holocaust memory, an attitude that was prevalent at the time. Alfred Hrdlicka and Ulrich Rückriem utilized stylistic approaches that were already a part of their oeuvres for their respective memorials at Hamburg Dammtor in the late 1980s. Unfinished and easily overlooked, Hrdlicka's memorial is evidence that even by the late 1980s, West Germany was not willing to make outright statements about perpetrators and victims. In the United States, Joel Shapiro, Ellsworth Kelly, Sol LeWitt, and Richard Serra retained elements of their artistic practice when fulfilling commissions for the USHMM in 1993, creating objects that quoted their previous works of art. Some of those earlier works, in turn, were dedicated to the Holocaust. The purely abstract works in the APSP signify a major shift in attitudes toward the Holocaust. When the USHMM opened in 1993, it was a statement to the world that the story of the Holocaust was part of the story of the United States. So, too, when Peter Eisenman's Berlin Holocaust Memorial opened in 2005, the German government made a statement: The Holocaust is a part of Germany's story. The work radically shifted how a memorial could function, and how it could look. Importing stylistic innovations from the United States to Germany, Eisenman and Serra created a radically new terrain of memorial architecture.

Sometimes artists depart from their previous stylistic approaches, but the reasons for doing so vary. For instance, Will Lammert's model for the memorial at Ravensbrück integrated prewar expressionism, reflecting his own prewar artistic ambitions. The commissioning body saw neither the content nor the style of his model as appropriate for East German needs. As a result, Fritz Cremer, Lammert's student, redesigned the model, now called Burdened Woman (1959). In 1963, Nathan Rapoport departed from previous works that feature highly representational human figures and instead integrated abstract elements. The Jewish community in Philadelphia embraced his work, but this was not the case for the larger non-Jewish public, which was not yet versed in Holocaust history. Will Lammert's Monument to the Deported Jews on the Große Hamburger Straße in Mitte, Berlin, was belatedly installed in 1985 (it was designed in 1959) and consists of figures with abstract modeling, a new form for East German artists, and a sign that memory of the Holocaust was taking a new turn. Peter Eisenman worked together with Richard Serra to create the Memorial to the Murdered Jews of Europe (2005), which was heralded as a major contribution to memorial sculpture. The very public dialogue about the memorial became *the* conversation about Holocaust memory in the united Germany from 1989 to 2005. Finally, Andy Goldsworthy departed from his ephemeral works of art in

nature to create a work that is meant to stay in place for generations, thereby reflecting a need in the United States for a collective memory that embraces the environment, stability, and growth over time. In this conclusion, I turn to Goldsworthy as a final case study, for his work introduces yet another mode of artistic engagement with the past that also reflects the concerns of the present: an empathy with the natural world, which becomes metaphorical for empathy with Holocaust survivors.

## Garden of Stones

In 2002, Andy Goldsworthy received the commission for a memorial at the MJH in New York City. By that time, postmodernism had already heralded in a wide variety of artistic styles and media. Since the mid-twentieth century, the options for artistic practice have been myriad: one could work in traditional media, such as clay, stone, or paint, or one could choose to work with found objects, detritus, installation, sound, or land art. Since the 1980s, Goldsworthy has been using natural materials: ephemeral objects such as twigs, leaves, stone, or ice, among others. Meanwhile, the Holocaust was talked about to such an extent in the United States—in contrast to the early 1960s—that scholars had been writing about the "commodification" of the Holocaust, which had implications for art making. In 1995, the exhibition *Mirrors of Evil: Nazi Imagery in Contemporary Art* at the Jewish Museum in New York was met with controversy even before it opened. Conceptual artists employed found objects, such as Lego sets, in order to comment on the commercialization of the Holocaust and the ease with which genocide can be re-created in toys. Members of the public saw Zbignew Libera's *Lego Concentration Camp* (1996) as particularly offensive. The work employed already-existing Lego pieces to create a toy concentration camp—and the artist even created a Lego look-alike box that might appear on the shelves of toy stores. For many survivors, this work was going too far—it was trivializing a memory that was still raw. From the artist's point of view, however, the work demonstrated that the tools for something as horrible as the Holocaust are available in our everyday lives and that we all—even children—have the capacity for evil.

By 2002, the USHMM in Washington, DC, had record-breaking attendance from visitors from around the globe. Holocaust Remembrance Day was regularly observed by Jewish and non-Jewish communities throughout the United States. Memoirs, films, and television programs about the Holocaust continued to be produced. Amid what was, by the early twenty-first century, widespread acceptance of the importance of Holocaust memory, one might ask: Why commission yet another Holocaust memorial? An artist's work primarily consists of finding new visual forms to respond to ideas. When an

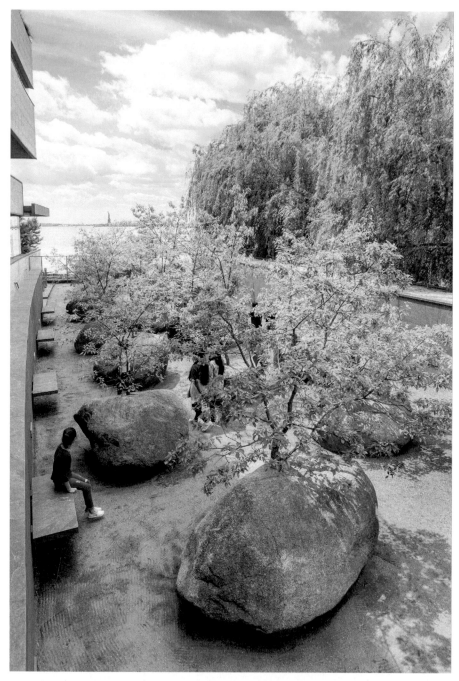

**Figure C.1** Andy Goldsworthy, Garden of Stones, 2003. Dwarf oak saplings, boulders. Permanent, site-specific installation: Museum of Jewish Heritage, Battery Park Plaza, New York. Sponsored by the Public Art Fund and the Museum of Jewish Heritage. (Photo: John Halpern. © Andy Goldsworthy. Courtesy Galerie Lelong & Co.)

artist chooses a completely new way of creating a public sculpture dedicated to the Holocaust, ideas are generated. Different ways of viewing history, the present, and the future are created.

The MJH in New York City is dedicated to Jewish life before, during, and after the Holocaust, and seeks to tell the history of American Jewry in the twentieth and twenty-first centuries, through the eyes of those who lived it. Permanent and special exhibitions, consisting of over twenty-five thousand artifacts, are complemented by Andy Goldsworthy's Garden of Stones (2003; Figure C.1), an outdoor installation meant to symbolize the fragility and tenacity of life.

This chapter, foregrounded by a discussion of Holocaust memorial culture in New York City, analyzes Goldsworthy's work in terms of his own artistic practice, the symbolism of trees, stones, and memorial gardens in Jewish culture, and German artist Joseph Beuys and his conception of "social sculpture," or works of art that involve the public and aim to heal society's ills. Specifically, I investigate Beuys's 1982 project, *7,000 Oaks* (Figure C.2), a project for which Beuys aimed to plant seven thousand trees, accompanied by basalt stones, in the city of Kassel. With Garden of Stones, Goldsworthy creates a new way of understanding the Holocaust—and he does so with a sympathy toward natural materials.

## Holocaust Memorials in New York City

In some ways, the history of the MJH can be traced to the unsuccessful attempt on the part of New York City Jewish communities to build a Holocaust memorial in Manhattan, the account of which appears in several sources.[3] Between 1947 and 1968 there were at least four attempts to create such a Holocaust memorial. In 1947, Adolf Lerner coordinated an effort and commissioned Jo Davison and architect Eli Jacques Kahn to design a memorial for Riverside Drive. Critic Heinz Politzer deemed the model "the worst features of sentimental nationalism" and the project was abandoned. A competition was thereafter announced by the New York City Art Commission, resulting in an exhibition of models submitted by artists including Erich Mendelsohn, Ivan Mestrovic, Percival Goodman, William Zorach, Leo Friedlander, and Chaim Gross. While the art commission approved the Goodman model, the Jewish community was not able to raise the funds and the project, once again, was left behind. In the mid-1960s, the Artur Zygelboim Memorial Committee tried to commemorate Zygelboim, a member of the Polish parliament in exile who committed suicide in London in the face of the Allies' inability to halt the Final Solution. Nathan Rapoport designed a sculpture of Zygelboim attempting to escape an inferno, which the committee deemed "horrifying." At the same time, the Warsaw Memorial Group, based in New

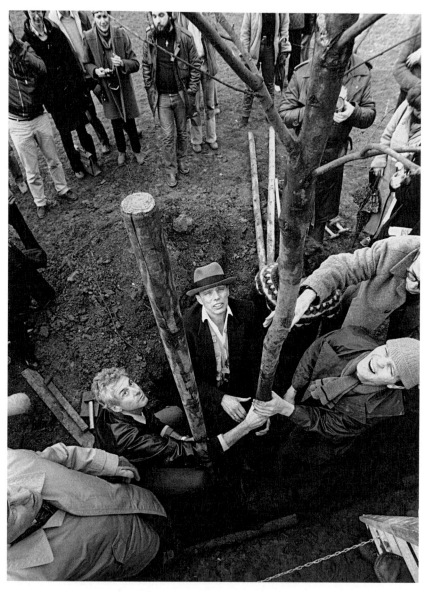

**Figure C.2** Joseph Beuys, *Aktion 7000 Eichen* (*Action 7,000 Oaks*; commonly referred to as *7,000 Oaks*). documenta 7, 1982. (© documenta archiv/Dieter Schwerdtle © 2018 Artists Rights Society [ARS], New York / VG Bild-Kunst, Bonn)

York, wanted to install a monument to commemorate the Warsaw Ghetto Uprising. In 1964 (shortly after the installation of his Philadelphia Holocaust memorial), Rapoport received the commission and designed *Scroll of Fire*, a sculpture in the shape of the Torah that depicts events of the Holocaust. The sculpture, however, was deemed too close to "special interests"—that is, too Jewish. The project for Riverside Drive was abandoned (today a brass plaque and informational plaques are in its place). In 1966, the Warsaw Memorial Group formed another commission, which invited Louis Kahn to be a member. Soon after, Kahn was notified that he was commissioned to design a Holocaust memorial for New York City.

His model was, in terms of style, far from Rapoport's Philadelphia Holocaust memorial of 1964 (see Chapter 2). Instead of utilizing a combination of figural and abstract forms, as in the Rapoport example, Kahn employed a modern, stripped-down aesthetic for which he was known in architecture. Consisting of a series of nine glass cubes around which visitors would be able to see their reflections, the model was revolutionary for the time. The model went through several changes, with the number of pillars reduced to seven (Kahn wanted to avoid the symbolism of the number six), and he sought a central pier to represent hope for the future. That central pier was subsequently redesigned to be hollow and to function as a chapel-like space. As Godfrey puts it, "The project encountered more problems, some financial, some institutional and some tectonic."[4] Kahn's death in 1974 terminated the project conclusively.

Departing from Rapoport's symbol-laden sculptures, Kahn's conception utilized a vocabulary of art making that would have been familiar to New York art world experts: minimalism. Minimalist sculpture, consisting of repeating forms and composed of simple materials, such as painted plywood, became *the* art form of the early 1960s. Artists such as Donald Judd, Carl Andre, and Robert Morris all believed at the time that art should not contain meaning, metaphor, or transcendental ideas. Instead, the artist should concentrate on making an object that takes up space in a gallery—space that confronts the viewer, making him or her aware of his or her own body in that very space. For example, Carl Andre's *Equivalent* series (of which *Equivalent VIII*, 1966, is an example), created out of 166 factory-produced firebricks, arranged in various rectangular forms. To astounded viewers at the time, there was no work on the part of the artist involving sculpting, arranging, or composing. Andre's point was that each work was "equivalent" because they all consisted of the same number of replicated firebricks. He also claimed that the work should "seize and hold the place": they should aggressively announce their presence in gallery space.[5] While Kahn chose a stripped-down form, it was not aligned with Andre's type of minimalism.

Kahn took his own interest in organic forms and the play of light on architecture to create a memorial that introduced an entirely new vocabulary of memorial making. Instead of aggressively seizing the space, as the minimalists would have it, his glass blocks function as evocative spaces of contemplation that invite viewers to meander around it. The model presented such revolutionary ideas for a Holocaust memorial that it was, in fact, rejected. Kahn's model was so devoid of symbols that the artist was encouraged by the commission to include *some* elements symbolic of Judaism. He complied and changed the model accordingly, incorporating a center dome-like structure with an eternal flame, but nonetheless the memorial was never built.[6]

The search to find a location for the museum and to create a living memorial gained momentum in the early 1980s, according to Ivy Barsky, former deputy director of the MJH. At that time, Mayor Ed Koch attended a Holocaust memorial service at Madison Square Garden, dedicated to survivors of the Warsaw Ghetto. As home to the largest community of Jews outside of Israel, said Koch, we need to do something to memorialize the Jewish victims of the Holocaust. He set up a commission—a task force dedicated to creating a "living memorial" to the Holocaust—one that did not focus on death but on the myriad aspects of Jewish life in Europe before World War II and in the United States afterward. This would become the MJH.

## The Museum of Jewish Heritage

The MJH is located on the waterfront at 36 Battery Place in Manhattan's Battery Park City, with a view of the harbor and the Statue of Liberty, firmly anchoring the museum to the history of Jewish immigration to the United States—about three million Jews immigrated to the United States via Ellis Island. The museum occupies a 112,000 sq. ft. structure designed by Pritzker Prize–winning architect Kevin Roche. The original building, with its six-sided shape and tiered roof, evokes the Star of David, intended as a symbol of the strength of the Jewish people and that encompasses Jews everywhere, including the six million Jews who perished in the Holocaust. The Robert M. Morgenthau Wing broke ground in November 2001 and opened in 2003. It houses rotating exhibitions and educational facilities while the main building provides space for the permanent exhibition of the history of American Jews, auditorium, and visitor services. Together, the physical context of the museum, including the Statue of Liberty and the symbolism of the architecture, convey a message of belonging, strength, and redemption.

The mission of the museum defines its role as a "living memorial," thereby differentiating itself from the USHMM in Washington, DC: "Created as a living memorial to those who perished in the Holocaust, the Museum

honors those who died by celebrating their lives—cherishing the traditions that they embraced, examining their achievements and faith, and affirming the vibrant worldwide Jewish community that is their legacy today."[7]

The phrase "living memorial" was first used in the United States in the post–World War I tradition of creating highways, buildings, stadiums, and gardens that functioned as "living memorials"—that is, memorials that would not just be statues to be visited but functional, large, public works that people use on a daily basis.[8]

The two biblical quotations that provide mottos for the museum's mission—"Remember, Never Forget" and "There Is Hope for Your Future"—focus the museum's perspective on the events of the twentieth-century Jewish experience. The remembrance of life before, during, and after the Holocaust is enriched and enhanced by a commitment to the principles of social justice, education, and culture in the Jewish community and beyond, goals that are reflected in the design of the architecture and exhibition spaces.

The entryway is an open, inviting interior space, filled with light, the geometric shape not easy to discern. The only object on exhibit in this space is a menorah, a traditional symbol of Jewish resistance and related to the heroic story of Hanukkah. The entrance to the Core Exhibition is straight ahead and leads to a darkened hallway that ends with the exhibition of a display case containing a Torah, which is core to Jewish faith as well as being a symbol of Jewish learning and religiosity. The Core Exhibition is organized around three themes, which are similar to those found at the USHMM in Washington: *Jewish Life a Century Ago*, the *War against the Jews*, and *Jewish Renewal*, each told on a separate floor. The Core Exhibition differs from other institutions of memory by telling the story of the Holocaust from the perspective of those who experienced it. Using first-person histories and personal objects, the museum explains the essence and beauty of Jewish life and serves as a repository for the memories of Holocaust survivors, whose stories will live on long after they are gone and will continue to teach future generations. Jewish Life a Century Ago begins with a multimedia room that contains numerous screens and voiceovers of interweaving stories attesting to the rich cultural life of Judaism one hundred years ago.

The Public Art Fund, in collaboration with the MJH, organized the competition that selected Goldsworthy's work for the site. A commission invited sixty artists to submit proposals and identified five finalists. The Holocaust survivors serving on the jury took the finalists through the Core Exhibition. They found Goldsworthy to be the most articulate about his work and the most sensitive to the messages of the Holocaust. The Public Art Fund's website states that "the Memorial Garden is a contemplative space dedicated to the memory of those who perished in the Holocaust and honoring those who survived."[9]

## Goldsworthy's Garden of Stones (2003)

Garden of Stones (2003; Figure C.1) consists of eighteen large gray boulders, each about 3–4 ft. in height and diameter, and each weighing 3–15 tons. It is situated on the eastern side of the museum, on the second-story roof terrace of the 2003 addition. The eighteen stones in Goldsworthy's work refer to the meaning of the number eighteen in Hebrew—"Chai," or "life." The artist worked with stonecutter Ed Monti to hollow out each of the boulders in order to create gigantic "pockets" in which dwarf chestnut oak trees grow.[10] The boulders are light, tawny-gray and have a fairly smooth surface. The ground on which they rest is covered in tan gravel and the boulders are situated in a staggered fashion. Depending on the weather, the sky may be reflected on the glass windows of the building on the left, thereby extending the natural element of the sky. The garden is surrounded by a 5 ft. high wall, and one can see trees growing over it from the other side. As the dwarf chestnut oak trees grow over time, they will fuse with the boulders as the trunks grow beyond the diameter of the opening.

Goldsworthy is a Scottish artist known for his painstaking approaches to the natural environment, creating ephemeral works out of leaves, twigs, or icicles, among other materials, as well as longer-lasting works. These works of longer duration, which he recently coined "projects," are nonetheless vulnerable to outdoor weather conditions. Whether the works are ephemeral or meant to last, Goldsworthy's working process remains the same. Hours of work, resulting in trial and error, ensure that the artist painstakingly gets to know the properties of the natural materials that he has chosen. He applies, for instance, golden leaves and pine needles carefully to one another (with saliva, not glue) in *Sycamore Leaves* (1987). The natural materials in such works remain in place until the work dries and the materials fall to the ground. Time and process are key for Goldsworthy, for each work is painstaking and requires hours—if not days—to create. For Goldsworthy, entropy—the natural destruction of art—is part of the work of art itself. This is also the case for his projects.

In *Wood through Wall* (1993, private commission), for instance, Goldsworthy takes an old stone wall, which he finds on the property, and rebuilds it to incorporate a horizontal tree trunk. The tree trunk is treated, so to say, as any other stone in the stone wall, and, like all stones in the wall, the other stones must fit neatly around it. But, unlike the other stones in the wall, the tree trunk, exposed to the elements, soon rotted away. The wall began to crumble. The challenge, explains Goldsworthy, is to accept the natural changes of entropy that happen to such works of art.[11] The crumbled wall is not a destroyed work of art but one that has undergone natural change due to entropy.

Like *Wood through Wall*, the memorial at the MJH was meant to change with time. While the boulders will remain in place, the trees will grow. Over

the years, the trunks have fused with the six-inch opening in the boulders and this, for Goldsworthy, is when the work is most beautiful. The trees may die (in fact, only one of the trees survived after the first year of installation and had to be replaced). Garden of Stones is one of the first Holocaust memorials created by an environmental artist that exclusively uses natural materials.

## Stones, Trees, and Memorial Gardens

A first step in understanding the significance of stones and trees in Goldsworthy's project is to better understand the significance of these objects, if any, for Jewish memory culture. Although there is no evidence that Goldsworthy knew of these connections, many of them are common knowledge in Jewish communities and therefore resonate with contemporary Jewish and non-Jewish viewers.

Stones have been used for mourning and memorialization since biblical times.[12] Idit Pintel-Ginsberg writes that "in the Bible, stones were mounted in heaps or erected as pillars (Gen. 31:45–46), to attest a meaningful event, as remembrance (Gen. 31:48; Josh. 7:26), and to mark sacred grounds (Gen. 28:18)."[13] Today, stones continue to be important in Jewish culture, as seen in the placing of a small stone on a tombstone of the deceased during a cemetery visit, known as Gal'ed—which derives from the ancient word meaning "a stone or a heap of stones that witnessed an event [that] has become marked off and become sacred."[14] Holocaust memorials employ stones and rocks such as the Treblinka Memorial, which integrates seventeen thousand stones, each representing a perished Jewish community, and the Valley of the Communities at Yad Vashem in Jerusalem, in which names of Jewish communities that were either fully or partially destroyed are carved in rocks.[15] Jews visit and kiss the stones of the Western Wall, or Kotel, on Jewish holidays and on the occasion of family celebrations. People tuck small scraps of paper with wishes written on them between the stones of the Western Wall, in the hope that those wishes will be fulfilled.[16] Trees have less of a memorial function than do stones in Judaism—in fact, one might say that they often celebrate life. Some Jews plant trees when a child is born and on the holiday Tu B'shvat (known as the "New Year for Trees"), especially in Israel.[17] Finally, the Torah is often referred to as "the tree of life."

Stones and trees are often elements in memorial gardens to the Holocaust, which Jewish communities have placed outside of community centers and synagogues at least since the 1980s. These gardens usually serve the more traditional purpose of offering places to sit in the outdoors and are often accompanied by traditional Jewish symbols in sculptural form, such as a menorah, as well as elements alluding to the Holocaust, such as barbed wire.[18] But the Jewish allusions to stones and trees are not the only ways to

interpret these elements in Goldsworthy's sculpture, for these materials have appeared in Goldsworthy's artistic practice for decades.

## Change and Time

In *Chalk Stones* (2003), Goldsworthy places fourteen oversized chalkstones along a path in the woods of West Dean. The stones respond to the environment, wearing down over time and changing color, from "white to the place" in which they are situated.[19] That is, the boulders first appear as contrasts to the natural environment, the stark white glowing amid the grays, browns, and greens of the earth below and the vegetation around them. Over time, the weather and interaction with nature change the boulders to a grayish-brown, contributing to the sense that the boulders are becoming a part of the place in which they reside. Goldsworthy's goal, he explains, is "not simply to wait for things to decay, but to make change an integral part of work's purpose so that, if anything, it becomes stronger and more complete as it falls apart and disappears. I need to make works that anticipate, but do not attempt to predict or control, the future. In order to understand time, I must work with the past, present and future."[20] The man-made boulders mark the passing of time, as the white chalk becomes gray and brown. When they were first installed, the white boulders appear as aliens in the countryside, a stark contrast to the landscape around them. As they weathered, the chalk became brown and gray, creating a kind of camouflage on the stones and thereby making them hard to distinguish from the surrounding landscape. Goldsworthy's invocation of change over time, and the embracing of multiple zones of time, is in dialogue with Henri Bergson's notion of *durée*, or duration, which simultaneously embodies a notion of memory as being a part of past, present, and future.

The boulders in Garden of Stones, on the other hand, will not weather over time but contain trees that will change over time. Like *Chalk Stones*, the boulders are of the place, but always foreign to it. As the dwarf chestnut oak trees in the boulders grow, they extend an invitation to the viewer: come see us when we are bare-branched, budding, in leaf, and turning color in the fall. By requesting that viewers revisit the installation, at all seasons, Garden of Stones extends an invitation to visitors to revisit the museum and the history it shares. As the trees have little symbolic or iconographic connection to the Holocaust, they open up meaning and memory for the viewer. Just as Ellsworth Kelly's *Memorials* in the USHMM provide blank screens on which to project ideas, memories, or feelings, so, too do the trees invite a space of quiet contemplation. Goldsworthy's use of natural elements, in turn, provides an ethical association with both nature and history.

Bryan Bannon writes that Goldsworthy's works are inherently ethical, as they embrace themes of temporal finitude and nonhierarchical collab-

oration.[21] Many of Goldsworthy's works, such as the leaf projects, involve a painstaking gathering of natural materials from a specific place and a willingness to let nature and the material move and affect the work. In Goldsworthy's film *Rivers and Tides*, rock walls fall down as the artist builds them.[22] Goldsworthy, in turn, recognizes that to build a better wall, he must better understand the nature of the rocks. The process of building the wall is a way to better understand the rocks' characteristics: there is something about one rock that makes it better suited to its neighbor than any other rock.

In other works, leaves blow away, and, in order to build a more effective sculpture, the artist sees it as his duty to better comprehend the movement of leaves on branches and in the wind. His own needs and goals for the artwork are determined by the materials' actions in nature. He does not dominate nature but rather encourages nature to guide him. Most of these works are meant to be ephemeral, some only lasting a few hours. The artist is not interested in changing the landscape forever but in remarking on it in visual form, in knowing the landscape, and the materials within it, in a new way.

In other projects, such as the *Sheepfolds Project* in Cumbria County, Scotland (2000–2001), Goldsworthy was interested in adding to existing sheepfolds, or stone structures that farmers used to contain sheep. In some of them, such as *Monjoy Tree Folds* (2000–2001), he places a boulder in the middle of the sheepfold. Goldsworthy hollowed out the boulders and planted in them rowan trees, in a strategy similar to the one he employs in Garden of Stones.[23] The rebuilt sheepfolds, which fall apart over time, are a mark of historical identity for the area, drawing on the history of sheep farming in the region. The stones, for the artist, also change over time, albeit at a different rate than the organic material that he usually uses, such as leaves, or dust, or branches.[24] It is this element of time—geologic time—that Goldsworthy introduces into the medium of stones. Bergson's *durée* addressed past, present, and future, but Goldsworthy's stones address deep time—the time in which the stones were made—or hundreds of thousands of years. When he rebuilds the *Sheepfolds*, the stone walls may fall down. But the boulders in Garden of Stones, unlike those in *Sheepfolds*, will not. They are large enough to stay in place for generations.

In both *Sheepfolds* and Garden of Stones, Goldsworthy addresses nature and time. Over the years, the trees have started to dominate the boulders, growing stronger and taller, their branches and leaves falling over the rocks. The stones, too, had a personal resonance for Goldsworthy, as they become metaphors for the survivors who were ripped from their homes:

> The stones have come from areas cleared for farms and homes. I prefer to take them from places like this rather than from where they have been rooted in woods. These glacier boulders have had a long and, at

times, violent past—both natural and man-made. Granite originated in fire at the earth's core and rose to the surface where it has been split, carried and worn down by glaciers. Farmers pulled out whatever they could to make fields, blasting those that they couldn't remove. When bulldozers arrived, the big stones were pushed to the edges of the fields intact, and this is the kind of boulder that I am lifting [using]. Without machines, these stones would not be there. Underlying the pastoral calm and beauty of a field is the destructive or creative violence of stones and trees being ripped out to make farmland . . . my working of the stones is a continuation of the journey these stones have made so far. They have a history of movement, struggle and change.[25]

While walking around these signs of life and struggle, the viewer is offered a space to honor the victims and survivors.

In another work, Goldsworthy experiments with the effects of time of day in a site-specific, privately owned sculpture that requires visitors to walk at night. *Moonlit Path* (2002) consists of a 3 km long trail made of ground chalk dust that meanders through the woods of Petworth Park, in West Sussex. He was intrigued with the notion of creating a sculpture that changes in the time span of one 24-hour period, as well as over the life of the work. The path was open to the public for viewing and walking on three nights from June 2002 to May 2003, around each full moon. Changes in nature and light are primary in this work, as Goldsworthy encourages viewers to return and visit the site several times a year to witness a greater variety of change.[26] Each time of day presents a different experience: one might perceive the white path as light gray at dusk, or a milky ribbon at midnight on a full moon, when it seems to glow in the moonlight. Each experience of walking along the path is a different one and Goldsworthy was acutely aware of how the owner of this work of art would experience it while walking. Hearing the sound of the chalk beneath the feet, in conjunction with the sounds of the forest, is vital. The sound of gravel underfoot, the necessity of ambulation, and the change of light on the sculptural object over time were all factors that would become important in Garden of Stones.

## Influence of Joseph Beuys's Social Sculpture

The impetus to interpret Goldsworthy through the lens of Joseph Beuys and social sculpture is not only due to both artists' interests in rocks, trees, and other natural materials; Goldsworthy, as an art student at Preston Polytechnic in England, was inspired by Beuys's early environmental work.[27] In his performance *Black Sand, Morecambe Bay, Lancashire, October 1976* for example, "Goldsworthy dragged himself through sea water and sand with deliberate

reference to Beuys's *Bog Action*, in which the latter aimed to draw attention to wetlands threatened by land reclamation along the Zuiderzee in the Netherlands." (*Morecambe Bay* is a large estuary in northwest England, just to the south of the Lake District National Park. It is the largest expanse of intertidal mudflats and sand in the United Kingdom.)[28] Helen Pheby explains, "In seeking to understand the properties and possibilities of materials (he talked about learning the 'sandness of sand,' for example), Goldsworthy, like Beuys, aimed to reconnect with the fabric of the earth to better appreciate and rehabilitate natural and human ecologies (which, for Beuys, included not only environmental but political, economic, cultural and social systems)."[29]

Beuys was a postwar German artist known for his holistic approaches to art, who created sculptures and performances and used unconventional materials such as fat, felt, trees, and dried sausages, among other materials. A pilot in the German Luftwaffe in World War II, after the war he circulated a story about his service that has since taken on mythic proportions. Beuys claims that he was shot down in the Crimea and that his severe wounds were tended to by local Tartars, who, to promote healing, wrapped his wounds in fat and felt. Beuys saw this healing process as vital to his development as an artist: if fat and felt could heal his body, he thought that using those very materials in works of art could metaphorically cure German society after the Holocaust. He saw himself as a spiritual healer. The aspect of healing society, in turn, would become for him "social sculpture."

Planting trees alongside basalt stones—namely, his *7,000 Oaks* of 1982 (Figure C.2)—was his first work of "social sculpture." Beuys believed that social sculpture "can transform the earth, humanity [and] the social order."[30] For Beuys, transformation of the social order was part and parcel of his belief that art could heal Germany in the postwar period. An aspect of this endeavor for him was creating works of art that demonstrated respect for the natural world—his interest in nature, in fact, has led to critics naming him as an early environmental artist. (He was also a founding member of Germany's Green Party.) The phrase *social sculpture* has been adopted by artists in the late twentieth and early twenty-first centuries to ground their practice in a theory of art making that bridges the studio to the social world.

*7,000 Oaks* was a public art project that involved planting oak trees and accompanying basalt stones in the city of Kassel as part of the exhibition dokumenta (an internationally recognized contemporary exhibition that takes place every five years) in 1982. When a contemporary artist plants trees as part of an art practice, it is hard *not* to make the association to Beuys and *7,000 Oaks*. For *7,000 Oaks*, Beuys invited the public to plant oak trees accompanied by basalt stones and intended that involvement to indicate the public's participation with Germany's past.[31] On June 19, the opening day of the exhibition, Beuys planted

the first of seven thousand oak trees on Friedrichsplatz, outside the Museum Fridericianum, one of the museum venues that make up documenta. Beuys had attached some fundamental conceptions to this tree "Action," or performance. He took the view that trees today are far more intelligent than people. In the wind that caresses their leaves, there blows the essence of suffering human beings, and the trees perceive it, for they themselves are sufferers. Beuys wanted to give these trees back their rights. To do so, he envisioned the planting and accompanying basalt stone as a *monument*. He stated: "My point with these seven thousand trees was that each would be a monument, consisting of a living part, the live tree, changing all the time, and a crystalline mass, the stone, maintaining its shape, size, and weight. This stone can be transformed only by taking from it, when a piece splinters off, say, never by growing. By placing these two objects side by side, the proportionality of the monument's two parts will never be the same."[32] He aimed to improve the quality of urban life by integrating trees into the urban landscape and to give concrete expression to "super time": time measured in terms of the life span of an oak, which he figured as eight hundred years. The funding of the project was through individuals: the cost to each purchaser—including transportation, planting, and ancillary work—was to be $210, with a total of $1.68 million. Each donation was acknowledged by a certificate and a "tree diploma," signed by Beuys and with the stamp of the Freie Internationale Universität.

In 1982, when Beuys's seven thousand basalt blocks were piled up, forming a range of wedge-shaped mountain peaks on Friedrichsplatz, there was a storm of protest from citizens of Kassel, who claimed that their downtown had been desecrated. Drivers feared loss of parking spaces, and others were anxious that urban afforestation would grow out of control and block utility lines. Even so, the 7,000 Oaks Coordinating Bureau in Kassel had some success to report. Local community councils, associations, and citizen initiatives came up with siting proposals; many patches of land outside of schools and playgrounds could be planted with Beuys's trees. However, Kassel citizens only donated a small proportion of the oaks—most donations were from out-of-towners. By the time Beuys died in 1986, fifty-five hundred of his oaks had been planted. At documenta 8 in 1987, his son Wenzel planted the final, seven thousandth oak.

Creativity to Beuys was a science of freedom. All human knowledge comes from art, he believed, and even the concept of science has evolved from creativity. History must consequently be seen sculpturally: history is plasticity, as is sculpture. Beuys's primary concern was the artistic education of the people. Not until art had been integrated into every area of education and life could there be an effective spiritual and democratic society—that is, a healed Germany. While Beuys's idea of social sculpture has shaped—and continues to shape—contemporary practice, his own connection to Holocaust memory is worth noting.[33]

Beuys was born in Krefeld in 1921 and grew up in Kleve; he was twelve years old when Hitler came to power. After 1936, he belonged to the Hitler Jugend, and after the outbreak of the war, was trained as a radioman, gunner, and later as a pilot for the Luftwaffe. Beuys flew combat missions on the eastern front and was wounded numerous times (including the mythical crash and subsequent healing with fat and felt). Late in the war, he was transferred to a paratroop division on the western front. After incarceration in a British internment camp at war's end, he returned to Kleve and in 1947 and began studies at the City Art Academy in Düsseldorf. The precise details of his war experiences have been the subject of speculation and dispute—namely, the story of his wounds and healing through fat and felt—but there is no question, as Gene Ray puts it, that Beuys belonged to the "perpetrating generation."[34]

Beuys did nothing to actively resist the Holocaust. But he had an inescapable relation to that catastrophe, and his art and actions unequivocally relate to the Holocaust—although it is a topic that has been avoided in the literature until recently. It is important to understand that in his development as an artist, Beuys submitted a model for the international art competition for a memorial on the site of Auschwitz II–Birkenau killing center, in 1957 and 1958. The competition was announced in 1956 by a group of Holocaust survivors, of which British sculptor Henry Moore was chair. Beuys was one of 426 artists who submitted proposals. For the proposal, he produced two dozen sketches, reworked several photographs, and constructed several models. The submitted design depicts "a railway line that entered the gates, crossed the camp and came to a halt outside the crematorium. His model accentuated the anguish of this deep perspective through the placing of red 'signal' sculptures, asymmetrical in shape and raised on two legs, at key places along the line: outside the camp, then somewhat smaller inside, and then very small at the crematorium."[35] He was not invited to the second round of proposals, and the 1958 commission was not fulfilled. "At a later stage Beuys took all the objects and drawings related to Auschwitz that he had done over the years and placed them in a single showcase entitled 'Auschwitz Demonstration.'"[36] Beuys's conception of social sculpture in 1982 came after his work related to Auschwitz, making the connection between healing the social world all the more prominent.

Just as Beuys involved citizens of Kassel to plant the trees in *7,000 Oaks*, so, too, did Goldsworthy invite individuals for the planting the trees—he asked Holocaust survivors to do so and sees the trees as metaphors for the survivors. Goldsworthy recalls staying in a hotel on Broadway, on the seventeenth floor, and seeing outside of his window that "a tree that had seeded itself, growing out of the side of the building opposite. It was for me a potent image of nature's ability to grow, even in the most difficult circumstances."[37] Goldsworthy saw the dwarf chestnut oaks not only as sufferers but also as survivors. "The trees

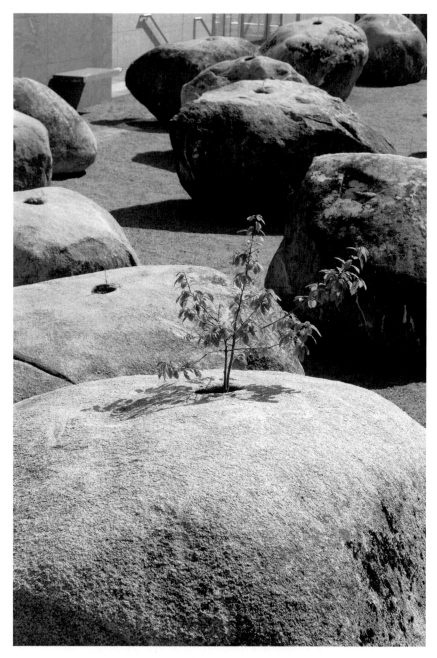

**Figure C.3** Andy Goldsworthy, Garden of Stones, 2003. Dwarf chestnut oak saplings, boulders. Permanent, site-specific installation: Museum of Jewish Heritage, Battery Park Plaza, New York. Sponsored by the Public Art Fund and the Museum of Jewish Heritage. (© Andy Goldsworthy. Courtesy Galerie Lelong & Co.)

I wanted couldn't be decorative," he stated, "they needed to be tough little S.O.B.s."[38] The trees for him are symbols of struggle and of overcoming hardship. And he plants them in an environment that is not especially friendly for trees: in boulders (Figure C.3).

While the small opening from which the tree grows in the top of the boulder is visible, we do not see that the interior of the boulder is entirely hollowed out, with a very wide opening at the base, thus enabling the roots to grow out of the boulder and into the soil on the rooftop beneath. Goldsworthy consulted with an arborist at Cornell University to determine what kind of tree would be best suited to grow in a hollowed-out boulder. The arborist did not guarantee the survival of the trees—but to Goldsworthy, the process of living, growing, and dying in extreme circumstances is a process similar to all of his works of art. If any of the trees should die in the future, Goldsworthy has a plan: the descendants of the survivors who planted the trees in the first place should replace those trees with healthy ones.

A memorial as social sculpture interacts with people and experiences the forces of nature, including growth and change over time. Embodying growth and change, while involving and purporting to heal the social world, Garden of Stones most succinctly fulfills the museum's mission to be a "living memorial" while at the same time embodying Beuys's notion of social sculpture. Goldsworthy's work encourages us to rethink the possibility of growth in unlikely circumstances. Gardens and places from which to view the water are often seen as contemplative spaces of beauty. And it is perhaps for this reason that natural elements, such as trees and rocks, with a view onto the water, lend themselves to be the materials for a Holocaust memorial. Those elements already put us in a mode of contemplation—we expect a certain feeling when we enter a garden or enjoy a vista of the water. Garden of Stones asks us to rethink our expectations and turn our contemplative, personal space into a space that is necessarily connected to history—and to the future.

## Concluding Remarks

The memorials and works of art in memorial spaces examined in this study demonstrate that shifting changes in attitudes are often reflected or elided in visual strategies chosen by artists. While Rapoport's Monument to the Six Million Jewish Martyrs helped the Philadelphia Jewish community bear witness to the Holocaust, it did so at a time when collective memory of the Holocaust, for the general public, had not yet been firmly established. By the 1990s, the works commissioned for the USHMM reflected a struggle that artists faced in determining the most effective visual strategies for works in dialogue with the Holocaust, when the recent examples of memorials were representational.

By the time Andy Goldsworthy created Garden of Stones in 2005, he necessitated ambulation through the memorial and invoked the future via the growth of trees at a moment when knowledge about Holocaust survivors and their trauma had reached a wide audience in the United States.

In West Germany, a difficulty in coming to terms with the past resulted in memorials that are illegible in public space, such as Gerson Fehrenbach's Münchener Straße Synagogue Monument. By the 1980s, a struggle with the past was visible in works of art, as artists started to conceive of their works as counter-monuments. Alfred Hrdlicka's Counter-Monument is a case in point. But individuals started to care for and commemorate monuments that had been previously neglected, such as Margit Kahl's Joseph-Carlebach-Platz Synagogue Monument, indicating that on the grassroots level, individuals care about the past and its representation in the present. In East Germany, politburo needs to valorize heroic workers resulted in Will Lammert's 1957 Burdened Women, for which some figures could not be installed, as they did not depict heroic acts. This attitude radically changed by the late 1980s, when some aspects of modern art were tolerated in contemporary art circles, and when Lammert's previously rejected figures found a home in an old Jewish neighborhood in East Berlin. By the late 1990s, when Peter Eisenman and Richard Serra won the first competition for the national Holocaust memorial in Berlin, many different sectors of the public were actively coming to terms with the past. Serra stepped out of the commission process, but Eisenman ended up inaugurating a watershed work of memorial architecture for Germany. The U.S. process of working through the past migrated across borders and helped German commissioners, and the public, think through its past in new ways.

For decades, the public has recognized that Holocaust survivors are dying, and with every death, another witness departs. Now, the youngest of the survivors are passing. Will Holocaust memorials continue to be built? Innovations developed by artists commissioned to the task of remembering the Holocaust have provided ways for many different groups to remember not only the Holocaust but also other catastrophes. It may be the case that as the last of the Holocaust survivors die, fewer memorials will be built. But it may also be the case that more countries might recognize that their Jewish populations were decimated during the Holocaust and/or that their countries provided a safe haven for Jews to live. Canada inaugurated its national Holocaust memorial in 2016. With deconstructive architect Daniel Libeskind as its designer, the memorial reflects current trends in the design of Holocaust memorials. But, as with many examples in this book, the accompanying plaque left things unsaid, for the writers of the plaque's text neglected to include the word "Holocaust" and any mention of Jewish victims.[39] Commissioning bodies, therefore, have not "gotten better" at creating commemorative plaques that accompany me-

morials in public space, and this clearly is an area, in the future, that designers and commissioners might think about more thoroughly.

So, too, cities and towns might continue to remember former Jewish communities. In October 2017, for instance, Gunther Demnig installed the first *Stolperschwelle* (stumbling threshold) outside of Europe. As opposed to *Stolpersteine*, which commemorates individuals, *Stolperschwelle* pays tribute to hundreds of thousands. The first *Stolperschwelle* was installed in front of the Pestallozzi School in Buenos Aires, in commemoration of the children who were forced to flee Europe between 1933 and 1945.[40] If these recent events are any indication, then memorials to victims—as well as to those who survived—will continue to be built. The continued dialogue across national borders regarding memory in visual form will enrich both public space and the commission process of works of art dedicated to tragedy that will inevitably follow. Those works will not put an end to such tragedies, but they will provoke us to remember the past, to learn, and to think about the future. They will help us remember by encouraging us to embark on memory passages.

# Notes

## INTRODUCTION

1. Pierre Nora and Lawrence D. Kritzman, eds., *Realms of Memory: The Construction of the French Past. Volume 1: Conflicts and Divisions*, trans. Arthur Goldhammer. (New York: Columbia University Press, 1996).

2. Maurice Halbwachs, *On Collective Memory*, trans. Lewis A. Coser (Chicago: University of Chicago Press, 1996).

3. Dori Laub and Daniel Podell, "Art and Trauma," *International Journal of Psycho-Analysis* 76 (1995): 991.

4. Theodor Adorno, "Cultural Criticism and Society," in *Prisms*, trans. Samuel and Shierry Weber (London: Neville Spearman, 1967), 34.

5. Theodor Adorno, *Aesthetics and Politics*, trans. and ed. Ronald Taylor (London: New Left Books, 1977), 188; Adorno, *Aesthetic Theory*, trans. C. Lenhardt (London: Routledge and Kegan Paul, 1970), 352–54, 443–44; and Adorno, "Cultural Criticism and Society," 245–71. Cited in Saul Friedländer, *Probing the Limits of Representation: Nazism and the "Final Solution"* (Cambridge, MA: Harvard University Press, 1992), 260.

6. Henry Moore and Alan Wilkinson, *Henry Moore: Writings and Conversations* (Berkeley: University of California Press, 2002), 135. Cited in Rudy Koshar, *From Monuments to Traces: Artifacts of German Memory, 1870–1999* (Berkeley: University of California Press, 2000), 201.

7. Friedländer, *Probing the Limits of Representation*, 2–3.

8. Marita Sturken, "The Wall, the Screen, and the Image: The Vietnam Veterans Memorial," in "Monumental Histories," special issue, *Representations* 35 (Summer 1991): 118–42.

9. Sybil Milton, *In Fitting Memory: The Art and Politics of Holocaust Memorials* (Detroit: Wayne State University Press, 1991).

10. Available at https://www.holocaustremembrance.com/sites/default/files/memo-on-spelling-of-antisemitism_final-1.pdf.

11. Doris Bergen, *The Holocaust: A Concise History* (New York: Rowman and Littlefield, 2009), 4.

12. For a discussion of the counter-monument in the context of the influence of American capitalism in Germany, see Kristine Nielsen, "Monumental Attack: The Visual Tools of the German Counter-Monument in Two Works by Jochen Gerz and Esther Shalev-Gerz, and Horst Hoheisel," *Images: A Journal of Jewish Art and Visual Culture* 9:122–39.

13. James E. Young, "Counter-Monument: Memory against Itself in Germany Today," *Critical Inquiry* 18, no. 2 (Winter 1992): 274.

14. James E. Young, *The Stages of Memory: Reflections on Memorial Art, Loss, and the Spaces Between* (Amherst: University of Massachusetts Press, 2016).

15. Lucy Lippard and David Chandler, "The Dematerialization of Art," *Art International* (February 1968): 31–36.

16. James E. Young, *The Texture of Memory: Holocaust Memorials and Meaning* (New Haven, CT: Yale University Press, 1993).

17. Young relates his involvement with these commissions in *Stages of Memory*.

18. James E. Young, ed., *The Art of Memory: Holocaust Memorials in History* (New York: Prestel, 1994); James E. Young, *At Memory's Edge: After-Images of the Holocaust in Contemporary Art and Architecture* (New Haven, CT: Yale University Press, 2000).

19. Peter Carrier, *Holocaust Monuments and National Memory Cultures in France and Germany* (New York: Berghahn Books, 2005).

20. Caroline Wiedmer, *The Claims of Memory: Representations of the Holocaust in Contemporary Germany and France* (Ithaca, NY: Cornell University Press, 1999).

21. The literal translation of "Stolpersteine" is "stumbling stones"; however, the word is equivalent to the English phrase "stumbling blocks," or things that get in the way of our ideas or actions.

22. Jennifer A. Jordan, *Structures of Memory: Understanding Urban Change in Berlin and Beyond* (Stanford, CA: Stanford University Press, 2006).

23. Jennifer Hansen-Glucklich, *Holocaust Memory Reframed: Museums and the Challenges of Holocaust Representation* (New Brunswick, NJ: Rutgers University Press, 2014).

24. For the traditional interpretation of modernism, see Clement Greenberg, "Modernist Painting," *Arts Yearbook* 4 (1961): 101–8. On minimalism's aggressive qualities, see Anna Chave, "Minimalism and the Rhetoric of Power," *Arts Magazine* 64, no. 5 (1990): 44–63.

25. See Mark Godfrey, *Abstraction and the Holocaust* (New Haven, CT: Yale University Press, 2007). The case is different in Germany, as Paul B. Jaskot points out in "Gerhard Richter and Adolf Eichmann," *Oxford Art Journal* 28, no. 3 (2005): 457–78.

26. Godfrey, *Abstraction and the Holocaust*.

27. Lisa Saltzman, "Gerhard Richter's Stations of the Cross: On Martyrdom and Memory in Postwar Art," *Oxford Art Journal* 28, no. 1 (2005): 27–44; Jaskot, "Gerhard Richter."

28. Samantha Baskind, *Jewish Artists and the Bible in Twentieth Century America* (University Park: Pennsylvania State University Press, 2014), 74.

29. Margaret Olin and Robert S. Nelson, eds., *Monuments and Memory, Made and Unmade* (Chicago: University of Chicago Press, 2003), 2–3.

30. Hasia K. Diner, *We Remember with Reverence and Love: American Jews and the Myth of Silence after the Holocaust, 1945–1962* (New York: New York University, 2009).

31. Thomas D. Fallace, *The Emergence of Holocaust Education in American Schools* (New York: Palgrave Macmillan, 2008).

32. Jeffrey Herf, *Divided Memory: The Nazi Past in the Two Germanys* (Cambridge, MA: Harvard University Press, 1997).

33. Daniel Levy and Natan Sznaider, *The Holocaust and Memory in the Global Age* (Philadelphia: Temple University Press, 2006).

34. Paul B. Jaskot, *The Nazi Perpetrator: Postwar German Art and the Politics of the Right* (Minneapolis: University of Minnesota Press, 2012), 3.

## CHAPTER 1

1. An early version of this analysis was published as Natasha Goldman, "From Ravensbrück to Berlin: Will Lammert's Monument to the Deported Jews (1957/1985)," *Images: A Journal of Jewish Art and Visual Culture* vol. 9, no. 1 (November 2016): 140–63. Reprinted with permission of Brill.

2. Günter Braun, ed., *Orte erinnern. Spuren des NS-Terrors in Berlin: Ein Wegweiser* (Berlin: Nicolai, 2003), 211.

3. Of those, fourteen hundred had been in hiding, forty-seven hundred survived in mixed marriages, and nineteen hundred came back from concentration camps.

4. Peter Reichel, *Politik mit der Erinnerung: Gedächtnisorte im Streit um die nationalsozialistische Vergangenheit* (München: C. Hanser, 1995), 186. See also Ulrich Puvogel, *Gedenkstätten für die Opfer des Nationalsozialismus*, vol. 2 (Bonn: Bundeszentrale für politische Bildung, 1999), 13.

5. Jennifer A. Jordan, *Structures of Memory: Understanding Urban Change in Berlin and Beyond* (Stanford, CA: Stanford University Press, 2006), 30.

6. Eberhardt E. Bartke, "Das Denkmal," in *Das Buchenwald-Denkmal: Mit Beiträgen von Eberhard Bartke, Ulrich Kuhirt, Heinze Lüdecke*, ed. Eberhard Bartke, Ulrich Kuhirt, Heinze Lüdecke (Dresden: Verlag der Kunst, 1960), 19–24. Cited in Susanne Scharnowski, "Heroes and Victims: The Aesthetics and Ideology of Monuments and Memorials in the GDR," in *Memorialization in Germany since 1945*, ed. Bill Niven and Chloe Paver (London: Palgrave Macmillan, 2010), 272.

7. Sergiusz Michalksi, *Public Monuments: Art in Political Bondage 1870–1997* (London: Reaktion Books, 1998), 135–36. Buchenwald was liberated in April 1945 by American troops; a day before, the inmates, led by a group of Communists, managed to free themselves.

8. "Nachruf für Will Lammert," *Neues Deutschland*, November 1, 1957, 4. His obituary appeared in many GDR newspapers.

9. For a review of the Dresden exhibition, see "Erinnerung an die Jahre der Verfolgung: Werke deutscher Künstler über den Widerstandskampf in einer Berliner Ausstellung," *Neue Zeit*, September 5, 1958, 6. For a review of the Berlin exhibition, see Elmar Jansen, "Dialog zwischen Natur und Kunst," *Neue Zeit*, August 21, 1960, 4.

10. For the FRG art historical attitude toward the GDR, see Achim Priess, *Abschied von der Kunst des 20. Jahrhunderts* (Weimar: VDG, 1999), the publication issued for the Weimar exhibition "Aufstieg und Fall der Moderne" (Rise and Fall of Modern Art) in Weimar, 1999. Exhibition catalog.

11. Lammert's life is described in many exhibition catalogs dedicated to his work. Especially useful is the 1992 exhibition catalog, Horst-Jörg Ludwig, ed., *Will Lammert (1892–1957)—Plastik und Zeichnungen: Ausstellung anlässlich des 100. Geburtstages des Künstlers* (Berlin: Akademie der Künste, 1992). Also important are Ernst Schmidt, ed., *Will Lammert in Essen* (Essen: Arbeiterwohlfahrt Essen, 1988); and Peter H. Feist, ed., *Will Lammert* (Dresden: Verlag der Kunst, 1963). Exhibition catalog.

12. Peter Feist, "Einleitung," in *Will Lammert*, preface by Fritz Cremer, introduction by Peter H. Feist, catalogue of works by Marlies Lammert (Dresden: Verlag der Kunst, 1963), 7. Exhibition catalog.

13. Feist, "Einleitung," 9.

14. Feist, "Einleitung," 10.

15. Fritz Cremer, "Im Gedenken an Will Lammert," in *Will Lammert—Gedächtnisausstellung*, ed. John Heartfield (Berlin: Akademie der Künste, 1959), 7. Exhibition catalog.

16. Cremer, "Im Gedenken an Will Lammert," 7.

17. Marlies Lammert, "Dokumentation," in *Will Lammert (1892–1957)—Plastik und Zeichnungen: Ausstellung anlässlich des 100. Geburtstages des Künstlers*, ed. Horst-Jörg Ludwig (Berlin: Akademie der Künste, 1992), 112. M. Lammert states that Will married Hedwig but not that she was Jewish.

18. Susanne Lanwerd notes that the Christ figure shares with the Ravensbrück monument the element of an upright-standing, striding figure. See Lanwerd, "Skulpturales Gedenken: Die 'Tragende' des Bildhauers Will Lammert," in *Die Sprache des Gedenkens: Zur Geschichte der Gedenkstätte Ravensbrück 1945–1995*, ed. Insa Eschebach, Sigrid Jacobeit, and Susanne Lanwerd (Berlin: Edition Hentrich, 1999), 40.

19. Shulamith Behr, David Fanning, and Douglas Jarman, eds., *Expressionism Reassessed* (Manchester: Manchester University Press, 1993), 74.

20. M. Lammert, "Dokumentation," 119.

21. Ludwig, *Plastik und Zeichnungen*, 102.

22. Angela Lammert, "Will Lammert's Ravensbrück Memorial: The Image of Woman in German Post-War Public Sculpture," *Sculpture Journal* 9 (2003): 94. The best source for Lammert's biography is Marlies Lammert, "Dokumentation," in *Will Lammert (1892–1957)—Plastik und Zeichnungen, Ausstellung anlässlich des 100. Geburtstages des Künstlers*, ed. Ludwig Horst-Jörg (Berlin: Akademie der Künste, 1992), 98–131. For Lammert's exile, see especially p. 124.

23. Ludwig, *Plastik und Zeichnungen*, 125.

24. "Neue Mitglieder der Akademie der Künste," *Neues Deutschland*, November 14, 1952, 2.

25. The Marx bust was shown in the Deutschen Kunstausstellung Dresden in 1953. *Neues Deutschland*, March 14, 1953, 4.

26. Bodo Uhse, *Reise- und Tagebuecher II* (Berlin: Aufbau Verlag, 1981), 337.

27. *Neues Deutschland*, October 4, 1959, 3.

28. "Will Lammert Gedächtnispreis verliehen," *Berliner Zeitung*, January 6, 1962, 1.

29. The Ravensbrück memorial site was designed by Kollektiv Buchenwald, engineers Ludwig Deiters, Hans Grotewohl, Horst Kutzat, and Kurt Tausendschön, and landscape architects Hubert Matthes and Hugo Namslauer. Anon., "Frauen, die dem Terror trotzen," *Neues Deutschland*, August 26, 1959, 4. For the history and analysis of Ravensbrück, see Irith Dublon-Knebel, ed., *A Holocaust Crossroads: Jewish Women*

*and Children in Ravensbrück* (London: Vallentine Mitchell, 2010); and Insa Eschebach, Sigrid Jacobeit, and Susanne Lanwerd, eds., *Die Sprache des Gedenkens: Zur Geschichte des Gendenkstätte Ravensbrück 1945–1995* (Berlin: Edition Hentrich, 1999).

30. Bill Niven, *Facing the Nazi Past: United Germany and the Legacy of the Third Reich* (London: Routledge, 2002), 20.

31. Thomas Fox, *Stated Memory: East Germany and the Holocaust* (Rochester, NY: Camden House, 1999), 41.

32. Jeffrey Herf, *Divided Memory: The Nazi Past in the Two Germanys* (Cambridge, MA: Harvard University Press, 1997), 167.

33. Marlies Lammert points out that Will Lammert may have been inspired to install the monument on the peninsula after the memorial design from J. L. Mathieu Lauweriks, who in 1915 Hagen/Westfalen—Lammert's former hometown—designed an anti–world war monument on a peninsula. See Marlies Lammert, "Ein Denkmalsprojekt für Berlin. Zur Aufstellung der Plastikgruppe von Will Lammert," in *Studien zur Berliner Geschichte*, ed. Karl-Heinz Klingenburg (Leipzig: E. A. Seeman, 1986), 283–84. For similarities and differences among Ravensbrück, Buchenwald, and Sachsenhausen, the other two major East German memorial sites, see Peter Fibich, "Buchwald—Ravensbrück—Sachsenhausen: Die städtebaulich-architektonische und landschaftsarchitecktonische Gestaltung der Nationalen Mahn- und Gedenkstätten," in Eschebach, Jacobeit, and Lanwerd, *Die Sprache des Gedenkens*, 262–81.

34. Lanwerd, "Skulpturales Gedenken," 45–51.

35. Lanwerd, "Skulpturales Gedenken," 44.

36. This account can be found in Lanwerd, "Skulpturales Gedenken," 45–51.

37. Lanwerd, "Skulpturales Gedenken," 45.

38. Gerd Brüne, *Pathos und Sozialismus: Studien zum plastischen Werk Fritz Cremers (1906–1993)* (Weimar: Verlag und Datenbank für Geisteswissenschaften, 2005), 212.

39. Lanwerd, "Skulpturales Gedenken," 45.

40. Lanwerd, "Skulpturales Gedenken," 45.

41. Brüne, *Pathos und Sozialismus*, 217.

42. Brüne, *Pathos und Sozialismus*, 217.

43. Quoted in Insa Eschebach, "Soil, Ashes, Commemoration: Process of Sacralization at the Ravensbrück Former Concentration Camp," *History and Memory* 23, no. 1 (Spring/Summer 2011): 142.

44. Kathrin Hoffmann-Curtis, "Caritas und Kampf: Die Mahnmale in Ravensbrück," in Eschebach, Jacobeit, and Lanwerd, *Die Sprache des Gedenkens*, 55. Fritz Cremer's sculpture of three striding women (1965) was meant to answer this objection. Rudy Koshar, *From Monuments to Traces: Artifacts of German Memory, 1870–1990* (Berkeley: University of California Press, 2000).

45. A. Lammert, "The Image of Woman," 98.

46. For the commission of this sculpture, see Brüne, *Pathos und Sozialismus*, 212–26.

47. For the role of mothers in East German remembrance of the Holocaust, see Janet Jacobs, *Memorializing the Holocaust: Gender, Genocide and Collective Memory* (New York: Macmillan, 2010).

48. Kathrin Hoffmann-Curtis, "Caritas und Kampf," 65. Nonetheless, by the late 1960s, Cremer "openly called for a more human scale in sculpture, in the hope of preventing 'certain megalomaniacal tendencies and realizations.'" Perhaps Lammert's

three-quarter life-size *Unfinished* figures had an impact on his old friend and student (but that is another project). Regarding Cremer's change in attitudes toward sculpture, see Brian Ladd, "East Berlin Political Monuments in the Late German Democratic Republic: Finding a Place for Marx and Engels," *Journal of Contemporary History* 37, no. 1 (2002): 94. Cremer was also responsible for sculptures in Vienna, Buchenwald, and Mauthausen. See Ulrich Krempel, "Moderne und Gegenmoderne, der Nationalsozialismus und die bildende Kunst," in *Der Nationalsozialismus—die Zweite Geschichte*, ed. Peter Reichel, Harald Schmid, and Peter Steinbach (Munich: Verlag C. H. Beck, 2009), 329.

49. Peter Feist, "Fragment der Erfüllung," in Heartfield, *Will Lammert— Gedächtnisausstellung*, 24–30. Quoted in M. Lammert, "Ein Denkmalsprojekt für Berlin," 286.

50. Eschebach, "Soil, Ashes, Commemoration," 141.

51. Eschebach, "Soil, Ashes, Commemoration," 136.

52. Eschebach, "Soil, Ashes, Commemoration," 138. There are similar path layouts at Buchenwald, Dachau, and Neuengamme. Detlef Hoffmann, for instance, calls Neuengamme a "secular path of spiritual purification," which follows the Catholic model of the Via Dolorosa. Volkhard Knigge writes that Buchenwald presents a pathway where visitors are meant to "pass through death and struggle to victory." Volkhard Knigge, "Zur Entstehungsgeschichte," in *Von der Erinnerung zum Monument: Die Entstehungsgeschichte der Nationalen Mahn- und Gedenkstätte Sachsenhausen*, ed. Günter Morsch (Berlin: Edition Hentrich, 1996), 112.

53. Eschebach, "Soil, Ashes, Commemoration," 139.

54. A. Lammert, "The Image of Woman," 96.

55. The sculpture was first named *The Ravensbrück Pietà* in the 1959 Akademie der Künste exhibition catalog. See Lanwerd, "Skulpturales Gedenken," 46. The adopted title also appears in newspaper articles after the memorial site's opening. See Elmar Jansen, "Mahnmal auf blugetränkter Erde: Die Nationale Gedenkstätte Ravensbrück," *Neue Zeit*, September 6, 1959, 3. Hoffmann-Curtis explains how different Lammert's sculpture is from a traditional pietà. Whereas in a Christian pietà Mary cries and the two figures are seated, in Lammert's sculpture, the female figure has been identified as Olga Benario Prestes; she strides forth and does not cry. See Hoffmann-Curtis, "Caritas und Kampf," 56. For the reception of Benario Prestes, see also Linde Apel, "Olga Benario—Kommunistin, Judin, Heldin?" in Eschebach, Jacobeit, and Lanwerd, *Die Sprache des Gedenkens*, 196–217.

56. Marlies Lammert, *Will Lammert Ravensbrück* (Berlin: Deutsche Akademie der Künste zu Berlin, 1968), 8.

57. M. Lammert, *Will Lammert Ravensbrück*, 10.

58. M. Lammert, *Will Lammert Ravensbrück*, 12; A. Lammert, "The Image of Woman," 197; and Brüne, *Pathos und Sozialismus: Studien zum plastischen Werk Fritz Cremers (1906–1993)*, 215.

59. Lanwerd, "Skulpturales Gedenken," 210.

60. A. Lammert, "The Image of Woman," 97.

61. Claudia Koonz discusses the absence of references to Jews in East European concentration camps in "Between Memory and Oblivion: Concentration Camps in German Memory," in *Commemorations: The Politics of National Identity*, ed. John Gillis (Princeton, NJ: Princeton University Press, 1994), 266–67.

62. Lanwerd, "Skulpturales Gedenken," 211. Woman as "anti-Fascist fighter" was an exception rather than a rule in GDR concentration camp exhibitions and memorials. "In the historical iconography of DDR sculpture," writes Koonz, "heroic males resist and women (if depicted at all) persevere." See Koonz, "Between Memory and Oblivion," 267.

63. Ulrike Goeschen, "From Socialist Realism to Art in Socialism: The Reception of Modernism as an Instigating Force in the Development of Art in the GDR," *Third Text* 23, no. 1 (January 2009): 46. This attitude is expressed by Koonz, who writes, "East German sculpture is strongly Socialist Realist in style." See Koonz, "Between Memory and Oblivion," 267.

64. Goeschen, "From Socialist Realism to Art in Socialism," 47. In 1988, the term *socialist realism* was replaced with *art in socialism* at the last Congress of the Artists' Association of the GDR. See Goeschen, "From Socialist Realism to Art in Socialism," 47.

65. M. Lammert, "Ein Denkmalsprojekt für Berlin," 286.

66. Elmar Jansen, *Deutsche Woche*, April 8, 1959, 9. Quoted in M. Lammert, "Ein Denkmalsprojekt für Berlin," 288.

67. Lothar Lang, "Berliner Künstler stellen aus," *Die Weltbühne*, May 1959, 604. Quoted in M. Lammert, "Ein Denkmalsprojekt für Berlin," 288.

68. Anon., *Thüringer Tageblatt*, Weimar, May 9, 1959.

69. Ingrid Beyer, *Bildende Kunst* 7, no. 1 (1959): 4. Quoted in Brüne, *Pathos und Sozialismus*, 216.

70. Georg Piltz, *Deutsche Bildhauerkunst* (Berlin: Verlag Neues Leben, 1962), 365. Quoted in Brüne, *Pathos und Sozialismus*, 216.

71. Heartfield's use of red with a black-and-white photograph harkens back to his prewar photo collages, in which he often used red, black, and white images to make anti-Fascist illustrations.

72. M. Lammert, "Ein Denkmalsprojekt für Berlin," 296.

73. Goeschen, "From Socialist Realism to Art in Socialism," 49.

74. Goeschen, "From Socialist Realism to Art in Socialism," 50.

75. Feist, "Fragment der Erfüllung," in Heartfield, *Will Lammert—Gedächtnisausstellung*, 24–30.

76. Lang, "Berliner Künstler stellen aus," 604. Quoted in M. Lammert, "Ein Denkmalsprojekt für Berlin," 288.

77. Feist, "Einleitung," 23.

78. Feist, "Einleitung," 23.

79. In the German literature on the artist—there is little to nothing in English—the forms are referred to as "Kubos," which does not have a direct English translation. It is best translated as "cube-like shapes." Therefore, I refer to them as "cube-like shapes," "cubes," or "blocks."

80. Christian Fuhrmeister, "The Advantages of Abstract Art: Monoliths and Erratic Boulders as Monuments and (Public) Sculptures," in *Figuration/Abstraction: Strategies for Public Sculpture in Europe 1945–1968*, ed. Charlotte Benton (Burlington, VT: Ashgate, 2004), 117.

81. Myra Wahrhaftig, *Deutsche jüdische Architekten vor und nach 1933—Das Lexikon: 500 Biographien* (Berlin: Dietrich Riemer, 2005).

82. The grafitti can be seen in a photograph in the collection of the Jewish Museum of Berlin, entitled *Zerstörter Innenraum der Synagoge Münchener Straße mit antisemitischen*

*Graffiti.* Photo ID: 2003/109/19. Accessed May 15, 2019, available at http://objekte.jmber lin.de/object/jmb-obj-208497;jsessionid=88219835883D753C643A340D06D8F3DE.

83. Many thanks to Steven Cerf for help with this translation and interpretation.

84. Astrid Rosenberg, *Gerson Fehrenbachs Beitrag zur Deutschen Plastik im Informel* (Münster: Lit Verlag, 1996), 6.

85. Jürgen Morschel, *Deutsche Kunst der sechziger Jahre: Plastik, Objekte, Aktionen* (Munich: Bruckmann, 1972), 19. Quoted in Rosenberg, *Gerson Fehrenbachs Beitrag*, 6. The most important publications on Fehrenbach are Heinz Ohff, *Gerson Fehrenbach: Plastiken und Zeichnungen 1955–1979* (Berlin: Neuer Berliner Kunstverein, 1979) and Stiftung für Bildhauerei, *Gerson Fehrenbach: Skulptur und Zeichnungen: Mit dem Werkverzeichnis der Skulpturen,* exhibition catalogue (Berlin: die Stiftung, 2000).

86. Sebastian Fehrenbach, email message to author, March 11, 2017.

87. The following biographical information can be found in Birk Ohnesorge, "In Analogie zur Natur: Das plastische Werk von Gerson Fehrenbach," in *Gerson Fehrenbach: Skulptur und Zeichnung,* 11–25.

88. Godehard Janzing, "National Division as a Formal Problem in West German Public Sculpture: Memorials to German Unity in Münster and Berlin," in Benton, *Figuration/Abstraction,* 129.

89. Ohff, *Gerson Fehrenbach: Plastiken und Zeichnungen 1955–1979.*

90. Ehrtfried Böhm, *Neu Plastik in Hannover / Kunstsinn, Mäzenatentum, Urbane Ästhetik / Ein Beispiel im Spiegel zweier Jahrzehnte* (Hannover: Steinbock-Verlag, 1967), 75. The summary of the sculpture's interpretation and history presented here is paraphrased from Janzing, "National Division," 127–29.

91. Heinz Ladendorf, "Denkmäler und Mahnmale seit 1945," in *Monumenta Judaica: 2000 Jahre Geschichte und Kultur der Juden am Rhein,* ed. Konrad Schilling (Cologne: Stadt Köln, 1963), 664.

92. Bernd-Heiner Berge, "Beton in den Bildhauerarbeiten von Gerson Fehrenbach," in *Gerson Fehrenbach: Skulptur und Zeichnungen,* 46.

93. Rosenberg, *Gerson Fehrenbachs Beitrag.* For a critique of Rosenberg, see Birk Ohnesorge, "In Analogie zur Natur: Das plastische Werk von Gerson Fehrenbach," in Josephine Gabler, ed., *Gerson Fehrenbach: Skulpturen und Zeichnungen,* 14–15.

94. Manfried Bauschulte, *Versuch über die Festigkeit: Die Steinkunst von Karl Prantl* (Vienna: Klever Verlag, 2014).

95. Accessed November 30, 2017, available at http://www.bildhauerhaus.at/en /history/symposion-of-european-sculptors.html.

96. Landesarchiv Berlin, B Rep. 211, 17. Bezirksverordnetenversammlung von Schöneberg, V. Wahlperiode am 16.03.1960.

97. Landesarchiv Berlin, B Rep. 211, 60. Bezirksverordnetenversammlung von Schöneberg, V. Wahlperiode am 09.01.1960.

98. Landesarchiv Berlin, B Rep. 211, 22. Bezirksverordnetenversammlung von Schöneberg, V. Wahlperiode am 21.09.1960.

99. Email with Sebastian Fehrenbach, March 7, 2017.

100. Landesarchiv Berlin, B Rep. 211, 60. Bezirksverordnetenversammlung von Schöneberg, V. Wahlperiode am 09.01.1960.

101. Landesarchiv Berlin, B Rep. 211, 60. Bezirksverordnetenversammlung von Schöneberg, V. Wahlperiode am 09.01.1960.

102. Anon., "Zur Erinnerung an die Synagoge," *Der Tagesspiegel*, November 25, 1963.

103. Landesarchiv Berlin, B Rep. 211, 36. Bezirksverordnetenversammlung von Schöneberg, V. Wahlperiode am 20.01.1988.

104. Landesarchiv Berlin, B Rep. 211, 36. Bezirksverordnetenversammlung von Schöneberg, V. Wahlperiode am 15.06.1988.

105. Doris Bergen, *War and Genocide: A Concise History of the Holocaust* (New York: Rowman and Littlefield, 2009), 110.

106. The following history of the words used to refer to November 9, 1938, is from Harald Schmid, *Erinnern an den "Tag der Schuld": Das Novemberpogrom von 1938 in der deutschen Geschichtspolitik* (Hamburg: Ergebnisse-Verlag, 2001).

107. Schmid, *Erinnern an den "Tag der Schuld."*

108. Alan E. Steinweis, *Kristallnacht 1938* (Cambridge, MA: Belknap Press of Harvard University Press, 2009), 161.

109. Serge Schemann, "Blunt Bonn Speech on the Hitler Years Prompts a Walkout," *New York Times*, November 11, 1988, accessed December 6, 2017, available at http://www.nytimes.com/1988/11/11/world/blunt-bonn-speech-on-the-hitler-years-prompts-a-walkout.html.

110. Steinweis, *Kristallnacht 1938*, 161.

111. James E. Young, *The Texture of Memory: Holocaust Memorials and Meaning* (New Haven, CT: Yale University Press, 1993), 28–36.

112. Heinz Ohff, "Gerson Fehrenbach oder Annäherung durch Entfernung von der Natur," in *Gerson Fehrenbach: Plastiken und Ziechnungen* (Berlin: Neue Berliner Kunstverein, 1979), unpag. 2.

113. John Sandford, *Encyclopedia of German Culture* (London: Routledge, 1999), 556. For a discussion of postwar public sculpture in Germany, see also Benton, *Figuration/Abstraction*.

114. By the 1980s, artists such as Martin Lupertz were expressing their reactions to World War II and the Holocaust in overt ways. See Linda Schwartz, "The Human Condition in Post-War Germany Revealed in Markus Lupertz's Sculptures," *Art Criticism* 19, no. 2 (2004): 105–20.

115. Many thanks to Anne Gianguilio and Antonio Castro of the Art Department at the University of Texas, El Paso, for a quick lesson on fonts and graphic design.

116. Accessed December 17, 2016, available at http://www.loecknitz-grundschule.de/auszuege_engl.htm.

## CHAPTER 2

Copyright © 2016 Johns Hopkins University Press. This article was first published in Journal of Jewish Identities 9.2 (2016), 159–192. Reprinted with permission by Johns Hopkins University Press.

1. Special thanks to the following individuals who were extremely helpful to me in acquiring archival sources, fact-checking, and/or editing: the late Abram Shnaper, Eddie Gastfriend, Debbie Feith Tye, and Douglas Feith.

2. Contemporary news sources refer to the monument as the "first" in the United States, but its status as such remains unresolved. An early iteration of this idea appears in "Jews Present Statue to Philadelphia to Honor Six Million Nazi Victims," *Philadelphia*

*Inquirer*, April 27, 1964. A more recent example appears in Vernon Clark, "Marking 50th Anniversary of the Holocaust Memorial," *Philadelphia Inquirer*, April 28, 2014.

3. Janet Kardon, *Urban Encounters* (Philadelphia: Falcon Press, 1980), 6. For the film *Nathan Rapoport: From the Holocaust of Man to the Holocaust of the Artist—The Artist That Israel Forgot* (2003), see "Information Center for Israeli Art," Israel Museum, Jerusalem, www.img.org.il, accessed August 25, 2015, available at http://www.imj.org.il/artcenter/newsite/en/videos-articles/?artist=Rapoport,%20Nathan&list=.

4. Hasia K. Diner, *We Remember with Reverence and Love: American Jews and the Myth of Silence after the Holocaust, 1945–1962* (New York: New York University Press, 2009).

5. For Holocaust education in U.S. public schools, see Thomas D. Fallace, *The Emergence of Holocaust Education in American Schools* (New York: Palgrave Macmillan, 2008), 29.

6. "Nathan Rapoport, Sculptor of Works on Holocaust, Dies," *New York Times*, June 6, 1987, available at http://www.nytimes.com/1987/06/06/obituaries/nathan-rapoport-sculptor-of-works-on-holocaust-dies.html.

7. Sybil Milton, *In Fitting Memory: The Art and Politics of Holocaust Memorials* (Detroit: Wayne State University Press, 1991), 12.

8. Diner, *Remember with Reverence and Love*; Alan Mintz, *Popular Culture and the Shaping of Holocaust Memory in America* (Seattle: University of Washington Press, 2001).

9. Deborah Lipstadt, *Denying the Holocaust: The Growing Assault on Truth and Memory* (New York: Free Press, 1993), 200. For a history of the publication of Anne Frank's diary, see Lisa Kuitert, "The Publication of Anne Frank's Diary," *Quaerendo* 40, no. 1 (2010): 50–65.

10. Hilene Flanzbaum, *Americanization of the Holocaust* (Baltimore: Johns Hopkins University Press, 1999), 3.

11. Peter Novick, *Holocaust in American Life* (New York: Mariner Books, 2000), 124.

12. Novick, *Holocaust in American Life*, 135.

13. Fallace, *Emergence of Holocaust Education*, 70.

14. Edward T. Linenthal, *Preserving Memory: The Struggle to Create America's Holocaust Museum* (New York: Columbia University Press, 2001).

15. Fallace, *Emergence of Holocaust Education*, 114.

16. See note 3. My attempts to get this film from Israel have been unsuccessful.

17. James E. Young, *The Texture of Memory: Holocaust Memorials and Meaning* (New Haven, CT: Yale University Press, 1993), 11.

18. Young, *Texture of Memory*, 11.

19. Translated by Neil Hollander.

20. Richard Yaffe, *Nathan Rapoport: Sculptures and Monuments* (New York: Shengold, 1980).

21. Young, *Texture of Memory*.

22. Edward Gastfriend, telephone interview, January 28, 2015.

23. Young, *Texture of Memory*, 155.

24. Yaffe, *Rapoport*, 2.

25. Yaffe, *Rapoport*, 3.

26. Yaffe, *Rapoport*, 3.

27. For the history of the Warsaw Ghetto Uprising, see Israel Gutman, *The Jews of Warsaw, 1939–1943: Ghetto, Underground, Revolt* (Bloomington: Indiana University Press, 1982), 283–400.

28. Yaffe, *Rapoport*, 4.

29. Yaffe, *Rapoport*, 3.

30. Janet Ward, "Capital Gardens: The Mall and the Tiergarten in Comparative Perspective," *Berlin–Washington, 1800–2000: Capital Cities, Cultural Representation, and National Identities*, ed. Andreas W. Daum and Christof Mauch (Cambridge: Cambridge University Press, 2005), 164.

31. Young, *Texture of Memory*, 155–84.

32. Yaffe mentions that while Rapoport was working on the monument for Kibbutz Yad Mordechai in 1948, he "returned to Paris, where he lived"; *Rapoport*, 6.

33. See David Ohana, *Modernism and Zionism* (New York: Cambridge University Press, 2012), 20. For the development of art in Israel from the settler years to the present, see Dalia Manor, *Art in Zion: The Genesis of Modern National Art in Israel* (New York: Routledge, 2005).

34. Novick, *Holocaust in American Life*, 114.

35. Hasia Diner, *Remember with Reverence and Love*, 35.

36. Mark Godfrey, *Abstraction and the Holocaust* (New Haven, CT: Yale University Press, 2007), 118.

37. Lucy Lippard and David Chandler, "The Dematerialization of Art," *Art International* (February 1968): 31. Rosalind Krauss, "Sculpture in the Expanded Field," in *The Originality of the Avant-Garde and Other Modernist Myths* (Cambridge, MA: MIT Press, 1985), 276–90.

38. Tom Finkelpearl, *Dialogues in Public Art* (Cambridge, MA: MIT Press, 2001), 20.

39. See Penny Balkin Bach, *Public Art in Philadelphia* (Philadelphia: Temple University Press, 1992), 130.

40. For the history of the national movement of public art, see Finkelpearl, *Dialogues in Public Art*, 21.

41. For the story of the New York City memorial, see Godfrey, *Abstraction and the Holocaust*; Rochelle G. Saidel, *Never Too Late to Remember: The Politics behind New York City's Holocaust Museum* (New York: Holmes and Meyer, 1996); and Gavriel Rosenfeld, *Building after Auschwitz: Jewish Architecture and the Memory of the Holocaust* (New Haven, CT: Yale University Press, 2011), 123–25.

42. Ilya Ehrenburg and Vasily Grossman, *The Complete Black Book of Russian Jewry*, trans. and ed. David Patterson; foreword by Irving Louis Horowitz; introduction by Helen Segall (New Brunswick, NJ: Transaction, 2002). The first English translation was published by the Jewish Black Book Committee in 1946. For the murder of two million Jews in the Ukraine by Germans and with the help of local townspeople, see Dieter Pohl, "The Murder of Ukraine's Jews under German Military Administration and in the Reich Commissariat Ukraine," in *Shoah in Ukraine: History, Testimony, Memorialization*, ed. Ray Brandon and Wendy Lower (Bloomington: Indiana University Press, 2008), 23–76. For postwar silence regarding the murder of the Jews in the USSR, see Zvi Gitelman, ed., "Politics and Historiography of the Holocaust in the Soviet Union," in *Bitter Legacy: Confronting the Holocaust in the USSR* (Bloomington: Indiana University Press, 1997), 14–42.

43. Law Offices of Silvers, Rosen, Sherwin, and Seltzer to Abram Shnaper, letter, October 30, 1962, Shnaper Papers.

44. Edward Gastfriend, telephone interview, January 28, 2015.

45. Articles of Incorporation: The Committee for a Monument in Memory of the Six Million Jewish Martyrs, undated, Shnaper Papers. Names of incorporators (and

titles) are listed as follows: Joseph Steinig (secretary), Gideon Rath, Harold Green-span, Edward Gastfriend (vice president), Harry Bass, Abram Shnaper (president), Olga Potok (treasurer), David N. Rosen, Jack Thalheimer, Louis E. Seltzer.

46. Abram Shnaper, interview with author, June 2011, Philadelphia, PA.

47. David Sluki, "Republics of Memory: American Jewish Survivor Networks and the Rise of Holocaust Consciousness," *Association of Jewish Studies*, December 2015.

48. Murray Friedman, ed., *Philadelphia Jewish Life* (Philadelphia: Temple University Press, 2003), 20.

49. For the use of the phrase "Holocaust survivor," see Beth B. Cohen, *Case Closed: Holocaust Survivors in Postwar America* (New Brunswick, NJ: Rutgers University Press, 2007). For AJNA name change, see entity number 763456, "Business," Pennsylvania Department of State, accessed September 9, 2014, available at www.dos.pa.gov.

50. Shnaper, interview with author, June 2011, Philadelphia, PA. He dates this incident to June 1961.

51. David Perleger, "Remember," *Association of Jewish New Americans Bulletin*, no. 6 (April 1962): 8.

52. Some details of Dalck Feith's life come from my interviews with his daughter, Deborah Feith Tye, telephone interview, January 27, 2015, and his son, Douglas Feith, telephone interview, January 28, 2015.

53. Jacob Shavit, *Jabotinsky and the Revisionist Movement 1925–1948* (London: Cass, 1988).

54. Dalck Feith, transcript of videotaped interview by Rose Landy, January 7, 1980, "Oral History in the Building of the Federation of Jewish Agencies 226 S. Sixteenth St., Philadelphia," SCRC 82 WLB Oral History Feith, Dalck, transcript, 7, Special Collections Research Center (SCRC), Temple University Libraries.

55. Among other causes, he was a major donor to the synagogue designed by Frank Lloyd Wright in Elkins Park, PA. He was later appointed by President Ronald Reagan to the commission to raise funds for and oversee the construction of the USHMM; Douglas Feith, telephone interview, January 28, 2015.

56. Some details of Dalck Feith's life come from my interviews with his daughter, Deborah Feith Tye, interview with author, telephone interview, January 27, 2015, and his son, Douglas Feith, interview with author, telephone interview, January 28, 2015.

57. Dalck Feith, transcript of videotaped interview by Rose Landy, January 7, 1980.

58. Dalck Feith, transcript of videotaped interview by Rose Landy, January 7, 1980.

59. Leon E. Brown, "Monumental Works from Warsaw to Philadelphia," *Jewish Times*, February 16, 1984.

60. Abram Shnaper to Dalck Feith, letter, May 20, 1964, Shnaper Papers.

61. Edward Gastfriend, telephone interview, January 28, 2015.

62. The model is now on permanent loan at the National Museum of American Jewish History in Philadelphia.

63. A 2 ft. plaster model was given to Edward Gastfriend by Nathan Rapoport and is in the private collection of David Gastfriend (Edward's son), who remembers hearing repeatedly, as a child, the story about Rapoport's reservations about the female form. David Gastfriend, telephone interview with author, January 28, 2015.

64. Rapoport gave the plaster model to Edward Gastfriend; telephone interview, January 30, 2015.

65. "Art Commission Oks Jewish Gift of Monument," *Daily News*, January 9, 1964.

66. Edward Gastfriend, telephone interviews, January 28 and 30, 2015.

67. "Art Commission Oks Jewish Gift of Monument."

68. Jacques Lipchitz to Lucy, letter, January 10, 1964, Michael Zagayski Papers, Jewish Theological Seminary Archives, folder 1/5.

69. For illustrations of models, see Yaffe, *Rapoport*, illustrations 60 and 65. For the dedication of *Brotherhood of Man*, see Susan Heller, "Sculpture of Amity," *New York Times*, May 24, 1986.

70. Douglas Feith, telephone interview, January 28, 2015.

71. Shnaper, interview with author, Philadelphia, PA. Edward Gastfriend, telephone interview, June 12, 2011; he reiterates these three themes.

72. Edward Gastfriend, telephone interview, 2011.

73. Monument to the Six Million Jewish Martyrs (1964), Amanda Aronczyk, video producer, Museum without Walls, www.museumwithoutwalls.org, recorded 2013, accessed January 23, 2015, available at http://museumwithoutwallsaudio.org /interactive-map/monument-to-six-million-jewish-martyrs#video.

74. Yaffe, *Rapoport*, 7.

75. *Evening Bulletin*, February 1963. The description of the original location was given by Josey Fisher, email to author, January 21, 2012.

76. Nathan Rapoport to Abram Shnaper, letter, November 19, 1960, Shnaper Papers, translated from Yiddish by Stanley Bergman.

77. Nathan Rapoport to Abram Shnaper, letter, November 19, 1960, Shnaper Papers, translated from Yiddish by Stanley Bergman.

78. Nathan Rapoport to Abram Shnaper, letter, September 20, 1963, Shnaper Papers, translated from Yiddish by Stanley Bergman.

79. Nathan Rapoport to Abram Shnaper, letter, July 28, 1963, Shnaper Papers, translated from Yiddish by Stanley by Bergman.

80. "Monument to 6 Million Jewish Martyrs En Route Here; Unveiling Set for April 26," *Philadelphia Jewish Times*, April 3, 1964.

81. "Phila Offered Statue for Martyred Jews," *Philadelphia Inquirer*, January 9, 1964.

82. Charlie Bannister, "Statue Commemorating Ghetto Heroes on Way," *Daily News*, March 12, 1962.

83. Minutes of the Fairmount Park Commission, March 9, 1964, 20, City Archives of Philadelphia. For newspaper coverage of the decision, "Monument to 6 Million Jewish Martyrs En Route Here."

84. Edward Gastfriend, telephone interview, 2011.

85. Minutes of the Fairmount Park Commission, April 13, 1964, 25.

86. Minutes of the Philadelphia Office of the Commissioners, April 13, 1964, City Archives of Philadelphia. In 1966, the Six Million Committee met to discuss the sculpture's base. One member asked what was being done to have the sculpture moved to a better location; another member said to leave it where it was. The matter does not come up again in minutes. Committee for the Monument Minutes, March 1, 1966, Shnaper Papers.

87. Edward Gastfriend, telephone interview, 2011.

88. Edward Gastfriend, telephone interview, 2011.

89. AJNA and the Federation of the Jewish Agencies of Greater Philadelphia, "The Monument to the Six Million Jewish Martyrs Unveiling," brochure, April 26, 1964, 1, Special Collections Research Center, Temple University Libraries, folder Inquirer Clipping, Rapoport Nathan, Sculptor.

90. "Jews Present Statue to Philadelphia to Honor Six Million Nazi Victims."

91. AJNA and the Federation, "The Monument to the Six Million Jewish Martyrs Unveiling," 2.

92. AJNA and the Federation, "The Monument to the Six Million Jewish Martyrs Unveiling," 2.

93. The title comes from the first line of the song, "Never say that you have reached the final road."

94. Monument to the Six Million Jewish Martyrs (1964).

95. Council of the City of Philadelphia, Office of the Chief Clerk, Room 402 City Hall, Resolution # 194: "To temporarily change the name of Arch St., at 16th Street and the Benjamin Franklin Parkway, to 'Avenue of the Six Million Jewish Martyrs,' during the weekend of April 15, 1966, in significant tribute to the heroic Jews of the Warsaw Ghetto and the six million Jewish martyrs who perished in the hands of the Nazis," signed Paul D'Ortona, JCRC files, ACC 7011966 JCRC Memorial Committee for the Six Million Jewish Martyrs, Temple University Archives. The resolution was reactivated yearly for the Yizkor Service.

96. Abram Shnaper to Levi Eshkol, telegram, May 28, 1964, Shnaper Papers.

97. Avraham Harman to Abram Shnaper, letter, May 27, 1964, Shnaper Papers.

98. David G. Wittels, "Eshkol Received Warmly Here and in Washington," *Jewish Exponent*, June 5, 1964, 65–66, Shnaper Papers.

99. Murray Friedman, ed., *Philadelphia Jewish Life: 1940–2000* (Philadelphia: Temple University Press, 2003), 73.

100. Friedman, *Philadelphia Jewish Life*, 78.

101. *Philadelphia Inquirer*, March 5, 1964, Inquirer Clippings, Jewish Martyrs Monument, folder 7–223.

102. Untitled newspaper clipping, *Jewish Times*, March 5, 1965, Shnaper Papers.

103. Novick, *Holocaust in American Life*, 20.

104. Committee for the Monument Minutes, March 1, 1966, Shnaper Papers.

105. Notes from Memorial Committee, February 2, 1967, JCRC Files, Folder ACC 201 JCRC "Memorial Committee for the Six Million Jewish Martyrs," SCRC, Temple University Libraries.

106. "Draft 10/9/72 Workshop Report–Holocaust Observance," JCRC Files, Folder ACC 701 JCRC Memorial Committee for the Six Million Jewish Martyrs 1971–72," SCRC, Temple University Libraries.

107. American Jewish Committee, "Guidelines to Jewish History in Social Studies Instructional Material," JCRC Files, Folder ACC 701 JCRC Jewish Martyrs: Teaching the Holocaust 1971–75, SCRC, Temple University Libraries.

108. Committee meeting notes, 1971–72, folder ACC 701 Memorial Committee for 6 Million Jewish Martyrs, 1971–72, SCRC, Temple University Libraries.

109. Hyman Chanover to Memorial Committee, letter, January 5, 1972, SCRC, Temple University Libraries.

110. Helen Humpreville, librarian at Abraham Lincoln High School, Philadelphia, to the Memorial Committee, letter, May 27, 1972, SCRC, Temple University Libraries.

111. Beth Razin, telephone interview, January 14, 2015.

112. "Youths Parade for Soviet Jews," *Philadelphia Inquirer*, October 18, 1970.

113. Gloria Campisi, "Channel 12 Off to See the Wizard," *Philadelphia Daily News*, July 21, 1977.

114. JCRC to WHYY, letter, undated, JCRC Files, folder ACC 701 JCRC Black Perspectives, SCRC, Temple University Libraries.

115. These letters can be found in JCRC Files, folder ACC 701 JCRC Black Perspectives, SCRC, Temple University Libraries.

116. From James H. Jones to James Karayn, president of WHYY, letter, August 12, 1977, SCRC, Temple University Libraries.

117. Letter, September 19, 1977, SCRC, Temple University Libraries.

118. Razin, telephone interview, January 14, 2015.

119. Monsignor Michael Carroll, telephone interview, January 15, 2015.

120. Monsignor Michael Carroll, telephone interview, January 15, 2015.

121. Monsignor Michael Carroll, telephone interview, January 15, 2015.

122. Monsignor Michael Carroll, telephone interview, January 15, 2015.

123. Paula Herbut, "Schools and the Holocaust," *Philadelphia Inquirer Sunday Bulletin*, February 27, 1977, Shnaper Papers. Herbut claims it is the first such course in the nation; other sources, however, prove this was not the case; see Fallace, *Emergence of Holocaust Education*, 29. For the development of Holocaust education in Philadelphia, see Marcia S. Littell, "Breaking the Silence: The Beginning of Holocaust Education in American," *Journal of Ecumenical Studies* 49, no. 1 (2014): 125–33. The change in curricula was not without controversy. See "Northeast Head of German-American Group Protests Holocaust Course in Schools," *Philadelphia Inquirer*, September 21, 1977.

124. Harold Kessler, assistant director, Division of Social Studies, School District of Philadelphia, Board of Education, to the Memorial Committee, letter, March 15, 1979, SCRC, Temple University Libraries.

125. The Reverend John F. Hartwick, diocese of Philadelphia, to the Memorial Committee, letter, April 22, 1979, folder ACC 1454 Memorial Committee—Correspondence 1979, SCRC, Temple University Libraries.

126. *Philadelphia Magazine*, September 1974, 118.

127. Gideon Hausner, chairman, Yad Vashem, to Solomon Fisher, chairman, Memorial Committee, letter, March 16, 1979, folder ACC 1454 Memorial Committee—Correspondence 1979, SCRC, Temple University Libraries.

128. Edward Gastfriend, telephone interview, June 2011.

129. The Holocaust Oral History Archive at Gratz College was established in 1979. Josey Fisher, email to author, January 21, 2012.

130. Razin, telephone interview, January 14, 2015.

131. Dubin Murray, "Students Crossing Boundaries to Understand the Holocaust," *Philadelphia Inquirer*, August 5, 1989.

132. Laurie L. Harris, ed., *Unbroken Chain: Celebrating 125 Years—The Park Avenue Synagogue* (New York: Park Avenue Synagogue, 2008), 293.

133. Betty Jean Lifton, *The King of Children: A Biography of Janusz Korczak* (New York: Farrar, Straus and Giroux, 1988), 323, 344–45.

134. Razin, telephone interview, January 14, 2015.

135. Stephan Salisbury, "Human-Rights Center Proposed for Philadelphia," *Philadelphia Inquirer*, January 28, 2010.

136. Marc Felgoise, telephone interview, October 16, 2011.

137. Private unveiling of plaza plans, May 4, 2016, Philadelphia. John Hurdle, "A Holocaust Memorial Expands in Philadelphia," *New York Times*, October 23, 2018.

138. See, for example, "Monument to Six Million Jewish Martyrs," Visit Philadelphia, visitphilly.com, accessed October 27, 2015, available at http://www.visitphilly.com/music-art/philadelphia/monument-to-six-million-jewish-martyrs/.

139. Monument to the Six Million Jewish Martyrs (1964). See the interactive map at the Association for Public Art, accessed May 14, 2019, available at https://www.associationforpublicart.org/explore/public-art/#map/all/.

140. Nathan Rapoport to Abram Shnaper, letter, May 6, 1964, Shnaper Papers, translated from Yiddish by Stanley Bergman.

## CHAPTER 3

Parts of this chapter originally appeared in Natasha Goldman, "From Ravensbrück to Berlin: Will Lammert's Monument to the Deported Jews (1957/1985)," *Images: A Journal of Jewish Art and Visual Culture* 9, no. 1 (2016): 140–63. Reprinted with permission of Brill.

1. An early version of this analysis appeared in Natasha Goldman, "Marking Absence: Remembrance and Hamburg's Holocaust Memorials," in *Beyond Berlin: Twelve German Cities Confront the Past*, ed. Gavriel D. Rosenfeld and Paul B. Jaskot (Ann Arbor: University of Michigan Press, 2008), 251–72.

2. James E. Young's work on the topic of Holocaust memorials and collective memory has been groundbreaking. The works at Hamburg Dammtor, however, only receive cursory analysis in his book, *Texture of Memory*. The details of the commissions and the problems encountered are not fully analyzed. See James E. Young, *The Texture of Memory: Holocaust Memorials and Meaning* (New Haven, CT: Yale University Press, 1993), 104–12. Other memorials to the Holocaust in Hamburg include the following: Gloria Friedman, Hier + Jetzt—den Opfern nationalsozialistischer Justiz in Hamburg (Here and Now—the Victims of National Socialist Justice in Hamburg, 1997); Jochen Gerz und Esther Shalev-Gerz, Mahnmal gegen Faschismus, Krieg, Gewalt—für Frieden und Menschenrechte (Memorial against Fascism, War, and Violence—for Peace and Human Rights, 1986–93); Sol LeWitt, Black Form—Dedicated to the Missing Jews (1987–89); and Lili Fischer, Rosengarten für die Kinder vom Bullenhuser Damm (Rose Garden for the Children of Bullenhuser Damm, 1985).

3. An early version of this analysis was published in Natasha Goldman, "From Ravensbrück to Berlin: Will Lammert's Monument to the Deported Jews (1957/1985)," *Images: A Journal of Jewish Art and Visual Culture* (November 2016): 1–24.

4. James E. Young, "Memory/Monument," in *Critical Terms for Art History*, ed. Richard Schiff (Chicago: University of Chicago Press, 1996), 240.

5. Volker Plagemann, *Vaterstadt, Vaterland—Denkmäler in Hamburg* (Hamburg: H. Christians, 1986), 163. See also Frank Kürschner-Pelkmann, *Jüdisches Leben in Hamburg* (Hamburg: Dölling und Galitz, 1997), 95.

6. See Kürschner-Pelkmann, *Jüdisches Leben in Hamburg*.

7. Frank Bajohr, "Von der Ausgrenzung zum Massenmord: Die Verfolgung der Hamburger Juden 1933–1945," in *Hamburg im "Dritten Reich*," ed. Josef Schmid (Göttingen: Wallstein Verlag, 2005), 477.

8. Bajohr, "Von der Ausgrenzung zum Massenmord," 477.

9. Bajohr, "Von der Ausgrenzung zum Massenmord," 472, 477.

10. Bajohr, "Von der Ausgrenzung zum Massenmord," 471–518.

11. Bajohr, "Von der Ausgrenzung zum Massenmord," 477.

12. Josef Schmid, ed. *Hamburg im "Dritten Reich."* Göttingen: Wallstein Verlag, 2005.

13. Frederic Spotts, *Hitler and the Power of Aesthetics* (New York: Woodstock, 2003), 373–75.

14. Peter Reichel and Harald Schmid, eds. *Von der Katastrophe zum Stolpersteine* (Hamburg: Dölling und Galitz Verlag, 2005), 53.

15. Joist Grolle, "Percy Ernst Schramm—ein Sonderfall in der Geschichtsschreibung Hamburgs," *Zeitschrift des Vereins für Hamburgische Geschichte* 81 (1995): 22–60.

16. Werner Johe, *Hitler in Hamburg: Dokumente zu einem besonderen Verhältnis* (Hamburg: Ergebnisse-Verlag, 1996), 7.

17. Susanne Rau, "Holsteinische Landesstadt oder Reichststadt? Hamburgs Erfindung seiner Geschichte als Freie Reichstadt," in *Nordlichter: Geschichtsbewusstsein und Geschichtsmythen nördlich der Elbe*, ed. Bea Lundt (Cologne: Taschenbuch, 2004), 159–77.

18. *Arbeiter in Hamburg: Unterschichten, Arbeiter und Arbeiterbewegung siet dem ausgehenden 18. Jahrhundert*, ed. Arno Herzig, Kieter Langewiesche, and Arnold Sywottek (Hamburg, 1983).

19. Geoffrey J. Giles, *Students and National Socialism in Germany* (Princeton, NJ: Princeton University Press, 1985).

20. See the homepage of the Institut für Zeitgeschichte in Hamburg, available at www.zeitgeschichte-hamburg.de.

21. Johe, *Hitler in Hamburg*, 8, 20.

22. A point curiously missing in the most recent literature on Hamburg and National Socialism is the Christopher Browning/Daniel Goldhagen debate about Reserve Battalion 101 from Hamburg. See Christopher Browning, *Ordinary Men: Reserve Battalion 101 and the Final Solution in Poland* (New York: HarperCollins, 1992) and Daniel Jonah Goldhagen, *Hitler's Willing Executioners: Ordinary Germans and the Holocaust* (New York: Vintage Books, 1996).

23. Peter Reichel and Harald Schmid, *Von der Katastrophe zum Stolpersteine* (Hamburg: Dölling und Galitz Verlag, 2005), 61.

24. Peter Paret, *German Encounters with Modernism, 1840–1945* (Cambridge: Cambridge University Press, 2001), 176–84.

25. Heinrich Lersch (1889–1936) was an autodidactic writer and commonly referred to as an *Arbeiterdichter* (proletarian poet). After World War I, Hamburg was the largest "red" city in Germany (after Berlin), and therefore the excerpt of this poem would have made sense to the 76th Regiment, a largely working-class regiment. See Reichel and Schmid, *Von der Katastrophe*, 52.

26. Plagemann, *Vaterstadt, Vaterland*, 155; also stated in Reichel and Schmid, *Von der Katastrope*, 61.

27. Plagemann, *Vaterstadt, Vaterland*, 158.

28. Plagemann, *Vaterstadt, Vaterland*, 158.

29. Reichel and Schmid, *Von der Katastrophe*, 62.

30. "Ideenwettbewerb, um dem Platz so umzugestalten, dass aus einer Kriegsverherrlichung ein Mahnmal gegen den Krieg wird," in Plagemann *Vaterstadt, Vaterland*, 171.

31. Plagemann, *Vaterstadt, Vaterland*, 172.

32. In the last days of war, Neuengamme concentration camp inmates were sent on a death march to the Lübeck Bucht and were put on the floating concentration camp Cap Arcona, only to be bombed by the British on May 3, 1945.

33. Young, *Texture of Memory*, 164–74.

34. Plagemann, *Vaterstadt, Vaterland*, 176.

35. Anna C. Chave, "Minimalism and the Rhetoric of Power," *Arts Magazine* 64, no. 5 (1990): 44–63.

36. For an analysis of modernism and its supposed neutrality in relation to U.S. identity and the Holocaust, see Ken Johnson, "Art and Memory," *Art in America* 81 (November 1993): 90–99.

37. Kürschner-Pelkmann, *Jüdisches Leben in Hamburg*, 111.

38. Reichel and Schmid, *Von der Katastrophe*, 65.

39. The area was already being used for extra parking for the university during the 1970s. Historical placards with pictures and text, organized by the Sociology Department of the Universität Hamburg, are now in the archive of the Museum für Hamburgische Geschichte. Interview with Christine Harff, member of the Grindelhof Citizen's Initiative (Grindelhof refers to the street of the same name, in the neighborhood of Grindel), December 2005.

40. The full text of the plaque reads as follows:

> *Hier am Bornplatz stand bis 1939 die größte Synagoge Norddeutschlands/ Sie wurde 1906 nach dem Planen der Architecten Friedheim und Engel/errichtet.*
>
> *Bis zur ihrem Zwangsabbruch durch die Nationalsozialisten im Jahr 1939/ war die Synagoge ein Mittelpunkt des religiösen jüdischen Lebens in Hamburg;/ in ihr fanden über 1100 Gläubige Platz.*
>
> *In der Pogromnacht vom 9./10. November 1938 machten die Nationalsozialisten/ diese geweihte Stätte zu einem Schauplatz der Judenvervolgung; die Synagoge/wurde in Brand gesteckt und schwer beschädigt. Nach dem Abbruch des Gotteshauses/wurde der Bunker errichtet.*
>
> *Für den Ort der ehemaligen Hauptsynagoge der Deutsch-Israelitische Gemeinde/ist ein Monument entworfen worden. Es soll ein Abbild des Deckengewölbes der/Zerstörten Synagoge auf ihrer ehemaligen Stätte erscheinen lassen.*
>
> *Das Monument soll an die Gestalt des Gotteshauses erinnenen, es soll eine Mahnung/sein, daß sinnlose Zerstörung ein Verbrechen gegen die Menschlichkeit gewesen ist./ Möge die Zukunft die Nachfahren von Unrecht bewahren.*

41. Christine Harff, interview with the author, November 2005.

42. Available at www.stolpersteine.com.

43. Kurt Jakob All-Kaduri and Michael Berenbaum, "Berlin 1933–39" and "Berlin 1939–45" in *Encyclopedia Judaica*, ed. Fred Skolnik, editor-in-chief and Michael Berenbaum, executive editor, vol. 3 (Detroit: Macmillan Reference USA in association with the Keter Publishing House, 2007), 448–51.

44. "Skulpturen in der Grossen Hamburger," *Berliner Zeitung*, May 4, 1985, 8.

45. Unless otherwise indicated, all translations are my own.

46. The family did not officially title the memorial. In 1985, a photograph and short description calls it "a figural group in remembrance of the thousands of deported Jewish citizens." See *Neues Deutschland*, July 13, 1985, 12. In 1991, it appeared in *Neue Zeit* as "Denkmal für die Opfer der Nazibarbarei" (Memorial for the Victims of Nazi Barbarism): Helmut Caspar, "Spuren einer Fahrt ohne Widerkehr: Vor 50 Jahren began die Deportation von Berliner Juden / Zeugnisse im Scheunenviertel," *Neue Zeit*, October 18, 1991, 19. In a 1992 article, it was referred to as "Denkmal am Alten Jüdischen Friedhof" (Monument in the Old Jewish Cemetery): Horst-Jörg Ludwig, "Zum 100. Geburtstag des Bildhauers Will Lammert am 5. Januar," *Berliner Zeitung*, January 4, 1992, 17.

47. Angela Lammert, "Will Lammert's Ravensbrück Memorial: The Image of Woman in German Post-War Public Sculpture," *Sculpture Journal* 9 (2003): 103. One article in German is essential to any study of the 1985 monument. It focuses primarily on post-1959 critical reactions to the *Unfinished* figures, and was written by a relative of the artist, Marlies Lammert, "Ein Denkmalsprojekt für Berlin. Zur Aufstellung der Plastikgruppe von Will Lammert," in *Studien zur Berliner Geschichte*, ed. Karl-Heinz Klingenburg (Leipzig: E. A. Seeman, 1986), 281–333. The Lammert family has been particularly active in publishing about the artist. His work, however, demands attention from scholars outside of the family. The current chapter is indebted to conversations and emails with Mark Lammert, the artist's grandson (and also an artist), and with his wife, Angela Lammert, an art historian.

48. *Tragende* is translated as either *Burdened Woman* or *Bearing Woman*, but it appears in most English publications as the former.

49. "Nachruf für Will Lammert," *Neues Deutschland*, November 1, 1957, 4. His obituary appeared in many GDR newspapers.

50. For a review of the Dresden exhibition, see "Erinnerung an die Jahre der Verfolgung: Werke deutscher Künstler über den Widerstandskampf in einer Berliner Ausstellung," *Neue Zeit*, September 5, 1958, 6. For a review of the Berlin exhibition, see Elmar Jansen, "Dialog zwischen Natur und Kunst," *Neue Zeit*, August 21, 1960, 4.

51. For the West German art historical attitude toward the former East Germany, see Achim Priess, *Abschied von der Kunst des 20. Jahrhunderts* (Weimar: VDG, 1999), the publication issued for the Weimar exhibition "Aufstieg und Fall der Moderne" (Rise and Fall of Modern Art) in Weimar, 1999. Exhibition catalog.

52. Mark Lammert, telephone interview, May 15, 2015.

53. Brian Ladd, "East Berlin Political Monuments in the Late German Democratic Republic: Finding a Place for Marx and Engels," *Journal of Contemporary History* 37, no. 1 (2002): 91–104.

54. M. Lammert, telephone interview, May 14, 2015.

55. M. Lammert, "Ein Denkmalsprojekt für Berlin," 282. For the history of the Neue Synagogue, see Harold Hammer-Schenk, "Baugeschichte und Architektur der Neuen Synagogue," in *"Tuet auf die Pforten": Die Neue Synagogue 1866–1995*, ed. Hermann Simon (Berlin: Stiftung Neue Synagogue Berlin—Centrum Judaicum, 1995).

56. Günter Braun, ed., *Orte Erinnern. Spuren des NS-Terrors in Berlin: Ein Wegweiser* (Berlin: Nicolai, 2003), 67–73.

57. Katharina Gerstenberger, *Writing the New Berlin: The German Capital in Post-Wall Literature* (Columbia, SC: Camden House, 2008), 78.

58. *Transnationalism and the German City*, ed. Jeffry M. Diefendort and Janet Ward (New York: Palgrave Macmillan, 2014).

59. Gerstenberger, *Writing the New Berlin*, 78.

60. M. Rapsilber, "Das Ghetto von Berlin," *Der Roland von Berlin* 7, no. 45 (November 4, 1909): 1475–77. Other descriptions are collected in Eike Geisel, ed., *Im Scheuen: Bilder, Texte und Dokumente* (Berlin: Severin und Siedler, 1981); and Verein Stiftung Scheuen, ed., *Das Scheu: Spuren eines verlorenen Berlins* (Berlin: Haude und Spener, 1994). For a history of the neighborhood, see also Michel S. Laguerre, *Global Neighborhoods: Jewish Quarters in Paris, London, and Berlin* (Albany: State University of New York Press, 2008).

61. Dora Apel, *Memory Effects: The Holocaust and the Art of Secondary Witnessing* (New Brunswick, NJ: Rutgers University Press, 2002), 55.

62. Beate Meyer, Hermann Simon, and Chana Schütz, *Jews in Nazi Berlin: From Kristallnacht to Liberation* (Chicago: University of Chicago Press, 2009), 328.

63. Beate Meyer, *A Fatal Balancing Act: The Dilemma of the Reich Association of Jews in Germany 1939–1945* (New York: Berghahn Books, 2013), 133.

64. Meyer, Simon, and Schütz, *Jews in Nazi Berlin*, 329.

65. Magdalena Waligorska, *Klezmer's Afterlife: An Ethnography of the Jewish Revival in Poland and Germany*.

66. Florian Urban, *Neo-historical East Berlin: Architecture and Urban Design in the German Democratic Republic 1970–1990* (Burlington, VT: Ashgate, 2009).

67. Urban, *Neo-historical East Berlin*, 69.

68. Urban, *Neo-historical East Berlin*, 74.

69. Urban, *Neo-historical East Berlin*, 76.

70. Jan Bauditz, "Aufbruch gegen Abriss—Die Bürgerinitiative Spandauer Vorstadt," in *Die Spandauer Vorstadt: Utopien und Realitäten zwischen Scheunenviertel und Friedrichstrasse*, ed. Gesellschaft Hackesche Höfe e.V., Verein zur Förderung Urbanen Lebens (Berlin: Argon Verlag, 1995), 42.

71. Heinz Knobloch, *Herr Moses in Berlin* (Berlin: Der Morgen, 1979).

72. Urban, *Neo-historical East Berlin*, 85.

73. Urban, *Neo-historical East Berlin*, 88.

74. Urban, *Neo-historical East Berlin*, 88.

75. Klaus Neumann, *Shifting Memories: The Nazi Past in the New Germany* (Ann Arbor: University of Michigan Press, 2000), 1–2.

76. Unless otherwise indicated, all translations are my own.

77. Many thanks to Margaret Olin for offering this additional interpretation.

78. Helmut Caspar, "Spuren einer Fahrt ohne Wiederkehr: Vor 50 Jahren begann die Deportation von Berliner Juden / Zeugnisse im Scheunenviertel," *Neue Zeit*, October 18, 1991, 19.

## CHAPTER 4

1. "All exhibits should be of an authentic documentary character in order to preempt attempts by those who would deny that the Holocaust took place from using the Museum as supporting evidence of Holocaust denial." Jeshajahu Weinberg and Rina Elieli, *The Holocaust Museum in Washington* (New York: Rizzoli, 1995), 29. For documents related to the APSP, please see the APSP folders at the USHMM.

2. Mark Godfrey, *Abstraction and the Holocaust* (New Haven, CT: Yale University Press, 2007).

3. James E. Young, ed. *The Art of Memory: Holocaust Memorials in History* (New York: Prestel, 1994), 28.

4. For an analysis of other submissions, and for James Freed's design, see Eran Neuman, *Shoah Presence: Architectural Representations of the Holocaust* (Surrey, U.K.: Ashgate, 2014), 103–48.

5. James Ingo Freed, "The United States Holocaust Memorial Museum," in *The Art of Memory: Holocaust Memorials in History*, ed. James E. Young (New York: Prestel, 1994), 92.

6. *The Architecture of the United States Holocaust Memorial Museum* (Washington, DC: United States Holocaust Memorial Museum, 1995), 6.

7. Gavriel D. Rosenfeld, "Remembering to Forget: Holocaust Memory through the Camera's Eye," *German Studies Review* 23, no. 1 (February 2000): 171.

8. For the debate over the need for explanatory text in educational museum spaces, see Peter Vergo, "The Reticent Object," in *The New Museology*, ed. Peter Vergo (London: Reaktion, 1989), 52–53.

9. Marianne Hirsch, *Family Frames: Photography, Narrative and Postmemory* (Cambridge, MA: Harvard University Press, 1997), 101.

10. Jonathan Rosen, "American Holocaust," *Forward*, April 12, 1991.

11. Matthew Baigell, *Jewish-American Artists and the Holocaust* (New Brunswick, NJ: Rutgers University Press, 1997).

12. Albert Abramson, "Report on Existing Public Holocaust Sculptures/Monuments," APSP, 1991.

13. James E. Young, *The Texture of Memory: Holocaust Memorials and Meaning* (New Haven, CT: Yale University Press, 1993).

14. Deborah R. Geis, ed., *Considering Maus: Approaches to Art Spiegelman's "Survivor's Tale" of the Holocaust* (Tuscaloosa: University of Alabama Press, 2003).

15. Dominick LaCapra, *History and Memory after Auschwitz* (Ithaca, NY: Cornell University Press, 1998), 155.

16. Dori Laub, Harvey Peskin, and Nanette C. Auerhahn, "Der Zweite Holocaust: Das Leben ist bedrohlich," *Psyche* 49, no. 1 (January 1995): 18–40.

17. APSP, "Short List," May 16, 1990.

18. The film was based on Thomas Keneally's *Schindler's Ark*, which won the Man Booker Prize in 1982.

19. Thomas D. Fallace, *The Emergence of Holocaust Education in American Schools* (New York: Palgrave Macmillan, 2008), 114.

20. APSP, "Art for Public Spaces Program," undated mission statement.

21. Minutes of the Meeting of the Ad Hoc Committee on Art for Public Spaces in the Museum, June 28, 1990.

22. Minutes of the Meeting of the Jury for the Art for Public Spaces Program, April 17, 1991.

23. Minutes of the Meeting of the Subcommittee for Art for Public Spaces, November 16, 1990, 3.

24. APSP, "Short List," May 16, 1990.

25. Minutes of the Meeting of the Subcommittee for Art for Public Spaces of the Committee on Collections and Acquisitions, November 16, 1990.

26. Memorandum from Nancy Rosen to Members of the Jury, February 8, 1991.

27. Memorandum, February 8, 1991.

28. Memorandum/Report, May 28, 1991.

29. Memorandum/Report, May 28, 1991.

30. "Update: Art for Public Spaces Program," July 26, 1991.

31. USHMM Art for Public Spaces Program, Current Artists List, July 1991.

32. Letter from Sara Bloomfield to Ellsworth Kelly, October 24, 1991.

33. Michael Kimmelman, "Marking Art of the Holocaust: New Museum, New Works," *New York Times*, April 23, 1993.

34. Helen L. Kohen, "U.S. Holocaust Museum: Monument to Hope, Sorrow," *Miami Herald*, April 23, 1993.

35. Paul Richards, "Obscene Pleasure: Art among the Corpses," *Washington Post*, April 18, 1993, G1.

36. Ken Johnson, "Art and Memory," *Art in America* 81 (November 1993): 93.

37. Godfrey, *Abstraction and the Holocaust*, 202.

38. Godfrey, *Abstraction and the Holocaust*, 235.

39. Godfrey, *Abstraction and the Holocaust*, 235.

40. Memorandum, March 17, 1993.

41. Joel Shapiro, "For the Dead and Surviving Children," commission proposal, undated.

42. Joel Shapiro, "For the Dead and Surviving Children."

43. Anon., "Art and Politics . . .," *Mirabella* (April 1993): 80.

44. Anon., "Art and Politics . . .," *Mirabella* (April 1993): 80.

45. Roberta Sokolitz, "Outdoors with Joel Shapiro," *Sculpture* 19, no. 9 (2000): 16–21.

46. Quoted in Godfrey, *Abstraction and the Holocaust*, 235.

47. Anna C. Chave, "Minimalism and the Rhetoric of Power," *Arts Magazine* 64, no. 5 (1990): 44–63.

48. Chave, "Minimalism and the Rhetoric of Power," 45.

49. Jock Reynolds, *Joel Shapiro: Sculpture in Clay, Plaster, Wood, Iron, and Bronze, 1971–1997*, exhibition catalog (Andover, MA: Addison Gallery of American Art, 1998), 84.

50. Quoted in Reynolds, *Joel Shapiro*, 84.

51. Deborah Leveton, "Interview," in *Joel Shapiro: Tracing the Figure* (Miami: Center for Fine Arts, 1991), 46.

52. Oral history interview with Joel Shapiro, July 15–December 14, 1988, Archives of American Art, Washington, DC.

53. Available at http://alpha137gallery.com/joel-shapiro-for-jewish-museum-5748-woodcut/.

54. Draft, USHMM Art for Public Spaces Program, undated.

55. Ulrich Wilmes, "Black and White," in *Ellsworth Kelly Black and White*, ed. Ulrich Wilmes (Ostfildern: Hatje Cantz, 2011), 11.

56. Wilmes, "Black and White," 16.

57. Michael Fried, "Art and Objecthood" *Artforum* (Summer 1967), 12–23.

58. See Erika Doss for an alternative interpretation of audience participation. Erika Doss, *Memorial Mania* (Chicago: University of Chicago Press, 2012), 127.

59. Diane Waldman and Roberta Bernstein, eds., *Ellsworth Kelly: A Retrospective*. (New York: Guggenheim, 1997), 25–26.

60. Diane Waldman and Roberta Bernstein, eds., *Ellsworth Kelly,* 36. The use of Christian iconography to memorialize Jewish victims reappears in Chapter 5, in the context of Kollwitz's *Pietà* in Berlin.

61. Draft, USHMM APSP, undated.

62. APSP, "Draft: Ellsworth Kelly," March 17, 1993.

63. Kelly's multipanel works have been associated with mural making in the French context. See Michael Plante, "'Things to Cover Walls': Ellsworth Kelly's Paris Paintings and the Tradition of Mural Decoration," *American Art* 9 (Spring 1995): 36–53.

64. Marita Sturken, "The Wall, the Screen, and the Image: The Vietnam Veterans Memorial," in "Monumental Histories," special issue, *Representations,* no. 35 (Summer 1991): 118–42.

65. Dave Hickey, *Ellsworth Kelly: New Paintings* (New York: Matthew Marks Gallery, 1998), 6.

66. Roberta Bernstein, "Ellsworth Kelly's Multipanel Paintings," in *Ellsworth Kelly: A Retrospective,* ed. Diane Waldman and Roberta Bernstein (New York: Guggenheim, 1996), 41.

67. Mark Rosenthal, "Experiencing Presence," in *Ellsworth Kelly: A Retrospective,* ed. Diane Waldman and Roberta Bernstein (New York: Guggenheim, 1996), 63.

68. Memorandum from Nancy Rosen to Albert Abramson and Jeshajahu Weinberg, June 9, 1992.

69. As the artist later recalled in *Sol LeWitt: A Retrospective* (New Haven, CT: Yale University Press, 2000).

70. A second work, *White Pyramid (Münster),* commissioned at the same time as Black Form, was originally installed in the city's Botanical Garden and is now located in Münster's City Hall Park.

71. Accessed December 12, 2017, available at http://fhh1.hamburg.de/Behoerden /Kulturbehoerde/Raum/artists/lewi.htm.

72. Available at http://fhh1.hamburg.de/Behoerden/Kulturbehoerde/Raum/artists /lewi.htm.

73. Memorandum from Nancy Rosen to Albert Abramson and Jeshajahu Weinberg, June 9, 1992.

74. As quoted in Andrea Miller-Keller, *Glenn–Ligon/MATRIX 120* (Hartford, CT: Wadsworth Atheneum, 1992), 1.

75. Samantha Baskind, "Navigating the Worldly and the Divine: Jewish American Artists on Judaism and Their Art," *Shofar: An Interdisciplinary Journal of Jewish Studies* 32, no. 1 (Fall 2013): 27–42, available at http://muse.jhu.edu/journals/shofar /v032/32.1.baskind.html.

76. Godfrey, *Abstraction and the Holocaust,* 213.

77. Susannah Singer, ed., *Sol LeWitt: Wall Drawings 1984–1992* (Andover, MA: Addison Gallery of American Art, Phillips Academy, 1992).

78. Godfrey, *Abstraction and the Holocaust,* 229.

79. Caitlin Whalen, a former student at Bowdoin College, examined this phenomenon in a research paper for my fall 2012 seminar, *Visual Strategies of Holocaust Remembrance.*

80. Adam D. Weinberg, "LeWitt's Autobiography: Inventory of the Present," in *Sol LeWitt: A Retrospective,* ed. Gary Garrels (New Haven, CT: Yale University Press, 2000), 101.

81. Saul Friedländer, *Probing the Limits of Representation: Nazism and the "Final Solution"* (Cambridge, MA: Harvard University Press, 1992).

82. Mel Bochner quoted in Lucy Lippard, *Eva Hesse* (New York: New York University Press, 1976), 201.

83. William Zimmer, "Art Takes a Cherished Spot in Chester's New Synagogue," *New York Times*, December 9, 2001.

84. There was very little critical response to LeWitt's installation, although a short review appears in *Kunstforum International*: Annelie Pohlen, "Sol LeWitt: 'Lost Voices': Synagoge Stommeln. (German)," *Kunstforum International* no. 176 (June 2005): 326–28. The Stommeln Synagogue website provides a very useful description of the projects commissioned there. Available at http://www.synagoge-stommeln.de/index.php?n1=6&n2=0&n3=0&Direction=101&s=0&lang=engl.

85. The project is listed among "Solo Exhibitions" in a 2013 monograph. See Béatrice Gross, ed., *Sol LeWitt* (Metz: Centre Pompidou-Metz, 2012), 287.

86. Godfrey, *Abstraction and the Holocaust*, 210.

87. Godfrey, *Abstraction and the Holocaust*, 210.

88. Robert Storr, "Tilted Arc: Enemy of the People?" *Art in America* 3, no. 9 (September 1985): 90–97. The sculpture was removed after a group of employees in the Federal Building in New York determined that it obstructed entrance into the building.

89. Richard Serra and Clara Weyergraf-Serra, *Richard Serra: Interviews, 1970–1980* (Yonkers, NY: Hudson River Museum, 1980), 99.

90. Richard Serra, *The Drowned and the Saved* (Cologne: Verlagshaus Wienand, 1992), 2.

## CHAPTER 5

1. Among the most helpful texts regarding the Berlin Holocaust Memorial is Michael S. Cullen, ed., *Das Holocaust-Mahnmal: Dokumentation einer Debatte* (Zurich: Pendo, 1999). Lea Rosh published her own collection of articles concerning the debate. See Lea Rosh, ed., *Die Juden, das sind doch die anderen: Der Streit um ein deutsches Denkmal* (Berlin: Philo-Verlagsgesellschaft, 1999). See also Achim Tischer, *Brauchen wir ein Denkmal?* (Temmen: Bremen, 2000); Matthias Reichlt, *Testversuch: Entwürfe zum Holocaust-Denkmal* (Berlin: Taschenbuch, 2001); Claus Leggewie and Erik Meyer, *"Ein Ort, and den man gerne geht": Das Holocaust-Mahnmal und die deutsche Geschichtspolitik nach 1989* (Munich: Carl Hanser Verlag, 2005); Klaus Frahm, *Memorial to the Murdered Jews of Europe* (Berlin: Nicolaische Verlagsbuchhandlung, 2005); Joachim Schloer, *Memorial to the Murdered Jews of Europe* (Munich: Prestel, 2005); Stiftung Denkmal für die Ermordeten Juden Europas, *Materials on the Memorial to the Murdered Jews of Europe* (Berlin: Nicolai, 2005); and Karen Till, *The New Berlin: Memory, Politics, Place* (Minneapolis: University of Minnesota Press, 2005). The most extensive publication is Ute Heimrod, Günter Schlusche, and Horst Seferens, *Der Denkmalstreit—das Denkmal? Die Debatte um das "Denkmal für die ermordeten Juden Europas": Eine Dokumentation* (Berlin: Philo Verlagsgesellschaft, 1999). For visitors' engagement with the memorial, including analyses of guided tours and visitors' responses, see Irit Dekel, *Mediation at the Holocaust Memorial in Berlin* (Houndsmills, U.K.: Palgrave Macmillan, 2013).

2. Mark Godfrey, *Abstraction and the Holocaust* (New Haven, CT: Yale University Press, 2007); Lisa Saltzman, *Making Memory Matter: Strategies in Contemporary Art* (Chicago: University of Chicago Press, 2010).

3. Heimrod, Schlusche, and Seferens, *Der Denkmalstreit*.

4. James E. Young, *At Memory's Edge: After-Images of the Holocaust in Contemporary Art and Architecture* (New Haven, CT: Yale University Press, 2000).

5. Heimrod, Schlusche, and Seferens, *Der Denkmalstreit*, 35.

6. Heimrod, Schlusche, and Seferens, *Der Denkmalstreit*, 35.

7. Heimrod, Schlusche, and Seferens, *Der Denkmalstreit*, 35.

8. Heimrod, Schlusche, and Seferens, *Der Denkmalstreit*, 35.

9. Heimrod, Schlusche, and Seferens, *Der Denkmalstreit*, 35. For the history of the Neue Wache, see Hanna Vorhalt, *Die Neue Wache* (Berlin: Taschenbuch, 2001); and Daniela Büchten and Anja Frey, eds., *Im Irrgarten Deutscher Geschichte: Die Neue Wache 1818 bis 1993* (Berlin: Schriftenreihe des Aktiven Museums Faschismus und Wiederstand in Berlin, 1998).

10. Heimrod, Schlusche, and Seferens, *Der Denkmalstreit*, 36.

11. Heimrod, Schlusche, and Seferens, *Der Denkmalstreit*, 167.

12. "Ausschreibung," Heimrod, Schlusche, and Seferens, *Der Denkmalstreit*, 177.

13. Heimrod, Schlusche, and Seferens, *Der Denkmalstreit*, 167.

14. The project came with an actual bus schedule. Renata Stih and Frieder Schnock, *Bus Stop: Fahrplan* (Berlin: Neuen Gesellschaft für Bildende Kunst, 1995).

15. Heimrod, Schlusche, and Seferens, *Der Denkmalstreit*, 275.

16. The story of Masada is interpreted in different ways. See Yael Zerubavel, *Recovered Roots: Collective Memory and the Making of Israeli National Tradition* (Chicago: University of Chicago Press, 1995).

17. Heimrod, Schlusche, and Seferens, *Der Denkmalstreit*, 275.

18. Heimrod, Schlusche, and Seferens, *Der Denkmalstreit*, 274.

19. Heimrod, Schlusche, and Seferens, *Der Denkmalstreit*, 274.

20. Heimrod, Schlusche, and Seferens, *Der Denkmalstreit*, 286. See also Stih and Schnock, *Bus Stop*.

21. Heimrod, Schlusche, and Seferens, *Der Denkmalstreit*, 167.

22. For a discussion on the submission and monumentality, see Andreas Huyssen, "Monumental Seduction," in *Acts of Memory: Cultural Recall in the Present*, ed. Mieke Bal, Jonathan Crewe, and Leo Spitzer (Hanover, NH: Dartmouth College, 1999), 191–207. There is a wide literature on Germany and its memorials. Among others, see Peter Reichel, *Politik mit der Erinnerung: Gedächtnisorte im Streit um die nationalsozialistische Vergangenheit* (München: C. Hanser, 1995).

23. Heimrod, Schlusche, and Seferens, *Der Denkmalstreit*, 509.

24. Heimrod, Schlusche, and Seferens, *Der Denkmalstreit*, 167.

25. Heimrod, Schlusche, and Seferens, *Der Denkmalstreit*, 543.

26. Heimrod, Schlusche, and Seferens, *Der Denkmalstreit*, 563.

27. Heimrod, Schlusche, and Seferens, *Der Denkmalstreit*, 589.

28. Heimrod, Schlusche, and Seferens, *Der Denkmalstreit*, 589.

29. Heimrod, Schlusche, and Seferens, *Der Denkmalstreit*, 769.

30. Heimrod, Schlusche, and Seferens, *Der Denkmalstreit*, 769. Young, *At Memory's Edge*, 197.

31. Young, *At Memory's Edge*, 197.

32. "Ausschreibung," in Heimrod, Schlusche, and Seferens, *Der Denkmalstreit*, 838.

33. "Ausschreibung," in Heimrod, Schlusche, and Seferens, *Der Denkmalstreit*, 838.

34. Heimrod, Schlusche, and Seferens, *Der Denkmalstreit*, 831.

35. For a discussion of Libeskind's architecture in terms of Jewish identity, see Gavriel Rosenfeld, *Building after Auschwitz: Jewish Architecture and the Memory of the Holocaust* (New Haven, CT: Yale University Press, 2011).

36. Petra Kipphoff, "Serra sagt ab: Das Holocaust-Denkmal und noch eine Krise," *Die Zeit*, June 4, 1998.

37. Heimrod, Schlusche, and Seferens, *Der Denkmalstreit*, 831.

38. Heimrod, Schlusche, and Seferens, *Der Denkmalstreit*, 1141.

39. Roger Cohen, "Schröder Backs Design for a Vast Berlin Holocaust Memorial," *New York Times*, January 18, 1999.

40. Roger Cohen, "Berlin Holocaust Memorial Approved," *New York Times*, January 26, 1999.

41. Roger Cohen, "Berlin Mayor to Shun Holocaust Memorial Event," *New York Times*, January 18, 2000. See also "Ein Denkmal in der Leere," *Die Tageszeitung*, January 28, 2000.

42. G. Schümaker and C. Richter, "Kritik an der Absage Diepgens," *Berliner Zeitung*, January 19, 2000, 4.

43. Anon., "Naumann knickt ein," *Speigel Online* 28, July 12, 2000, available at http://www.spiegel.de/kultur/gesellschaft/mahnmal-diskussion-naumann-knickt-ein -a-84775.html. See also Anon., "Begrenzung der Baukosten für Denkmal und Ort der Information auf 50 Millionen DM," October 27, 2000, available at https://www .stiftung-denkmal.de/startseite/neues/detail/begrenzung-der-baukosten-fuer-denkmal -und-ort-der-information-auf-50-millionen-dm.html.

44. Philipp Gessler, "Streit um 'the ort' beendet, aber Kosten gestiegen," *Die Tageszeitung*, July 19, 2000, 8. See also Christian Moehler, "Der Weg für den Bau des Holocaust-Mahnmals ist frei," *Der Tagesspiegel*, no. 17 (July 8, 2000): 2.

45. Harriet Dreier, "Ich bin nicht aus der Politik geflohen," *Spiegel Online*, March 4, 2001, available at www.spiegel.de/kultur/gesellschaft/0,1518,120787,00.html.

46. "Philosophische Argumente in der kulturpolitischen Praxis," *Neue Züricher Zeitung*, Monday, January 8, 2001, 21.

47. Jörg Lau, "Lichtschrein für die Aufklärung," *Die Zeit*, no. 16, April 11, 2001, 46.

48. Yve-Alain Bois combines notions of walking and the picturesque in his analysis of Serra's *Clara-Clara*. He focuses more on the "picturesque" than on "walking." See Bois, "A Picturesque Stroll around Clara-Clara," in *Richard Serra*, ed. Hal Foster and Gordon Hughes (Cambridge, MA: MIT Press, 2000), 59–98.

49. Friedrich Teja Bach, "Interview by Friedrich Teja Bach," in *Richard Serra: Writings and Interviews*, ed. Richard Serra (Chicago: University of Chicago Press, 1994), 29.

50. Lynne Cooke, "Thinking on Your Feet: Richard Serra's Sculpture in the Landscape." *Richard Serra Sculpture: Forty Years*, ed. Kynaston McShine and Lynne Cooke (New York: MOMA, 2007), 82.

51. Richard Serra and Peter Eisenman, "Interview," *Skyline* (April 1983): 16.

52. Liza Bear, "Interview by Liza Bear," reprinted in *Richard Serra: Writings and Interviews*, ed. Richard Serra (Chicago: University of Chicago Press, 1994), 48.

53. Cooke, "Thinking on Your Feet," in *Richard Serra Sculpture*, 80–81.

54. Godfrey, *Abstraction and the Holocaust*, 230.

55. Godfrey, *Abstraction and the Holocaust*, 232.

56. Godfrey, *Abstraction and the Holocaust*, 230. Jeshajahu Weinberg and Rina Elieli, *The Holocaust Museum in Washington* (New York: Rizzoli, 1995), 23.

57. Frances A. Yates, *The Art of Memory* (Chicago: University of Chicago Press, 1966).

58. Amos Funkenstein, *Perceptions of Jewish History* (Berkeley: University of California Press, 1993), 23.

59. Among the Latin words that mean *witness*, there is *superstes*, or "survivor." See Emile Benveniste, *Indo-European Languages and Society* (London: Faber, 1973), 522–26.

60. Yates, *Art of Memory*, 1–26.

61. Gerdien Jonker, *Topography of Remembrance* (Cologne: E. J. Brill, 1995), 18–19.

62. Mary Carruthers, *The Craft of Thought: Meditation, Rhetoric, and the Making of Images, 400–1200* (Cambridge: Cambridge University Press, 2000), 43.

63. Marita Sturken, "The Wall, the Screen, and the Image: The Vietnam Veterans Memorial," in "Monumental Histories," special issue, *Representations*, no. 35 (Summer 1991): 118–42.

64. Carruthers, *The Craft of Thought*, 37.

65. Ilya Kabakov, "Public Projects or the Spirit of a Place," *Third Text* 17, no. 4 (2003): 404.

66. Kabakov, "Public Projects," 404.

67. Michel de Certeau, *The Practice of Everyday Life*, trans. Steve F. Randall (Berkeley: University of California Press, 1984), 100.

68. de Certeau, *Practice of Everyday Life*, 101.

69. Dori Laub and Daniel Podell, "Art and Trauma," *International Journal of Psycho-Analysis* 76 (1995): 991.

70. Charles Baudelaire, "The Painter of Modern Life," in *The Norton Anthology of Theory and Criticism*, ed. Vincent B. Leitch (New York: W. W. Norton, 2001), 795.

71. The ramifications of a second- or third-generation survivor stumbling into the void of the memorial and encountering that metaphorical trauma could be investigated, especially as trauma has been demonstrated to be inherited to children and grandchildren of survivors. Nechama Sorscher and Lisa J. Cohen, "Trauma in Children of Holocaust Survivors: Transgenerational Effects," *American Journal of Orthopsychiatry* 67, no. 3 (July 1997): 493.

72. Peter Eisenman, "Memorial to the Murdered Jews of Europe," in Foundation for the Memorial, *Materials on the Memorial*, 11.

73. Henri Bergson, *Matter and Memory*, trans. N. M. Paul and W. S. Palmer (London: Allen and Unwin, 1910), 274.

74. Bergson, *Matter and Memory*, 274.

75. Bergson, *Matter and Memory*, 274.

76. Bergson, *Matter and Memory*, 281–82.

77. Peter Eisenman, *Written into the Void* (New Haven, CT: Yale University Press, 2007). For a discussion of the ways in which the void has figured as a metaphor for absence since Eisenman's early works, see Cynthia Davidson, *Tracing Eisenman: Peter Eisenman Complete Works* (New York: Rizzoli, 2006), 25–48.

78. Heimrod, Schlusche, and Seferens, *Der Denkmalstreit*, 986–87.

79. For a close analysis of Eisenman's architectural theory, see Eran Neuman, *Shoah Presence: Architectural Representations of the Holocaust* (Surrey, U.K.: Ashgate, 2014), 149–79.

80. Directly across the street from the Holocaust Memorial is the Memorial to the Homosexuals in the Tiergarten, designed by Ingar Dragset and Michael Elmgreen, unveiled in May 2008. See "Remembering Different Histories: Monument to Homosexual Holocaust Victims Opens in Berlin," *Spiegel Online International* (May 27, 2008). Accessed December 14, 2012. For an analysis of this debate, see Thomas O. Haakenson, "(In)Visible Trauma: Michael Elmgreen and Ingar Dragset's Memorial to the Homosexuals Persecuted under the National Socialist Regime," in *Memorialization in Germany*, ed. Bill Niven and Chloe Paver (New York: Palgrave Macmillan, 2010), 146–56. In October 2012, a memorial to the Sinti and Roma, designed by Dani Karavan (and fraught with controversy) was dedicated in Berlin. See "Sinti and Roma Holocaust Victims Remembered in Berlin," *Spiegel Online International* (October 24, 2012). Accessed December 14, 2012. The Memorial to the Victims of National Socialist "Euthanasia" Killings was installed in 2014. See Melissa Eddy, "Monument Seeks to End Silence on Killings of the Disabled by the Nazis," *New York Times,* September 2, 2014, available at https://www.nytimes.com/2014/09/03/world/europe/monument-seeks-to-end-silence -on-killings-of-the-disabled-by-the-nazis.html.

81. Robert Musil, "Monuments," in *Posthumous Papers of Living Author*, trans. Peter Wortsman (Hygiene, CO: Eridanos, 1987), 61.

## CONCLUSION

1. Robert Musil, "Denkmale," in *Gesammelte Werke*, ed. Adolf Frise (Reinbek bei Hamburg: Rowolt, 1978), 480–83.

2. Musil, "Denkmale," 480–83.

3. Mark Godfrey, *Abstraction and the Holocaust* (New Haven, CT: Yale University Press, 2007); Rochelle G. Saidel, *Never Too Late to Remember: The Politics behind New York City's Holocaust Museum* (New York: Holmes and Meyer, 1996); Gavriel D. Rosenfeld, *Building after Auschwitz: Jewish Architecture and the Memory of the Holocaust* (New Haven, CT: Yale University Press, 2011); and James E. Young, *The Texture of Memory: Holocaust Memorials and Meaning* (New Haven, CT: Yale University Press, 1993).

4. Mark Godfrey, *Abstraction and the Holocaust*, 126–27.

5. Anna Chave, "Minimalism and the Rhetoric of Power," *Arts Magazine* vol. 64, no. 5 (1990): 44–63.

6. For the story of the New York City memorial, see Godfrey, *Abstraction and the Holocaust*, 113–40; and Saidel, *Never Too Late to Remember*.

7. Accessed May 16, 2019, available at http://www.greatermedia.com/view/exhibi tions/5741_garden_of_stones.

8. Andrew M. Shanken, "Planning Memory: Living Memorials in the United States during World War II," *Art Bulletin* 84, no. 1 (March 2002): 130–47.

9. Accessed May 16, 2019, available at http://www.greatermedia.com/view/exhibi tions/5741_garden_of_stones.

10. Simon Schama and Andy Goldsworthy, "Garden of Stones," in *Passage: Andy Goldsworthy*, ed. Andy Goldsworthy (New York: Harry N. Abrams, 2004), unpaginated.

11. Andy Goldsworthy and Molly Donovan, public conversation, Museum of Jewish Heritage, New York, December 12, 2017.

12. Idit Pintel-Ginsberg, "Stones," in *Encyclopedia of Jewish Folklore and Traditions*, ed. Haya Bar-Otzhak and Raphael Patai, vol. 2 (London: Routledge, 2013), 515.

13. Pintel-Ginsberg, "Stones," 516.

14. Mira Engler, "A Living Memorial: Commemorating Yitzhak Rabin at the Tel Aviv Square," *Places* 12, no. 2 (Winter 1999): 11; Harriet Senie, "Andy Goldsworthy's Garden of Stones," *Public Art Review* 15, no. 2 (Spring/Summer 2004): 35.

15. Pintel-Ginsberg, "Stones," 516.

16. Pintel-Ginsberg, "Stones," 516.

17. Geoffrey Wigoder, Fred Skolnik, and Shmuel Himelstein, eds. "New Year for Trees," in *The New Encyclopedia of Judaism*, 2nd ed. (New York: New York University Press, 2002), 571. For more examples of trees in Judaism, see Amots Dafni, "Plants," in *Encyclopedia of Jewish Folklore and Traditions*, ed. Haya Bar-Itzhak and Raphael Patai, vol. 2 (London: Routledge, 2013), 412–15.

18. For example, see the Holocaust Memorial Garden in Rochester, NY. Available at http://jccrochester.org/about-the-jcc/col/jcc-holocaust-memorial-garden-and-courtyard.

19. Oliver Lowenstein, "Natural Time and Human Experience: Andy Goldsworthy's Dialogue with Modernity," *Sculpture* 22, no. 5 (June 2003): 6.

20. Andy Goldsworthy and Terry Friedman, *Time* (New York: Harry N. Abrams, 2008), 7.

21. Bryan Bannon, "Re-Envisioning Nature: The Role of Aesthetics in Environmental Ethics," *Environmental Ethics* 33, no. 4 (Winter 2011): 428.

22. *Andy Goldsworthy's Rivers and Tides*, directed by Thomas Riedelsheimer, 2004.

23. Andy Goldsworthy and James Putnam, *Enclosure* (New York: Harry N. Abrams, 2007), 126.

24. Jeffrey Kastner, ed., *Land and Environmental Art* (London: Phaidon, 1998), 220.

25. Andy Goldsworthy, *Passage* (New York: Harry N. Abrams, 2004), 62.

26. Lowenstein, "Natural Time and Human Experience," 36.

27. Helen Pheby, "Layered Land: Andy Goldsworthy at Yorkshire Sculpture Park," Tate Papers #17 (Spring 2012), available at http://www.tate.org.uk/research/publications/tate-papers/17/layered-land-andy-goldsworthy-yorkshire-sculpture-park.

28. Pheby, "Layered Land."

29. Pheby, "Layered Land."

30. David Adams, "Joseph Beuys: Pioneer of a Radical Ecology," *Art Journal* (Summer 1992): 28.

31. For an overview of the project, see Heinrich Stachelhaus, *Joseph Beuys* (New York: Abbeville, 1987).

32. Joseph Beuys, quoted in Johannes Stüttgen, *Beschreibung eines Kunstwerkes* (Düsseldorf: Free International University, 1982), 1.

33. See the discussion of Beuys in relation to the Holocaust in Gene Ray, "Joseph Beuys and the After-Auschwitz Sublime," in *Joseph Beuys: Mapping the Legacy*, ed. Gene Ray (New York: Distributed Art Publishers and John and Mable Ringling Museum of Art, 2001).

34. Gene Ray, *Terror and the Sublime in Art and Critical Theory* (New York: Palgrave Macmillan, 2005), 36.

35. Caroline Tisdall, *Joseph Beuys* (New York: Solomon R. Guggenheim Museum, 1979), 21.

36. Tisdall, *Joseph Beuys*, 21.

37. Theodore Eisenman, "Memory Never Stands Still," *Landscape Architecture* 94, no. 6 (2004): 115.

38. Andy Goldsworthy and Simon Schama, "Garden of Stones: New York," in Andy Goldsworthy, *Passage*, 60.

39. Dan Bifelsky, "Canada Holocaust Memorial Neglects to Mention Jews," *New York Times*, October 5, 2017, available at https://www.nytimes.com/2017/10/05/world/canada/holocaust-memorial-jews.html.

40. Accessed March 2, 2018, available at http://www.stolpersteine.eu/en/news/.

# Selected Bibliography

Adams, David. "Joseph Beuys: Pioneer of a Radical Ecology." *Art Journal* (Summer 1992): 26–34.

Adorno, Theodor. *Aesthetic Theory*. Translated by C. Lenhardt. London: Routledge and Kegan Paul, 1970.

———. *Aesthetics and Politics*. Translated and edited by Ronald Taylor. London: New Left Books, 1977.

———. "Cultural Criticism and Society." In *Prisms*, translated by Samuel and Shierry Weber. London: Neville Spearman, 1967.

Akademie der Künste, ed. *Will Lammert (1892–1957): Plastik und Zeichnungen*. Berlin: Akademie der Künste, 1992.

Apel, Dora. *Memory Effects: The Holocaust and the Art of Secondary Witnessing*. New Brunswick, NJ: Rutgers University Press, 2002.

Apel, Linde. "Olga Benario—Kommunistin, Judin, Heldin?" In *Die Sprache des Gedenkens: Zur Geschichte des Gendenkstätte Ravensbrück 1945–1995*, edited by Insa Eschebach, Sigrid Jacobeit, and Susanne Lanwerd, 196–217. Berlin: Edition Hentrick, 1999.

Baigell, Matthew. *Jewish-American Artists and the Holocaust*. New Brunswick, NJ: Rutgers University Press, 1997.

Bajohr, Frank. "Von der Ausgrenzung zum Massenmord: Die Verfolgung der Hamburger Juden 1933–1945." In *Hamburg im "Dritten Reich,"* edited by Forschungsstelle für Zeitgeschichte in Hamburg, 471–518. Göttingen: Wallstein Verlag, 2005.

Bal, Mieke, Jonathan Crewe, and Leo Spitzer, eds. *Acts of Memory: Cultural Recall in the Present*. Hanover, NH: Dartmouth College, 1999.

Balkin Bach, Penny. *Public Art in Philadelphia*. Philadelphia: Temple University Press, 1992.

Bannon, Bryan. "Re-Envisioning Nature: The Role of Aesthetics in Environmental Ethics." *Environmental Ethics* 33, no. 4 (Winter 2011): 415–36.

Bar-Itzhak, Haya, and Raphael Patai. *Encyclopedia of Jewish Folklore and Traditions.* London: Routledge, 2013.

Bartke, Eberhard. "Das Denkmal." In *Das Buchenwald-Denkmal: Mit Beiträgen von Eberhard Bartke, Ulrich Kuhirt, Heinze Lüdecke*, edited by Eberhard Bartke, Ulrich Kuhirt, Heinze Lüdecke, and Fritz Cremer Bartke. Dresden: Verlag der Kunst, 1960.

Bartke, Eberhard, Ulrich Kuhirt, Heinze Lüdecke, and Fritz Cremer Bartke, eds. *Das Buchenwald-Denkmal: Mit Beiträgen von Eberhard Bartke, Ulrich Kuhirt, Heinze Lüdecke.* Dresden: Verlag der Kunst, 1960.

Baskind, Samantha. *Jewish Artists and the Bible in Twentieth Century America.* University Park: Pennsylvania State University Press, 2014.

———. "Navigating the Worldly and the Divine: Jewish American Artists on Judaism and Their Art." *Shofar: An Interdisciplinary Journal of Jewish Studies* 32, no. 1 (Fall 2013): 27–42.

Bauditz, Jan. "Aufbruch gegen Abriss—Die Bürgerinitiative Spandauer Vorstadt." In *Die Spandauer Vorstadt: Utopien und Realitäten zwischen Scheunenviertel und Friedrichstrasse*, edited by Peter Schubert, 30–42. Berlin: Argon Verlag, 1995.

Behr, Shulamith, David Fanning, and Douglas Jarman, eds. *Expressionism Reassessed.* Manchester: Manchester University Press, 1993.

Benton, Charlotte, ed. *Figuration/Abstraction: Strategies for Public Sculpture in Europe 1945–1968.* London: Routledge, 2017.

Bergen, Doris. *The Holocaust: A Concise History.* New York: Rowman and Littlefield, 2009.

Bergson, Henri. *Matter and Memory.* Translated by N. M. Paul and W. S. Palmer. London: Allen and Unwin, 1910.

Böhm, Ehrtfried. *Neu Plastik in Hannover / Kunstsinn, Mäzenatentum, Urbane Ästhetik / Ein Beispiel im Spiegel zweier Jahrzehnte.* Hannover: Steinbock-Verlag, 1967.

Braun, Günter, ed. *Orte Erinnern. Spuren des NS-Terrors in Berlin: Ein Wegweiser.* Berlin: Nicolai, 2003.

Browning, Christopher. *Ordinary Men: Reserve Battalion 101 and the Final Solution in Poland.* New York: HarperCollins, 1992.

Brüne, Gerd. *Pathos und Sozialismus: Studien zum plastischen Werk Fritz Cremers (1906–1993).* Weimar: Verlag und Datenbank für Geisteswissenschaften, 2005.

Büchten, Daniela, and Anja Frey, eds. *Im Irrgarten Deutscher Geschichte: Die Neue Wache 1818 bis 1993.* Berlin: Schriftenreihe des Aktiven Museums Faschismus und Wiederstand in Berlin, 1998.

Carrier, Peter. *Holocaust Monuments and National Memory Cultures in France and Germany.* New York: Jewish Museum with Prestel-Verlag, 1994.

Carruthers, Mary. *The Craft of Thought: Meditation, Rhetoric, and the Making of Images, 400–1200.* Cambridge: Cambridge University Press, 2000.

Chave, Anna. "Minimalism and the Rhetoric of Power." *Arts Magazine* 64 (January 1990): 44–63.

Cohen, Beth B. *Case Closed: Holocaust Survivors in Postwar America.* New Brunswick, NJ: Rutgers University Press, 2007.

Cooke, Lynne. "Thinking on Your Feet: Richard Serra's Sculpture in the Landscape." In *Richard Serra Sculpture: Forty Years*, edited by Kynaston McShine and Lynne Cooke, 77–104. New York: MOMA, 2007.

Cullen, Michael S., ed. *Das Holocaust-Mahnmal: Dokumentation einer Debatte*. Zurich: Pendo, 1999.

Daum, Andreas W., and Christof Mauch, eds. *Berlin–Washington, 1800–2000: Capital Cities, Cultural Representation, and National Identities*. Cambridge: Cambridge University Press, 2005.

Davidson, Cynthia. *Tracing Eisenman: Peter Eisenman Complete Works*. New York: Rizzoli, 2006.

de Certeau, Michel. *The Practice of Everyday Life*. Translated by Steve F. Randall. Berkeley: University of California Press, 1984.

Dekel, Irit. *Mediation at the Holocaust Memorial in Berlin*. Houndsmills, U.K.: Palgrave Macmillan, 2013.

Diefendort, Jeffry M., and Janet Ward, eds. *Transnationalism and the German City*. New York: Palgrave Macmillan, 2014.

Diner, Hasia K. *We Remember with Reverence and Love: American Jews and the Myth of Silence after the Holocaust, 1945–1962*. New York: New York University, 2009.

Doss, Erika. *Memorial Mania*. Chicago: University of Chicago Press, 2012.

Dublon-Knebel, Irith, ed. *A Holocaust Crossroads: Jewish Women and Children in Ravensbrück*. London: Vallentine Mitchell, 2010.

Eisenman, Peter. *Written into the Void*. New Haven, CT: Yale University Press, 2007.

Eschebach, Insa. "Soil, Ashes, Commemoration: Process of Sacralization at the Ravensbrück Former Concentration Camp." *History and Memory* 23, no. 1 (Spring/Summer 2011): 131–57.

Eschebach, Insa, Sigrid Jacobeit, and Susanne Lanwerd, eds. *Die Sprache des Gedenkens: Zur Geschichte des Gedenkstätte Ravensbrück 1945–1995*. Berlin: Edition Hentrick, 1999.

Fallace, Thomas D. *The Emergence of Holocaust Education in American Schools*. New York: Palgrave Macmillan, 2008.

Feist, Peter H. "Einleitung." In *Will Lammert*. Preface by Fritz Cremer. Introduction by Peter H. Feist. Catalogue of works by Marlies Lammert. Exhibition Catalogue, 7–23. Dresden: Verlag der Kunst, 1963.

Finkelpearl, Tom. *Dialogues in Public Art*. Cambridge, MA: MIT Press, 2001.

Flanzbaum, Hilene. *Americanization of the Holocaust*. Baltimore: Johns Hopkins University Press, 1999.

Foster, Hal, and Gordon Hughes, eds. *Richard Serra*. Cambridge, MA: MIT Press, 2000.

Foundation for the Memorial to the Murdered Jews of Europe. *Materials on the Memorial to the Murdered Jews of Europe*. Berlin: Nicolaische Verlagsbuchhandlung, 2005.

Fox, Thomas. *Stated Memory: East Germany and the Holocaust*. Rochester, NY: Camden House, 1999.

Frahm, Klaus. *Memorial to the Murdered Jews of Europe*. Berlin: Nicolaische Verlagsbuchhandlung, 2005.

Fried, Michael. "Art and Objecthood." *Artforum* (Summer 1967): 12–23.

Friedländer, Saul. *Probing the Limits of Representation: Nazism and the "Final Solution."* Cambridge, MA: Harvard University Press, 1992.

Friedman, Murray, ed. *Philadelphia Jewish Life.* Philadelphia: Temple University Press, 2003.

Fuhrmeister, Christian. "The Advantages of Abstract Art: Monoliths and Erratic Boulders as Monuments and (Public) Sculptures." In *Figuration/Abstraction: Strategies for Public Sculpture in Europe 1945–1968,* edited by Charlotte Benton, 107–26. Burlington, VT: Ashgate, 2004.

Funkenstein, Amos. *Perceptions of Jewish History.* Berkeley: University of California Press, 1993.

Gabler, Josephine. *Gerson Fehrenbach: Skulptur und Zeichnungen mit dem Werkverzeichnis der Skulpturen.* Exhibition catalogue, Georg Kolbe Museum. Berlin: Stiftung für Bildhauerei 2000.

Garrels, Gary. *Sol LeWitt: A Retrospective.* New Haven, CT: Yale University Press, 2000.

Gerstenberger, Katharina. *Writing the New Berlin: The German Capital in post-Wall Literature.* Columbia, SC: Camden House, 2008.

Giles, Geoffrey J. *Students and National Socialism in Germany.* Princeton, NJ: Princeton University Press, 1985.

Godfrey, Mark. *Abstraction and the Holocaust.* New Haven, CT: Yale University Press, 2007.

Goeschen, Ulrike. "From Socialist Realism to Art in Socialism: The Reception of Modernism as an Instigating Force in the Development of Art in the GDR." *Third Text* 23, no. 1 (January 2009): 45–53.

Goldhagen, Daniel Jonah. *Hitler's Willing Executioners: Ordinary Germans and the Holocaust.* New York: Vintage Books, 1996.

Goldsworthy, Andy. *Passage.* New York: Harry N. Abrams, 2004.

Goldsworthy, Andy, and Terry Friedman. *Time.* New York: Harry N. Abrams, 2008.

Goldsworthy, Andy, and James Putnam. *Enclosure.* New York: Harry N. Abrams, 2007.

Gross, Béatrice, ed. *Sol LeWitt.* Metz: Centre Pompidou-Metz, 2012.

Gutman, Israel. *The Jews of Warsaw, 1939–1943: Ghetto, Underground, Revolt.* Bloomington: Indiana University Press, 1982.

Haakenson, Thomas O. "(In)Visible Trauma: Michael Elmgreen and Ingar Dragset's Memorial to the Homosexuals Persecuted under the National Socialist Regime." In *Memorialization in Germany,* edited by Bill Niven and Chloe Paver, 146–56. New York: Palgrave Macmillan, 2010.

Halbwachs, Maurice. *On Collective Memory.* Translated by Lewis A. Coser. Chicago: University of Chicago Press, 1996.

Hansen-Glucklich, Jennifer. *Holocaust Memory Reframed: Museums and the Challenges of Holocaust Representation.* New Brunswick, NJ: Rutgers University Press, 2014.

Heartfield, John, ed. *Will Lammert—Gedächtnisausstellung.* Berlin: Akademie der Künste, 1959.

Heimrod, Ute, Günter Schlusche, and Horst Seferens, eds. *Der Denkmalstreit—das Denkmal? Die Debatte um das "Denkmal für die ermordeten Juden Europas": Eine Dokumentation.* Berlin: Philo Verlagsgesellschaft, 1999.

Herf, Jeffrey. *Divided Memory: The Nazi Past in the Two Germanys.* Cambridge, MA: Harvard University Press, 1997.

Hickey, Dave. *Ellsworth Kelly: New Paintings*. New York: Matthew Marks Gallery, 1998.

Hirsch, Marianne. *Family Frames: Photography, Narrative and Postmemory*. Cambridge, MA: Harvard University Press, 1997.

Hoffmann-Curtis, Kathrin. "Caritas und Kampf: Die Mahnmale in Ravensbrück." In *Die Sprache des Gedenkens: Zur Geschichte des Gendenkstätte Ravensbrück 1945–1995*, edited by Insa Eschebach, Sigrid Jacobeit, and Susanne Lanwerd, 55–67. Berlin: Edition Hentrick, 1999.

Huyssen, Andreas. "Monumental Seduction." In *Acts of Memory: Cultural Recall in the Present*, edited by Mieke Bal, Jonathan Crewe, and Leo Spitzer, 191–207. Hanover, NH: Dartmouth College, 1999.

Jacobs, Janet. *Memorializing the Holocaust: Gender, Genocide and Collective Memory*. New York: Macmillan, 2010.

Jaskot, Paul B. *The Nazi Perpetrator: Postwar German Art and the Politics of the Right*. Minneapolis: University of Minnesota Press, 2012.

Johe, Werner. *Hitler in Hamburg: Dokumente zu einem besonderen Verhältnis*. Hamburg: Ergebnisse-Verlag, 1996.

Johnson, Ken. "Art and Memory." *Art in America* 81 (November 1993): 90–99.

Jonker, Gerdien. *Topography of Remembrance*. Cologne: E. J. Brill, 1995.

Jordan, Jennifer A. *Structures of Memory: Understanding Urban Change in Berlin and Beyond*. New York: Jewish Museum with Prestel-Verlag, 1994.

Kabakov, Ilya. "Public Projects or the Spirit of a Place." *Third Text* 17, no. 4 (2003): 401–7.

Kastner, Jeffrey, ed. *Land and Environmental Art*. London: Phaidon, 1998.

Koonz, Claudia. "Between Memory and Oblivion: Concentration Camps in German Memory." In *Commemorations: The Politics of National Identity*, edited by John Gillis, 258–80. Princeton, NJ: Princeton University Press, 1994.

Koshar, Rudy. *From Monuments to Traces: Artifacts of German Memory, 1870–1999*. Berkeley: University of California Press, 2000.

Krauss, Rosalind. "Sculpture in the Expanded Field." In *The Originality of the Avant-Garde and Other Modernist Myths*, 276–90. Cambridge, MA: MIT Press, 1985.

Krempel, Ulrich. "Moderne und Gegenmoderne, der Nationalsozialismus und die bildende Kunst." In *Der Nationalsozialismus—die Zweite Geschichte*, edited by Peter Reichel, Harald Schmid, and Peter Steinbach. Bonn: Bundeszentrale für Politische Bildung, 2009.

Kürschner-Pelkmann, Frank. *Jüdisches Leben in Hamburg*. Hamburg: Dölling und Galitz, 1997.

LaCapra, Dominick. *History and Memory after Auschwitz*. Ithaca, NY: Cornell University Press, 1998.

Ladd, Brian. "East Berlin Political Monuments in the Late German Democratic Republic: Finding a Place for Marx and Engels." *Journal of Contemporary History* 37, no. 1 (2002): 91–104.

Lammert, Angela. "Will Lammert's Ravensbrück Memorial: The Image of Woman in German Post-War Public Sculpture." *Sculpture Journal* 9 (2003): 94–103.

Lammert, Marlies. "Dokumentation." In *Will Lammert (1892–1957)—Plastik und Zeichnungen, Ausstellung anlässlich des 100. Geburtstages des Künstlers*, edited by Ludwig Horst-Jörg, 98–131. Berlin: Akademie der Künste, 1992.

———. "Ein Denkmalsprojekt für Berlin: Zur Aufstellung der Plastikgruppe von Will Lammert." In *Studien zur Berliner Geschichte*, edited by Karl-Heinz Klingenburg, 281–96. Leipzig: E. A. Seeman, 1986.

———. *Will Lammert Ravensbrück*. Berlin: Deutsche Akademie der Künste zu Berlin, 1968.

Lanwerd, Susanne. "Skulpturales Gedenken: Die 'Tragende' des Bildhauers Will Lammert." In *Die Sprache des Gedenkens: Zur Geschichte der Gedenkstätte Ravensbrück 1945–1995*, edited by Insa Eschebach, Sigrid Jacobeit, and Susanne Lanwerd. Berlin: Edition Hentrich, 1999.

Laub, Dori, Harvey Peskin, and Nanette C. Auerhahn, eds. "Der Zweite Holocaust: Das Leben ist bedrohlich." *Psyche* 49, no. 1 (January 1995): 18–40.

Laub, Dori, and Daniel Podell. "Art and Trauma." *International Journal of Psycho-Analysis* 76 (1995): 991–1005.

Leggewie, Claus, and Erik Meyer. *"Ein Ort, and den man gerne geht": Das Holocaust-Mahnmal und die deutsche Geschichtspolitik nach 1989*. Munich: Carl Hanser Verlag, 2005.

Levy, Daniel, and Natan Sznaider. *The Holocaust and Memory in the Global Age*. Philadelphia: Temple University Press, 2006.

Linenthal, Edward T. *Preserving Memory: The Struggle to Create America's Holocaust Museum*. New York: Columbia University Press, 2001.

Lippard, Lucy. *Six Years: The Dematerialization of the Art Object from 1966 to 1972*. New York: Praeger, 1972.

Lippard, Lucy, and David Chandler. "The Dematerialization of Art." *Art International* (February 1968): 31–36.

Lipstadt, Deborah. *Denying the Holocaust: The Growing Assault on Truth and Memory*. New York: Free Press, 1993.

Littell, Marcia S. "Breaking the Silence: The Beginning of Holocaust Education in America." *Journal of Ecumenical Studies* 49, no. 1 (2014): 125–33.

Lowenstein, Oliver. "Natural Time and Human Experience: Andy Goldsworthy's Dialogue with Modernity." *Sculpture* 22, no. 5 (June 2003): 6.

Ludwig, Horst-Jörg, ed. *Will Lammert (1892–1957)—Plastik und Zeichnungen: Ausstellung anlässlich des 100. Geburtstages des Künstlers*. Berlin: Akademie der Künste, 1992.

Maier, Charles. *The Unmasterable Past: History, Holocaust and German National Identity*. Cambridge, MA: Harvard University Press, 1995.

McShine, Kynaston, and Lynne Cooke, eds. *Richard Serra Sculpture: Forty Years*. New York: MOMA, 2007.

Meyer, Beate. *A Fatal Balancing Act: The Dilemma of the Reich Association of Jews in Germany 1939–1945*. New York: Berghahn Books, 2013.

Meyer, Beate, Hermann Simon, and Chana Schütz, eds. *Jews in Nazi Berlin: From Kristallnacht to Liberation*. Chicago: University of Chicago Press, 2009.

Michalski, Sergiusz. *Public Monuments: Art in Political Bondage 1870–1997*. London: Reaktion Books, 1998.

Miller-Keller, Andrea. *Glenn–Ligon/MATRIX 120l*. Hartford, CT: Wadsworth Atheneum, 1992.

Milton, Sybil. *In Fitting Memory: The Art and Politics of Holocaust Memorials*. Detroit: Wayne State University Press, 1991.

Moore, Henry, and Alan Wilkinson. *Henry Moore: Writings and Conversations*. Edited by Alan Wilkinson. Berkeley: University of California Press, 2002.

Morsch, Günter, ed. *Von der Erinnerung zum Monument: Die Entstehungsgeschichte der Nationalen Mahn- und Gedenkstätte Sachsenhausen*. Berlin: Edition Hentrich, 1996.

Morschel, Jürgen. *Deutsche Kunst der sechziger Jahre: Plastik, Objekte, Aktionen*. Munich: Bruckmann, 1972.

Musil, Robert. "Denkmale." In *Gesammelte Werke*, edited by Adolf Frise, 480–83. Reinbek bei Hamburg: Rowolt, 1978.

———. "Monuments." In *Posthumous Papers of Living Author*, translated by Peter Wortsman. Hygiene, CO: Eridanos, 1987.

Neuman, Eran. *Shoah Presence: Architectural Representations of the Holocaust*. Surrey, U.K.: Ashgate, 2014.

Neumann, Klaus. *Shifting Memories: The Nazi Past in the New Germany*. Ann Arbor: University of Michigan Press, 2000.

Niven, Bill. *Facing the Nazi Past: United Germany and the Legacy of the Third Reich*. London: Routledge, 2002.

Nora, Pierre, and Lawrence D. Kritzman, eds. *Realms of Memory: The Construction of the French Past. Volume 1: Conflicts and Divisions*, translated by Arthur Goldhammer. New York: Columbia University Press, 1996.

Novick, Peter. *Holocaust in American Life*. New York: Mariner Books, 2000.

Ohana, David. *Modernism and Zionism*. New York: Cambridge University Press, 2012.

Ohff, Heinz. *Gerson Fehrenbach: Plastiken und Zeichnungen 1955–1979*. Berlin: Neue Berliner Kunstverein, 1979.

Ohnesorge, Birk. "In Analogie zur Natur: Das plastische Werk von Gerson Fehrenbach." In *Gerson Fehrenbach: Skulpturen und Zeichnungen—mit dem Werkverzeichnis der Skulpturen*, edited by Josephine Gabler, 11–26. Berlin: die Stiftung, 2000.

Olin, Margaret, and Robert S. Nelson, eds. *Monuments and Memory, Made and Unmade*. Chicago: University of Chicago Press, 2003.

Paret, Peter. *German Encounters with Modernism, 1840–1945*. Cambridge: Cambridge University Press, 2001.

Pheby, Helen. "Layered Land: Andy Goldsworthy at Yorkshire Sculpture Park." Tate Papers #17 (Spring 2012). Available at http://www.tate.org.uk/research/publications /tate-papers/17/layered-land-andy-goldsworthy-yorkshire-sculpture-park.

Plagemann, Volker. *Vaterstadt, Vaterland—Denkmäler in Hamburg*. Hamburg: H. Christians, 1986.

Plante, Michael. "'Things to Cover Walls': Ellsworth Kelly's Paris Paintings and the Tradition of Mural Decoration." *American Art* 9 (Spring 1995): 36–53.

Priess, Achim. *Abschied von der Kunst des 20. Jahrhunderts*. Weimar: VDG, 1999.

Puvogel, Ulrich. *Gedenkstätten für die Opfer des Nationalsozialismus*. Vol. 2. Bonn: Bundeszentrale für politische Bildung, 1999.

Ray, Gene, ed. *Joseph Beuys: Mapping the Legacy*. New York: Distributed Art Publishers and John and Mable Ringling Museum of Art, 2001.

———. *Terror and the Sublime in Art and Critical Theory*. New York: Palgrave MacMillan, 2005.

Reichel, Peter. *Politik mit der Erinnerung: Gedächtnisorte im Streit um die nationalsozialistische Vergangenheit*. München: C. Hanser, 1995.

Reichel, Peter, and Harald Schmid, eds. *Von der Katastrophe zum Stolpersteine.* Hamburg: Dölling und Galitz Verlag, 2005.

Reichelt, Matthias. *Testversuch: Entwürfe zum Holocaust-Denkmal.* Berlin: Taschenbuch, 2001.

Reynolds, Jock. *Joel Shapiro: Sculpture in Clay, Plaster, Wood, Iron, and Bronze, 1971–1997.* Andover, MA: Addison Gallery of American Art, 1998.

Rosenberg, Astrid. *Gerson Fehrenbachs Beitrag zur Deutschen Plastik im Informel.* Münster: Lit Verlag, 1996.

Rosenfeld, Gavriel. *Building after Auschwitz: Jewish Architecture and the Memory of the Holocaust.* New Haven, CT: Yale University Press, 2011.

Rosenthal, Mark. "Experiencing Presence." In *Ellsworth Kelly: A Retrospective,* edited by Diane Waldman. New York: Solomon R. Guggenheim Museum, 1996.

Rosh, Leah, and Eberhard Jäckel, eds. *Die Juden, das sind doch die anderen: Der Streit um ein deutsches Denkmal.* Berlin: Philo Verlagsgesellschaft, 1999.

Saidel, Rochelle G. *Never Too Late to Remember: The Politics behind New York City's Holocaust Museum.* New York: Holmes and Meyer, 1996.

Saltzman, Lisa. *Making Memory Matter: Strategies in Contemporary Art.* Chicago: University of Chicago Press, 2010.

Scharnowski, Susanne. "Heroes and Victims: The Aesthetics and Ideology of Monuments and Memorials in the GDR." In *Memorialization in Germany since 1945,* edited by Bill Niven and Chloe Paver, 267–75. London: Palgrave Macmillan, 2010.

Schmid, Harald. *Erinnern an den "Tag der Schuld": Das Novemberpogromnacht von 1938 in den deutschen Geschichtspolitik.* Hamburg: Ergebnisse-Verlag, 2001.

Schmid, Josef, ed. *Hamburg im "Dritten Reich."* Göttingen: Wallstein Verlag, 2005.

Schmidt, Ernst, ed. *Will Lammert in Essen.* Essen: Arbeiterwohlfahrt Essen, 1988.

Schubert, Peter. *Die Spandauer Vorstadt: Utopien und Realitäten zwischen Scheunenviertel und Friedrichstrasse.* Berlin: Argon, 1995.

Schwartz, Linda. "The Human Condition in Post-War Germany Revealed in Markus Lupertz's Sculptures." *Art Criticism* 19, no. 2 (2004): 105–20.

Senie, Harriet. "Andy Goldsworthy's Garden of Stones." *Public Art Review* 15, no. 2 (Spring/Summer 2004): 34–35.

Serra, Richard. *The Drowned and the Saved.* Cologne: Verlagshaus Wienand, 1992.

———, ed. *Richard Serra: Writings and Interviews.* Chicago: University of Chicago Press, 1994.

Shanken, Andrew M. "Planning Memory: Living Memorials in the United States during World War II." *Art Bulletin* 84, no. 1 (March 2002): 130–47.

Singer, Susannah, ed. *Sol LeWitt: Wall Drawings 1984–1992.* Andover, MA: Addison Gallery of American Art, Phillips Academy, 1992.

Sorscher, Nechama, and Lisa J. Cohen. "Trauma in Children of Holocaust Survivors: Transgenerational Effects." *American Journal of Orthopsychiatry* 67, no. 3 (July 1997): 493–500.

Spotts, Frederic. *Hitler and the Power of Aesthetics.* New York: Woodstock, 2003.

Stachelhaus, Heinrich. *Joseph Beuys.* New York: Abbeville, 1987.

Steinweis, Alan E. *Kristallnacht 1938.* Cambridge, MA: Belknap Press of Harvard University Press, 2009.

Stier, Oren Baruch. *Holocaust Icons: Symbolizing the Shoah in History and Memory.* New Brunswick, NJ: Rutgers University Press, 2015.

Stiftung Denkmal für die Ermordeten Juden Europas. *Materials on the Memorial to the Murdered Jews of Europe.* Berlin: Nicolai, 2005.

Stih, Renata, and Frieder Schnock. *Bus Stop: Fahrplan.* Berlin: Neuen Gesellschaft für Bildende Kunst, 1995.

Sturken, Marita. "The Wall, the Screen, and the Image: The Vietnam Veterans Memorial." In "Monumental Histories." Special issue, *Representations* 35 (Summer 1991): 118–42.

Stüttgen, Johannes. *Beschreibung eines Kunstwerkes.* Düsseldorf: Free International University, 1982.

Till, Karen. *The New Berlin: Memory, Politics, Place.* Minneapolis: University of Minnesota Press, 2005.

Tischer, Achim. *Brauchen wir ein Denkmal?* Temmen: Bremen, 2000.

Tisdall, Caroline. *Joseph Beuys.* New York: Solomon R. Guggenheim Museum, 1979.

Urban, Florian. *Neo-historical East Berlin: Architecture and Urban Design in the German Democratic Republic 1970–1990.* Burlington, VT: Ashgate, 2009.

Vergo, Peter, ed. *The New Museology.* London: Reaktion Books, 1989.

Vorhalt, Hanna. *Die Neue Wache.* Berlin: Taschenbuch, 2001.

Waldman, Diane, and Roberta Bernstein, eds. *Ellsworth Kelly: A Retrospective.* New York: Solomon R. Guggenheim Museum, 1997.

Weinberg, Jeshajahu, and Rina Elieli. *The Holocaust Museum in Washington.* New York: Rizzoli, 1995.

Wiedmer, Caroline Alice. *The Claims of Memory: Representations of the Holocaust in Contemporary Germany and France.* Ithaca, NY: Cornell University Press, 1999.

*Will Lammert.* Preface by Fritz Cremer. Introduction by Peter H. Feist. Catalogue of works by Marlies Lammert. Dresden: Verlag der Kunst, 1963.

Wilmes, Ulrich, ed. *Ellsworth Kelly Black and White.* Ostfildern: Hatje Cantz, 2011.

Yaffe, Richard. *Nathan Rapoport: Sculptures and Monuments.* New York: Shengold, 1980.

Yates, Frances A. *The Art of Memory.* Chicago: University of Chicago Press, 1966.

Young, James E., ed. *The Art of Memory: Holocaust Memorials in History.* New York: Prestel, 1994.

———. *At Memory's Edge: After-Images of the Holocaust in Contemporary Art and Architecture.* New Haven, CT: Yale University Press, 2000.

———. "Counter-Monument: Memory against Itself in Germany Today." *Critical Inquiry* 18, no. 2 (Winter 1992): 267–96.

———. *The Stages of Memory: Reflections on Memorial Art, Loss, and the Spaces Between.* Amherst: University of Massachusetts Press, 2016.

———. *The Texture of Memory: Holocaust Memorials and Meaning.* New Haven, CT: Yale University Press, 1993.

Zerubavel, Yael. *Recovered Roots: Collective Memory and the Making of Israeli National Tradition.* Chicago: University of Chicago Press, 1995.

# Index

Page locators followed by an "f" refer to a figure. Thus, 93f refers to a figure on page 93.

**Natasha Goldman** is research associate in Art History at Bowdoin College and president of WISSEN, Inc., a higher education and nonprofit consulting firm. She lives with her two sons and husband in Brookline, MA. For more information, visit: www.memorypassages.com and www.natashagoldman.com.